THE
MIRROR
BOOK

THE MIRROR BOOK

Using Reflective Surfaces in Art, Craft, and Design

**JAY HARTLEY NEWMAN
& LEE SCOTT NEWMAN**

CROWN PUBLISHERS, INC., NEW YORK

For Mah

Printed in the United States of America
Published simultaneously in Canada by
General Publishing Company Limited

Library of Congress Cataloging in Publication Data

Newman, Jay Hartley.
 The mirror book.

 Bibliography: p.
 Includes index.
 1. Mirrors. 2. Mirrors—Frames. 3. Reflective materials. 4. Handicraft. I. Newman, Lee Scott, joint author. II. Title.
TT898.3.N48 700 77-20225
ISBN 0-517-52965-3
ISBN 0-517-52966-1-pbk.

CONTENTS

ACKNOWLEDGMENTS

More than anything else, the help and encouragement of the many contributors to this book made it what it is. To them goes our deepest appreciation.

We owe very special thanks to a group of artists and craftsmen who gave us enormous help by allowing us to photograph them at work, arranging to have photographic sequences taken, and supplying photographs of their work: Carol Jeanne Abraham, Jan Axel, Julie Connell, Malcolm Fatzer, James Gilbert, Tim Glotzbach, Maud Guilfoyle, Lynda Katz, George Kunze, Dan Lawrence, Marcia Lewis, Marcia Lloyd, James Morgan, Peggy Moulton, Arlene Pitlick, Ginna Sadler, Cynthia Schira, Jason Seley, Ken Willis.

We would also like to acknowledge the National Association of Mirror Manufacturers and the Rohm and Haas Company for their great contributions to the field and to this book.

Another fine job of photo processing was done by Norm Smith, for which we are grateful.

Thanks also to Connie Joy Newman for her support. And last, but never least, our most profound thanks to our parents, Jack and Thelma Newman, who made major contributions to this book.

CONTRIBUTORS

Carol Jeanne Abraham
Joyce and Edgar Anderson
Judith Anderson
Arteluce
The Artist Shack
Jan Axel
Lillian Ball
T. R. Bambas
Raymond Barnhart
Bavarian National Museum
Dale Beckmann
Larry Bell
Suzanne Benton
Dale Binford
Scott Bliss
June Blum
Wendy Brawer
Hans Breder
Tad Bridenthal
Jeffrey Briggs
The British Museum
Richard Brooker
Hal Buckner
Erni Cabat

Jim Cantrell
Castelli Graphics
Wendell Castle
John Cederquist
Shirley Charron
Dennis Ching
Cirrus Gallery
Sas Colby
Julie Connell
Anna Continos
Rochella Cooper
Sharon Corgan-Leeber
Corning Glass Works
Lane Coulter
Andrew Crispo Gallery
Dee Davis
Davlyn Gallery
Jack Denst Designs
Design magazine
Terry Dintenfass, Inc.
Sara Drower
Don Drumm
Mike Duguay
Tom Eckert

Doug Edge
Fred Eversley
Greer Farris
Malcolm Fatzer
Jeanette Feldman
Susan Felix
Nancy Flanagan
Penelope Fleming
Ford Motor Company
Jacqueline Fossée
Mary Jean Fowler
Phyllis Freeman
French Tourist Office
Dee Frenkel
Priscilla Gagnon
Angelo C. Garzio
Glenn A. Gauvry
Gemini G.E.L.
Ed Ghossen
James Gilbert
Lukman Glasgow
Glass Arts of California
Tim Glotzbach
Stuart Golder
Robert Graham
Greenfield Village and
 Henry Ford Museum
Robert A. Griffith
Barbara Grygutis
Maud Guilfoyle
Perregrine Higgins
Saara Hopea-Untracht
William O. Huggins
Max Hutchinson Gallery
Linda S. Jackier
Brent Jenkins
Richard John
Jude Johnson
Lynda Katz
Peggy Kent
Kevin Roche/John Dinkeloo
 and Associates
Ed Kienholz
E. M. Klim
Sacha Kolin
Lew Korn
George Kunze
Murray Kusmin

La Barge Mirrors, Inc.
Stanley Landsman
Sharon La Pierre
Bradley Lastname
Gerald R. Laurence
Dan Lawrence
Leslie Leupp
Marcia Lewis
Libbey-Owens-Ford Company
Roy Lichtenstein
Marcia Lloyd
Steve Loar
Elisa Lottor
Jan Brooks Loyd
David Luck
John Makepeace
Mary Anne Mauro
Frank Mayer
Metropolitan Museum of Art
Barry Miller
Mirrex Corporation
Monique Knowlton Gallery
James Morgan
Peggy Moulton
Multiples, Inc.
Bill Nagengast
National Aeronautics and Space Administration
National Association of Mirror Manufacturers
National Gallery, London
National Products, Inc.
Newark Museum
Peter Nicholson
Barbara Anne Nilaūsen
Louise Odes-Neaderland
Meret Oppenheim
John Ottiano
Irene Pasinski
Victor Perez
Perkin-Elmer Corporation
Ron Pessolano
Arlene Pitlick
Laura K. Podenoe
John Portman and Associates
Marilyn Rabetz
Man Ray
Beverly Reiser
Gary Remsing
Steve Resz

Bob Richardson
George Rickey
Sharon Robinson
Rohm and Haas Company
Charles Roitz
Nelle Rootes
Richard Rosengarten
James Rosenquist
Charles Ross
Paul Rudolph
Betye Saar
Ginna Sadler
Ray Sage
Lucas Samaras
Sandia Laboratories
Carol Savid
Cynthia Schira
Herb Schumacher
Joel A. Schwartz
Norman L. Scutt
Jason Seley
Helen Shirk
Dusty Shuler
Carol Sitarsky
Robert Smithson

Florence Sohn
Sommer and Maca Industries, Inc.
Sheila Speller
Jean McMann Stein
Carren and Noel Strock
Pat Tavenner
Paul Taylor
Thermoplastic Processes, Inc.
Tomorrow Designs, Ltd.
Transilwrap Co.
Paul Tzanetopoulos
Lillian Vernon
Ed Viola
Walker Art Center
Edward Warner
Bea Wax
William Rockhill Nelson Gallery of Art
Ken Willis
Diana Schmidt Willner
Merry Moor Winnett
J. Fred Woell
Frank Wright
Sue Wrightsman
Elyn Zimmerman

PREFACE

The use of reflective materials has grown dramatically during the past twenty years. Craftsmen, artists, architects, and interior decorators have all found new and creative applications for the mirror medium.

Part of this increase in the use of reflective material can be accounted for by the larger range of reflective materials now on the market. Metal and glass are no longer the sole media. Acrylic mirror, metallized plastic specialty products, and metallized polyester film are revolutionary reflectors: lighter in weight and much more readily worked. As each of these new reflective materials came on the scene, the designer's mirror vocabulary grew.

Part of the increased use of mirror can be explained by a growing interest in the expansion of space. Mirror is a design tool that adds light and depth—a particularly appropriate property in a society where living spaces keep shrinking in size.

The result of this growth has been the development of reflective materials as a medium in their own right, as well as in forms primarily constructed of soft materials, ceramic, leather, or wood. This book documents the entire range. The creative designs included here reflect some of the best work being done today with mirror and the mirroring of images. We hope they'll inspire reflections of your own.

JAY HARTLEY NEWMAN
LEE SCOTT NEWMAN

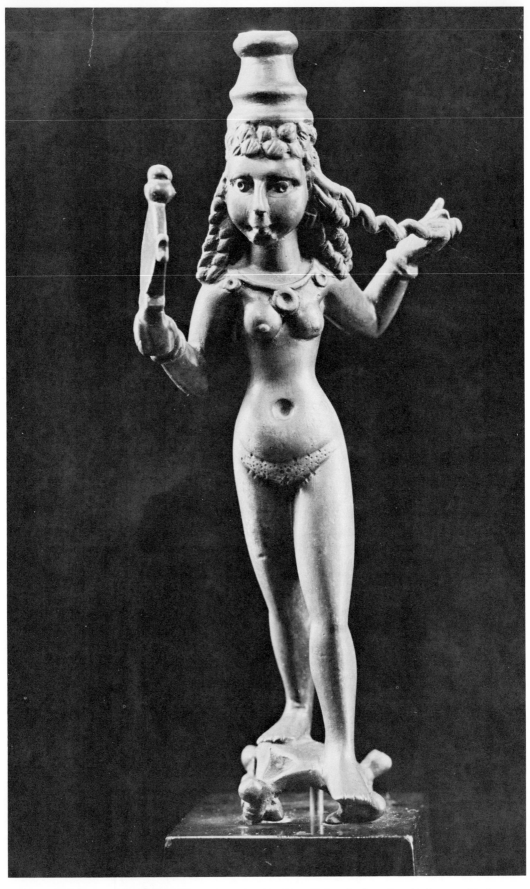

This bronze Astarte (goddess of love) is a Parthian (?) hand mirror handle from c. third century A.D. (7¾″ h). Man's vanity has been a driving force in the perfection of the mirror. *Courtesy: William Rockhill Nelson Gallery of Art, Nelson Fund*

1

REFLECTIONS ON MIRRORS

PEOPLE HAVE ALWAYS BEEN INTRIGUED BY THEMSELVES, AND SUBTLETIES OF feature and expression have been a large part of that fascination. Understandably, reflective surfaces—mirrors—have been sought, pondered, worshiped, and treasured for thousands of years.

Still pools probably served as the first mirrors. The ethereal quality of those shimmering images, which seemed to emerge from the water's depths, caused early man to seek mystical explanations of their existence. Legends of mermaids, water-souls, and creatures of darkness were born. A person's reflection, like his shadow, was thought to symbolize the soul. The illusory space beyond the reflecting surface was thought to be the next world. Not surprisingly, people in many cultures avoided the likeness in fear that a prolonged gaze might allow their spirit to be trapped forever. Similar superstitions persist. In many contemporary cultures, mirrors are covered in sickrooms to prevent the too easy transit of a weakened soul from this world to the next. Some peoples cover mirrors for a time after the death of a family member to avoid the added grief of seeing a lost loved one in the illusory space.

Tangible records of earlier man, his achievements, and his beliefs have survived because of the search for a more suitable means of reflection. Once man understood that *he* was the being staring up from the depths, fear subsided and curiosity increased. Mere pools would no longer suffice. He wanted to transport—to possess—the image.

1

Polished obsidian mirrors were among the first of man's portable reflectors. *Courtesy: The British Museum*

Glassy rocks like obsidian and phengite were man's first improvement on the puddle or pond. Both obsidian, a dark gray, semitransparent volcanic glass, and the translucent phengite could be highly polished to reflect accurately (if darkly). The Incas and the Chinese used them as long as four thousand years ago.

MIRRORS OF METAL

The Chinese were probably among the first to create metal mirrors. Bronze disks found in Honan tombs dating from the eighth century B.C. were almost certainly mirrors. But mirrors were not widely used, even in China, until the fifth century B.C. From that time on they appeared in great numbers and variety.

Ancient Chinese mirrors were valued funerary and religious objects, since mirrors were believed to be sources of light that would illuminate the everlasting darkness of the tomb. Of course, mirrors were toilet articles, too, and were regarded as sources of symbolic illumination, self-knowledge.

Most often, Chinese bronze mirrors were flat disks with highly polished faces and finely decorated backs. The earliest were small disks, probably worn at the waist. But as craftsmen grew more skillful, they created hand mirrors and much larger pieces that were mounted on stands. Nearly all of the portable mirrors had a loop handle or pierced boss on the back that served as a grip or accommodated a tassel.

The Chinese skill at casting and polishing was extraordinary. Fullest attention was paid to the execution of intricate designs that cover the mirror

backs. Mirrors were decorated with zigzag lozenge shapes, animals, dragons, and geometric devices. Some have astrological patterns or embody mythical forces of Tao folklore. Others appear to have been commemorative plaques with brief congratulatory inscriptions and the name of the maker.

Though the Chinese were among the first to create mirrors, ancient Egyptian mirrors are among the best known, perhaps because of their variety and significance in Egyptian culture. As in China, mirrors were regarded as sources of light—symbols of the sun, life-giver of the universe. Mirror handles were often symbolic, too. Many were shaped like the papyrus stalk, symbol of youthful vigor. Some were decorated in a relief design of plaits and twists, occasionally capped with the head of a goddess. Figures of minor gods also served as mirror handles, and in the Eighteenth Dynasty handles in the form of nude serving maids held polished disks for their owners. For this luxury-loving people, mirrors were an essential part of the toilet, an aid in applying protective oils and unguents, and cosmetics of malachite, galena, and red ochre.

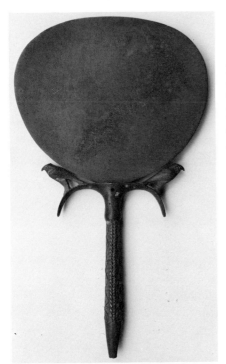

Egyptian costume and toilet mirror from Thebes. Egyptians had many costly mirrors of gold, silver, and bronze. This bronze piece dates from the Eighteenth Dynasty, c. 1500 B.C. *Courtesy: The Metropolitan Museum of Art, Carnarvon Collection. Gift of Edward S. Harkness, 1926*

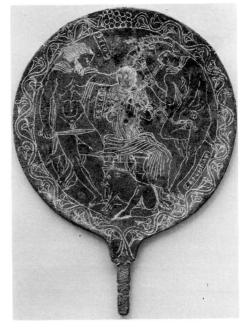

In this Etruscan bronze mirror, Odysseus attacks Circe in the presence of Elpenor. Their names are inscribed. It dates from the fourth century B.C. *Courtesy: The Metropolitan Museum of Art, Rogers Fund, 1909*

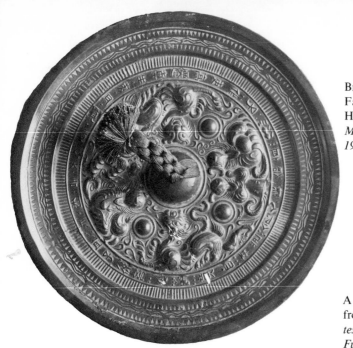

Bronze was a popular mirror throughout the Far East. This cast Chinese mirror is from the Han Period (206 B.C.–A.D. 220). *Courtesy; The Metropolitan Museum of Art, Rogers Fund, 1917*

A concave polished bronze Chinese mirror from the Six Dynasties (A.D. 265–618). *Courtesy: The Metropolitan Museum of Art, Rogers Fund, 1917*

Most Egyptian mirrors were highly polished bronze, probably because of the durability and quality of its reflecting surface. But the Egyptians also employed many other materials in their mirrors. Obsidian and black glass were used, and handles of bronze, wood, ivory, and faience often supported the oval and leaf-shaped forms. In contrast to Chinese mirrors, few Egyptian works were round.

Most precious of all, however, were the mirrors of gold and silver, possessions prized by the wealthy both for the rarity of the metals and for the fineness of the mirrors. Unfortunately, only a few silver mirrors and bronze mirrors showing traces of gold and silver plating have survived centuries of tomb robbers.

However, mirrors were never the sole province of China and Egypt. They have been a part of almost every culture. The Japanese introduced many refinements in the art of making mirrors of bronze, gold, and silver. Japanese craftsmen developed the so-called magic mirror—which could project pictures from the reflecting surface onto a nearby wall when exposed to bright light.

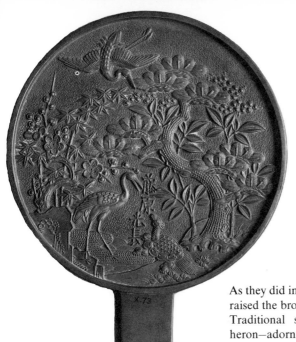

As they did in many forms of art and craft, the Japanese raised the bronze mirror to a high level of development. Traditional symbols of longevity—the tortoise and heron—adorn the back of this mirror. The piece dates to nineteenth-century Japan, Tokugawa Period (1603–1868). *Courtesy: The Metropolitan Museum of Art*

Their secret was to engrave the surface with fine lines first and then polish it. While the surface reflected accurately and the lines were invisible when viewed directly, traces of the engraving remained in the metal and bright light brought them out. In addition to the Japanese, Indian and Ceylonese artisans were skilled metalworkers in ancient times. East Asian idols, then as now, were often decorated with many, many small mirrors.

While mirrors appear to have received less attention in ancient Western cultures, the Greeks, Etruscans and Romans knew of mirrors and used them. In the fourth century B.C., Socrates urged his pupils to study their images carefully and to be wary of fouling their beauty by dishonor. Perseus slew Medusa while viewing her reflection in a mirror to avoid that lethal glance. Praxiteles, Plato, and Aristotle referred to mirrors. And legend has it that Archimedes, the Greek mathematician and scientist, used a large concave mirror of his own construction to set fire to an enemy's fleet of wooden ships. Considering the mirrors then available, however, it is doubtful that the legend contains much fact. Greek and Roman mirrors took a somewhat different form from those of the Far East or Fertile Crescent. Until the first century A.D., all were hand mirrors and quite small. Most consisted of a thin, slightly convex disk of highly polished bronze, gold, or silver that fit within a larger disk for support and protection. The larger disk was often incised with patterns or decorated in repoussé. By the end of the Dark Ages, the Celts had adopted the use of hand mirrors from the Romans, and their manufacture—usually they were made of silver—and their use became common throughout Europe.

During the Middle Ages metal mirrors were often made of an alloy of copper and tin known as speculum or steel. This hard, whitish amalgam took a high polish quite readily and, because of the quality of its surface, remained in use for a considerable period, even after mirrors of other materials became popular. Women began to wear small "steel" mirrors, encased in highly ornamented ivory, gold, and silver, from their belts. The reflective surface was sometimes protected from abrasion by transparent glass.

Although metal mirrors served people for hundreds of years, they were—and are—of limited usefulness in many applications. Reflective surfaces must be smooth, even, and flat to transmit images accurately. Metal mirrors, usually beginning as rough cast blanks ready to be ground and polished to a uniform level and surface, must be thick and, therefore, heavy to withstand processing and to maintain the necessary rigidity. Without weight and support behind the reflective surface, twisting and bending occur; this distorts the image, as would any surface imperfection.

MIRRORS OF GLASS

Glass mirrors remedied many of metal's deficiencies as a reflective medium. Relatively thin glass has good torsional stability—eliminating the need for thickness and weight in achieving accurate reflecting surfaces over larger spans. In addition, the plasticity of glass, and the fact that it is mirrored—coated with metallic foil or film—after it has been formed, broadly expands the range of mirror as a design medium.

Of course, perfection of glass mirror was a slow process. Even during the Middle Ages people knew that metal-backed glass would reflect like speculum, but impure materials and awkward processes impeded progress. The earliest glass mirrors of consistent quality were probably made by a method pioneered at Nuremberg during the twelfth and thirteenth centuries A.D. German craftsmen, who had by then developed considerable skill in the manufacture of bottles and containers of blown glass, introduced molten lead or tin into the still hot blown forms through the iron blowpipes. These small glass globes were then rotated until they were covered with a film of metal and were cut to size when cool. Because of their contours, such mirrors were often referred to as bull's-eyes. Larger mirrors were also made this way, as is suggested by the convex mirror that reflects the contents of a room (the painter's tour de force) in Van Eyck's 1434 painting of Giovanni Arnolfini on page 14.

Nuremberg remained a center for glass and mirror manufacture, but it was overshadowed by Venice during the sixteenth and early seventeenth centuries. In the early 1500s, Andrea and Domenico del Gallo obtained the exclusive rights to a vastly superior mirroring process invented in Germany or France. The del Gallos used only fine Venetian glass—the key to the success of their enterprise. The Venetian glass industry surpassed all others of mid-millennium in skill, diversity, and secrecy. The glassworks, housed on the island of Murano to concentrate the hazard of fire, monopolized world trade in their products by forbidding Venetian craftsmen to travel, reveal the secrets of their art, or export glassmaking tools or broken glass (which might be remelted elsewhere). Eventually, some artisans did defy the doges and carry their secrets

abroad but not before the world envied the quality of Murano's exports—and especially its glass mirrors.

The Venetians employed the so-called broad process of making glass panes for mirroring. As did Nuremberg mirror glass, Venetian glass began as a blown form. But rather than creating bubbles, the craftsmen blew long tubes. Each tube was severed from the blowpipe, its end cut away, and its body slit down the side and opened to create a flat sheet. The glass was then cooled slowly for several days in an annealing oven. After cooling, the plate of glass was ready for finishing.

No glass was smooth or optically perfect immediately after this broad forming, and both sides of each pane were ground and polished by rubbing the surfaces with abrasives of increasing fineness. Coarser abrasives were employed first to remove the most visible—the largest—imperfections, while the finer compounds were used later to impart a glossy finish.

After being polished, the glass was ready to be mirrored by the technique brought to Venice by the del Gallo brothers in the early 1500s. In that process, often known as foiling, tinfoil was made to adhere to glass with mercury. In one method, fine tinfoil was laid over chalk-sprinkled paper, mercury was poured and distributed evenly over the foil surface with a fur brush or cotton, and the glass was placed on top. Weights applied to the glass squeezed out excess mercury. When the adhesive dried, the mirror was complete. There were, of course, many variations, but tin-mercury remained the primary method of mirroring glass for four hundred years—long after emigrant craftsmen carried it throughout the world.

While Venice's monopoly lasted, fine glass mirrors remained extremely expensive, and large mirrors were scarce at any price. The wealthy protected their specular investments with clear glass and with ornate frames of carved wood and precious metal. One such looking glass, two feet by four feet and framed in hand-wrought silver, was valued in the late 1600s at three times the worth of a painting by Raphael. Much of that value lay in the uniqueness of fine mirrors, however, and mirror prices fell considerably when the French and British broke the Venetian monopoly in the mid-seventeenth century.

The first French mirror factory was probably constructed in Paris in 1668 and moved soon after to the site of the famous St. Gobain glassworks. By the 1670s French craftsmen had reinvented and begun the practice of a process known to but little used by the Romans, and unknown in Venice—glass casting. This technique represented a great technical advance over the broad glass process in which blown glass forms were opened and flattened to produce sheets. The French cast glass by pouring the molten material onto a flat metal-topped table with raised sides, the height of the desired thickness in the finished plate, which supported the flowing mass. A metal rod was rolled over the surface of the still malleable material to flatten and smooth it as much as possible before grinding and polishing. By this method, sheets seven feet by four feet—nearly double the size of broad process panes—were manufactured. Such large panes made possible the Hall of Mirrors at Versailles, where Louis XIV dazzled his court with brilliant and endless reflections from his jeweled crown. The example inspired royal courts throughout Europe to employ mirrors as architectural and decorative elements.

STYLES OF MIRROR FRAMES

Chippendale
(1740-1779)

A style named for a master craftsman of the era, Thomas Chippendale, who combined the various details of Rococo, Gothic and Chinese in his furniture. The design effect, ponderous and ornate, comes from the richly carved surfaces and not the ornamentation.

Louis XV
(1715-1774)

Decorative and beautiful, mirrors of this period were marked by feminine Rococo style, dainty scale, free naturalistic ornament, sinuous curves and flowing lines.

Contemporary

Contemporary is a number of things—all part of our times, reflecting the here and now —and it will continue to grow and change as new concepts and materials are developed. Earmarks of good modern design: the use of machine-age materials (often glass, chrome, steel), clean, uncluttered style stemming directly from function, absence of applied ornamentation. A contemporary style mirror can strike a beautiful balance with antique French, English and Italian furniture because they share the same design integrity.

Queen Anne
(1702-1714)

The Queen Anne period of design concentrated on gentle curved forms. Curves were sophisticated and sleek, showing restraint and discipline.

Hepplewhite
(1770-1790)

The individual style of George Hepplewhite, London cabinetmaker and designer, emphasized lightness, gracefulness and elegance with a pure beauty of line. His work was refined, free from bizarre motifs; painting was the favorite decoration.

Regency Convex
Wall Mirror

An Empire style circular convex mirror in a carved and molded gold frame...originally introduced from France toward the end of the 18th century. It is strongly identified with the Federal period in America (1789-1830). Cresting was usually surmounted with a spread eagle, and the base was ornamented with carved foliage.

Federal
(1780-1830)

A classic style from the early years of the American Republic when the eagle was a popular motif. Mirrors were architectural in feeling and of simple proportions, outlined in thin gilt frames of Pompeiian inspiration.

Spanish Colonial

This provincial style reflects the European influence as interpreted by Spanish peasants in the 17th and 18th centuries. The design is robust and direct, marked by heavy scale, dark finishes and bold carving.

Venetian

Designs from Venice of the mid-18th century were highly flamboyant, ornamental, and theatrical in outline. Mirrors were often elaborately painted and/or gilded.

Courtesy: Libbey-Owens-Ford Company

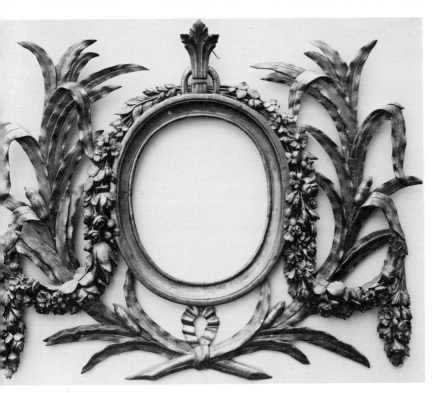

French gilded wood mirror frame from the seventeenth to eighteenth centuries. *Courtesy: The Metropolitan Museum of Art. Gift of J. Pierpont Morgan*

Architectural applications for mirror began stunningly at Versailles. The Hall of Mirrors is an example of the first Louis XIV style, which makes a point of using noble materials such as marble, bronze, carved or gilded brass, and copper, and many mirrored surfaces. *Courtesy: French Government Tourist Office*

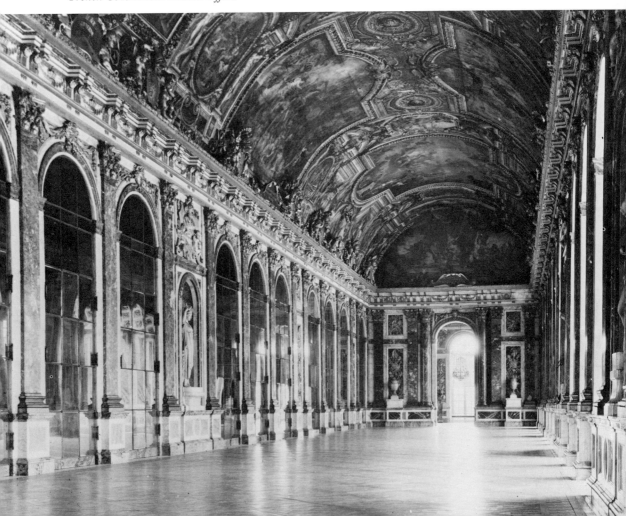

The English, however, probably undertook the manufacture of glass and glass mirror with the greatest vigor. Glass is believed to have been made in England since Roman times, but until the early seventeenth century, no one produced panes—or any glass product—of quality sufficient to rival Venetian wares. However, with Elizabeth I's encouragement, emigrant craftsmen took up the manufacture of glass products in England during the late 1500s. Employing other Venetians, these early glass producers marketed glass greatly superior to previous English efforts and, by some accounts, better than imports from Murano. By mid-century, good quality mirror had begun to be produced in many parts of England, and by century-end the industry was sufficiently developed to sustain a twenty percent tax on its product to help support a war against the French.

The eighteenth century saw the establishment of still more glasshouses and mirror-making enterprises. By the 1750s, the British Plate Glass Company had begun the manufacture of glass by casting and rolling—the process developed in France. The famous firm of Pilkington Brothers (which soon acquired British Plate Glass) began its existence at nearly the same time and began, as well, its history of innovation in glass manufacture. Pilkington developed the use of conveyors in producing plate glass, a system by which glass is moved continuously while being ground and polished on both sides. In 1958 the company revolutionized glass manufacture with its "float" glass process—used today by virtually all large glassmakers—in which fluid glass is floated on molten tin in such a manner that the glass adopts the smooth surface of the metal. The resulting product, which needs no grinding or polishing, is believed to be as fine and free of blemishes as the best ground plate glass.

The intensive efforts of the French and British to improve their glass and mirror technology brought about great increases in pane (and mirror) size and production. With this new-availability, many new applications were discovered for the material. Before the successful seventeenth-century campaign to wrest control of the glassmaking and tinning arts from the Venetians, mirrors were too expensive and scarce to be used as other than small, personal toilet articles. But then access to larger quantities of finer quality mirror at somewhat lower prices spurred exploration of previously unforeseen uses. Mirrors were soon employed in furniture and, increasingly, as architectural elements. Louis XIV's unique, extravagant mirror gallery may have been the first and grandest example of newly perfected products, but if the scale was not duplicated, the idea became much copied. By the 1670s, fine quality mirror could be found covering entire walls and rooms of Sir Samuel Morland, Nell Gwynne, and the Duchess of Portsmouth. However, by that time, larger mirrors were no longer the sole province of royalty and the very wealthy. A growing middle class had discovered the practical—as well as aesthetic—advantages offered by mirrors. Wall mirrors were recognized to significantly multiply the brightness of a room when strategically placed to reflect a light source. In this role, glass mirrors soon replaced the traditional, but much less efficient, technique of placing candles before polished metal plates that directed more light into a room. In addition, people began to appreciate the uplifting illusion of increased space created by mirrors.

While fine quality mirrors have never been inexpensive, the combined

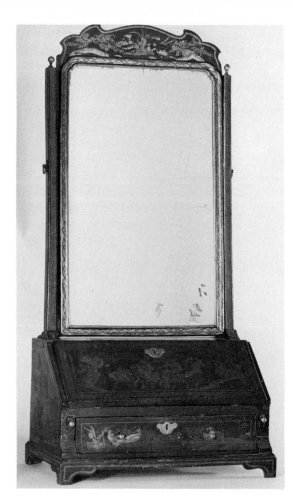

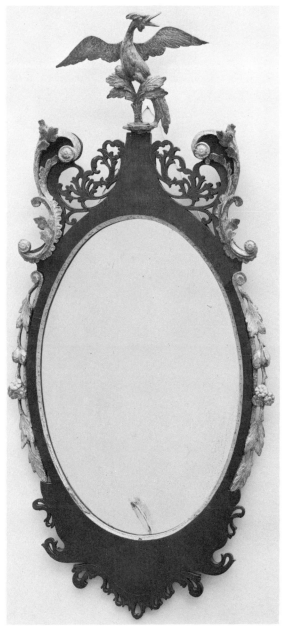

The mirror can be tilted in this American (?) dressing stand, c. 1720. The stand is made of oak and is decorated with decoupage (japanning). *Courtesy: The Metropolitan Museum of Art, Purchase, 1940, Joseph Pulitzer Bequest*

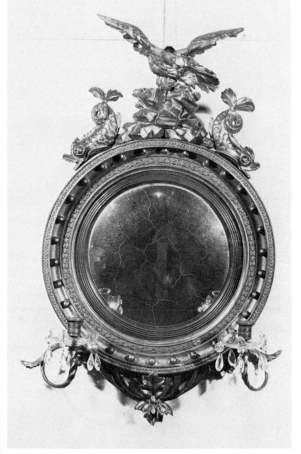

Oval mirror (45″ × 20½″) in the Chippendale style, carved of mahogany and gilded, was made during the third quarter of the eighteenth century in New York. *Courtesy: The Metropolitan Museum of Art, Sansbury-Mills Fund, 1952*

The Empire Style convex mirror is often associated with the American Federal period. This American carved and gilded piece (31″ × 21″) dates from the 1800s. *Courtesy: William Rockhill Nelson Gallery of Art, Nelson Fund*

factors of appreciation for their beauty, increased prosperity, and price reductions resulting from technological advances and economics of scale, encouraged many more people to acquire ever larger pieces. In fact, by the eighteenth century, most homes contained at least one wall mirror. And with proliferation of mirrors came not only further interest in and application of the material, but increased ornamentation and variation of mirror frames—a cycle of fad and fancy begun during the 1600s.

Mirror frames became the vehicle for some of the finest craftsmanship ever seen—with magnificent (and sometimes garish) results. Frames were constructed of silver, ivory, and tortoiseshell and were carved of every variety of wood. In the 1690s large mirrors were set upon elaborate mantelpieces. In the eighteenth century British designers followed the interest in Oriental lacquer and created frames of decoupage or japanning. Frames decorated with dyed straw were another rage, and during the same period the French evidenced a preference for circular mirrors in gilt frames.

Of course, mirror frames have ever since reflected contemporary design trends, and as our concern with space and illusion has developed, so has the fascination with mirror's reflective properties and potential. From the home, the use of mirrors spread to restaurants and stores. Today, every kind of commercial structure seems to have been covered with mirrors and mirrorlike materials—out to and including the expansive glass façades of twentieth-century skyscrapers.

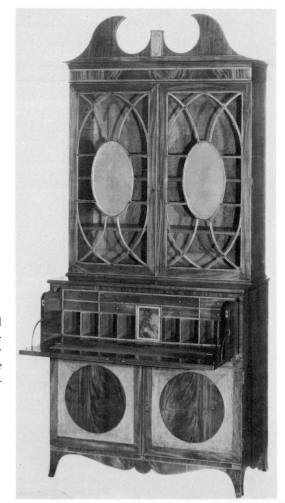

A pair of oval mirrors are integral elements in the design of this Hepplewhite dish and book case. *Courtesy: Collections of Greenfield Village and the Henry Ford Museum, Dearborn, Michigan*

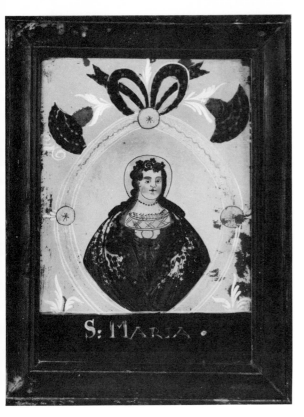

European folk painting on glass, which was later mirrored. *Courtesy: Bavarian National Museum, Munich, Germany*

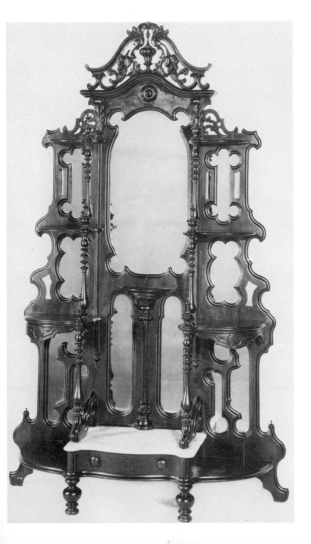

This Sheraton chest of drawers with a pivoting oval mirror also dates from the late eighteenth century. *Courtesy: Collections of Greenfield Village and the Henry Ford Museum, Dearborn, Michigan*

Victorian étagère, with elaborate carvings surrounding mirror panels. *Courtesy: Collection of Greenfield Village and the Henry Ford Museum, Dearborn, Michigan*

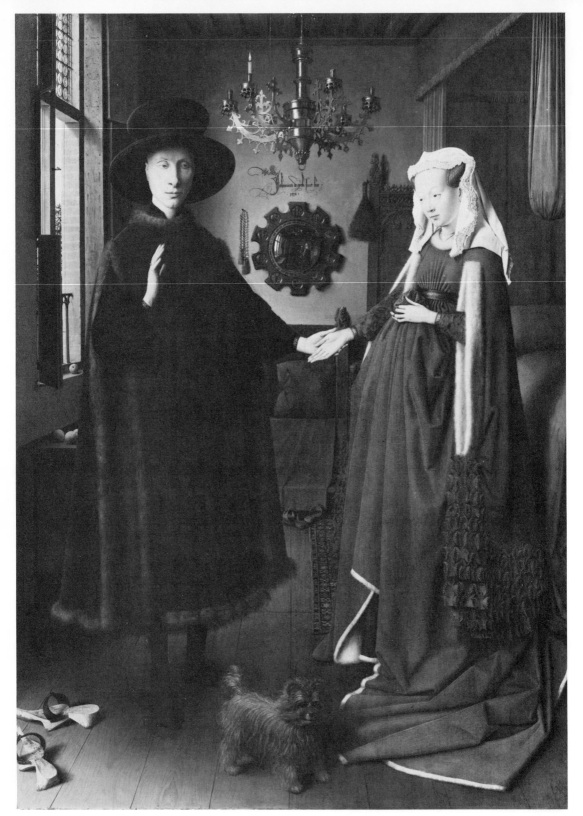

Jan van Eyck. *Giovanni Arnolfini and His Bride* (1434) (33″ × 22½″). A convex mirror in the bridal chamber reflects not only the backs of the bride and groom but also two other figures who have entered the room— probably the artist and another witness to the ceremony. "Jan van Eyck was here" is printed above the mirror. *Courtesy: The Trustees, The National Gallery, London*

SILVERED MIRRORS AND OTHER INNOVATIONS

Good glass, however, is only one branch of the technological developments that have made fine quality glass mirror possible. In fact, "modern" mirrors really date from the discovery, in the 1840s, of the chemical reaction that allowed silver to be deposited on glass to create a brilliant mirror simply by combining the chemicals and pouring the solution. Different chemists and inventors are credited with this breakthrough; the British claim Thomas Drayton as originator of the method, the Italians name Signore Choron, and the French offer Tony Petitjean. While all fully appear to have contributed suggestions and refinements to the basic process (many of which were recorded and protected by patents), the German chemist Justus von Liebig is named most often as the first observer and communicator of the elemental chemical reaction in which silver is reduced by aldehydes and deposited on glass.*

Liebig himself appears not to have had very great commercial success with his several silvering enterprises, perhaps because, as one contemporary commentator has suggested, Liebig's basic formula omitted the use of a solution that sensitizes the glass, allowing it to accept the silver coating more readily. Nonetheless, silvering was soon perfected and supplanted the more cumbersome (though equally effective) tinning process. Innumerable refinements and variations of the silvering process, which remains the predominant method of making mirrors, have emerged since the 1840s. In addition to being poured onto glass, silver solutions are now often sprayed onto the surface, and mirrors need not be only silver in color. Gold mirrors were made as long ago as 1855 by both Liebig and Petitjean, and while this metal is expensive, semitransparent (thinly coated), gold mirrors are particularly effective in specialized applications, such as screening heat radiation. A formula for making copper mirrors, which produce pink images, was patented in 1900, and lead-sulfide has been employed to create gray-blue mirrors of somewhat reduced reflectivity.

The chemical techniques of making glass mirrors—tinning and silvering—have quite a long history in comparison to the most modern methods in which metals are physically, rather than chemically, deposited. The first successful physical deposition of metal on glass was reported in 1852, but the earliest practical applications of the technique did not emerge until the early part of the twentieth century. A vacuum and the use of high-voltage electricity characterize both of the basic deposition processes: "sputtering" and "evaporation." The latter (also known as vacuum metallizing) is used most often because of its greater efficiency. The principles involved are simple. The object or material to be metallized—and it might be anything from glass to paper, fabric, wood, plastic, or leather—is placed within a vacuum chamber, along with the metal to be deposited, which is hung on tungsten coils. After the chamber has been exhausted, a high current of electricity is passed through the

* See Appendix for details of the chemical and physical processes associated with making silver mirrors.

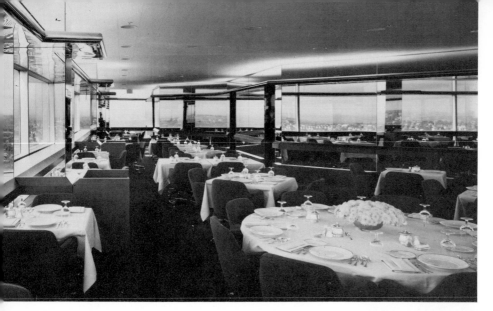

The horizon continues to expand for the applications of mirror in architecture. The scenery and light provided by the windows is repeated and intensified by plate-glass mirrors in this dining room atop the Worcester County National Bank. *Courtesy: Kevin Roche/John Dinkeloo and Associates*

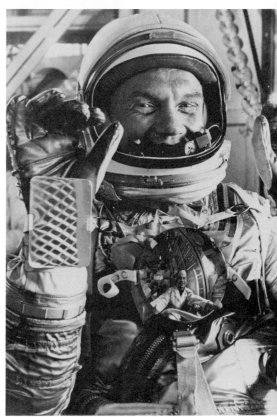

Convex mirrors haven't lost their usefulness in art *or* science. Former astronaut John H. Glenn, Jr., had convex mirrors strapped to his chest and arms to give him a broader visual field in the Mercury-Atlas 6 rocket. *Courtesy: National Aeronautics and Space Administration*

coil of tungsten, causing it to become very hot and vaporize the metal, which condenses on the glass or other material in its path. Any metal can be deposited by this technique, including gold, silver, copper, and chromium. Aluminum, however, is used often because it is less expensive, is highly resistant to corrosion, adheres to glass best, and produces a harder film, which can be cleaned with less fear of damaging the metal or removing it from the glass.

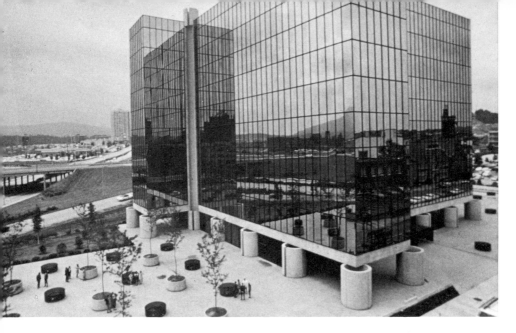

Sensational architectural effects can be achieved by using reflective surfaces on the outside of skyscrapers. The reflective gold tint of the Blue Cross/Blue Shield Office Building in Chattanooga, Tennessee, helps the structure adapt to its location.

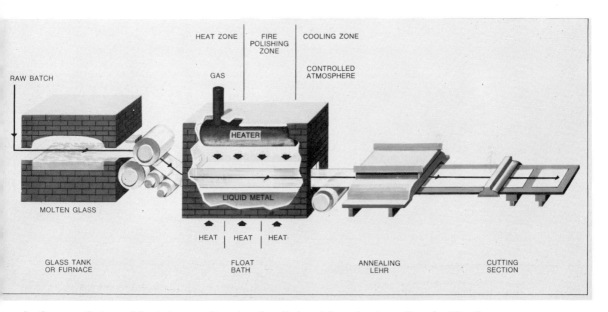

In the manufacture of float glass, molten glass is rolled and flowed onto molten tin. The tin float is divided into three zones. In the first zone, heat from molten tin and the top heater causes glass to float uniformly over the perfectly flat surface, creating a ribbon of glass with parallel surfaces. The second zone gives the glass a brilliant finish. The third zone (cooling zone) maintains flatness and transparency of glass until it is hard enough to be conveyed to an annealing oven (lehr). Here the temperature of glass is lowered through temperature zones. *Courtesy: National Association of Mirror Manufacturers*

17

Mirrors made by evaporating metal are most often "front" or "first" surface mirrors in which the surface doing the reflecting is not protected or covered, as is the case with most silvered forms. Such mirrors are important in scientific applications (for which they are made to exacting specifications, often using beryllium as well as aluminum), since they eliminate the ghost, or shadow, reflection from the front surface of highly polished glass, which occurs in back mirrored pieces. The reflective surface is protected from abrasion and corrosion with coatings of transparent lacquer.

Vacuum metallizing has other applications as well, particularly in depositing reflective metal film on materials such as paper and fabric. But the most extensive use is in coating plastics, especially polyester film and acrylic.

Mirrors of plastic, which can also be made by silvering or by using a wide range of related processes, offer the greatest design potential of all innovations in mirror production technology. Not only do they bring man a step closer to the goal of lightweight, unbreakable mirrors, but they expand design perimeters dramatically. Acrylic, for example, may be heat-formed and then silvered or silvered and then bent with strip heaters. Both before and after silvering, acrylic may be cut easily with a band saw into intricate shapes. Mirrored polyester films offer unique advantages of their own. Reflective films have been stretched over frames of extruded metal to create extremely light and true reflectors with very large spans.

Sunshine can be brought indoors by means of mirrors. Mike Duguay and R. M. Edgar have developed a system in which mirrors on the roof track the sun and relay its beams through holes in the roof. Inside, the sunlight beams can be relayed throughout the building by means of mirrors and convex lenses. Cool lighting is obtained by using special dielectric mirrors that separate visible light from infrared. The infrared part of the solar spectrum can be used to generate electricity and usable heat in solar energy cells, while visible light is piped on. Mirrors can keep the light moving throughout the building, and they can also relay parts of the light onto diffuser screens to light each room.

CONTEMPORARY APPLICATIONS OF MIRRORS

In addition to their increasing use as practical, decorative, and architectural elements, mirrors have become indispensable in many other fields. Their extensive use in art and craft is, for example, the very reason for this exploration of the vast aesthetic potential for reflective materials. In the sciences, however, mirrors have become truly essential.

Today, mirrors are part of most cameras, and precise reflectors are the essence of the reflecting telescope. Parabolic concentrators that employ hundreds or thousands of mirrors to focus the rays of the sun (as Archimedes was reputed to have done) may become a basic means of harnessing solar energy for use both on earth and in space. And the mirror plays a pivotal role in the process of concentrating light in lasers—which play significant functions in industry, medicine, communication, space exploration, and defense.

Mirrors, in short, are more useful, more effective, more various, more versatile, and a source of greater pleasure than ever before. But as their history suggests, mirrors probably remain a resource of greater potential than anyone now imagines.

Light coming down from the roof is intensified by a convex lens and a series of mirrors that direct it through space.

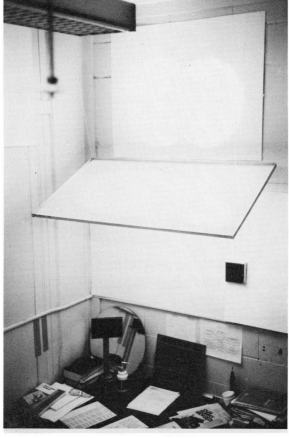

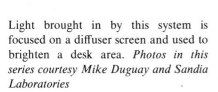

Light brought in by this system is focused on a diffuser screen and used to brighten a desk area. *Photos in this series courtesy Mike Duguay and Sandia Laboratories*

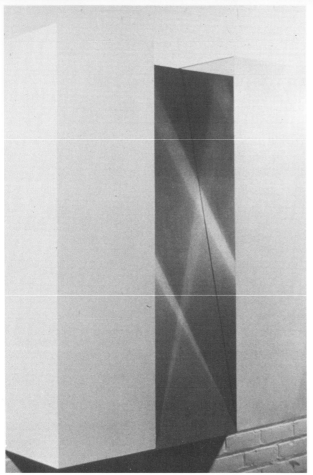

Richard Brooker uses mirror's ability to reflect light in his sculpture constructions such as *Construction with Mirrors* (1974) (4′ × 5′ × 14″). *Courtesy: Richard Brooker*

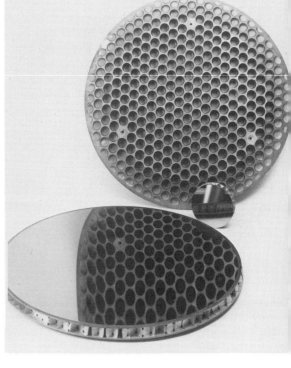

Highly polished beryllium mirrors represent one of the greatest developments in mirror technology. The eggcrate construction that backs the mirror reinforces the surface. First surface beryllium mirrors have important application in science, particularly in telescopes and high-energy lasers. *Courtesy: Perkin-Elmer*

Stargazing with reflective surfaces has different meaning for scientist and artist. Chromed mylar, foil stars, mirrored sunglasses, and color Xerox were combined in this print, *Portrait of Peter Alexander* (1976) (8½″ × 14″) by Victor Perez, from *The Venice, California, Suite. Courtesy: Victor Perez*

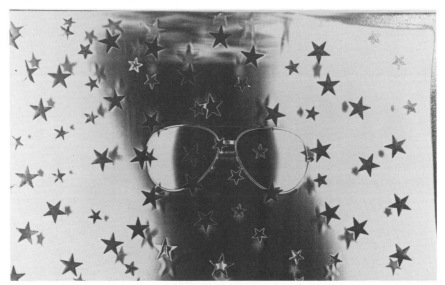

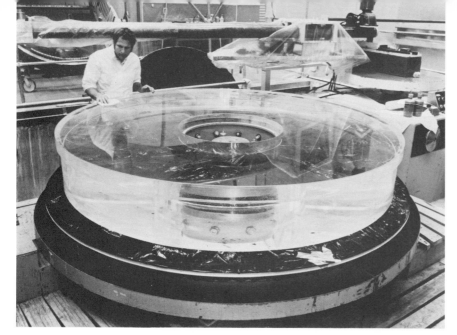

A technician at the Optical Science Center of the University of Arizona at Tucson inspects the 101″-diameter glass mirror blank made for the Carnegie Southern Observatory. The fused silica mirror was made by Corning Glass Works for the observatory's Du Pont telescope in Chile. The disc has required three years of grinding and polishing into a paraboloidal surface. In Chile, it will be mirrored on its first surface with a thin film of aluminum "steamed" onto it inside a huge steel vacuum tank. A mirror is used instead of a lens because the emphasis of the telescope must be on light-gathering ability and high resolving power, rather than on magnification. *Courtesy: Corning Glass Works*

This 144″-diameter fused silica mirror blank was manufactured by Corning for the European Southern Observatory, also in Chile. Glass is used in these mirrors because of the material's great tolerance for temperature changes. If the disc were to shrink, expand, or change curvature by even a few millionths of an inch, its usefulness for astronomical observation would be severely impaired. *Courtesy: Corning Glass Works*

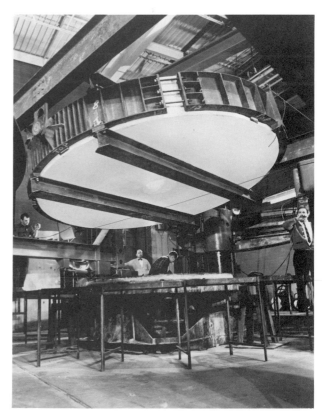

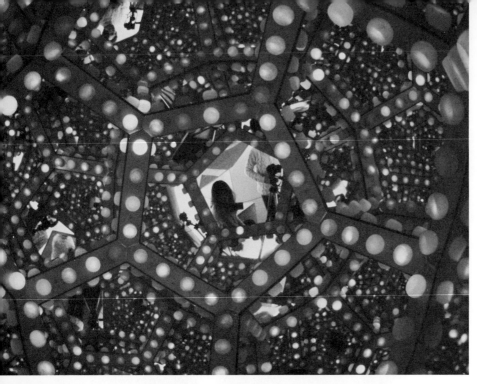

A mirrored, colored-light environment by Tad Bridenthal, *Limbic System.* Lighting keeps changing, and the person inside the environment must constantly reckon with the changes and infinity of repeated images. *Courtesy: Tad Bridenthal*

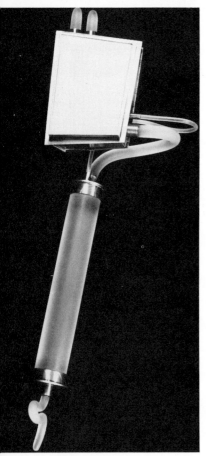 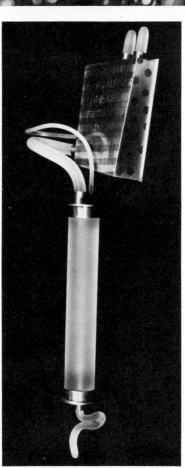

Hand mirror design has come a long way in two thousand years. This hand mirror (1976) by Leslie Leupp was constructed from sterling silver and copper sheet stock. The decorative polka dots and stripes are not a surface treatment but penetrate through the entire thickness of the silver and are soldered in place. Lucite rods were used to construct handle and appendages. A frame of delrin sheet surrounds the mirror. *Courtesy: Leslie Leupp*

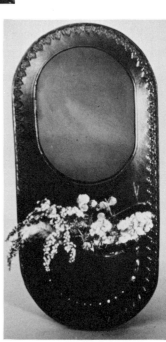

Leather also has a sumptuousness compatible with mirror design. Steve Resz's planter mirror is made from 3/16″-thick 8-oz. top-grain cowhide. The molded and tooled leather is attached with brass tacks and made watertight so that the planter is functional. *Courtesy: Steve Resz. Photo: Justin A. Schaffer*

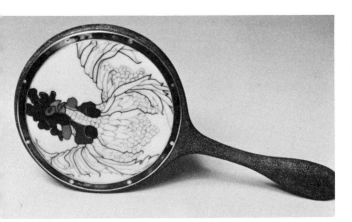

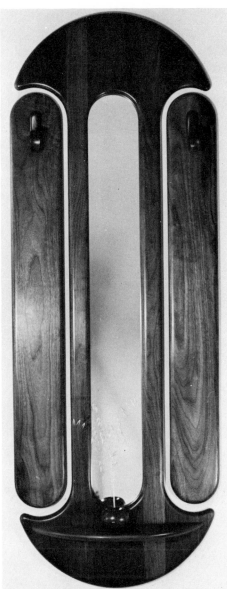

In this hand mirror by David Luck, acrylic is cut into mosaic pieces and set in a mirror frame of sand-cast aluminum. The mosaics are grouted with epoxy resin. Upon hardening, the mosaic design was sanded flat and polished. *Courtesy: David Luck*

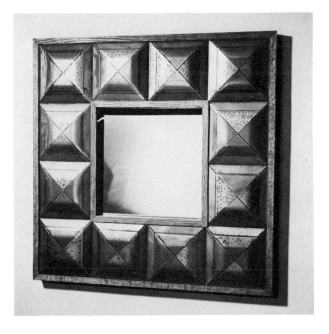

The richness of wood combined with the clarity of mirror has always had great appeal for the craftsman. This *Hall Tree* (57″ × 22″ × 6″) by Richard John is black walnut with plate-glass mirror. *Courtesy: Richard John*

Between inner and outer frames of chestnut wood (20½″ square) are 12 convex panels of transparent gold, green, and orange enamel on copper by Saara Hopea-Untracht. *Courtesy: Saara Hopea-Untracht. Photo: Oppi*

23

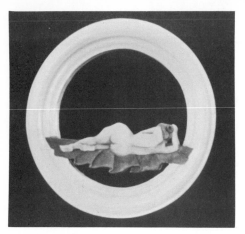

Ceramics can be combined with mirror to serve both decorative and functional interests. Ceramic mirror by Marilyn Rabetz, made of white stoneware and carved in bas-relief. *Courtesy: Marilyn Rabetz*

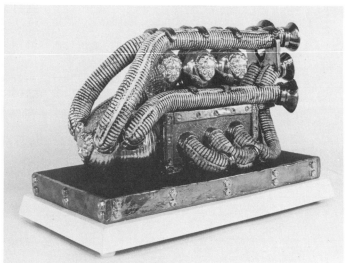

Ceramic can accept also a mirror-like luster glaze to become a reflecting object itself, as in this sculpture by Greer Farris. *Courtesy: Greer Farris*

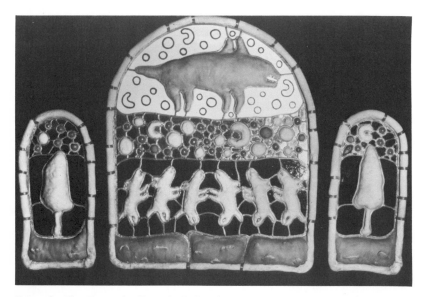

Triptych: The Prayer by Beverly Reiser is made of ceramic, stained glass, and mirror pieces that have been combined with lead caming. *Courtesy: Beverly Reiser*

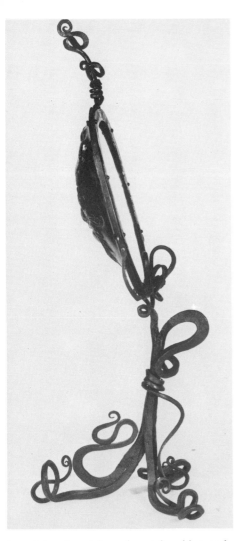

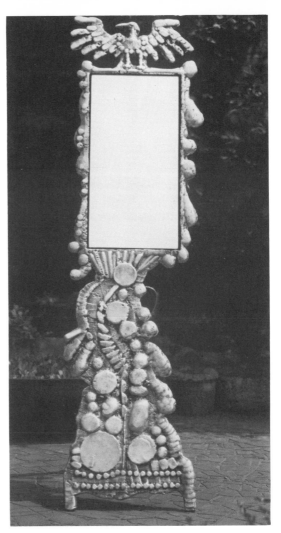

A variety of metals and metalworking techniques has been employed by mirror craftsmen. This 22″-high mirror by Robert A. Griffith is backed by sheet steel repoussé. The stand is hand-forged iron. *Courtesy: Robert A. Griffith. Photo: Aaron Macsai*

Cast aluminum is the medium for Don Drumm's 5½′ standing floor mirror. The spread eagle seems to wink at those Empire style pieces of the nineteenth century. *Courtesy: Don Drumm*

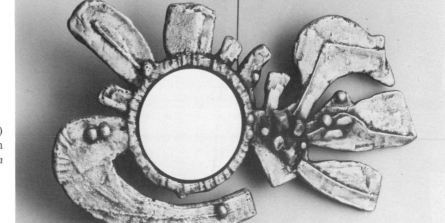

A large wall mirror (30″ long) of cast aluminum by Don Drumm. *Courtesy: Don Drumm*

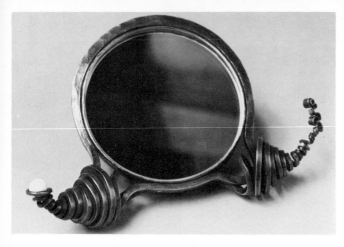

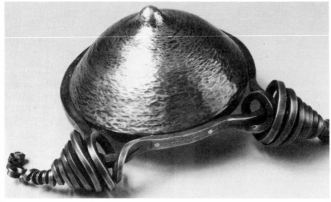

Hand mirror of forged copper, with a raised bronze back and ivory bead by David Luck. *Courtesy: David Luck*

Landscape Pin (1976) by Lane Coulter, of 18-gauge sterling silver sheet, a dark bronze casting (the landscape) and ⅛″ blue acrylic mirror. *Courtesy: Lane Coulter. Photo: Curt Clyne*

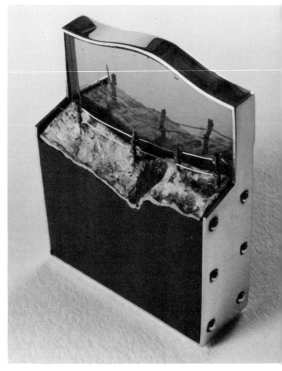

16 on White (1970) by Jason Seley. Chrome-plated bumper guards. *Courtesy: Jason Seley. Photo: Charles Uht*

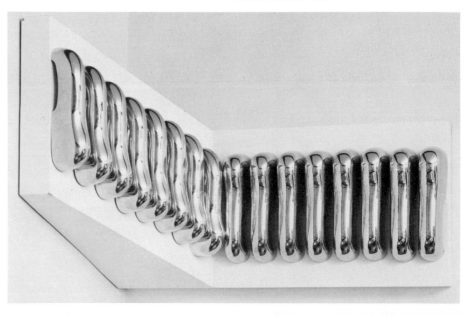

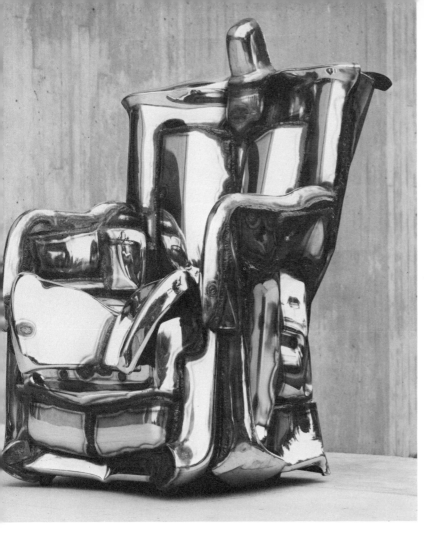

Reflective qualities of chrome are responsible for the glow of this chair (1973) by Jason Seley. Welding marks become part of the chair design. *Courtesy: Jason Seley. Photo: Charles Uht*

Sculptor Jason Seley occasionally combines the reflective qualities of chrome-plated car parts with plate-glass mirror, as in this whimsical *Hat Rack (with Bra)* (1967). *Courtesy: Jason Seley. Photo: Charles Uht*

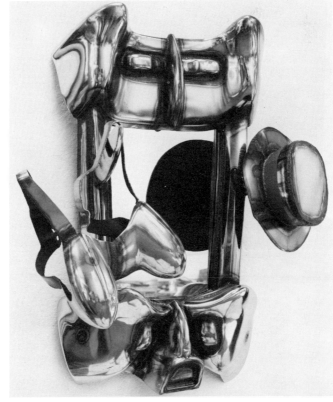

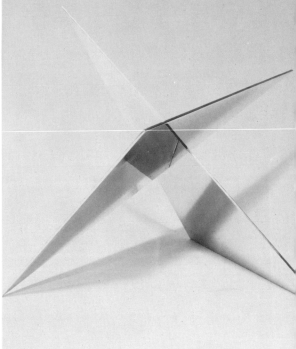

Mirrored Staircase (1973) by Doug Edge. The case can be closed to form a black box. When opened, it reveals multifaceted reflections in the mirrors that constitute the stairs. *Courtesy: Cirrus Gallery*

Illusion Nr I by Sacha Kolin. Polished stainless steel. The intersecting planes appear to pass unbroken through each other. The way the metal reflects light and creates shadow contributes to the sculpture's drama. *Courtesy: Sacha Kolin and Davlyn Gallery*

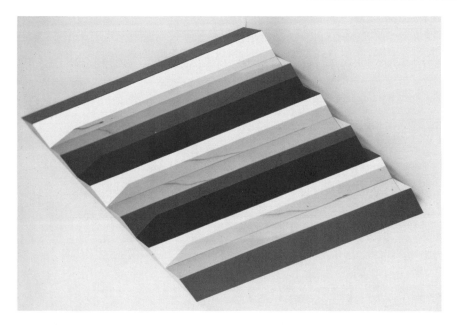

Angular mirrored planes are the elements of *Extrovert* (1976) (3′ × 4′) by Doug Edge. The piece uses both acrylic and acrylic mirror. Darkest reflections are black acrylic reflecting onto itself. The lighter gray is mirror. The piece produces an extremely strong illusion of being flat and then of being three-dimensional. *Courtesy: Cirrus Gallery*

Sculptural Collage (12½″ h × 12½″ w × 11½″ d) by Phyllis Freeman. Collage on and with mirror. *Courtesy: Phyllis Freeman. Photo: Barbara Baker*

Seleymobile (1972–1973). An all-chrome car by Jason Seley turns heads. *Courtesy: Jason Seley. Photo: Charles Uht*

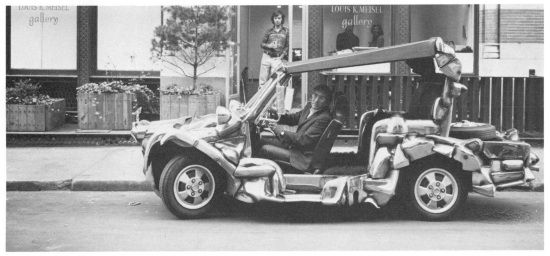

Library Piece (1976) by Brent Jenkins uses the reflective qualities of highly polished metals—copper, aluminum, and brass. *Courtesy: Brent Jenkins*

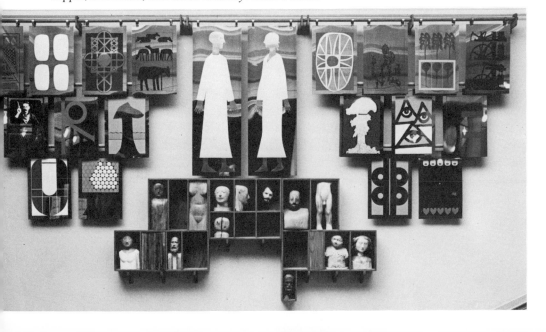

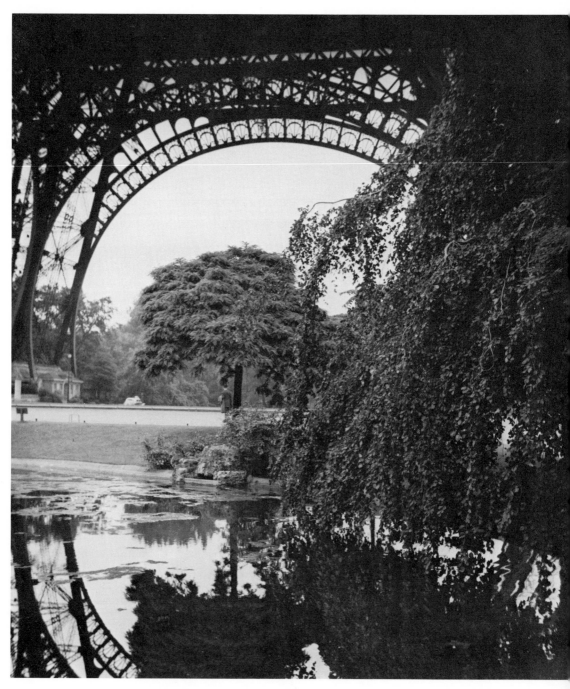

Eiffel Tower, 1951 by Thelma R. Newman. Boughs and beams reflect in nature's own mirror—the still pond. *Courtesy: Thelma R. Newman*

MIRROR DESIGN CONSIDERATIONS

A HANGING BRANCH REFLECTED IN A STILL POOL. WAS THIS THE FIRST MIRROR? Nature's ponds teach two lessons about the use of reflective surfaces. Mirror can be *functional*—making it easier to shave, tie a bow, preen. Or mirror can be *decorative*—actively repeating the beauty of nature. Craftsmen design mirrors that combine the functional and the decorative in many different proportions. Most of the history of mirror craft has been concerned with the mirror as the strictly functional "looking glass." In his vanity, man found tools and materials that would duplicate his image. In his curiosity, he refined the reflective surface to make it easier to view the heavens through telescopes. And so mirrors evolved from crudely polished bronze plates to precise silvered glass and acrylic.

Mirror transmits light reflected from any object, sincerely reproducing all shapes, colors, values, and intensities. But there is more to mirror than our pedestrian interest in perfect reflection. Mirror can play magician. Everything we see in mirror seems real but is illusion. A wall covered with mirror makes a room seem double in size—the space and depth are illusion. Distortions in a fun-house mirror make legs long and trunks stout. Concave mirrors shrink the world and intensify light, whereas convexity imparts an expanded, bug-eye view. And on top of all these visual deceptions, mirror has psychological effects. As a celebration of light, mirror adds glitter and gaiety—like the spinning, sparkling mirrored mosaic ball in a dance hall. We formulate a self-image by looking and talking into mirrors. And walking down the street, who

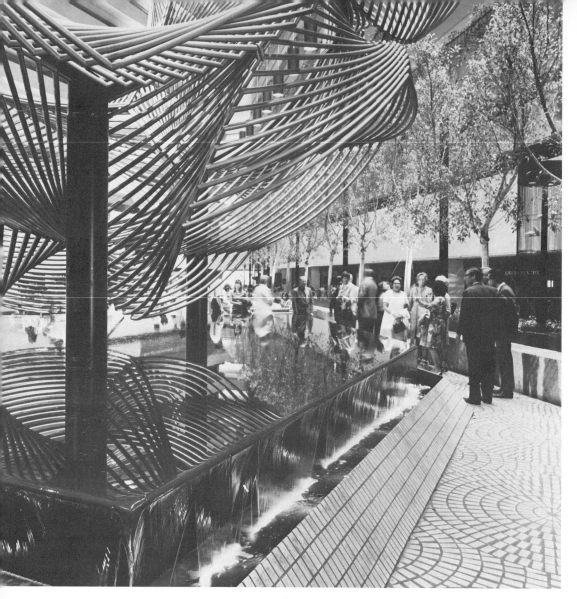

Architects—like John Portman and Associates—have learned to harness the reflective qualities of water in their invented environments. See how the contours of sculpture double—enhancing the work's impact at the Embarcadero Hotel. *Courtesy: John Portman and Associates. Photo: Alexandre Georges*

can avoid sneaking a glimpse of self reflected in store windows? So much for our pedestrian interest in mirrors.

Artists use reflective surfaces functionally, decoratively, and at times symbolically. Paintings on mirrored surfaces integrate the viewer as part of the art. Here simple functional reflection works for the artist. If a pair of mirrors is set facing each other, any image between the two can reflect infinitely; thus, compound reflection works for the artist. Fractured images, repeated kaleidoscopic anglings, reflective planes, curves, and distortions are aspects of the artist's mirror repertoire, as illustrated in Chapter 10.

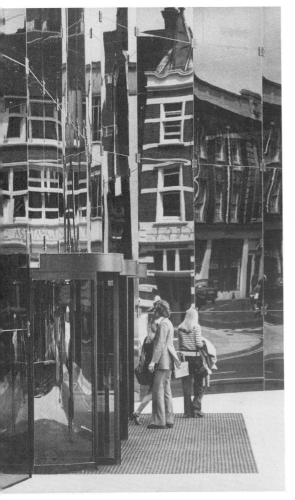

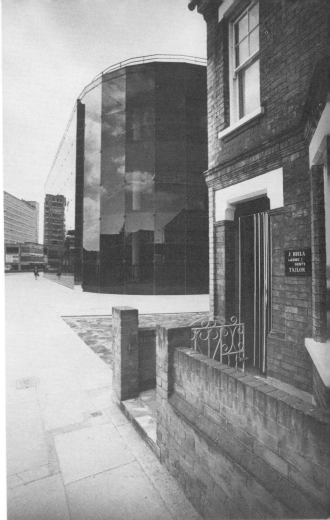

The Willis, Faber, and Dumas building in Ipswich, England, mirrors its surroundings. Flat sides of the building almost seem to disappear by reflecting neighboring buildings. But as the building curves, its own shape and presence are reconfirmed. *Courtesy: Design magazine. Photos: Philip Sayer*

Both functional and decorative reflective surfaces have been harnessed by architects and interior decorators interested in achieving special environmental effects. Witness the mirrored skyscrapers, reflecting pools, or the Hall of Mirrors at Versailles. The reflective surface's power to transmit light, to impart the illusion of space, to multiply, magnify, focus, and psychologically influence make it a dynamic force and an essential element of interior and exterior design.

One way to see how mirror contributes to interior design is to consider how successfully mirrors solve some common design problems. To open up cramped areas; to give light to dark, windowless rooms; to enliven dull expanses of wall; or to mask structural flaws, try one of the many mirror solutions.

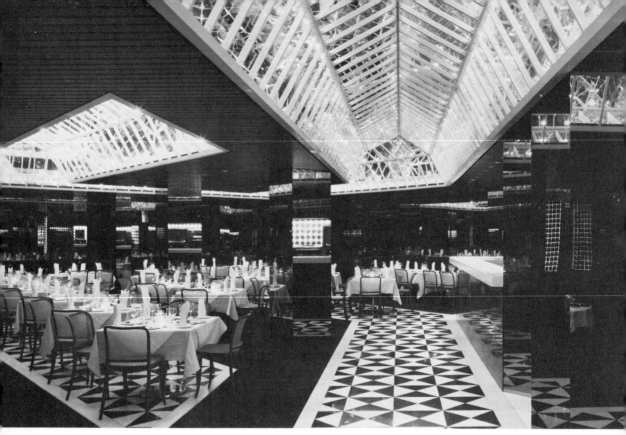

Below:

In interior design, mirrored surfaces can make room furniture and inhabitants part of the environment. Jack Denst silkscreened a pattern of Indiana dune grass onto mirrored acrylic. The mirroring adds depth to the bedroom, and the silkscreen surface treatment reminds us of mirror's two-dimensionality. The mural is entitled *In Three Months and Eleven Days, Summer Begins.* *Courtesy: Jack Denst Designs, Inc. Photo: Yuichi Idaka*

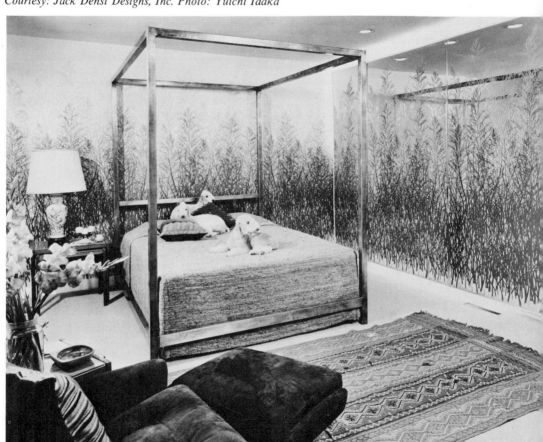

r truly effective use of mirror, the designer takes advantage of several of
e material's qualities. For instance, in the United Nations Plaza Hotel
e ceiling of stretched Mylar panels (Mirrex) capitalizes on how mirror
flects light, produces an infinity effect, interrupts images, and alters
ject continuity by changing angles of reflection. Mirror-clad pillars not
ly contribute to the distribution of light but also mask otherwise
sightly structural supports. The overall effect is one of spaciousness,
tivity, and gaiety. The architects are Kevin Roche/John Dinkeloo and
sociates. *Courtesy: Kevin Roche/John Dinkeloo and Associates*

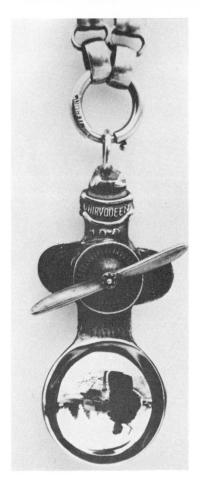

At times the use of mirror may be
solely decorative, as in *Straighten Up
and Fly Right* ($2\frac{1}{4}''$ × $1\frac{1}{16}''$ × $\frac{1}{2}''$)
by J. Fred Woell. The highly pol-
ished silver in this cast pendant acts
as a convex mirror. *Courtesy: J. Fred
Woell*

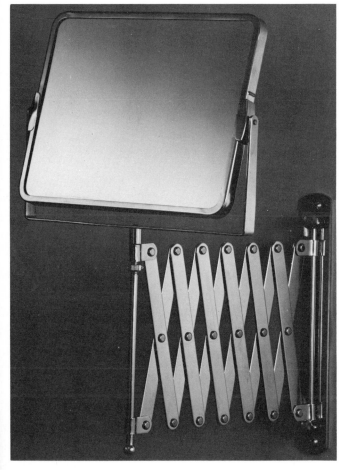

On the other hand, the *functional* properties of mirror may
seem more critical when it comes to shaving or applying
makeup. This rectangular two-faced mirror flips from plain to
magnifying glass, and it extends up to 20″ from the wall.
Using such a mirror near a wall mirror permits you to glimpse
yourself from behind. *Courtesy: Lillian Vernon*

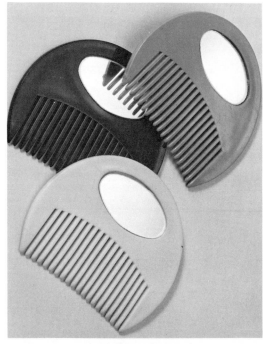

These comb mirrors emphasize the practical side of mirroring.
Where would the practice of combing be without the mirror?
Courtesy: Lillian Vernon

GENERATING MULTIPLE AND FRACTURED IMAGES

We rely heavily on the way mirrors produce a double image. But consider the decorative qualities of *more* than just double. By putting two mirrors parallel to each other, the image of the woman between the glass appears to repeat infinitely. *Courtesy: Ford Motor Co. and National Association of Mirror Manufacturers*

It is this property of reduplication that makes mirror the liberator of cramped hallways or, as in the case of this linear environment by Tad Bridenthal, the generator of an infinity of fractured images. *Days and Days, Piet* (1975) is 18′ long and 8′ high. Says Bridenthal: "The mirrors are joined by mirrored gold rod, which gives the effect of gold lines being mirrored to infinity. The title refers to Mondrian, whose rectilinearity I have reflected—on and on—changing." *Courtesy: Tad Bridenthal*

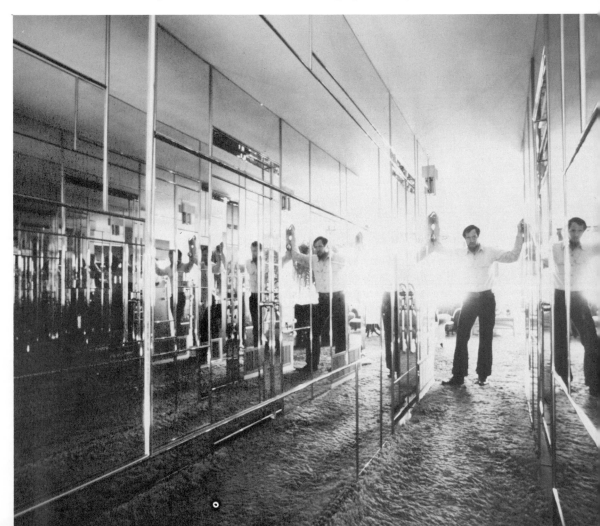

Just as a single mirror doubles, two mirrors set at right angles to each other *quadruple*. Wendy Brawer first sketches some ideas for fabric designs and then holds up two mirrors to see how the design will look in quadruplicate. She finds it a useful tool in fabric designing.

Made With Honey is a batik by Wendy Brawer designed with the aid of mirrors. Note the two planes of symmetry generated in the design. *Photos: Ray Sage*

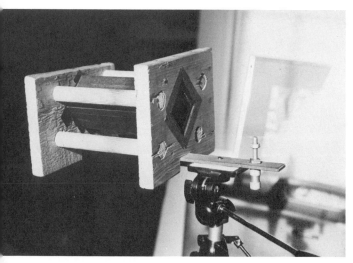

A kaleidoscope is simply a set of three or four rectangles of mirror abutting one another to form a tube. Objects viewed through the tube will reflect and refract off the walls to form the characteristic set of fractured images. Ray Sage constructed a kaleidoscope from four mirror strips, and he has attached it to his camera tripod.

An infinite variety of patterns of color, texture, light/dark, and shape are generated by looking or photographing through the kaleidoscope, by Ray Sage. *Photos: Ray Sage*

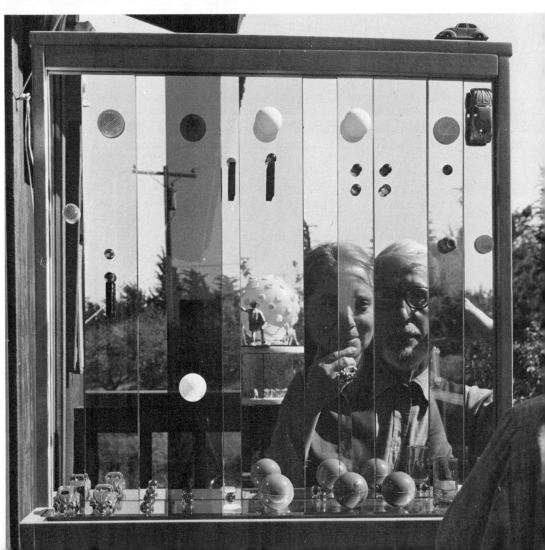

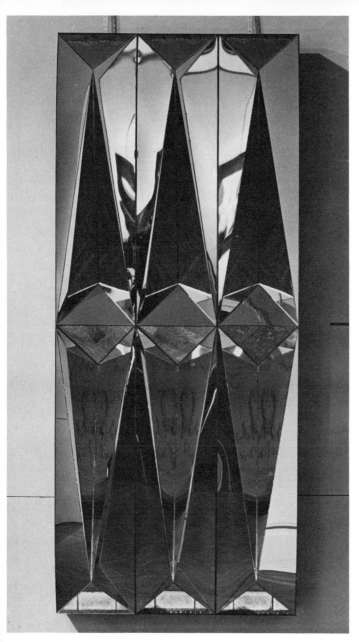

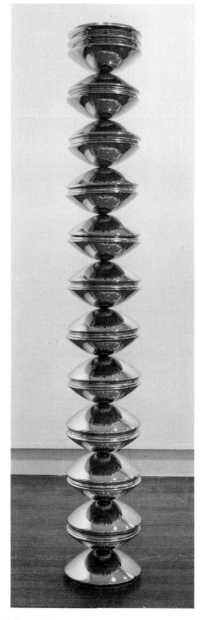

An almost kaleidoscopic effect is obtained by Irene Pasinski when she angles mirrored acrylic (5' × 3'). *Courtesy: Irene Pasinski*

n by Raymond Barnhart also plays upon fractured ...s and mirror angles, testing the viewer with questions of ...tion. *Courtesy: Raymond Barnhart*

Many of Jason Seley's works emphasize the repetition of images in the reflective surfaces of shiny car parts. *Column* (1969) (6'3" h) is made from hubcaps. *Courtesy: Jason Seley. Photo: Charles Uht*

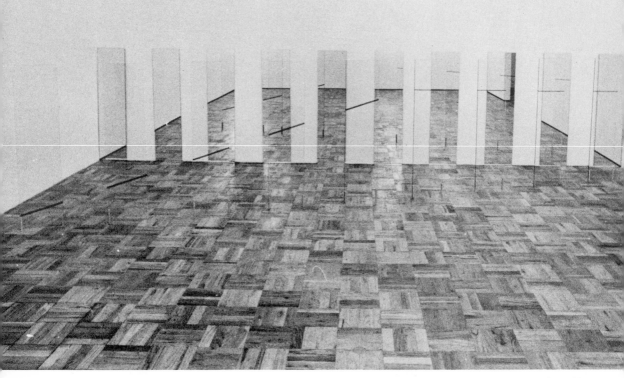

Elyn Zimmerman's untitled construction is like a three-dimensional optical illusion. A row of ten 1′ × 4′ plate-glass mirrors line a wall. Several feet in front are nine 1′ × 4′ free-standing pieces of clear plate glass. On the glass are strips of black tape, which, because of their angle and spacing, reflect in unusual ways in the mirror background. Add to that your own reflection passing from mirror to mirror as you walk by, and you've got a lot of visual cues to cope with. The artist writes: "An object has no stable perceptual place, size or relationship to other objects. These are a function of our positions as perceivers." *Courtesy: Elyn Zimmerman*

MIRROR'S INTERACTION WITH LIGHT

When we perceive an object, it is because light rays bounce off that object and in turn impinge on the back of our retinas, sending coded messages to the brain. When we see something "in the mirror," the light reaching our eyes has bounced off the original object, bounced off the mirrored surface, and *then* enters our eyes. Of course any distortion in the object or in the mirror-intermediate is interpreted by us as some peculiar property of the object, the mirror, or our eyes. By experience we come to learn that when a reflected object appears "fuzzy," it is more likely due to cloudy mirror than smeared makeup. William James captured some of the wondrousness of this mirroring process in a letter to Henry James. He said it was "the illusion of a solid object, made wholly out of impalpable materials, air, and the prismatic interference of light, ingeniously focused by mirrors upon empty space." It is when your eyes move into that "empty space" that you see a reflection "in" the mirror.

1

Regular or specular reflection is reflection in a mirror. A ray of light hits the material and is reflected off. The angles at which the ray strikes and leaves the surface of the mirror are the same.

2

Diffuse reflection is when reflected light is scattered in all directions.

3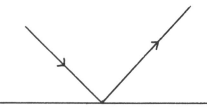

Spread reflection is usually off a matte surface.

4

Mixed reflection occurs when part of the light is diffused and some is regularly reflected as off a shiny painted surface.

5

Scattered reflection happens when tiny portions of the surface act like mirrors causing a multiplicity of separate reflected rays as in rippled plastic or crinkled metal foil.

Hello. Thank you for looking into
J Scott G's "Looking Glass Piece."

While reading this ad, notice that your
head is half its normal size on the mirror's
surface. To prove it, stand before a steam-
ed mirror; at arm's length, finger-draw the
outline of your head and measure.

While the mirror itself may be one foot from your face, the image you see has traveled two feet (to reach the mirror, reflect, and return to your eyes). This example of the concept was designed and executed by J. Scott G. *Courtesy: IMMEDIA and Gerald Robert Laurence*

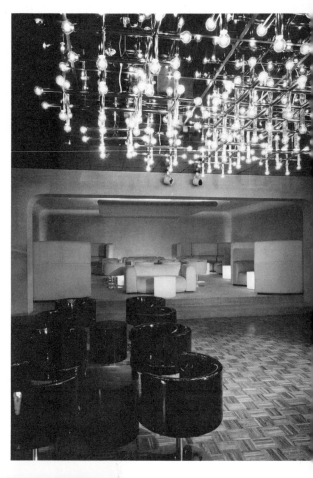

Incandescent lighting can also be combined to good advantage with a mirrored ceiling, as in this entertainment lounge at the Embarcadero Hotel. The simple crisscrossing chrome fixture becomes intricately patterned and much more effective in this mirrored situation than it would have been suspended from a nonreflective ceiling. *Courtesy: John Portman and Associates. Photo: Jeremiah O. Bragstad*

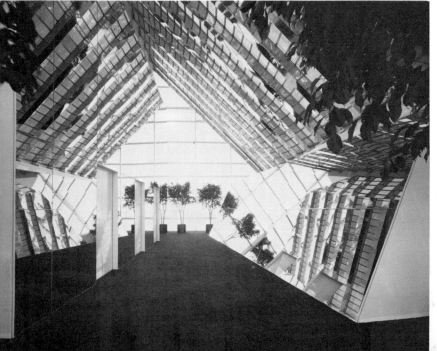

Mirror produces spectacular effects with natural light. An area that already has abundant windows can be made even brighter with mirrored walls, as in the Worcester County National Bank designed by Kevin Roche/John Dinkeloo and Associates. *Courtesy: Kevin Roche/John Dinkeloo and Associates*

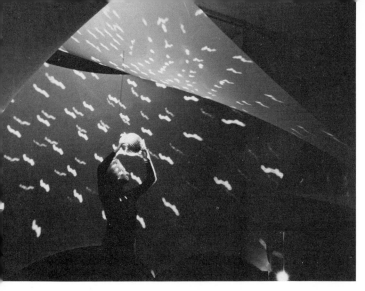

June Blum's *Light Environment* (1973) with mirror ball shows the effects mirror has when reflections of light meet fabric planes. *Courtesy: June Blum*

Corridor (1976) (27″ × 50″ × 11″) by Richard Brooker is a 6-panel construction with styrene, glass mirrors, and painted wood. Notice how light plays off the walls of the piece, casting reflections in geometric patterns. "Light is an integral part of the work," the artist writes. "Reflected light and shadow alter the shape and painted surfaces of the structures, creating a magical balance between illusionistic space and physical presence inherent to constructions." *Courtesy: Richard Brooker*

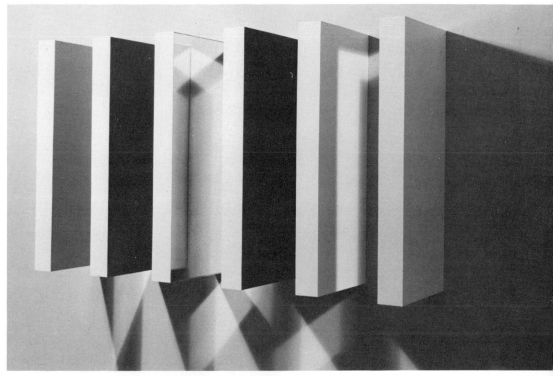

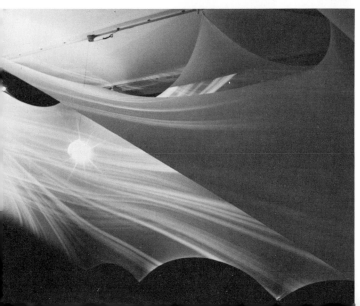

June Blum's interest in light and mirror is in some ways quite similar to Brooker's. But her use of the medium is extremely different. *Light Environment* (1973) by June Blum was part of a show entitled "Sculpture for the Dance." Light projected onto a mirrored ball reflects onto fabric that has been stretched about the room.

43

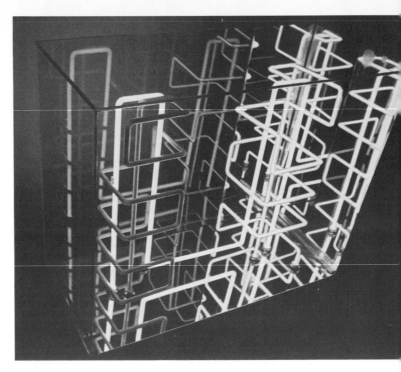

Two types of reflection interact in this neon sculpture by Thelma R. Newman. There are less intense reflections produced by clear acrylic walls and precise reflections produced by mirrored acrylic base and wall segments. As illustrated above, an essentially simple lighting fixture becomes more significant with the use of reflection. The neon lights are timed to go on and off periodically, adding to the activity and movement. Because some walls of the piece are clear acrylic and some are mirrored acrylic, the distinct and duller reflections contrast, adding to the visual intrigue.

A mirror needn't reflect direct light to add illumination. In this Italian design, lights built into the mirror illuminate the user's face. And after the light hits the face, the enhanced illumination is reflected by the mirror. *Courtesy: Arteluce. Photo: Colore Industriale*

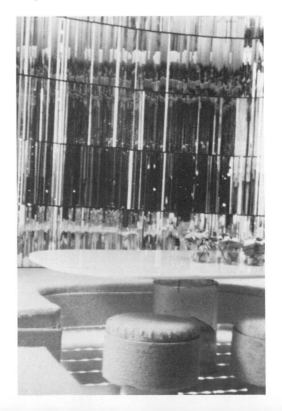

Some of the most dramatic uses of mirror and light in interior design have been made by architect Paul Rudolph. The *Mirror Curtain, Series #100,* of acrylic mirror strips (⅜″ × 16″) connected with clear vinyl, sweeps around a dining area. As manufactured by Modulighter, Inc., it stands 94″ high and can be ceiling or wall mounted on sliding tracks. *Photos in this series courtesy: Paul Rudolph*

Detail of the reflections produced by Paul Rudolph's *Light Curtain*.

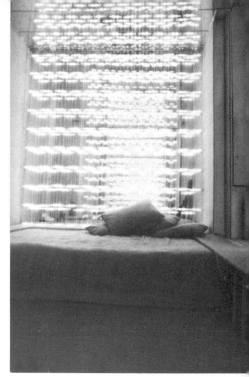

Mirror Light Curtain, Series#300 adds miniature lights to the mirror curtain. The lights are enclosed in 5/8″ diameter translucent plastic tubes that are strung from suction cups on the ceiling of this bedroom. By having several walls—and the ceiling—covered with mirror also, the reflection of the light curtain repeats infinitely.

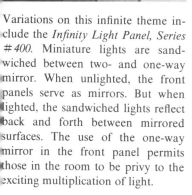

Variations on this infinite theme include the *Infinity Light Panel, Series #400*. Miniature lights are sandwiched between two- and one-way mirror. When unlighted, the front panels serve as mirrors. But when lighted, the sandwiched lights reflect back and forth between mirrored surfaces. The use of the one-way mirror in the front panel permits those in the room to be privy to the exciting multiplication of light.

Paul Rudolph's *Infinity Light Table* also uses miniature lights in translucent tubes. One-way mirror is employed on top and sides. A two-way mirror bottom conceals the transformer. Unlighted, it is a mirror table; lighted, a repeating grid of light with power to mesmerize.

PLANAR VERSUS CURVILINEAR PROPERTIES

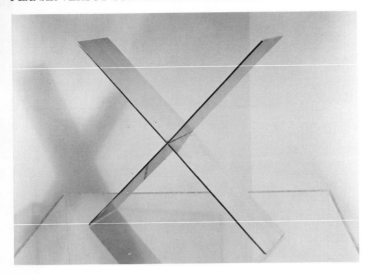

For the most part, we talk of planar mirror—flat reflective surfaces. We feel secure with the two-dimensional mirror. The reflections are clear and honest. The reflective surface itself becomes secondary—the slave scribe of anyone who stands before it. Sacha Kolin's *Illusion Nr X* is an 8′ stainless steel sculpture that emphasizes the planar/linear properties of reflective surfaces. *Courtesy: Sacha Kolin*

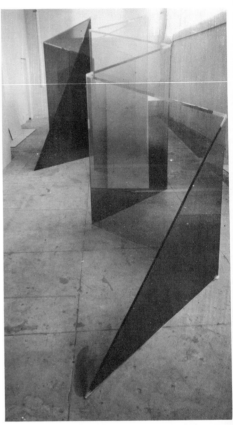

Reflections by planes can play tricks. This section of *Iceberg* (1975) by Larry Bell is made of glass that both reflects other planes and allows the viewer to see yet other planes through the glass. *Courtesy: Larry Bell. Photo: F. Thomas*

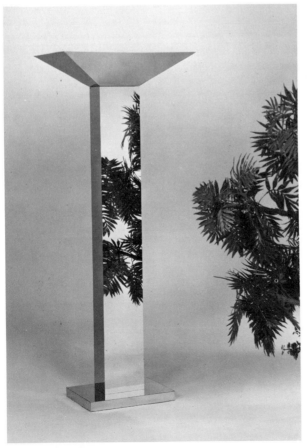

Furniture that incorporates mirror planes automatically integrates with the decor and may seem "invisible" in some rooms. This polished chrome floor lamp, 68″ tall, provides 300 watts of indirect lighting. And there's additional illumination and sense of spaciousness provided by the reflective surfaces. *Courtesy: George Kovacs Lighting, Inc.*

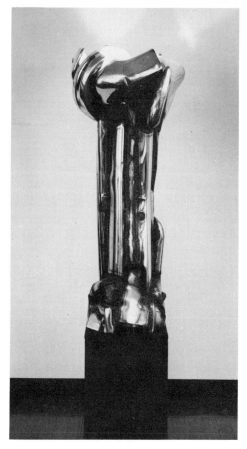

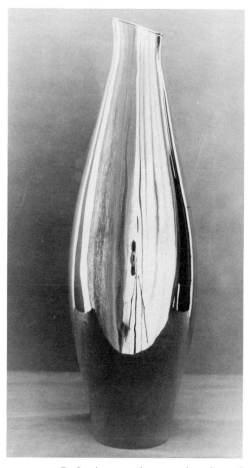

But when mirrored objects curve into three dimensions, they no longer simply accept the environment. The reflected distortions become part of the piece's own form—and that form itself becomes a point of interest. Indirect lighting is provided by bulbs encased by the top of Jason Seley's lamp (1973). But this time the lamp's form is more sculptural, less dependent on the environment for its identity. The lamp is made of welded chrome-plated car bumpers. *Courtesy: Jason Seley. Photo: Charles Uht*

Reflections on the curved surface of this raised silver decanter reemphasize the piece's own shape. The decanter is by Thomas R. Bambas. *Courtesy: T. R. Bambas*

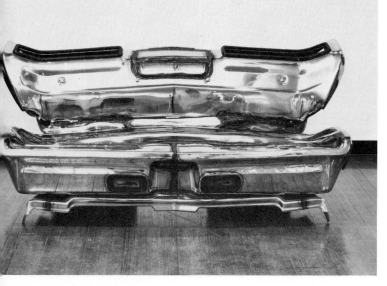

Jason Seley often celebrates reflective surfaces in startling ways. This welded chrome bumper *Sofa* (1974) is a shining example of mirroring in furniture. Creases in the bumpers, discolorations created by welded joints, and the manufactured indentations in the chrome become part of the total couch design. And it's comfortable, too. *Courtesy: Jason Seley. Photo: Charles Uht*

TO RELIEVE AN UNINTERESTING
EXPANSE OF WALL

Walls with no interest, no activity, often detract from a room's appeal. A variety of mirror effects, from large to small, enliven such a dull expanse.

One solution is to cover the entire wall (or a large part of it) with mirror. Do-it-yourself stick-on mirror squares can be installed in minutes. Or cut and beveled mirrors can be made to order. Large area mirrors add new dimensions to the wall and to the room. The mirror pirates extra depth and color from the room's carpet, furniture, and other walls. The effect is naturally in harmony with the rest of the decor. A sense of spaciousness is the bonus.

Smaller, framed looking glasses—or perhaps mirrors decorated with silk-screen, etching, or decoupage—accentuate an otherwise dull expanse of wall. A rhythm of form is created when several of these mirrors are hung in a series. Here the mirror itself is the focus of attention. It becomes interesting in and of itself, and not just as a reflective device.

The mirror needn't focus on itself. It can attract attention to other objects with which it is grouped. For example, a mirror behind an end table will focus interest on plants, vases, objects on that table. (Several plants and a few mirrors can create the illusion of a jungle.) Room furniture integrates with the wall. A built-in wall niche that is lined with mirrors makes any possession in that cubbyhole seem more precious and outstanding.

INTERIOR DESIGN SOLUTIONS WITH MIRROR

It's a small living room. But several factors make it more open and appealing. The furniture is light-colored and not bulky. There is no clutter. Reflective surfaces are built into furniture—as in the chrome-glass table at left, the coffee table, and the front of the stereo cabinet. Plate-glass mirror adds depth and light. It's like having an extra window. The attractive use of teak wood slats with the mirror helps integrate the cabinet with the wall mirror. Mirror is treated as an important decorator's tool—and succeeds. *Courtesy: National Association of Mirror Manufacturers*

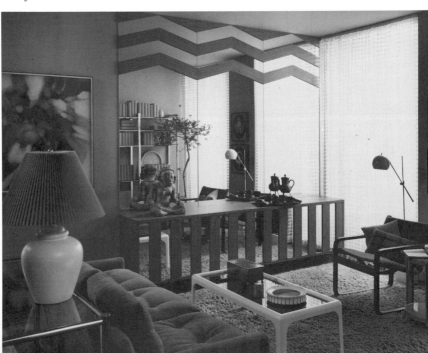

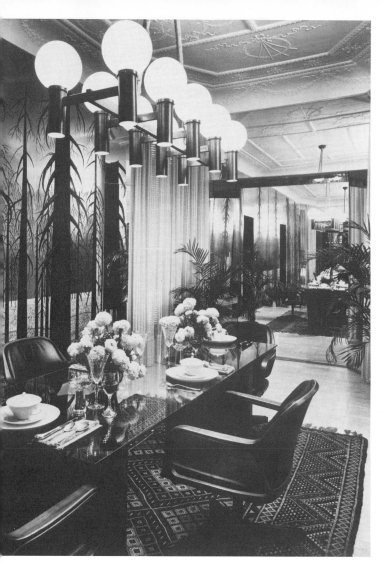

Silkscreened Mylar and plain mirror are used by Jack Denst to add both depth and enchantment. *My First Dance Was Promised to Winter—but Ah, Spring!* makes a tribute to nature. The 10½'-high, three-panel design was custom-painted to complement the 12' ceiling. Panels are silkscreened silvery Mylar in black, beige, and olive. The mural is seen repeated in mirrored walls, enhancing the winter wildwood mood and increasing the depth of the dining area. The total effect is heightened by the use of muted colors in the rug, furniture, and walls. *Courtesy: Jack Denst Designs, Inc. Photo: Yuichi Idaka*

A mirror doesn't have to cover an entire wall to make a decorative functional contribution. This simple, handsome mirror design (38″ × 42″) plays the classical role of looking glass. But a few delicate lines—the beveled mirror center and clear mirror border—emphasize the piece's own decorative merit. This LaBarge piece is set in a gold anodized aluminum frame. *Courtesy: LaBarge Co.*

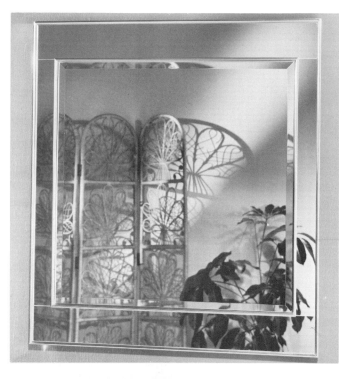

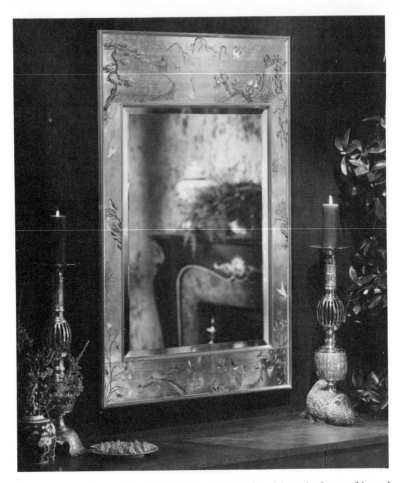

A mirror set in front of a cabinet can enhance the objects in front of it and serve as a vanity glass. Beveled mirror with anodized gold aluminum frame has a hand-decorated border of gold leaf. Overall dimensions: 42″ × 28½″. *Courtesy: LaBarge Co.*

Try hanging mirrors among paintings and prints in a wall arrangement. The mirrors call attention to the grouping and incidentally make the viewer part of the wall gallery. Remember when you are arranging prints and mirrors that formal symmetry is static. Group the pictures with informal balance.

Bathrooms typically have at least a medicine cabinet mirror. But often all the other walls are barren. A gay solution is to cover a wall with a collection of many small decorative mirrors with unusual handmade frames. Multiple reflections rebound among these pieces and the standard functional shaving mirror. With these interrupted images and the collection of eclectic frames, you experience the unusual sensation of seeing yourself coming and going.

Bull's-eye by James Morgan. Metallized polyester film that is silk-screened and stretched onto frames. *Courtesy: James Morgan.*

Wall mirror carved of Africa mahogany, sugar pine, and white pine, by Jeffrey Briggs. *Courtesy: Jeffrey Briggs.*

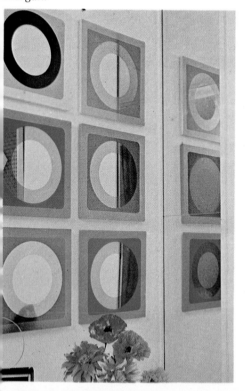

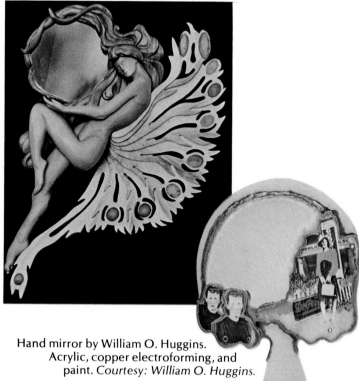

Hand mirror by William O. Huggins. Acrylic, copper electroforming, and paint. *Courtesy: William O. Huggins.*

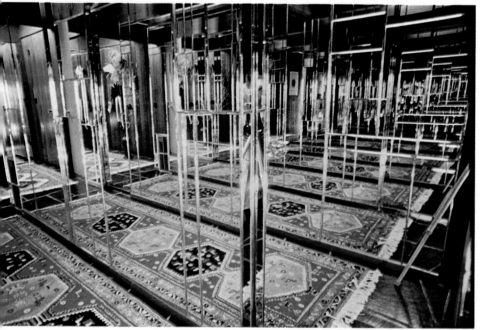

Doors of Hesse by Tad Bridenthal. An 18-foot-long mirrored hallway with gold acrylic rods. *Courtesy: Tad Bridenthal.*

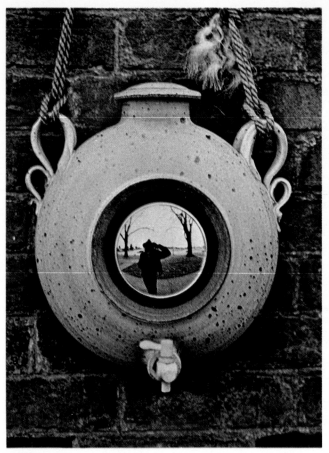

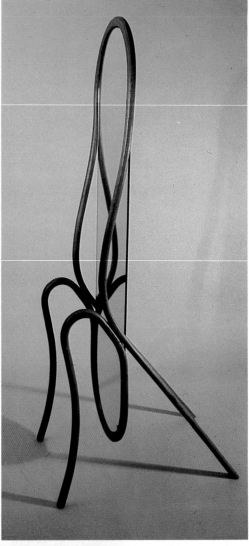

This stoneware mirror (1975) by Jim Cantrell is a hanging beverage server. *Courtesy: Jim Cantrell.*

Laminated veneer and acrylic mirror by Glenn A. Gauvry. *Courtesy: Glenn A. Gauvry.*

Ripple Split Series (1968) (12" x 12" x 24") by Gary Remsing. Heat-formed and metallized acrylic. *Courtesy: Gary Remsing.*

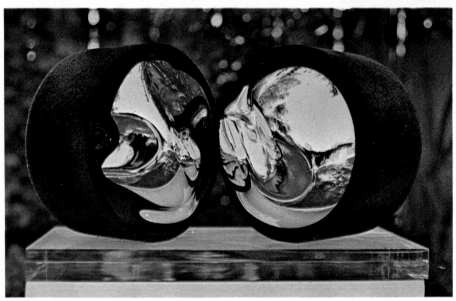

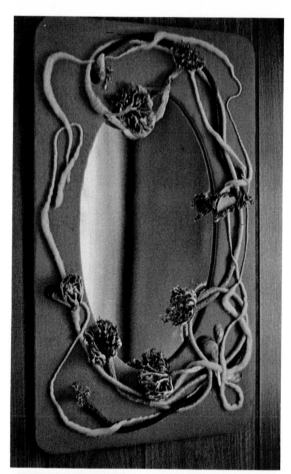

Wrapped and sewn collage by Nelle Rootes. Oval mirror is set in plywood clad with gabardine. *Courtesy: Nelle Rootes.*

Mexican Carnival by Peggy Moulton is an embroidered pillow that incorporates a number of small, round "shisha" mirrors. *Courtesy: Peggy Moulton.*

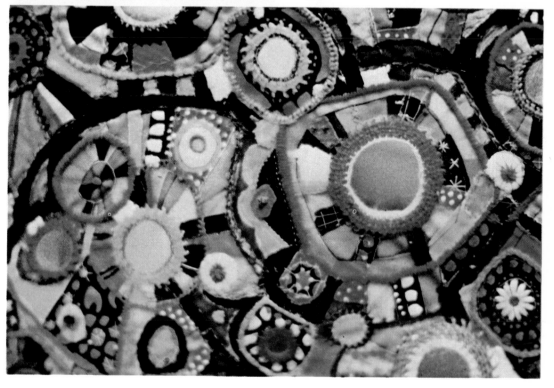

Introspection by Arlene Pitlick. Done by coiling, wrapping, and knotting. *Courtesy: Arlene Pitlick.*

Hand Mirror I (18″ x 12″ x 6″) is by Marcia Lloyd. Made of wet-formed cowhide with a wet-formed calf rose.

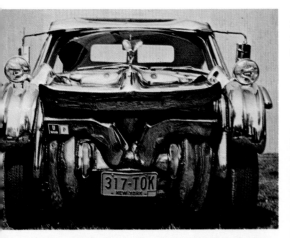

Seleymobile (1972—1973) by Jason Seley. The car is entirely covered with welded chrome-plated bumpers and accessories. *Courtesy: Jason Seley.*

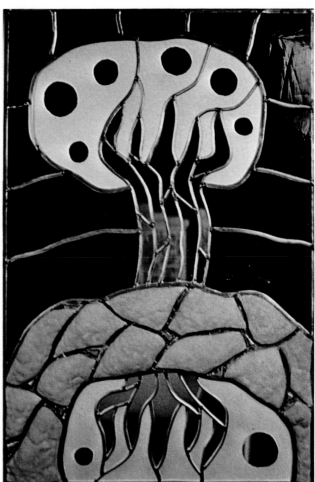

Ching/Tree-well, by Beverly Reiser. Sandblasted mirror, ceramic, black glass, and lead caming. *Courtesy: Beverly Reiser.*

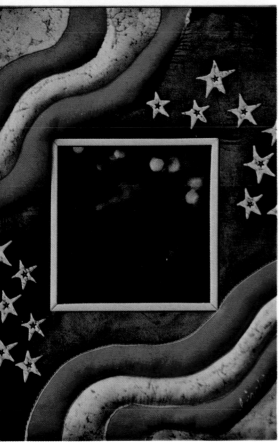

Reflections of America (1975) by Linda S. Jackier combines mirror with quilting and batik. *Courtesy: Linda S. Jackier.*

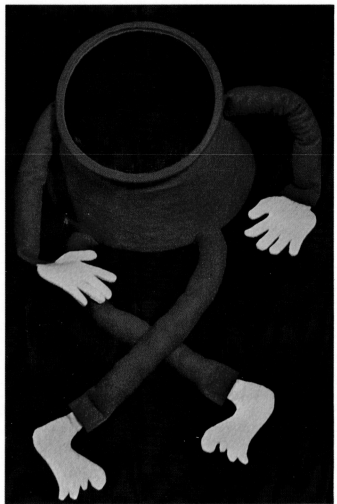

Jay-babe by Lee Newman. Stuffed felt and acrylic mirror.

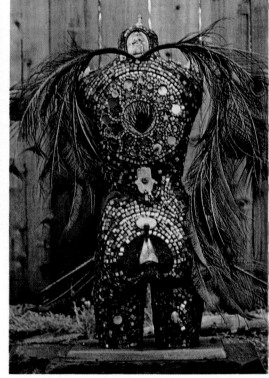

Dark Angel (1975) (3½′ tall) by Laura K. Podenoe. Mosaic sculpture with colored bits of cut-glass mirror. *Courtesy: Laura K. Podenoe.*

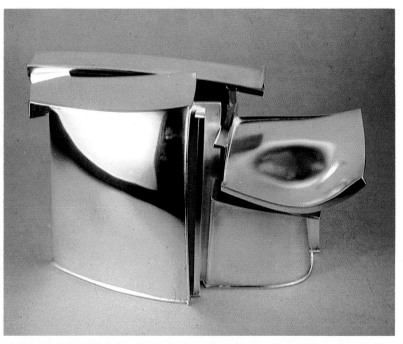

Silver Form II (4½″ x 7″) by Helen Shirk. *Courtesy: Helen Shirk.*

Painted panels with mirrors (1974) (5′ x 8′) by Richard Brooker reflect light and produce shadows.
Courtesy: Richard Brooker.

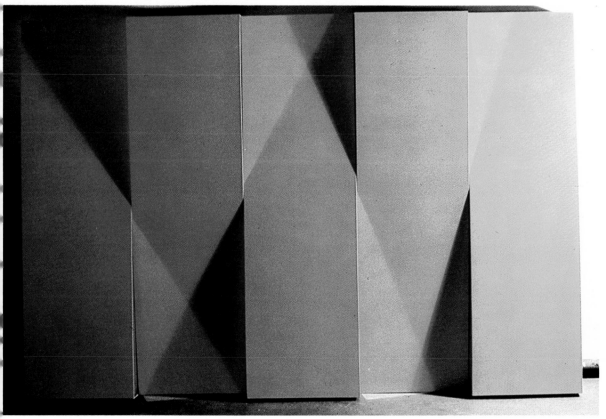

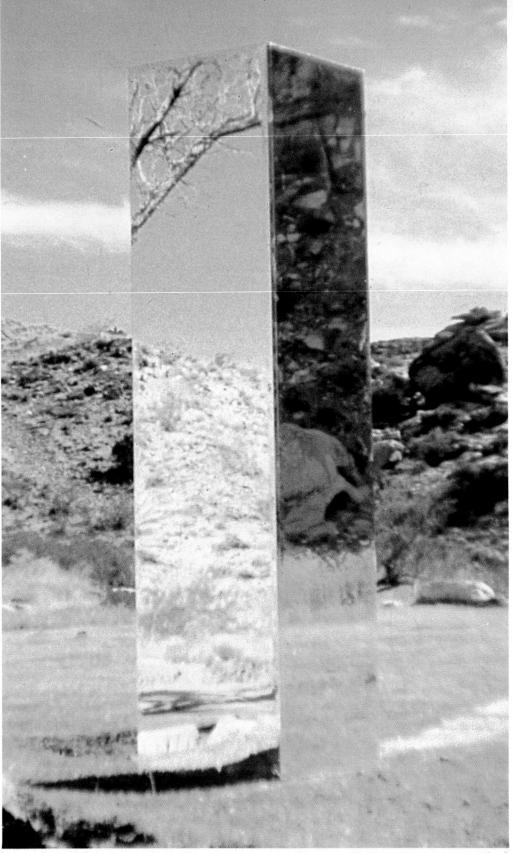

Tower Series 3 Days (1973) (9′ × 5′ × 5′) by Paul Tzanetopoulos. Metallized polyester film stretched over tubular steel framework. *Courtesy: Paul Tzanetopoulos.*

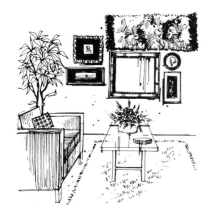

To arrange a grouping of symmetrical balance, imagine a vertical line in the center of the composition. Now arrange your grouping so that an equal amount of area is covered on both sides of this vertical line. The objects used should be in pairs, or one large size balanced by an equal number of smaller items. Symmetrical balance is easier to achieve, and generally creates a more formal and dignified feeling.

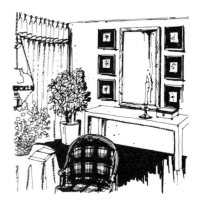

Arrangements of mixed mirrors and pictures can be a very exciting way to decorate a room. The key to a good arrangement is balance. There are two types of balance: symmetrical (formal) or asymmetrical (informal). Imagine a wall grouping with a frame going around the entire outside and a line down the center. If the same amount of area is covered in each half, you have symmetrical balance (see drawing at upper right). If an unequal amount is covered in each half, you have asymmetrical balance (see drawing at upper left).

To form an asymmetrical grouping, imagine again the vertical line in the center of the composition and arrange an odd number of objects on both sides of the line. Then add the rest of the objects you wish to include in the grouping on each side of this arrangement. Make sure that at least one edge of each object lines up with an adjacent edge. Asymmetrical balance requires more judgment, but it offers more freedom of imagination and more intriguing results. (See drawings below for more examples of pleasing asymmetrical arrangements.)

ADDITIONAL TIPS: If your arrangement appears heavier on one side than the other, it may require the addition of a lamp, table, or plant to achieve visual balance. A mix of color and texture also contributes to good balance.

Leave some "breathing space" between adjoining objects in a group ... more for larger ones, less for smaller ones.

An odd number of objects in an asymmetrical arrangement tends to be more visually exciting.

To save time and effort, work out your arrangement of mirrors and pictures on the floor before you start hanging.

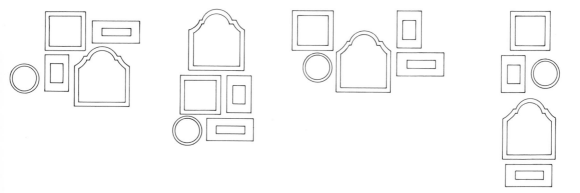

Courtesy: Libbey-Owens-Ford Company

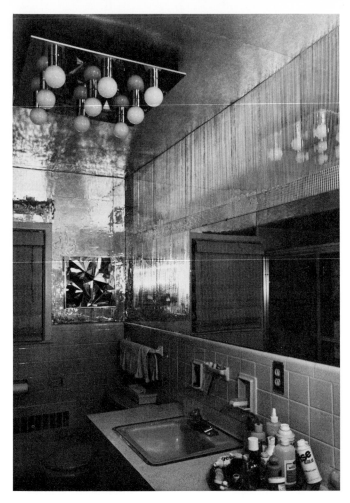

This bathroom was covered with plate-glass mirror (used over the sink area), small mirror tiles, and reflective silver wallpaper. The entire room preys on our vanity.

A bathroom wall (or walls) covered with a variety of mixed-media mirrors has a lively effect on an otherwise dull room.

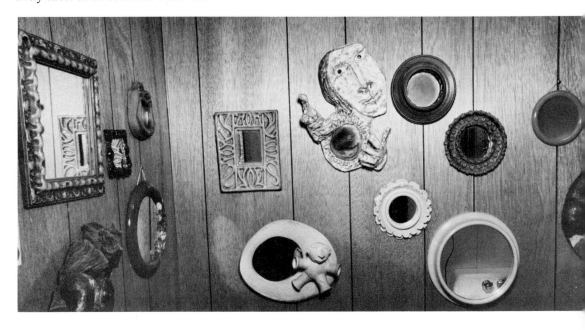

TO BRIGHTEN A DARK ROOM

Hallways, attic bedrooms, and basement recreation rooms are among several areas in the home that notoriously lack sufficient lighting. Shadows linger. Sunshine is muted, if it invades these areas at all.

"There are two ways of spreading light, to be the candle or the mirror that reflects it," wrote Edith Wharton. With experimentation, you can bring light into dark rooms with mirrors. Experiment by placing a piece of mirror on the various walls in the room or foyer that needs light. Study how the mirror does or does not improve the lighting. You'll usually find that there is some optimal position in the room where the mirror "taps" light from some underutilized source.

Brighten the room by reflecting artificial light produced by ceiling and table lamps. This will at least double the apparent brightness of the area. But beware—mirror can overamplify light. Position mirror so that it does not reflect glare. Or use a neutral gray or bronze tinted mirror—these tints permit honest reproduction of colors but mute any glaring lights.

If there is a window in the room or across the hallway, use it to best advantage. A mirror installed opposite and parallel to the window will give the illusion of a second window. Viewed from certain angles, a mirror placed at right angles (90°) to a window also gives the doubling illusion: twice the window and twice the light. Again, experimentation is the key to mirror placement. Try setting the mirror at various angles to the window—and try to coordinate the angling with the way that the room is used. For instance, if most of your time is spent in one easy-chair corner, arrange the mirror so that window light reflects most completely where you generally sit.

Whether you are tapping artificial or natural light sources, the result is a brighter living space through increased reflection of light and color.

TO ADD SPACIOUSNESS TO A CRAMPED AREA

Every house has some area that seems a little cramped, or that could do with some dramatic lengthening, heightening, or widening. Whether the room is too narrow or too short, mirror can provide a ready-made solution One of mirror's most obvious capabilities is to double apparent space. Lewis Carroll's Alice *knew* there was another world through the looking glass. She could see it. (All its books were printed backwards, she observed.)

The lesson learned is that a large mirror, or a totally mirrored wall, will double the size of any room. A mirror at one end of a dining room generates new depth and perspective. If double size is not enough, try putting mirror on two adjacent walls, meeting at the corner of the room—the apparent size of the room will quadruple! The difference is remarkable. After all, we *know* that the room is the same cramped room that it was before, except now with the mirror it *seems* so expanded. With mirror you can buy breathing room even in tight spots. Psychologically the size of the room has improved. And that's what really counts when it comes to living spaces.

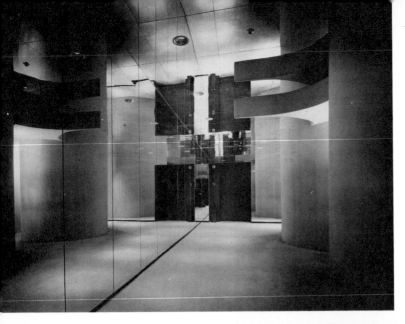

Mirror gives narrow spaces added height and width. Quadrupled size is generated by mirroring one wall and the ceiling at the Embarcadero Hotel. *Courtesy: John Portman and Associates. Photo: Jeremiah O. Bragstad*

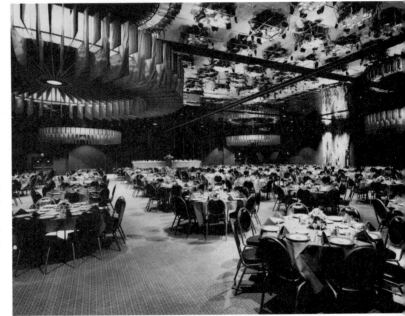

Again the mirrored wall and ceiling combination enhances lighting and depth. But in this case it takes an already expansive ballroom and makes it more grand and elegant. *Courtesy: John Portman and Associates. Photo: Jeremiah O. Bragstad*

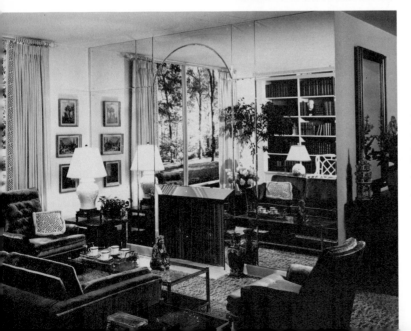

Beveled plate-glass mirror was installed around an already existing fireplace providing a second view of the outdoors. The beveling itself forms a pattern on the wall. One must be careful when doing such extensive mirroring not to mirror in areas that are already very "busy." Otherwise the room becomes *too* active or too cluttered to be comfortable. *Courtesy: Libbey Owens-Ford Company*

This mirror effect will vary according to which wall you cover. To make a narrow room seem wider, put the mirror on the larger walls, doubling room width. To add height to a low-ceilinged room, use a floor-to-ceiling mirror.

In some apartment layouts it would be nice to be able to divide one room into two. But usually the division produces two areas that are too small to be comfortable. Try a freestanding mirrored room divider. Each half of the room doubles in apparent size.

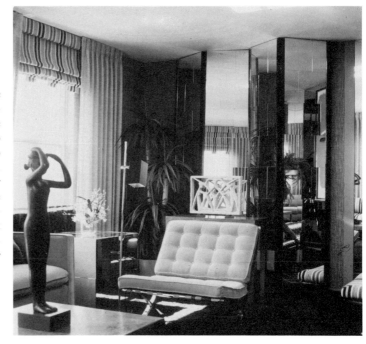

Mirrored room dividers should not be underestimated as an interior design device. This piece-mirror divider can hide ugly pipes, divide a large room into two living areas, convert a boxlike room into one with some three dimensional character. In this room, note that the silver mirror theme is carried through the decor—chrome chair legs, chrome lampstand, and an almost invisible mirror-cube end table next to the couch. *Courtesy: Ford Motor Company and National Association of Mirror Manufacturers*

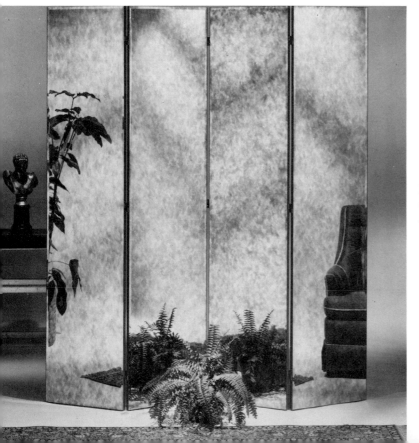

Four-panel screen with antique beveled glass. Each panel is 18″ wide and 80″ high. *Courtesy: LaBarge Co.*

A word of caution: there are times when this kind of doubling with mirror can go wrong. If the room is cluttered—knickknacks, a splotchy, piebald rug, seven styles of ornate chairs, and a busy couch—mirroring will backfire. Instead of camouflaging, the mirror may abet the muddle. A mirror wall reflects only what it "sees"—a cluttered room reflected is just double the clutter.

Large pieces of furniture in a small room make that space all the more claustrophobic. To increase the sense of spaciousness, decorate with furniture made of mirror and glass. A coffee table clad with mirror almost disappears by picking up reflections of carpet and other furniture, making the room seem more open. Again it's all illusion—but that's what counts. If a wooden or metal end table makes the room crowded and a mirror version doesn't, then by all means, fool the eye! One quirk of reflective surfaces should be pointed out, however. Just because a piece of furniture is reflective, it will not automatically become "camouflaged" in the room. Furniture that incorporates *flat planes* of mirror will obliterate its own form—it masks behind "honest" reflections of the rest of the room. But mirror on *curved* surfaces—like the chrome legs of a chair or the globe of a contemporary lamp—does not disappear. The curve distorts the reflection and helps mirrored forms retain their *own* shape and fill space like any other solid object.

CAMOUFLAGING STRUCTURAL FLAWS

If the corner of a room has an unappealing set of exposed pipes, a radiator, or a wall irregularity, try setting a mirrored room divider in front of the flaws. Mirror excludes without being too obtrusive. Is there a wall marred by cracks, pits, and scars? Apply mirror right over the flaws.

Unsightly square or cylindrical columns can detract considerably from the looks of a recreation room. Clad columns with flat surfaces of mirror to make them "invisible." If you're not interested in a column disappearing act but you do want to make the pillars part of the decor, clad them with flexible mirror sheet or with metallized plastic film. You'll have a brighter, more attractive room without performing radical surgery on those columns.

THE DESIGNING PROCESS

How important is function? How important is decoration? You have to ask yourself these questions when planning any mirror design. At the functional extreme, the mirror must be unadulterated by surface treatments; sufficiently large to reflect a face, full-length figure, or entire room; firmly fixed in place or set on a manipulable support. If decoration is the sole objective, then just a glimpse of reflection from strips of metallized film or dots of mirror might suffice, depending on the nature of the adornment.

A mirror can be both practical and attractive. Obviously, function and

decoration must be considered concomitantly, according to your needs and the effect sought.

Mirror forms, at their best, treat the mirror as an intrinsic part of the design. Whether you are framing mirror with wood, cloth, leather, ceramic, metal, or a combination of materials, the mirror or reflective surface can and should be remembered as a key aspect of the work. The mirror should not be added as afterthought.

Consider decorating the mirror surface as well as the frame that might surround it. Try decoupaging both frame *and* mirror. Silkscreen the mirror and continue that design onto a frame of ceramic or wood or plastic. Accentuate mirror's depth-producing effects by setting it deeply in an inward-beveled frame. Manipulate pieces of mirror at different angles to play with light and refraction. Etch the front of mirror—it reflects the scratches so that you become aware that mirror *is* two-dimensional. At the same time you see deep reflections telling you that three dimensions exist *in* that 2-D surface. By trying out a variety of mirror treatments you will come to appreciate Alice's dilemma as she designed to step through the looking glass.

As we've seen earlier, mirror can camouflage. Where is the fireplace? Both chimney and fireplace base are mirror-clad, serving as foil for the Jack Denst silkscreened mirrored acrylic. Ceiling beams are lighted by silver-tipped bulbs set in mirrored acrylic strips. Mural is entitled *50 Ways to Hear a Cricket. Courtesy: Jack Denst Designs, Inc. Photo: Yuichi Idaka*

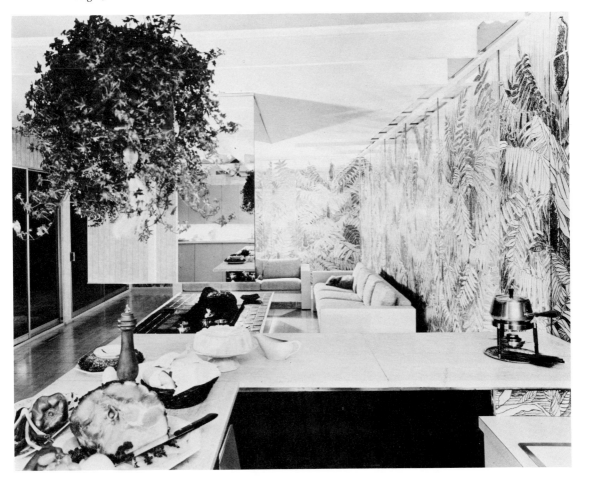

BASIC MATERIALS and WORKING PROCESSES

THE REFLECTIVE MATERIALS USED MOST FREQUENTLY BY ARTISTS AND CRAFTS-men today are glass mirror, acrylic mirror (such as Plexiglas mirror, manufactured by the Rohm and Haas Company), and, to a lesser but increasing extent, metallized plastic films (such as metallized Mylar). This chapter will explore these materials and the basic processes by which each is worked. Metal, although it can be highly reflective, will not be discussed. (See Chapter 6 on the use of metals in mirror craft.)

GLASS MIRROR

Choosing Mirror Glass

Glass mirrors, like anything else, are manufactured in different qualities. The finest are generally believed to be those that produce a true image—one without distortion of form, color, or motion. Ground plate glass or float glass mirrors are usually of this top grade and are available in several thicknesses and in a wide range of sizes. Most such mirrors are sealed with a backing of copper and enamel to prevent separation or oxidation of the silver backing. Professional glaziers will usually supply glass mirror in large sheets, will cut special shapes or sizes, and will order custom sizes if particularly large pieces

are needed for decorative or architectural applications. Thinner mirror glass, sometimes of inferior quality, is frequently used in specialty mirrors, such as the small precut adhesive-backed shapes that do not require precise reflection.

In addition to smooth silver-color sheet, mirror in many other colors and textures is available. Some is created by mirroring colored or textured glass so that the color "tints" the reflection. Amber glass, for example, forms "gold" mirror when silvered. Further variations are achieved by using metals other than silver in the metallizing solution or by varying the mirroring formula (see Appendix). Special effects, such as antiquing, are often obtained by painting the back of the glass before mirroring or by manipulating the sensitizing solution. The range of such special mirrors is always increasing, too. Endeavor Products of 443 East First Avenue, Roselle, New Jersey 07203, for instance, recently began to offer mirrored stained glass in 20 colors, available in 8″ × 12″ and 25″ × 21″ sheets as well as in larger sizes by order. The availability of mirrors in every color of the spectrum greatly enhances the design potential of reflective materials. Special effects and moods may be created by the use of color.

Sheet mirror, although it remains the basic mirror form for most purposes, has been supplemented by many specialty products. Myriad precut shapes and sizes of mirror hold their own design potential, and, of course, almost any shape can be cut. Concave mirrors and convex mirrors that magnify and compress images, respectively, are also available. But perhaps most intriguing of these thematic variations is flexible mirror, such as that manufactured by National Products, Inc., of 900 Baxter Avenue, Louisville, Kentucky 40204 under the name Flex-sheet. Flexible mirror is fine-quality mirror glass that has been cut into uniform patterns of small squares, rectangles, triangles, etc., and backed by cotton cloth. This material may be bent to accept the contours of both concave and convex forms, and it may be applied to flat surfaces as well. Flex-sheet mirror is available in more than a dozen colors, and in textured glass, too.

Flex-sheet mirror, manufactured by National Products, Inc., is available in a wide variety of patterns, colors, and textures. It is backed by cotton cloth and may be made to adhere to flat, concave, and convex surfaces. *Courtesy: National Products, Inc.*

Mosaic mirrored placemat, coasters, and napkin ring by Tomorrow Designs, Ltd. *Courtesy: Tomorrow Designs, Ltd.*

Planter cubes of mirror mosaic by Tomorrow Designs, Ltd. *Courtesy: Tomorrow Designs, Ltd.*

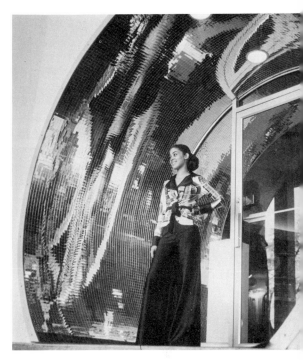

Flexible mirror bathroom installation expands the illusion of space and brightens a small room.

Flexible mirror in a concave application. *Courtesy: Ford Motor Company and the National Association of Mirror Manufacturers*

Cutting Glass Mirror

Glass mirror and glass are cut in the same way. Both may be scored and broken to obtain intricate curves and precise shapes. This essential skill may be learned readily with practice and patience.

The first step is to clean the glass thoroughly to remove all grease and dust (see discussion of cleaning solutions and methods). The mirror is then laid upon a flat surface, backing side down. That working area must be completely free of dirt and impurities that might scratch the mirror backing and the silver. Cardboard, Neolite, and wood surfaces generally serve well.

A pattern may be attached to the surface of the mirror temporarily with Plasti-Tak or double-stick tape to serve as a template. Or the outline of a form may be traced onto the glass with a fine-tip marker. A wooden straightedge may also be used as a guide to scoring the glass.

The scoring, or cutting, is done with a glass cutter. Cutters are available at most crafts and hardware stores. There are several types, with the primary difference being in the cutter wheel. Some wheels are harder—and will last longer—but they also cost more. If held and used properly, all should cut glass precisely. Another variation among glass cutters is the noncutting end—which in some consists of a heavy metal ball that many craftsmen find useful in tapping along under the score line. The tapping initiates the running of the cut and aids the break.

61

Most professionals grip the glass cutter, as shown in the accompanying photographs, between index and middle fingers and use the thumb to support the cutter from the underside. However, some people have difficulty with this position. While this position does give great control, do try others if this one is impossible to master. In any event, you should hold the tool firmly, without tensing the arm muscles. Place the cutter edge-down on the glass, pressing until you hear the sound of the wheel biting the glass, and then begin to draw the cutter along the pattern line, all the while applying just enough pressure to hear the wheel cutting into the surface. Achieving this control over the pressure takes some practice, and it is a good idea to experiment cutting on a few pieces of inexpensive or scrap mirror. The test of a successful cut is whether the mirror breaks readily and cleanly. And the key is to trace a firm, solid line. A ragged or broken line could produce a cut that will run off in an unwanted direction. Never retrace a cut, since this damages the cutter blade.

Whenever possible, each cut should be "broken" as it is made, and before any others are made in the same piece of mirror. Breaking can be accomplished in several ways. To break a large piece of glass mirror, lay it with the score line up and parallel to the edge of a table—and slightly over the edge—and snap the hanging portion down. Or just snap the pieces apart between the fingers of both hands. If you are breaking long strips or small pieces, pliers may provide the best solution. *Running pliers* are wide pliers made especially for breaking long strips of glass. Usually the larger part of the glass to be broken apart is gripped in one hand, and the part to be broken away is gripped with the wide-jawed pliers. With smaller pieces the same method is employed using *grozing pliers* to achieve a good grip on the small unit. In some cases, grozing pliers may be necessary to hold both sides. As with cutting, experiment with breaking by cutting different shapes, different lines and curves, and breaking them by hand and with the aid of pliers. You will soon get the "feel" of how to score and break mirror.

Glass cutters will eventually get dull and worn-out. With simple care, however, most will remain serviceable through many applications. Occasionally dipping the cutter into kerosene before use will extend the blade's life. Store cutters between uses in a small jar with flannel or steel wool at its bottom, and add enough kerosene, or kerosene and a light oil, to keep the cutter wheel and axle covered.

A "clean-cut" edge results from a well-made break. But since this natural edge is usually very sharp and rough, it should be treated. Where the edge will *not* be exposed, all that need be done is to "groze" the edge by nibbling it with grozing pliers. This removes the sharp ridges. Of course, special care must be taken to avoid nibbling away the mirror backing. When edges will be visible, more refined edge treatments are called for. The glass may be ground to leave a satin finish, seamed by using an abrasive belt, polished to create a smooth surface, and beveled to varying widths. Many glaziers will provide these edge treatments to their customers, thereby eliminating the need to invest in expensive tools and machinery.

Small holes may be drilled into glass with special drills, which are usually lubricated with oil or kerosene. As illustrated here, larger holes may be cut into glass with the aid of a glass cutter designed for that very purpose.

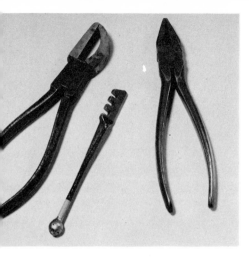

CUTTING GLASS MIRROR

Tools for glass cutting include a glass cutter (here with a ball end useful in tapping the cut on the underside of the glass to start it running) and pliers for grozing or nibbling rough edges and breaking the glass after cutting.

The glass should be cleaned thoroughly with a non-acidic, nonabrasive solution. The glass cutter is held between index and middle fingers and supported by the thumb. It is placed at the edge of the glass; pressed until it bites the surface, and drawn across the line to be scored in an even, uninterrupted stroke.

The glass is then tapped on its underside along the score line to initiate the running of the cut.

In the case of this straight cut, the score line is placed just over the edge of a table (cover with felt to avoid scratching of the mirror or its backing) and the glass is broken away.

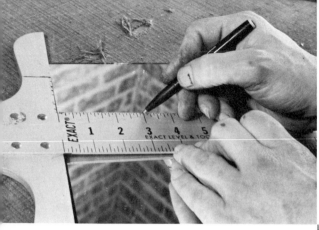

CUTTING A CIRCLE IN GLASS MIRROR
BY MALCOLM FATZER

Cutting a circle in the center of a piece of glass is a craftsman's tour de force. Malcolm Fatzer is doing just that, here, on a piece of mirror. His first step is to find the center of the circle and mark it clearly.

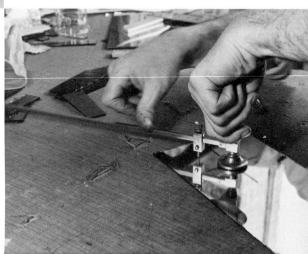

Using only very sharp diamond-tipped blades, Malcolm Fatzer scores the glass with a glass circle cutter.

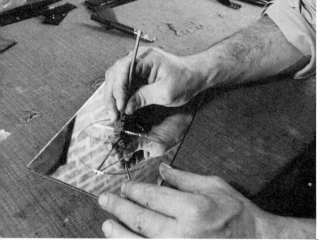

Next he triangulates the circle and adds many many fine parallel score lines within the triangle.

He applies pressure from behind to initiate the running of the score lines.

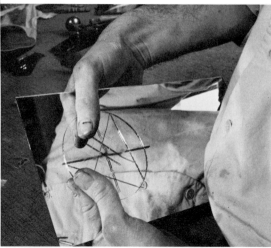

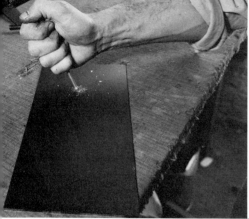

The ball end of the glass cutter is pressed through the back of the mirror to make a hole in the center of the circle.

The glass is then nibbled out of the center from the back using tool pressure.

The glass center pops out along the score lines. Works in stained glass by Malcolm Fatzer that employ such artfully cut pieces of glass are included in Chapter 9.

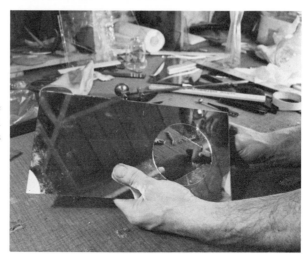

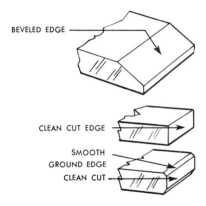

The edges of glass mirror may be finished in many ways. They may be allowed to remain clean cut or be ground, beveled, or rounded to create a pencil edge. *Courtesy: National Association of Mirror Manufacturers*

Cleaning and Care of Glass Mirror

Because glass is easily scratched and broken, special care should always be taken to protect it. Mirror faces should never be allowed to rub against sharp edges, corners, rough surfaces, or glass chips during packing, unpacking, cutting, or installation. Care should also be taken in cleaning glass mirrors. Harsh solutions—those that contain abrasives, alkali, or strong acids—are harmful to mirrors and should not be used. The National Association of Mirror Manufacturers recommends three types of mirror cleaning solutions: (1) weak (5 percent to 10 percent) methyl, ethyl, or isopropyl (rubbing) alcohol solutions (many household glass cleaners are of this type); (2) weak household ammonia water solutions (provided that they *do not* contain any alkali—which many do); and (3) weak (5 percent) household vinegar solutions. Abrasives, knives, scrapers, or dirty, gritty rags should not be used. Always apply cleaning solutions with a soft, clean rag or paper towel.

When cleaning mirror, avoid application of excessive amounts of cleaning solutions at the edges of the glass. Spillover to the backing attacks the mirroring at its most vulnerable point: mirrors most commonly fail—turn black—at their edges. To protect critical edges, apply cleaner to the cloth rather than to the glass. Make a practice of wiping the edges clean and dry of such spillover.

Installation of Glass Mirror

Glass mirror sheet may be mounted mechanically, with adhesives, or by a combination of these two methods.

For several reasons, mechanical mounting, by brackets or fixtures designed especially for use with mirror, should be used whenever possible. First, mechanically mounted mirror can be removed easily—whereas mirror made to adhere directly to a wall becomes an almost permanent fixture. But more importantly, adhesive mastics may attack the backing of certain sheet mirrors. Over the course of time, the silver may be affected, too. Also, mastic or adhesive backing used alone places enormous stress on the bond between the glass and the silvering where large pieces of mirror are used. Where an adhesive application is required or desirable, it is advisable to employ mechanical fasteners, too. Of course, the stress is a much less significant consideration when smaller sections of mirror are involved. It should be noted, too, that good quality glass mirror does receive a corrosion-resistant coating. And glass mirror specialty products such as mirror tile, precut shapes, and flexible mirror are designed to be used primarily or solely with adhesives. As long as the instructions and recommendations of the maker are followed, professional results should be readily obtainable. One mastic designed specifically for use with mirror is Mirro-Mastic, available from Palmer Products Corporation, 146 Palmer Avenue, PO Box 7155, Louisville, Kentucky 40207. (A primer, Mastic-Bond, is available, too.)

One of the easiest ways to mount smaller sections of glass (here a mirror glass wall tile) is with double-faced foam tape. This material is available in precut sizes (such as the 1″ squares shown here) or in rolls 1″ wide from which lengths may be cut.

MIRROR PEDESTAL DESIGNED
BY GLASS ARTS OF CALIFORNIA

Mirror cubes, pedestals, tables, and planters are designed and manufactured by Glass Arts of California (15250 East Stafford Street, City of Industry, California 91744) and are available in kit form from local glass shops. The base for this pedestal is composition board held together with white glue at the joints and reinforced with finishing nails.

All nails are countersunk deeply so that they will not pop up and affect the backing and silver of the mirror.

All edges are sprayed with black lacquer so that any of the substrate that might be visible after the glass mirror panels have been applied will be finished.

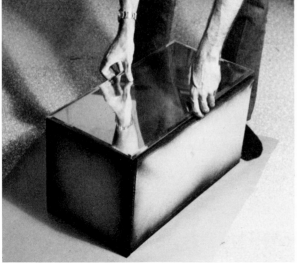

Two thin beads of clear silicone caulking are applied the back of each mirror panel. The first should be from the outer edge, the second 3″ within the first bea The caulking must not be too thick—if it is, the mirr will not lie flat.

The first mirror panel is then aligned and pressed firmly onto the composition board base. Masking tape at top and bottom edges may be used to hold the panels in place while the caulking cures (allow 24 hours).

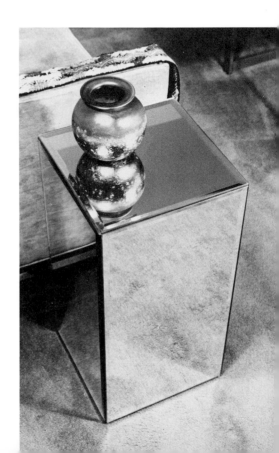

The finished mirror pedestal of finest quality beveled edge plate-glass mirror from a Glass Arts of California kit.

Although it is wisest to avoid the use of adhesives or mastics in mounting mirrors, and to use mechanical techniques wherever possible, mastics are effective in certain applications. Always consult the mirror supplier or manufacturer to determine which brand is recommended. This diagram shows a pattern for applying mastic over 25 percent of the back surface of a mirror—a technique that spreads the load bearing over a larger area and places less stress on any given part of the mirror backing. This pattern also allows for free circulation of air so that the adhesive will cure completely. Most mastics are available in tubes, cans, and pails. As a safety precaution—and for additional support and protection of the reflective backing—use clips or molding in combination with adhesives whenever possible. *Courtesy: National Association of Mirror Manufacturers*

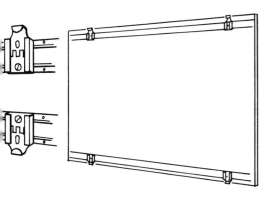

A variety of mounts are used for standard, unframed mirrors. At the top left, a Venetian wall mirror has been mounted on a hardboard, to which two adjustable hangers and one swivel have been mounted. This mirror may be hung vertically or horizontally—the screws incorporated in the hanger assembly allow for leveling of the mirror. At the top right, four strap hangers are mounted to the hardboard backing before assembly. Heavy picture hooks or wire will be used for hanging. The mirror at the bottom left has no hardboard backing, since it will be mounted flush to the wall with clips attached to metal strips screwed into the wallboard. The bottom clips are permanent; the top clips are adjustable so that they may be pressed tightly against the mirror top to hold it in place. (They may also be raised later for removal of the mirror.) At bottom right, two harness straps hold the mirror (without hardboard backing). Adjustable screws secure the mirror. Mounting will be accomplished by hanging one strap on two heavy brads or picture hooks—the other strap will serve as a bumper and keep the mirror at an even distance from the wall. Whenever possible, mirrors should be allowed to hang slightly away from the wall or backing.

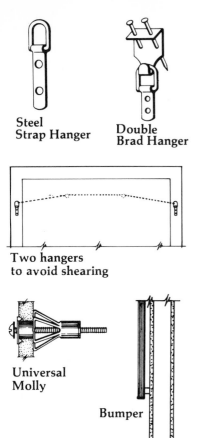

Steel Strap Hanger

Double Brad Hanger

Two hangers to avoid shearing

Universal Molly

Bumper

If a framed mirror is to be mounted, a steel strap hanger set on a double-brad hanger may be the most secure hanging method. A double loop of heavy-duty picture wire should be strung between the strap hangers—remember that glass mirror is heavy, and if the frame falls, the glass will most likely break. To avoid cracking or chipping walls, place an X of masking tape across the points where the nails will enter the surface. For mirrors weighing less than 35 pounds, hooks may be placed four inches apart. With larger mirrors, placed the hooks farther apart to distribute weight more evenly. If there is no wall stud, drill a hole and use a universal molly or toggle bolt to hold the hook. This type of fastener will provide additional support. On a brick or concrete wall, drill holes and use masonry nails or screws. Avoid adhesive-backed hooks for hanging mirrors. And try to use felt tabs or bumpers at the base of the mirror frame to provide space between the mirror and the wall for ventilation. Air circulation will minimize discoloration of the covered wall. *Courtesy: National Association of Mirror Manufacturers*

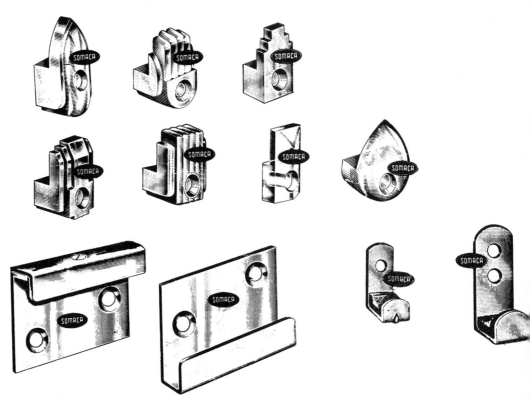

A standard method of mounting mirrors is to use clips or brackets of plastic or metal. Those shown here are just a few of the available forms. *Courtesy: Sommer and Maca Industries, Inc.*

Metal channels may also be used effectively to provide good support and a finished appearance. *Courtesy: National Association of Mirror Manufacturers*

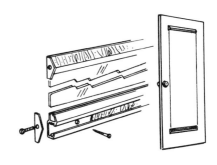

Many types of mirror brackets are available. These two, manufactured by J. W. Goss Co. (Warren, Ohio), have the mirror sit in a U-shaped channel or in just two bent clips. In both types of Mirraco mirror hangers, the hardware is screwed into the wall. The one with clips is adjustable, since the clips themselves can slide up and down in notched channels. The one with the extruded aluminum channel lends a finished framed look to top and bottom mirror edges.

A mirror may be mounted to a door, using plastic clips, by installing two clips at the bottom, resting the mirror on them, and installing clips at the top and sides. Mirrors may also be installed with the door removed from its hinges and laid flat. *Courtesy: National Association of Mirror Manufacturers*

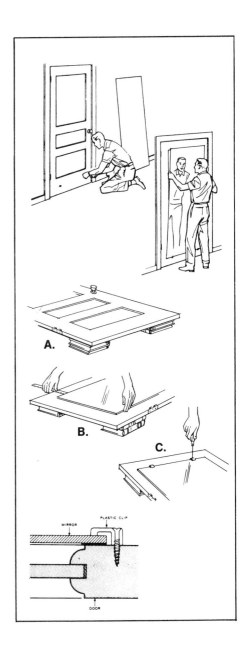

Decorative Techniques with Glass Mirror

APPLIQUÉ

One of the easiest and most attractive of the many surface and backing treatments possible with glass mirror is the application of various materials and objects to the front surface. Precut shapes (of glass or acrylic mirror) may be made to adhere to mirror sheet with mastic or with foam tape. Wood, metal, raffia, shell, or other materials may be applied the same way. Decoupage—the process of making cut-paper designs adhere to a surface with a clear varnish—has long been practiced on mirrored glass with considerable success.

Precut mirror shapes may be used to create appliquéd designs in—or on—mirror.

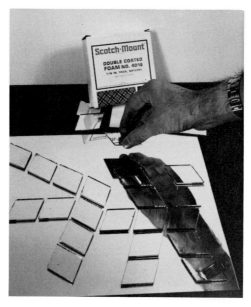

Shapes of mirror may be applied to mirror with foam tape . . .

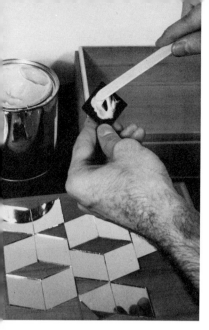

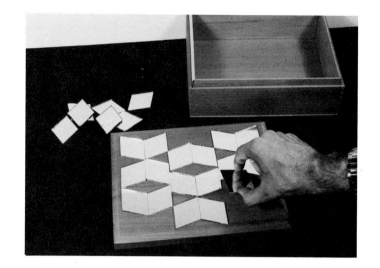

. . and to other surfaces with mastic. First create the design, then apply adhesive and press the shape to the surface being decorated.

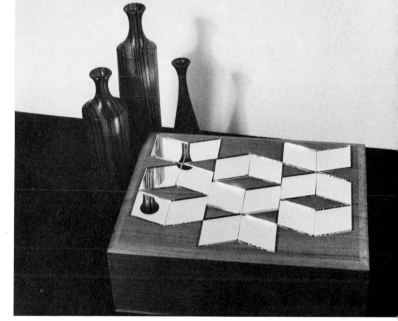

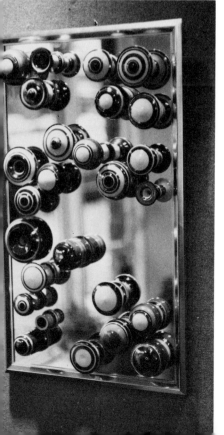

A wide variety of other shapes and materials may also be made to adhere to mirror—as in this piece by Bill Nagengast. *Courtesy: Bill Nagengast*

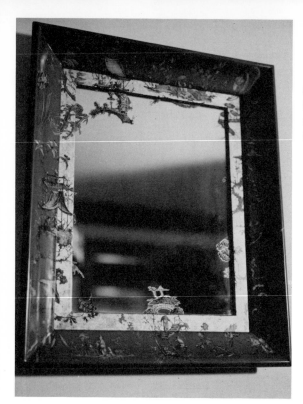

One form of appliqué is decoupage. Fran Cohen applied chinoiserie figures to a dark red and gold frame and overlapped some shapes directly onto the mirror.

Dee Davis and Dee Frenkel's *Venus* mirror. A cutout from a Botticelli reproduction is glued directly to the mirror.

PAINTING

Mirror and glass may be painted, too. Paints are formulated especially for use on glass. Generally speaking, turpentine-based paints are employed when the mirror will be spray painted. Enamels (in at least two coats—to achieve opacity) are most often used in hand painting.

Glass may be painted either before mirroring (on the back), which results in a painted image under the silver, or after mirroring (on the front of already mirrored glass). Obviously if you paint on the back and then mirror over the paint, both silver and paint finishes will be "behind" the glass. In either event, the vast range of painting methods may be employed. Silkscreening offers particular flexibility and control. Fine lines and images may be transferred to the glass quickly. Designs may also be painted with the aid of templates, stencils, or resists, which will prevent the flow of paint into protected areas.

MASKING, PAINTING, AND SILVERING GLASS
BY JAMES MORGAN

James Morgan uses a variety of painting and silkscreening techniques in his art. Here he masks certain areas of glass. After mirroring, he then paints the back of the glass in some areas. He starts by producing a sketch on graph paper. To add realism to his sketch, he applies strips of metallized plastic tape to suggest where the mirroring will go. In this case, his design of the numbers 1 through 9 will be in silver.

Clear Con-Tact paper is applied to the glass to serve as the resist.

With a sharp knife and straightedge, he cuts the Con-Tact paper to shape and then peels away the Con-Tact paper from the area that is to be silvered.

With fingernail, he improves the contact between resist and glass.

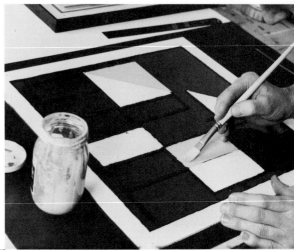

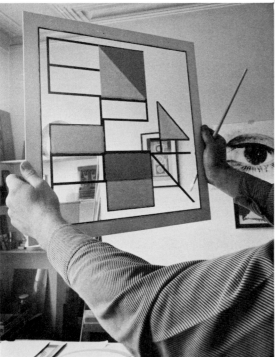

Once he has masked all areas that are not to be silvered, James Morgan brings his piece to a local company for silvering. After the design has been silvered, he paints over the back of the silver to protect the thin metal coat, using backing paints. The Con-Tact paper must then be peeled away carefully so that it does not tear the paint or the silver from the glass. He uses a sharp blade to assist in this peeling process. Then the glass is cleaned. James Morgan opts to paint various parts of the glass, using turpentine-base paints.

He applies two coats of the paint to make it opaque and then holds the piece up to the light to check the opacity.

After the paint has dried, James Morgan can try out this silvered and back-painted glass on a variety of backgrounds, such as solid black.

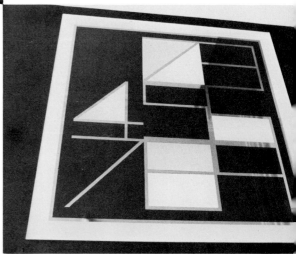

Or he could try out a silkscreen print image with it. Here, for instance, he studies what happens to the design when a silkscreen eye is superimposed on part of the piece.

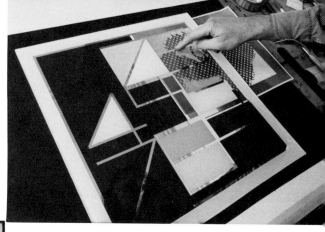

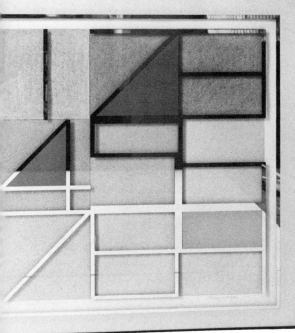

Rather than silkscreen, James Morgan sticks to his original sketch pattern, setting the mirrored/painted glass in front of a hand-painted paper in a simple frame. He uses the space between glass and ground to allow the mirror to float, creating an illusion of depth. Shadows add to this image. *One to Nine* (1977) by James Morgan.

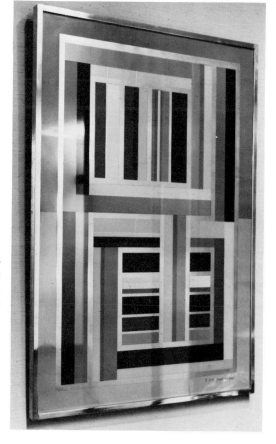

R by James Morgan. Instead of having the glass silvered, James Morgan applied mirror card—a type of cardboard that has metallized polyester film applied to its surface. Letraset graphic sheets are also utilized. *Courtesy: James Morgan*

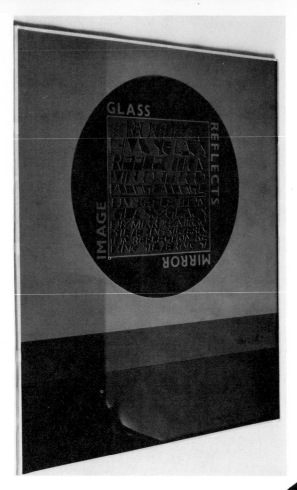

Telsa (1976) by James Morgan. The large circle is gold-foil mirror. Accents around the words are sandblasted into glass and silvered over. Light picks up on the sandblasted edges. The interplay of words and the media has a poster effect, enhanced by the neutral ground colors that allow the colors of silvering to stand out. Quarter-inch Spectra-Float glass is used. *Courtesy: James Morgan*

Reflective Birds (6′ × 3′) by Tavenner. Photographic silkscr on glass and mirror. *Copyright: Tavenner*

Other reflective surfaces may be photo silkscreened too, as in *Skyscape II* on anodized aluminum by Merry Moor Winnett. *Courtesy: Merry Moor Winnett*

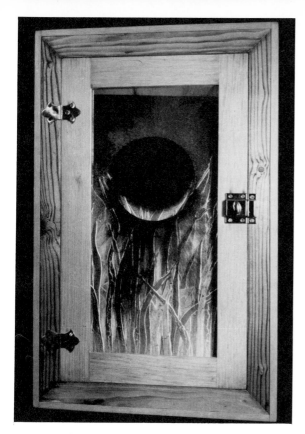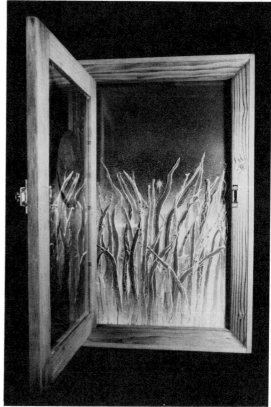

The door in *Morning Star* ($18\frac{1}{4}'' \times 28\frac{1}{4}'' \times 1\frac{1}{2}''$) by Dusty Shuler opens onto a scene of leaflike forms in a deep impasto of Latex paint. The door is glass mirror, which has been etched—not by using acid but by scraping with an etching needle. The underlayer is spray-painted metallized Mylar.

ETCHING AND SANDBLASTING

Etching and sandblasting, like the painting of glass, may be done on either front or back surface. Both techniques can be used to create line and texture. The two may be combined with each other or with other decorative techniques, such as painting or appliqué. Glass may be readily—but very, very carefully—etched with hydrochloric acid. Sandblasting is probably best done commercially to the design of the artist.

MANIPULATING THE SILVER BACKING

An extension of the painting techniques is the process of stripping already silvered mirror of its backing and silver and then repainting the bared areas. Stripping, like painting, may be controlled by masks, templates, and even adhesive-backed vinyl. At least two products have been developed for this very purpose. Mirror Magic (Deep Flex Plastic Molds, Inc., 2740 Lipscomb Street, Fort Worth, Texas 76110) is a two-part system consisting of sprays. Part A removes the protective mirror backing; Part B removes the silvering. Mir-off (The Artist Shack, Inc., Route 31, Pennington, New Jersey 08534) is a liquid, which is applied to fine steel wool and then used to abrade and remove the backing and silver in one step. With all such products, the newly bared glass may be painted or decoupaged by making paper cutouts or photographs

adhere to the glass. Backing paints or materials should then be applied to protect the new surfaces. Mirror-Bac paint, available from Palmer Products Corporation, 146 Palmer Avenue, P.O. Box 7155, Louisville, Kentucky 40207, is one such protective material. It may be sprayed or painted onto the back of mirror. Other mirror backing materials—and a wide range of products related to the manufacture and installation of mirrors—are available from Peacock Laboratories, Inc., Fifty-fourth Street and Paschall Avenue, Philadelphia, Pennsylvania 19143.

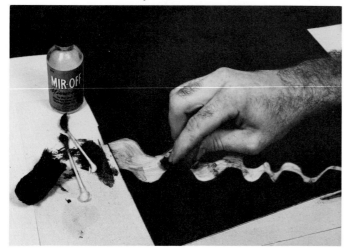

The silvering of mirror may be removed and manipulated by a variety of techniques. It may be etched, scraped, or sandblasted away, and, as here, it may be removed by a combination of solvent and abrasion. A mask was first constructed by slitting plastic tape and making it adhere firmly to the mirror back. Miroff was then applied and the silver to be removed was rubbed with steel wool.

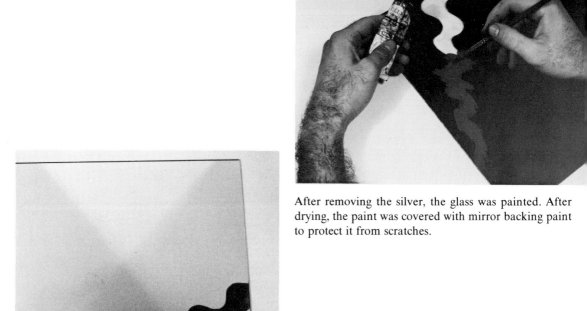

After removing the silver, the glass was painted. After drying, the paint was covered with mirror backing paint to protect it from scratches.

Mirror for Yesterday by Raymond Barnhart, of wood, fabric, ceramic, and glass mirror from which the silvering has been partially removed. *Courtesy: Raymond Barnhart*

PLASTIC MIRRORS AND REFLECTIVE MATERIALS

Most of us subconsciously associate the word *mirror* with glass. The connection is a predictable one, since, until recently, glass was the only medium practical for inexpensive, good-quality mirrors that were serviceable in a wide variety of commercial and personal applications. Plastics have changed this state of affairs and have influenced the way that artists, craftsmen, and designers think about reflective media.

Acrylic mirror, for example, has properties that allow reflective materials to be used in more places and in more ways than glass. Glass remains the most practical and effective mirror for certain applications, since its rigidity allows for true reflection over large spans. However, that advantage of glass is slight compared to the advantages of plastic. Acrylic mirror is half the weight of glass mirror. It has excellent shatter-resistance ($\frac{1}{4}''$ acrylic is fourteen times more breakage-resistant than $\frac{1}{4}''$ plate glass). Most significant, though, is the readiness with which acrylic mirror may be cut into intricate shapes, drilled, sanded, polished, and otherwise machined, and bent or formed by heat. Acrylic mirror may be successfully manipulated with minimal experience. The physical characteristics offer particular advantages to craftsmen and artists who need special, often complex, mirror shapes quickly.

Metallized plastic films offer other possibilities. Highly reflective surfaces can be created by simply stretching these films over a rigid frame or making them adhere to a solid base. And since most such films can be die-cut or cut with scissors, knives, or paper cutters, a decorative potential once limited by weight and expense of cutting glass mirror has been further expanded.

The other basic plastic material that we will discuss here is one that is probably best known of all: *acrylic*. This versatile plastic is the same one used to make acrylic mirror. Both mirrored and unmirrored acrylic are discussed here because they are fabricated in the same ways—with one exception. Although mirrored acrylic can be heat formed to the limited extent of bending after strip heating (see below), the more extensive forming operations (such as blow molding) will cause the reflective coating to separate from the acrylic. However, acrylic may be mirrored after it is heat formed, making up for this deficit, as discussed below. In addition to standard sheet acrylic, other forms, including rods, tubes, balls, and custom-cast pieces are readily available and are frequently employed as structural materials and decorative elements in designing everything from mirror frames to furniture.

While craftsmen and designers have come to utilize many hundreds of plastics in as many applications, we focus upon these three basic materials because they have been relied upon more frequently than most in creating mirrors, mirror frames, and mirror structures. All offer enormous potential in developing forms conveniently, quickly, and relatively inexpensively—without sacrifice of quality or aesthetics. As the name implies, plastic is responsive and versatile, and its promise is open to all who have the basic knowledge and skills to work with it.

Acrylic and Acrylic Mirror

Although acrylic weighs approximately half as much as glass and is more flexible, it is just as optically clear, much more readily fabricated, and available in a wide range of thicknesses, colors, textures, and opaque, translucent, and transparent colors.

Acrylic sheet is manufactured from methyl methacrylate resin under heat and pressure. In addition to sheets in standard sizes ranging up to 4′ × 8′ and thicknesses ranging from $\frac{1}{16}''$ to several inches, acrylic is manufactured in tubes, rods, balls, large blocks, and it is cast in custom shapes. Because it breaks less easily than glass, both clear and colored acrylic have been used for years in airplanes, school windows, recreational vehicles, toys, and household appliances. In addition to an indefinite shelf life and the readiness with which it may be fabricated, acrylic is especially notable as a material that may be formed by the application of low-temperature heat.

Acrylic mirror is a comparatively recent addition to the range of acrylic products, but the enthusiasm with which this material has been received has already resulted in the expansion of the selection of acrylic mirror products that are available commercially. Acrylic mirror sheet is, for example, manufactured not only in the traditional silver color but also in yellow, bronze, amber, green, gray, and blue. Like unmirrored acrylic, mirror sheet is manufactured under the Plexiglas trademark (Rohm and Haas Company) and other brand names. It is available in standard sizes from 24″ × 24″ to 4′ × 8′, and in $\frac{1}{8}''$ and $\frac{1}{4}''$ thickness at Cadillac Plastics outlets throughout the country as well as at lumberyards, hardware stores, plastics distributors, and craft and art suppliers. Nonstandard sizes (up to 6′×9′), thicknesses, colors, and patterns of Plexiglas mirror can also be ordered. In addition to acrylic mirror

In addition to mirrored sheet, acrylic comes in a wide variety of
mirrored specialty products. Thermoplastic Processes, Inc., offers
tubing of various shapes (here: round, square, twisted rod), sizes,
and colors through plastic suppliers.

sheet, specialty products are also becoming increasingly available and popular.
Mirrored round (½″ to 12″ O.D.), square (⅜″ to 6″ O.D.), and twist (½″ to 1″
O.D.) tubings (Mirron Tubing) are now available in 48″ lengths in metallic
chrome, gold, brass, pink, smoke, green, and red from Thermoplastic
Processes, Inc., Valley Road, Stirling, New Jersey 07980. Mirron fittings in the
same colors as the tubings (connectors, elbows, crosses, and caps) are also
available. Large structures are feasible and aesthetically pleasing because this
system allows the designer both the latitude and the completeness to produce
finished pieces quickly. Mirror sheets of acrylic that have been blow molded to
create patterns of concave or convex mirrors within each sheet are also
becoming increasingly available in a variety of geometric patterns.

WORKING PROCESSES FOR ACRYLIC
AND ACRYLIC MIRROR

Acrylic mirror is, in many ways, a miracle material for those wanting to
employ highly reflective elements that are readily worked. However, when
designing with acrylic mirror, bear in mind that it is somewhat flexible and
subject to thermal expansion. For that reason it should be allowed some space
to move with temperature and humidity changes. Some distortion will occur as
a result of this temperature/humidity differential relative to its two surfaces.
The amount of distortion will increase as the size of the sheet grows and as the
viewing distance increases. Sufficient material thickness and proper installa-
tion techniques (discussed below) will help to reduce visual distortion but
cannot eliminate it entirely. Consider the following table, showing average
deflection of Plexiglas framed horizontally and unsupported but with at least
the specified edge engagement (compiled by the Rohm and Haas Company).

Average Deflection of Plexiglas Mirror *

	$\frac{1}{8}''$ Plexiglas mirror	$\frac{1}{4}''$ Plexiglas mirror	Edge Engagement
Under 18″ x 18″	$\frac{1}{16}''$	Less than $\frac{1}{16}''$	$\frac{1}{2}''$
24″ x 24″	$\frac{3}{16}''$	$\frac{1}{16}''$	$\frac{1}{2}''$
30″ x 30″	$\frac{5}{16}''$	$\frac{1}{8}''$	$\frac{1}{2}''$
24″ x 48″	$\frac{5}{16}''$	$\frac{1}{8}''$	$\frac{1}{2}''$
36″ x 36″	$\frac{7}{16}''$	$\frac{1}{4}''$	$\frac{15}{16}''$
48″ x 48″	$\frac{3}{4}''$	$\frac{9}{16}''$	$\frac{15}{16}''$
48″ x 72″	$\frac{11}{16}''$	$\frac{5}{8}''$	$\frac{15}{16}''$
60″ x 60″	$\frac{11}{16}''$	$\frac{5}{8}''$	$\frac{15}{16}''$

* Three-year data. Panels mounted horizontally and unsupported in frames.

Courtesy: Rohm and Haas Company

If significant visual distortion is undesirable, avoid designs in which deflection will exceed $\frac{1}{8}''$. Controlled temperature and humidity will further minimize distortion in horizontally mounted acrylic mirror.

Storage, Handling, and Care of Acrylic and Acrylic Mirror

Although acrylics will sustain severe shocks without breaking, the surface may be marred by rough handling and contact with abrasives. Care should be taken to avoid scratches and jolts. Acrylic may be stored almost indefinitely. Full cartons may be stored on an edge or flat. Open cartons and single sheets are best stored flat to prevent bending and warpage but may also be stored on edge in angled storage racks. Acrylic—and the backing of acrylic mirror (and glass mirror)—should not be exposed to dirt, oils, detergents, or chemicals that might affect the plastic or the backcoat and silver. When you remove sheets of acrylic mirror from storage, always be careful to avoid scratching the backcoat. Placing tissues between sheets until the plastic is used will help to prevent abrasion. Optimal atmospheric conditions are temperatures between 60°F and 80°F and a relative humidity of 40 percent to 60 percent. Never store acrylic or acrylic mirror near heat.

Acrylic and acrylic mirror may be cleaned by spraying a wax such as Johnson's Pledge on the mirror front and wiping with a soft cloth. Wax tends to fill and hide small scratches in the surface. Acrylic may also be cleaned by wiping with water, but wax provides protection besides cleaning.

In order to protect acrylic and acrylic mirror after it leaves the factory, the Rohm and Haas Company masks its Plexiglas with a strong polyethylene film. This allows the color and pattern of the material to be readily identified without removing the mask. This covering should be left on the plastic during all machining operations. It may be left on the plastic during heating and forming, too. (Note: This covering is not the type of paper covering used by some other acrylic manufacturers, however. Those papers should always be removed before heating acrylic. The paper can be left on during machining.)

When acrylic mirror is being cut, the masked side should always be *facedown*—to avoid scratching the mirrored backcoat.

Laying Out Patterns on Acrylic and Acrylic Mirror

Patterns or cut lines may be sketched on either the backcoat of acrylic mirror (which in the case of unmirrored acrylic may be either clear polyethylene or paper) or on the polyethylene film mask. Use a grease pencil or felt-tip marker.

For painting operations, this mask can serve another function. Areas of the film may be scribed with a frisket knife (taking care not to cut the surface of the acrylic) and removed. The bared area may then be painted while the remaining mask protects the covered acrylic. (See discussion of decorative techniques, which follows.)

Cutting Acrylic and Acrylic Mirror

Acrylic sheet, mirror, and specialty products have working qualities similar to those of hardwood and may be machined much as wood and metal are.

Sheet acrylic and acrylic mirror may, for example, be cut by scribing with a tool developed specifically for this purpose. With a straightedge as a guide, the tool is drawn over the plastic approximately five times for ⅛″ thick material and ten times for ¼″ sheet—mirror should always be scribed on its back surface. After scribing, a ¾″ dowel at least as long as the break line is placed under the scribed line (with the scribed line still facing up). One hand is then placed on the acrylic 2″ from the line to steady the material. The other hand is similarly positioned on the other side of the line and used to apply firm downward pressure to make the break. Cuts should not be closer to the edge of the sheet than 1½″ if this scribing technique is to be employed.

Acrylic may also be cut with table, band, radial arm, jig, saber, panel—or most other—power saws. Band and jigsaws are particularly effective for cutting tight curves and intricate patterns. The manufacturer's masking should always be allowed to remain in place during machining. (The masking—and not the mirror backing—should face the work surface, to avoid scratches. For the same reason, all tools and work areas should be clean and free of burrs.) When being cut, the plastic should be held down firmly and fed slowly to avoid chipping and gumming that occurs when excessive heat builds up.

With circular saws—most effective for straight cuts—choose carbide-tipped or crosscut blades. The former should have at least five to eight teeth per inch, the latter at least six teeth per inch. All teeth should be of identical height, shape, and distance from each other, and should be allowed to extend slightly above (or below) the surface of the sheet being cut in order to avoid chipping of the edges. Blades for band saws should have a minimum of ten teeth to the inch, saber saw and jigsaw blades should have 14 teeth per inch for ¼″ sheet and 32 teeth per inch for ⅛″ material.

Acrylic and acrylic mirror may also be engraved, trimmed, and rabbeted by routing. Again, carbide-tipped blades should be used, and all blades should be sharp for optimum performance.

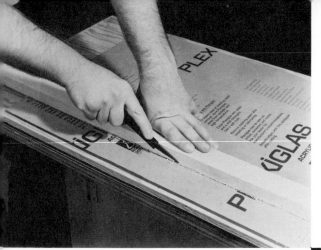

Acrylic thicknesses up to ¼″ can be scribed and broken—similar to cutting glass—with a sheet cutting tool. Set the tool at the edge of the material next to a straightedge guide. Apply firm pressure; draw the cutting point the full width of the material. Repeat five to seven times for thickness from .10″ to .187″ and seven to ten times for ¼″. Keep masking paper on the acrylic during this and the breaking procedure. *Courtesy: Rohm and Haas Company*

The scribed line should then be positioned faceup over a ¾″-diameter wood dowel running the length of the intended break. To break, hold the sheet with one hand and apply downward pressure on the short side of the break with the other. Hands should be kept adjacent to each other and successively repositioned about two inches in back of the break as it progresses along the scribed line. The minimum cutoff width is about 1½″. *Courtesy: Rohm and Haas Company*

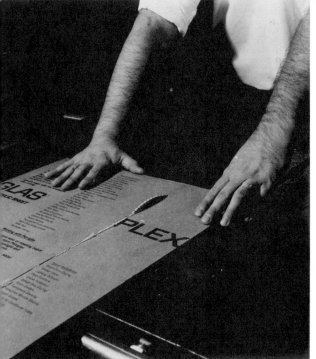

Of course, acrylic may also be cut with hand and power saws. Circular saws are ideal for making straight cuts. Use a saw blade designed specifically for acrylic or a steel crosscut blade recommended for finish cuts on veneers, plywood, or laminates. The blade should extend slightly above the surface of the acrylic to prevent chipping. Hold the material firmly to the saw table and never force-feed. *Courtesy: Rohm and Haas Company*

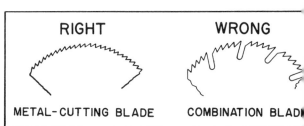

RIGHT WRONG

METAL-CUTTING BLADE COMBINATION BLAD

Proper blades for cutting acrylic on power saws have tee identical height, shape, and distance from one another. Ci saw blades should have at least six teeth to the inch. *Cou Rohm and Haas Company*

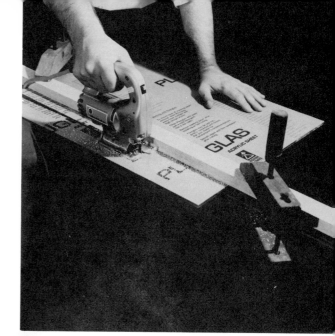

Curved shapes are easily cut in acrylic using saber, band, or jigsaws. Saber and reciprocating jigsaw blades should have at least 14 teeth per inch when cutting ¼″ sheet—and 32 teeth per inch for ⅛″ material. Band saw blades should have at least 10 teeth per inch. Hold acrylic down firmly during cutting; never force-feed; and always follow correct shop safety procedures. *Courtesy: Rohm and Haas Company*

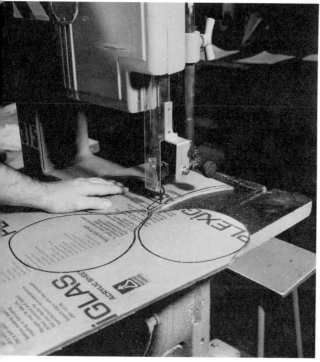

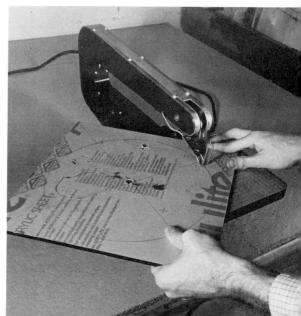

Drilling Acrylic and Acrylic Mirror

Drill presses, hand drills, or portable power drills may all be used with acrylic. The best bits are those designed specifically for use with acrylic. (These are available at hardware stores and plastics suppliers.) Twist drills used for drilling soft metals may also be used. The most important characteristic of any drill used on acrylic is that the cutting edges be ground off to a zero-degree rake angle—to reduce the risk of chipping the surface upon penetration of the plastic. Drill speed should not exceed 3,000 rpm and speeds of 1,000 and 2,000 rpm will improve the quality of holes ⅜″ or larger in diameter. To minimize chipping when the drill breaks through the back surface, the backing of the mirror or the drill press table should be a soft wood. The acrylic should be clamped or held firmly.

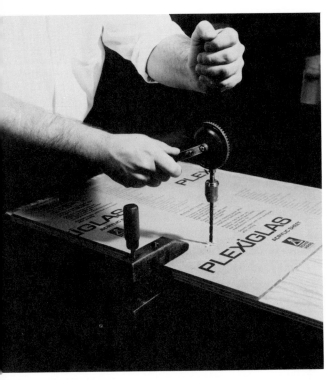

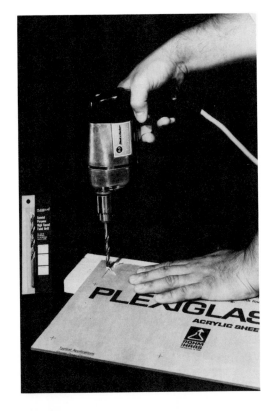

Holes may be drilled in acrylic with a hand drill, with a portable power drill, or by drill press. The sheet should be held firmly in place with a clamp or by hand, and backed with soft wood. With power tools, use the highest drill speed available up to 3,000 rpm. However, when drilling holes ⅜″ or larger, a slower speed (1,000–2,000 rpm) will produce better results. Never force-feed, and proceed very slowly as the drill bit penetrates the second surface. *Courtesy: Rohm and Haas Company*

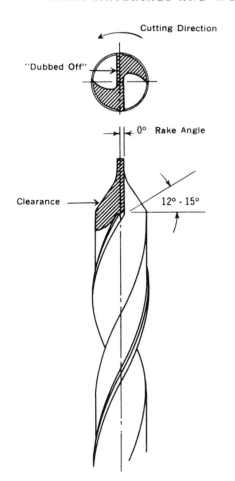

Special drill bits with a 0° rake angle are manufactured specifically for use with acrylics. *Courtesy: Rohm and Haas Company*

Edge Finishing

The only finishing that must be done to acrylic and acrylic mirror sheet is removal of saw marks on the edges that may reduce its impact resistance. This may be done by routing, sanding with a medium (80-grit) sandpaper, or scraping with a sharp, flat blade such as those used in woodworking.

For cosmetic and design reasons, however, a dressed or polished edge may be desired. Scraping, and then sanding (wet or dry) with a succession of grits from coarse (80) to fine (400), and then buffing will create a translucent matte finish known as a "dressed" edge. A fully transparent, glossy edge can be obtained by polishing the surface after buffing. The best system for this involves a two-wheel buffer with fairly loose 10″ muslin wheels—one for compound, the other to buff clean. Buffing wheels mounted on hand drills serve well, too—just be careful that (in the case of a 10″ wheel) the speed does not exceed 2,000 rpm, since greater speed may develop heat, which causes the plastic to gum up. Use stick wax to bind a fine buffing compound (such as white tripoli) to the wheel.

The edges of acrylic sheet and acrylic mirror may also be beveled by cutting (at an angle), routing, or sanding ¼″ sheet. To maintain strength, though, chamfer the edges rather than feather them.

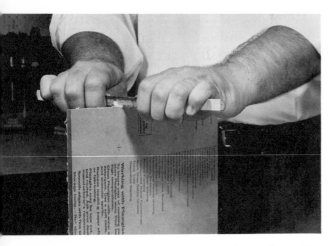

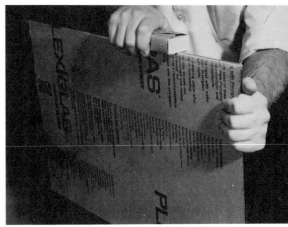

Remove saw marks and unevenness from edges with a flat-bladed scraper made of steel. *Courtesy: Rohm and Haas Company*

After scraping, a translucent or "dressed" edge may be created by sanding (wet or dry) with progressively finer sandpapers. Begin with 80-grit and progress to 400-grit. *Courtesy: Rohm and Haas Company*

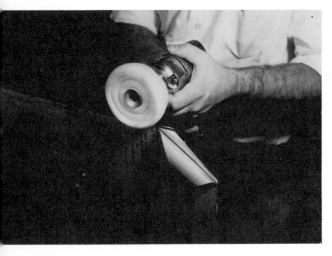

To achieve a high polish after obtaining a dressed edge, buff with a fine compound on a loose muslin wheel. *Courtesy: Rohm and Haas Company*

For pieces that may be hand-held, a two-wheel 10″ buffing system is best. Apply tallow stick wax to bind the tripoli compound to one wheel. Use the other wheel to buff the acrylic clean. The 10″ wheel should rotate at 1,200 rpm.

Cold and Hot Forming

Acrylic may be bent around or into large curves while cold and be permanently secured to create large cylindrical shapes. The tightest radius that a ⅛″ sheet may be bent without cracking is 22.5′; the minimum radius for a ¼″ sheet is 45″.

Most frequently, however, acrylics are heat formed. As thermoplastics, acrylics become soft, flexible, and rubberlike after ten to fifteen minutes of heating at 240°F to 340°F. Once softened, they can be readily formed into three-dimensional shapes. If they are held until cool, the shape will be retained.

Unmirrored acrylic offers extraordinary design possibilities through this property. Of course, the material may be mirrored after forming. And, in fact, this is the procedure that *must* be followed if mirrored acrylic is to be formed extensively.

Mirrored acrylic sheet cannot be formed as completely as unmirrored acrylic because the heat causes a loss of reflective quality. Mirrored acrylic can, however, be strip heated and formed into angled bends. Strip heaters heat acrylic locally along a straight line to 290°F to 325°F. Once heated, the acrylic mirror may be bent along the line to any desired angle in either direction.

To strip heat, the acrylic mirror is placed facedown over the heater—at least ¹⁄₁₆″ from the heating element. (The transparent polyethylene masking film

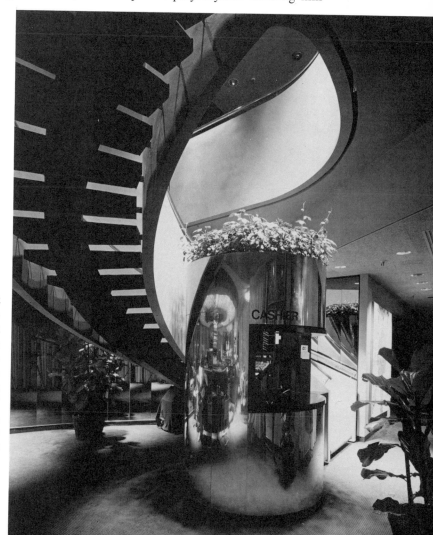

The cashier's booth at the Market Street Restaurant in the Embarcadero Hotel, designed by John Portman and Associates, is clad in metal. But acrylic and acrylic mirror may be used to similar advantage. In fact, acrylic and acrylic mirror may be cold formed: ⅛″ sheet to a 22.5″ minimum radius, and ¼″ sheet to a 45″ minimum radius. *Courtesy: John Portman and Associates*

may be allowed to remain in place during heating and forming, and may be removed easily after the acrylic cools. This is not true of paper masks, however.) When the plastic becomes soft, it may be bent gently in either direction and held (or firmly supported) for a few minutes until it cools enough to set. Be careful not to bend it too quickly or before it is fully heated, since small internal fractures may occur. You will notice a "blush," or less reflective area, of $\frac{1}{8}''$ to $\frac{1}{4}''$ width along the heated line. As noted above, this is the effect of heat on the mirror backing. As long as the heated area is not too wide, this should pose no problems. Strip heating elements are available at many hardware, crafts, and plastics suppliers, as well as from authorized Plexiglas distributors. Commercial strip heaters are available from Hydor Therme Corp., 7155 Airport Highway, Pennsauken, New Jersey; Trent, Inc., 201 Leverington Avenue, Philadelphia, Pennsylvania 19127.

Unmirrored acrylic may be formed by heating the entire sheet, but only limited forming may be done with acrylic mirror, since its reflectivity is affected by application of too much heat. This diagram shows the construction of a strip heater using a Briskeat RH-36 heating element. *Courtesy: Rohm and Haas Company*

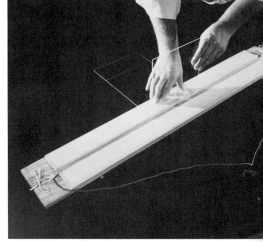

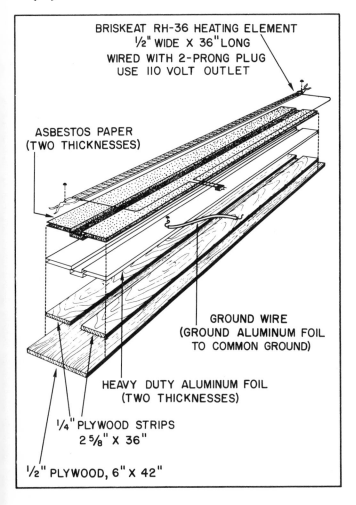

BRISKEAT RH-36 HEATING ELEMENT
$\frac{1}{2}''$ WIDE X 36" LONG
WIRED WITH 2-PRONG PLUG
USE 110 VOLT OUTLET

ASBESTOS PAPER
(TWO THICKNESSES)

GROUND WIRE
(GROUND ALUMINUM FOIL
TO COMMON GROUND)

HEAVY DUTY ALUMINUM FOIL
(TWO THICKNESSES)

$\frac{1}{4}''$ PLYWOOD STRIPS
$2\frac{5}{8}''$ X 36"

$\frac{1}{2}''$ PLYWOOD, 6" X 42"

Protective masking paper should be removed from acrylic and acrylic mirror before any heating and forming operations, but the clear polyethylene mask that Rohm and Haas uses to protect its Plexiglas mirror may be allowed to remain in place during strip heating. The line to be bent should be centered over the heating element with the mirror backing faceup. The material should be allowed to heat thoroughly (until it softens or "wilts" in the area to be formed). This should take five to six minutes for $\frac{1}{8}''$ sheet, and twelve to fifteen minutes for $\frac{1}{4}''$ sheet. Bend in either direction with mirrored acrylic. When bending unmirrored acrylic, try to keep the heated side on the outside of the bend. Hold or prop firmly in place until cool. Always avoid premature bending since internal fractures and crazing will result. Over-heating will cause scorching and bubbling—make certain that the material is at least $\frac{1}{8}''$ from the heating element. And never leave a strip heater unattended. Work in a well-ventilated area, and use a commercial strip heater for bending acrylic greater than $\frac{1}{4}''$ in thickness. At all times during heating and forming operations have a general-purpose ABC rated (dry powder) fire extinguisher nearby in case of accident. *Courtesy: Rohm and Haas Company*

DECORATING A VASE WITH HEAT-FORMED ACRYLIC MIRROR

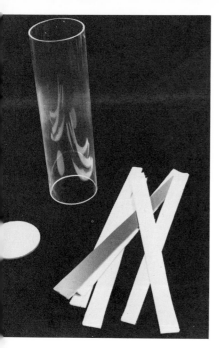

This clear acrylic tube will be clad with the strips of acrylic mirror at right. (The circle at the left will bottom the vase.)

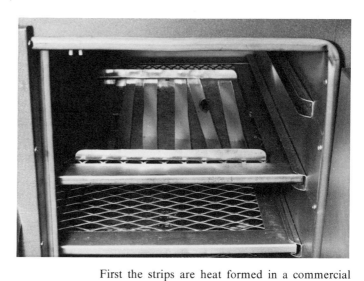

First the strips are heat formed in a commercial oven. Since heat affects the reflectivity of acrylic mirror, this process must be carried out with the utmost care and attention, using very low temperatures.

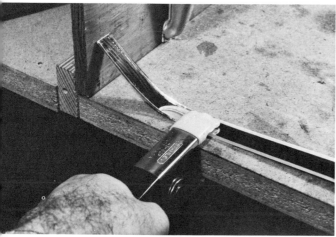

Each strip is then bent outward at one end by clamping it to a worktable.

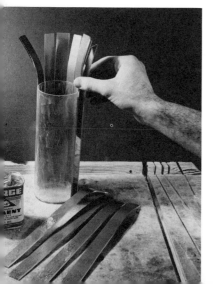

Each strip is made to adhere to the vase with Barge All-Purpose Cement.

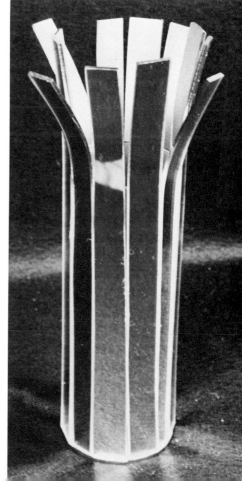

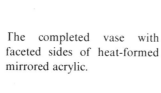

The completed vase with faceted sides of heat-formed mirrored acrylic.

Edge Cementing

Strong, almost invisible bonds can be made between pieces of acrylic and pieces of acrylic mirror. However, when acrylic or acrylic mirror is to be attached to the back of acrylic mirror, the backcoat of silver must be routed down or otherwise removed. Solvent cements such as methylene chloride (MDC), ethylene dichloride (EDC), and 1,1,2 trichloroethane, which are most often used, are available where acrylic is sold. Edges to be bonded are first scraped or routed to remove deep saw marks or unevenness that would interfere with a solid bond. If surfaces are to be bonded, they should be thoroughly cleaned. The areas to be connected are then abutted and taped or otherwise supported. Solvent cement is introduced into the joint by drawing a brush or flexible-nosed hypodermic needle along the joint. The cement flows into the entire joint by capillary action. The joint should be allowed to dry thoroughly before removing its supports. Most will be machine safe in three to four hours. The bond is a strong one, which reaches full strength after about a day.

While solvent cement is used in the construction of acrylic mirror, it attacks the backing and should be applied with care. A two-part (resin and catalyst) cement system known as PS-30 is probably better used when extensive bonding is to be done. PS-30 is syruplike and, because of its thickness, requires some accommodation in the structure of the joint (such as routing at a slight angle to leave room for the adhesive). This material creates one of the strongest bonds possible. It should be used in all high-stress situations and in those applications in which the joint will come in frequent contact with water.

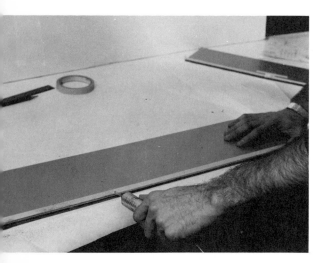

The basic technique for cementing all acrylic is to scrape and sand (but not polish) or rout the edges to be joined, tape them or otherwise support them . . .

Because acrylic will not adhere to the backing of acrylic mirror, it is necessary to remove the backing and silver before cementing edges. This may be done most easily by routing, but it may also be done by sanding or grinding (as here with a flexible-shaft tool).

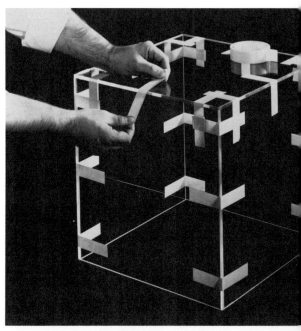

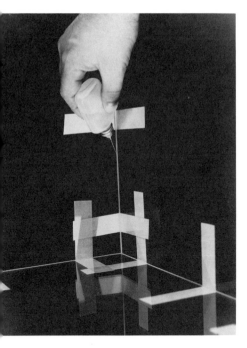

... and apply solvent cement along the joint with a brush, syringe, or needle-nosed squeeze bottle. The cement flows into the entire joint by capillary action. Solvents such as methylene chloride may be toxic if inhaled for extended periods of time or if swallowed—many of the solvents are also flammable. Always use in a well-ventilated area; keep away from flame and small children. *Courtesy: Rohm and Haas Company*

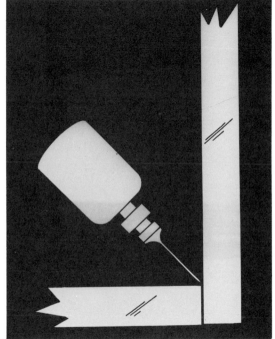

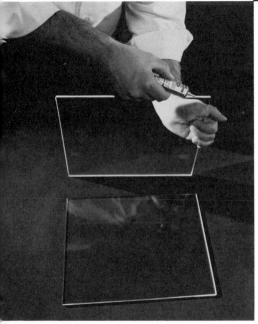

Thickened cements, and two-part systems such as PS-30, may be used to produce joints of very high strength with good outdoor weatherability. After scraping, sanding, and checking for fit of the parts, apply a thin bead as shown. Gently join the pieces and clamp or hold firmly until set. Allow the cement to cure. Observe the same cautions as with solvent cements with respect to toxicity and flammability. Thickened cement may also be used to mend and/or fill scratches (several applications may be necessary to fill a scratch—allow 24 hours between each). Once the area has been filled, sand and polish as in edge finishing. *Courtesy: Rohm and Haas Company*

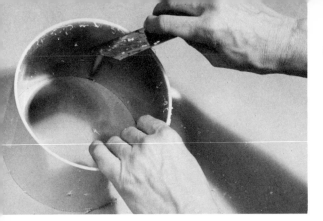

CONTAINER OF MIRRON TUBING

Mirron tubing, made by Thermoplastic Processes, Inc., and widely available through plastics suppliers including Cadillac Plastics (throughout the country), is acrylic tubing with a highly reflective silver on its first (outer) surface. Here, a section is being prepared to be made into a container. The top and bottom edges are scraped. The top edge is also sanded and polished.

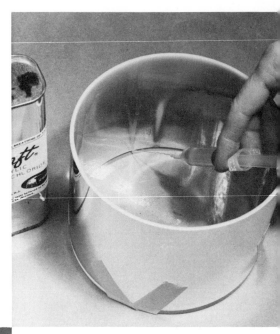

A circle of clear acrylic was cut and is being made to adhere to the cylinder of mirrored tubing with a solvent cement.

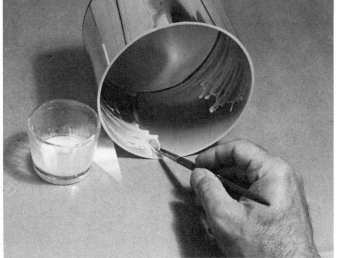

The bottom will be allowed to remain clear, but the sides will be flocked by applying a white glue . . .

. . . and then applying a flocking material such as Suede-Tex by Donjer.

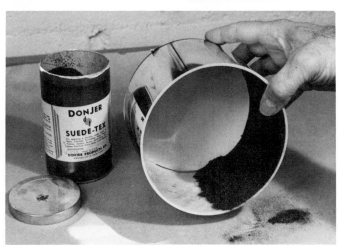

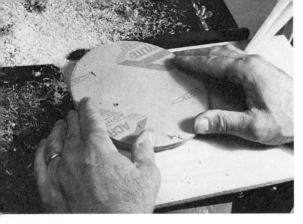

A lid, the same size as the bottom, is cut, and a lip routed.

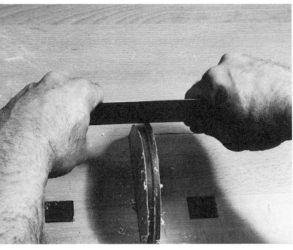

The edge of the lid and the edge of the lip are scraped and polished.

The completed container with a plain lid and a lid decorated with rings of acrylic made to adhere with PS-30.

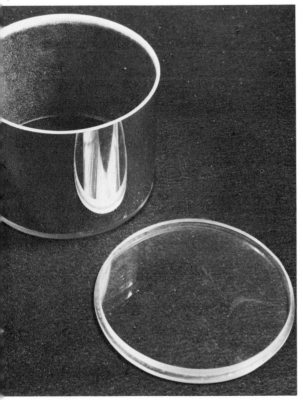

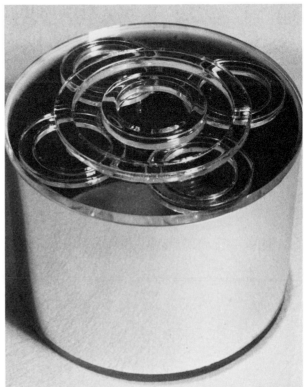

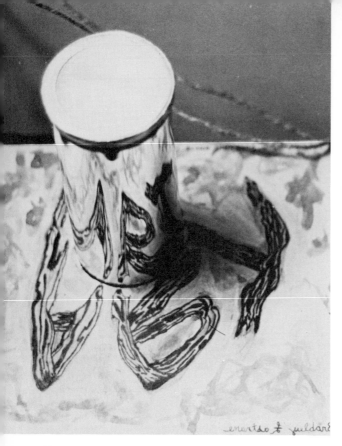

The reflective possibilities of a mirrored cylinder are suggested by this anamorphosis by Bradley Lastname. *Courtesy: Bradley Lastname*

Reflective cylinders and circles on glass mirror. *Courtesy: Ford Motor Company and the National Association of Mirror Manufacturers*

SURFACE DECORATION
OF ACRYLIC AND ACRYLIC MIRROR

Painting

Acrylic and acrylic mirror may be painted on either side—unmirrored acrylic may be painted on the back and silvered, or the backcoat and silver may be removed from mirrored acrylic as it is from glass (see above). Acrylic-based lacquers and enamels work best and may be applied by silkscreening, brushing, spraying, and rolling. Water-based paints show poor adhesion to acrylic and should not be used.

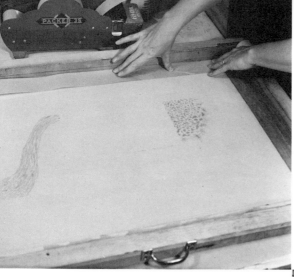

Acrylic can be silkscreened easily. The screen, which can be reused many times, is made by stretching silk or polyester screening fabric tautly over a frame using thumbtacks or a staple gun. Two or three layers of brown packing tape are applied around the edges of the screen—inside and out—to keep ink from escaping later. The tape is shellacked and the shellac painted over ¼″ of the screen to ensure a good bond between fabric and tape.

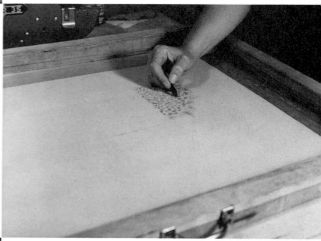

One technique of silkscreening involves the use of a litho crayon as a tusche to seal the areas of screen through which you *will* want ink to pass.

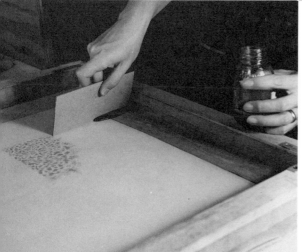

The entire screen is then sealed by sweeping a glue mixture across it to prevent passage of ink. When the glue was dried, the litho crayon is dissolved with turpentine. The ink will pass through areas it had previously covered.

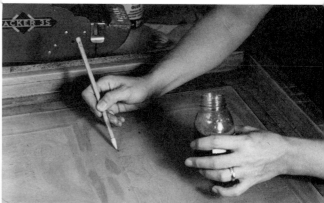

Another technique for designing a screen is to paint on it directly with the glue to block passage of the ink.

When the screen is ready, cardboard guides are taped in place to aid in positioning the acrylic precisely.

To print, the ink is poured on the packing tape border and . . .

. . . spread over the screen with a rubber squeegee in one steady sweep.

The printed acrylic is removed by lifting the screeen.

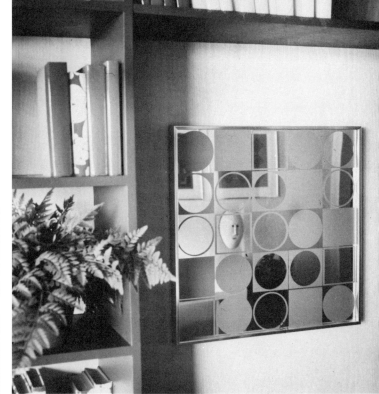

Glass can be screen printed, too, as this piece was. *Courtesy: Ford Motor Company and National Association of Mirror Manufacturers*

Self-Portrait in Silvered Glass (1976) by Jean McMann Stein was made by first silkscreening the lace design onto the back of the glass and then silvering (and backing with black paint). *Copyright © 1976 Jean McMann Stein*

This piece by Jean McMann Stein was made in the same fashion—first silkscreening the design, then silvering. *Copyright © 1975 by Jean McMann Stein*

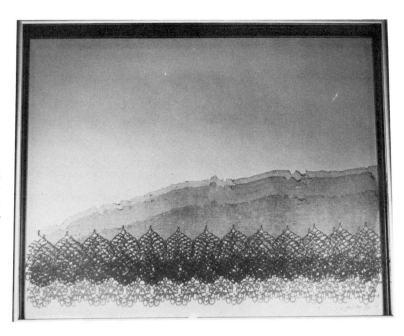

Stenciling or Frisketing

The protective coverings of paper or polyethylene film serve as effective masks for painting acrylics. A design may be sketched, the areas to be painted removed by cutting the mask with an X-acto knife or single-edge razor blade and then peeling the mask away, and the paint applied. The mask may be removed entirely later.

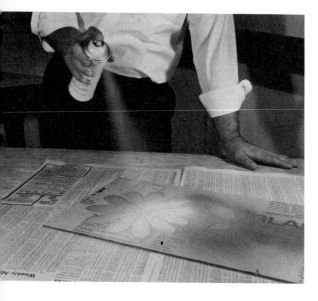

The paper or polyethylene that protects acrylic and acrylic mirror may be used as a mask for spray or hand painting the front surfaces. *Courtesy: Rohm and Haas Company*

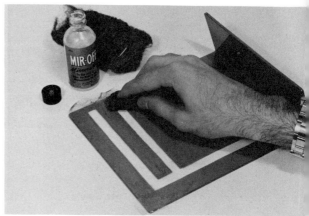

Materials for removing the backing and silver may be used on acrylic as well as glass mirrors—though with the former the surface of the material may be affected. Here, Mir-off is applied. The area to be desilvered is defined by plastic tape.

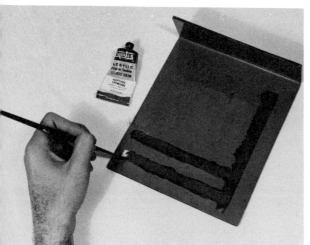

The clear areas within the acrylic mirror are painted . . .

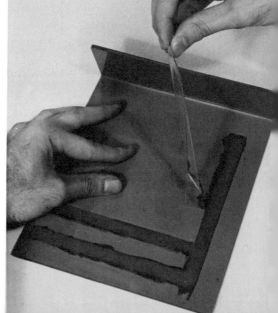

. . . and the tape removed.

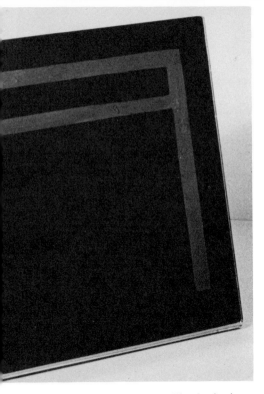

The final mirror.

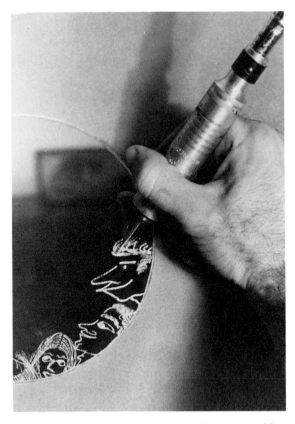

Acrylic mirror may be etched chemically, by scratching with a sharp instrument, or with a fine bit in a flexible shaft drill, as illustrated here.

Appliqués

A wide variety of materials may be applied to the front surface of acrylic or acrylic mirror. Adhesive-backed papers, metal foils, and decorative materials such as Con-Tact may be used. Pieces of acrylic and acrylic mirror may be made to adhere, too, as may sections of wood or high-pressure plastic laminates such as Formica. Means of attachment (other than acrylic cements already mentioned) are discussed below.

Engravings

Acrylic and acrylic mirror may be engraved on either surface. This is done, in the case of mirrored stock, by cutting through the backing and silver to the plastic. When a back surface has been engraved, paint may also be used to accentuate or vary the design. Engraving may be done by hand, using metal engraving tools—the acrylic being treated like metal. Or machine tools may be used. One effective intermediate level is the use of a hand or flexible shaft drill with a very fine bit. Try engraving both front and back surfaces of a single piece for interesting effects.

INSTALLATION AND ATTACHMENT TECHNIQUES

Adhesive Attachment

Double-faced foam tapes: Because acrylic is much lighter in weight than glass and is often employed in smaller sections, double-faced foam tape may be used for most mounting needs. It is a clean, simple method of obtaining adhesion of acrylic to other acrylic, wood, metal, wallboard, or nearly any other material. This tape also facilitates removal of the mirror by cutting behind the sheet with a flat, sharp knife.

For optimal support, this double-faced tape should be distributed evenly across the panel in strips that run its length. The tape should not, however, be closer than ¼″ to the edge. The length of 1″ wide tape necessary to support a panel of a given size may be determined by reference to the accompanying table. The tape itself, manufactured by the 3M Company (3M Company Industrial Tape Division, 3M Center, St. Paul, Minnesota), is widely available through hardware and building material suppliers.

Foam Tape Recommendations

	Plexiglas Mirror Thickness	Foam Tape Thickness	Total Length of Tape
Up to 12″ x 12″	⅛″	¹⁄₁₆″	3′ minimum
Up to 36″ x 48″	¼″	⅛″	16′ minimum
Up to 48″ x 96″	¼″	¼″	32′ minimum
Over 48″ x 96″	¼″	⅜″	Twice the long dimension

Courtesy: Rohm and Haas Company

Silicone sealants: Silicone sealants, such as those manufactured by Dow Corning (DC 780 Silicone Building Sealant), Midland, Michigan, may be used in place of mastics or panel adhesives that may attack the backcoat of acrylic mirror. (Though even with silicone it is recommended that only pigmented sealants be used since clear sealant may affect the mirror, too.) Silicone, which is widely available in both small tube and caulking gun sizes, should be applied evenly in open-end beads that will allow air to circulate so that it will cure. After application the acrylic may need support for a day or so until the sealant does cure. It should, thereafter, provide a long-lived, flexible bond.

Mastics and contact cements: Certain mastics and contact cements may be used to good effect with acrylic mirror. And they can be particularly useful when installing mirror in places that are difficult to reach. Contact cements are useful when a fast-setting bond will be desirable. Each material is accompanied by specific instructions as to its use, but generally contact cements are applied to both surfaces by brush, roller, or spray. The cement is then allowed

to dry until it is tacky. Contact before the solvent evaporates may affect the mirror. Because this bond is permanent, great care must be taken to align the material. With large sections, a slip sheet of brown paper may be used to position the mirror while preventing premature bondage. It should be noted that when later removal of acrylic mirror is contemplated, tapes or contact cements should *not* be used because of the risk of separating the silvering from the acrylic. Mechanical mounts will better suit such applications. One additional consideration in the use of contact adhesives is the expansion of acrylic and acrylic mirror as a result of changes in temperature and humidity. Consult the accompanying chart for the maximum tolerable temperature variation at a given long dimension of acrylic that has been made to adhere with contact cement.

Panel Size Limits for Contact Cements

Maximum long dimension	Temperature Variation
Up to 12″	±70°
Up to 24″	±40°
Up to 36″	±30°
Up to 48″	±20°
Up to 72″	±15°
Up to 96″	±10°

Courtesy: Rohm and Haas Company

When choosing specific cements, always opt for those with the least solvent attack—and when in doubt, test the material on a scrap over a period of time. Effective cements include the following: Formica #140, Formica Corp., Spring Grove Avenue, Cincinnati, Ohio 45232; Armstrong D220, Armstrong Cork Co., Lancaster, Pennsylvania; Instant-Lok #41-4060, National Adhesives Division, National Starch and Chemical Company, 750 Third Avenue, New York, New York 10017; PL-600 Permalastic Products, Division of Durabond Products Company, 11705 Levan Road, Livonia, Michigan 48150.

Mechanical Attachment

Screws and bolts: Acrylic may also be attached with screws and bolts through holes drilled in the plastic. Holes for such fasteners should always be oversized to accommodate expansion and contraction of materials. A minimum overage for holes in a panel of given size may be determined by reference to the accompanying table. As ever, this will be primarily a function of the temperature range to which the panel will be exposed. Please note that to maximize strength and to minimize distortion, no hole should be closer than ¼″ to any edge.

Oversize Hole Recommendation for Through-Bolting Plexiglas Mirror

Size of Plexiglas	± of Temp. Change						
A	10°	15°	20°	30°	40°	50°	60°
12″	$1/16$	$1/16$	$1/16$	$1/16$	$1/16$	$1/8$	$1/8$
24″	$1/16$	$1/16$	$1/16$	$1/16$	$1/8$	$1/8$	$1/8$
36″	$1/16$	$1/16$	$1/16$	$1/8$	$1/8$	$3/16$	$1/4$
48″	$1/16$	$1/16$	$1/8$	$1/8$	$3/16$	$1/4$	$1/4$
60″	$1/16$	$1/16$	$1/8$	$1/8$	$1/4$	$1/4$	$3/8$
72″	$1/16$	$1/8$	$1/8$	$3/8$	$1/4$	$5/16$	$3/8$
84″	$1/8$	$1/8$	$3/16$	$3/16$	$5/16$	$5/16$	$1/2$
96″	$1/8$	$1/8$	$3/16$	$1/4$	$5/16$	$3/8$	$1/2$

Courtesy: Rohm and Haas Company

Framing: Acrylic and acrylic mirror may also be mounted in frames of wood, metal, plastic, ceramic, soft materials, etc. Again allowance should be made for expansion and contraction of the plastic. This chart provides a means for setting such tolerances. Where optimal trueness of reflection is desired, it may be appropriate to combine mechanical and adhesive attachment methods—tapes, for example, will help ensure flatness within a frame.

Thermal and Humidity Expansion Allowances for Framed Plexiglas Mirror

Long Dimension	Possible Temp. Change ± Degree						
Panel	15°	20°	25°	30°	40°	50°	60°
12″	$1/16$	$1/16$	$1/16$	$1/16$	$1/16$	$1/16$	$1/16$
24″	$1/16$	$1/16$	$1/16$	$1/16$	$1/16$	$1/16$	$1/8$
36″	$1/16$	$1/16$	$1/16$	$1/16$	$1/16$	$1/8$	$1/8$
48″	$1/16$	$1/16$	$1/16$	$1/16$	$1/8$	$1/8$	$1/8$
60″	$1/16$	$1/16$	$1/16$	$1/8$	$1/8$	$1/8$	$3/16$
72″	$1/16$	$1/16$	$1/8$	$1/8$	$1/8$	$3/16$	$3/16$
84″	$1/16$	$1/8$	$1/8$	$1/8$	$1/8$	$3/16$	$1/4$
96″	$1/16$	$1/8$	$1/8$	$1/8$	$3/16$	$1/4$	$1/4$

Courtesy: Rohm and Haas Company

An acrylic mirror is framed within sections of extruded aluminum to provide a base for an overhead diffuser lamp.

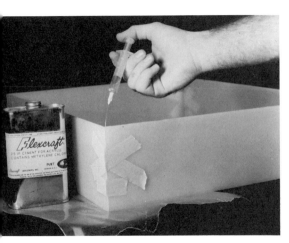

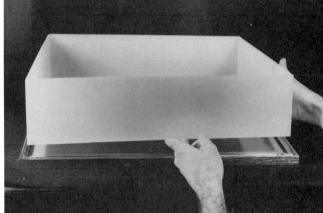

The diffuser itself is constructed from rectangles of opaque acrylic bonded with methylene chloride.

The diffuser is set onto the framed mirror.

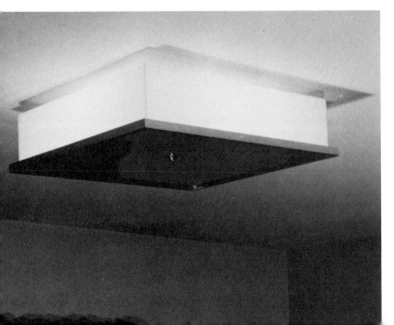

The completed ceiling lamp is held in place by a knurled nut that screws onto threaded pipe, which passes through a hole in the mirror. This does create stress in the acrylic, but its only effect is to slightly distort the reflection—an insignificant factor in this design.

Overhead installations: Effective use of acrylic mirror can be made in overhead installations where glass mirror may prove too hazardous. Such mountings are best done with edge-engaging frames such as a T-bar system. Tapes and mastic or contact cement are generally ill-suited to ceiling installations, since they support the entire weight of the sheet and separation of the silvering may occur. However, extensive use of acrylic mirror may be ill-advised owing to its combustibility characteristics. Local building codes should be considered before it is installed.

Combustibility and Building Code Considerations

Before you employ acrylic or acrylic mirror on walls or ceilings, the local building code should always be consulted. The use of these materials, which are classified as slow-burning plastic materials with combustibility comparable to wood, is subject to limitations applicable to combustible interior finish. Always protect acrylics from heat and flame.

Metallized Polyester Film

Polyester film, with its extraordinary thinness and considerable strength, is a marvel of modern technology. Often referred to by the trade name Mylar, its combination of high tensile strength and light weight have made it effective for many applications. With one type of coating it serves as audio tape; with another it becomes video tape. When metallized, this transparent film becomes highly reflective—a mirror surface.

Because the film is so thin, it cannot provide its own support in the way glass and acrylic mirror do, but this thinness works to its advantage in certain applications. Recently this metallized plastic film was used to camouflage the plywood fence surrounding a New York City construction site. It was simply made to adhere to the wood surface. Of course, since the film is thin and the plywood uneven, passersby do not meet a starkly accurate reflection. The image seen is a bit bubbly but clear and readable. Its very softness is a welcome change from perfectly resolved visual images—and an especially pleasant alternative to plywood or chain-link barriers so common to urban renovation.

The principle, of course, is adaptable. Metallized plastic film may be made to adhere to surfaces both more and less finished than the rough grade construction plywood. The nature of the reflective surface obtained will be a function of the substrate. Many of the tall columnar planters and pedestals that have become attractive elements in department store windows and displays are actually metallized plastic film wrapped around cardboard tubes of different diameters and taped at the seam with double-stick or metallized plastic film tape. Walls, ceilings, and tabletops have been covered with this material, too. And although the film is not inexpensive, the completed forms are generally less expensive than if they had been executed in glass or acrylic mirror—if such materials could even have been used in the particular application. Metallized film has much of the flexibility of function that glass and acrylic have as decorative media: it can be silkscreened, painted, or printed with ease.

Probably the most novel characteristic of metallized plastic films is their potential as large, relatively true reflective surfaces of minimal weight. To span a large area with this material it is not necessary to create a solid form to support the film. The plastic need only be stretched over a rigid frame. The frame may be metal (extruded aluminum is very effective), reinforced cardboard, or wood—like the stretchers used with canvas. At least one company, the Mirrex Corp., 1634 East Elizabeth Avenue, Linden, New Jersey 07036, offers prestretched units in a wide range of standard sizes and will custom-make almost any size desired up to a width of 56″ and length of 12′. Custom shapes such as triangles, circles, and trapezoids are possible. On average, Mirrex mirrors weigh 6 oz. per square foot; a 4′ × 8′ Mirrex mirror weighs approximately 12 lbs. A recent Broadway show utilized panels 15′ tall as a dazzling reflective backdrop in which each panel rotated to reveal a dark, nonreflective back when required by the stage design. No doubt, the light weight of even these large units eased the technical burdens (and possible safety hazard) that might have intruded had heavy plate glass mirror been required. Film mirror panels lend themselves readily to covering walls and ceilings. Though it is never quite as rigid as glass (since the film is stretched between the sides of a frame), the reflection is excellent in most applications, providing optically clear, ghostless, distortion-free color images. In addition to being lightweight, portable, and shatterproof, such mirrors withstand shock and vibration well. Such units are easily mounted on walls or other flat surfaces, or suspended from ceilings.

Metallized polyester film is available in many thicknesses—and in a wide variety of specialty products. Metallized film tapes, for example, have many decorative applications, in addition to serving as an attachment mechanism for larger units of the material. Adhesive-backed sheets (such as that employed in *Metal Mouth* in Chapter 7) are also available from plastics suppliers. Different colors of metallized polyester film have also made their appearance, and further extend the range of this material.

Two of the most exciting specialty products are diffraction grating Mylar, manufactured by the Diffraction Co., Inc., Riderwood, Maryland 21139, and iron-on metallized Mylar, which is an experimental product of the Transil-wrap Company, Inc., 2615 North Paulina Street, Chicago, Illinois 60614. The use of diffraction grating Mylar is shown in Chapter 5; iron-on Mylar is applied in Chapter 7. Both have a multitude of possible applications as elements of point-of-purchase displays, clothing, or product decoration, and, of course, art and craft.

There are metallized plastic films for specific, functional applications, too. For example, plastic film with a microscopically thin metal film embedded within it is now available for use in the windows of residences. The result of such installation is the same as the factory glazed or tinted glass so frequently used on office buildings. Both materials act as one-way mirrors. But the best part is not even the decorative effect. These reflective films greatly reduce solar heat-gain, and therefore lower air conditioning costs.

In sum, the range of film products is growing—and experimentation with them is still in infancy.

Paul Tzanetopoulos creates mirror columns of metallized film stretched over frames of tubular steel. They introduce a startling twist into our perceptions of space. *Courtesy: Paul Tzanetopoulos*

The Mirrex Corporation manufactures lightweight, high-quality mirrors of a metallized film over aluminum frame and rigid core. (Under license from British Aircraft Corporation and its own U.S. patents). *Courtesy: Mirrex Corporation*

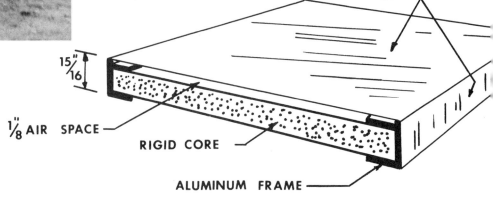

MIRREX FILM

$\frac{15}{16}$"

$\frac{1}{8}$" AIR SPACE

RIGID CORE

ALUMINUM FRAME

Panels of nearly any size may be made to order. The air space between film and core allows the mirror surface to give under most forms of impact and spring back to its original shape without damage. Because of their light weight, Mirrex panels may often be mounted with no more than a few inches of Velcro tape.

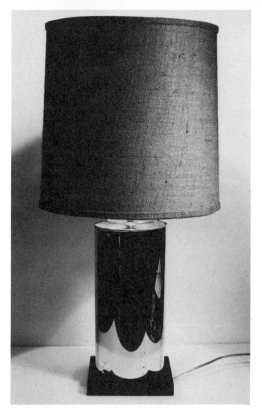

Curved surfaces may be quickly and easily wrapped with metallized film to create mirrors—as in the case of this acrylic tube lamp base being clad with Mylar. The film may be made to adhere with double stick tape or with metallized film tape, which becomes invisible on the form.

Metallized polyester film can be sewn by hand or machine, stuffed, quilted, or worked in trapunto. The only secrets are to avoid high-tension stitches, overstitching, and fine stitches, which may create perforations. (See Chapter 7.)

111

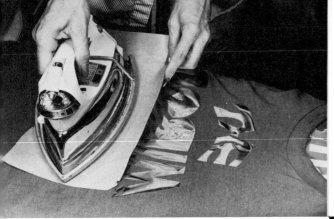

Iron-on metallized film is an experimental product of the Transilwrap Company. It should have great potential in decorative applications.

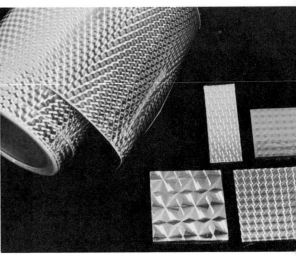

Another exciting metallized film specialty product is diffraction grating, which is available with and without adhesive backing and comes in many colors and patterns.

The adhesive-backed diffraction grating film may be peeled from its backing and made to adhere to nearly any solid material. Here it is being applied to clear acrylic sheet. (See Chapter 5.)

WOOD MIRRORS

WOOD IS RIGID AND DENSE ENOUGH TO FULFILL A VARIETY OF DESIGN requirements with a wide range of treatments. And yet it is soft enough to be cut and shaped with simple tools. The rich textures and colors of wood, paired with the sharp clarity of mirror, make it an appealing medium for mirror craftsmen. Traditionally, wood has been employed as a framing material for mirror. It functions well in protecting the mirror edges and in keeping the glass from warping. At one point in the history of framing mirrors, wood frames became so elaborate that the frame became the form and obliterated the mirror function.

Wood is a living substance—until the tree is felled—and should be treated as if the material still lives. Even after seasoning, wood cells still contain a small percentage of water for many years. Because some of the water eventually does evaporate, the wood moves. It shrinks and expands, and in doing so wood can warp and crack easily unless treated. Each kind of wood has its own grain and texture. In fact, each tree has a characteristic grain pattern that has been determined by its environment—where it lived, what the climate was, where branches grew out, catastrophes such as insects, lightning, high wind, fire, and so on.

Wood is worked in basically three ways. (1) We cut it away (with saws, chisels, carving and planing tools, sandpaper. The first step in working with wood is a cutting away process—squaring boards by running them through a planer to ensure that all surfaces are flat). (2) We build it up by fastening or

113

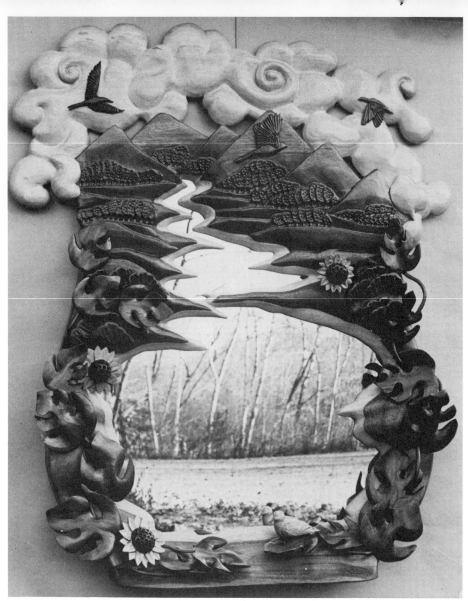

Leafy Springlade (42″
× 34″ w × 6″ d) h
Priscilla Gagnon. T▮
mirror is an integral pa▮
of the carving ma▮
from mahogany, walnu▮
maple, and obec▮
woods. *Courtesy: Pr▮
cilla Gagnon*

laminating two or more pieces together (using glues and/or a variety of special
mechanical attachments). (3) We also bend wood by heating and wetting it.

WORKING WITH WOOD

Tools

Because wood was one of man's first manipulable resources, the technology
of woodworking has had time to become quite sophisticated. Many kinds of
tools and machinery have been invented over these centuries to cope with the
material. Yet it is quite possible to create finely finished wood forms with a few
basic hand tools. There are three levels of equipment: hand tools; hand-held
machine-powered tools; and stationary motor-driven equipment. Within each
grouping there are a variety of tools and equipment ranging from hobby
instruments to heavy-duty specialized, professional equipment.

114

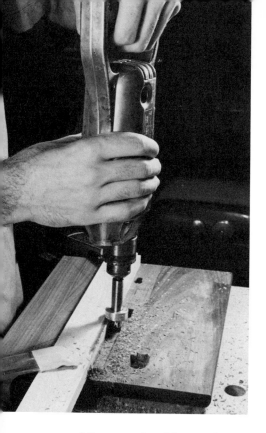

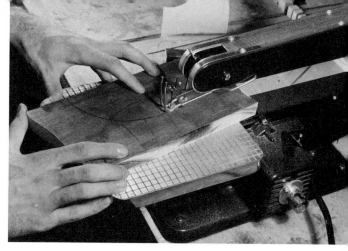

Even a small electric jigsaw, like this Dremel model, can cut down woodworking time considerably.

Hand drills can be fitted with a variety of attachments to facilitate woodworking. Here, for instance, a router attachment is used to rout a channel in mahogany. A piece of pine is clamped over the wood to serve as a guide for the drill.

Most woodworking tools are designed to cut, drill, gouge, or carve the wood—subtractive processes. Even the tools and machines used for finishing will slightly cut into the surface while refining the wood piece.

Saws, measuring and squaring devices, chisels and gouges, drills, vises, clamps, and planes are among the very basic necessities for most woodworking processes. Specialized kinds of operations require additional tools and equipment. For instance, a coping saw is used to cut fine curves in tight spots. Specially constructed jigs—like the miter box used to cut 45° angles—are also useful in specific situations like frame making. Most woodworkers, today, utilize motor-driven equipment when time is too valuable to spend using only hand-propelled tools.

Joining and Gluing Wood

The longest lasting—and often most attractive—way to join wood is to cut joints into it and then attach the parts with adhesives. The least satisfactory way to attach hardwoods (which are denser than soft woods and may split) is with mechanical fasteners such as nails or screws.

Before any joining is begun, ends and sides of the wood must be planed flat and square so that the parts to be assembled fit together without gaps. After that there are many alternatives. Doweled joints are used to reinforce simple butt joining in some frames where the square end of one piece butts up against the flat surface of another. Holes drilled into the butted sections accommodate the reinforcing dowels and help secure an otherwise weak joint.

When there is a need for mitered corners, feathers, or keys (straight or triangular pieces of wood) are inserted into slots cut through both sections of the mitered joint. This process is known as splining.

Dovetail joints are another widely used and efficient joint for wood forms. Zigzaglike negative and positive sections are cut into the wood ends with female areas chiseled or sawed out of each end so that the corners interlock tightly.

Suffice it to say that there is a type of joint for any purpose. The details of these joints will be left to the woodworking texts listed in the Bibliography.

Two types of adhesives are commonly used to make wood adhere. One is Weldwood, a plastic resin that comes in powdered form and requires mixing with a small amount of water. The other type is liquid animal or plastic glue in either the brown, cream-color, or white form. These glues result in nearly invisible joints that are often stronger than the surrounding wood. Titebond, Sobo, and Elmer's are some of the most popular brands.

Contact adhesives are excellent for joining nonsimilar surfaces, such as wood to mirror, metal, or glass, but they are too visible and not strong enough for use in joints or laminations. After glue has been applied to both surfaces, clamping is required until the glue sets. The success of any gluing operation will depend heavily on how well the clamping job has been performed.

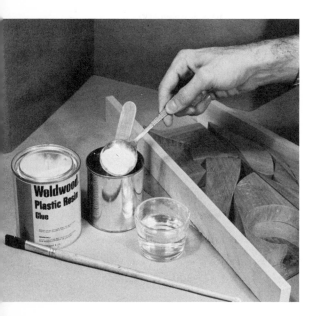

Weldwood Plastic Resin Glue comes in powdered form, and it is one of the best adhesives for wood.

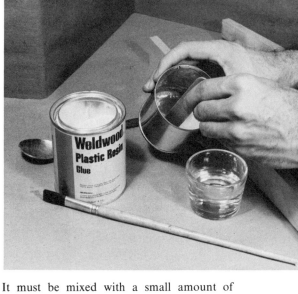

It must be mixed with a small amount of water—a little bit at a time.

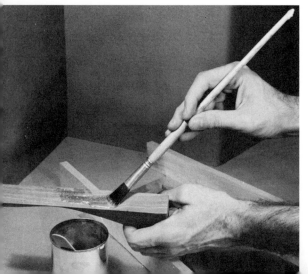

Use a brush to apply the glue to the surfaces to be made to adhere. The resin remains workable for about twenty minutes after mixing.

Wood Finishing

Pine and common types of plywood, when not surfaced with veneer (thin sheets of hardwood that can be glued to less attractive woods), can be successfully painted. Most hardwoods have an attractive grain and surface, which it would be a pity to mask with opaque materials. Even some types of pine look attractive when stained and varnished.

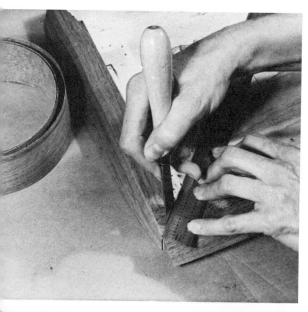

APPLYING VENEER

A badly marred piece of pine may be used as a mirror frame, but it must be disguised somehow. Walnut veneer offers one good solution. Veneer comes as a sheet or roll of thin wood that can be cut with scissors or knife, bent to suit a shape, and glued in place. Before you add the veneer, however, all other operations on the pine frame should be completed—such as cutting to size. To attach veneer, cut four lengths and trim the strips at the corners of the pine using knife and ruler so that a 45° angle is formed.

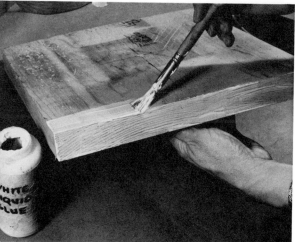

After cutting and folding the veneer, apply an even coat of white glue to the wood.

Allow the glue a minute to dry—until it becomes sticky. Lay on the veneer, beginning at one corner. Press it down firmly, making certain that the "mitered" corners meet.

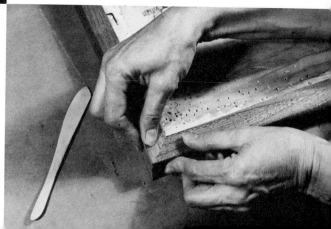

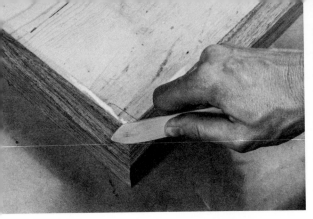

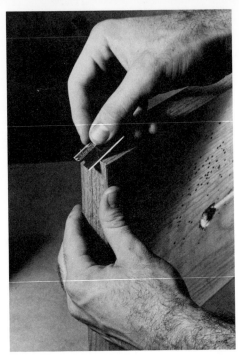

To ensure the veneer's bond to the base, use a burnishing tool, a smooth stick, or the back of a pair of scissors to rub out any air pockets or unevenness in the veneer.

Trim the corners with a single-edged razor blade, making certain that there are no excess flaps of veneer.

A wide variety of oils, waxes, lacquers, stains, and varnishes are available. Some type of surface protection is usually needed to prevent wood's porous surfaces from staining and becoming ingrained with dirt—and to help retain some small amount of water. Perhaps the most attractive coating is a mixture of one part turpentine to two parts boiled linseed oil, which is applied with a brush or soft rag at room temperature. At least five applications are necessary, each being allowed to penetrate and dry over night. The final coat can be applied with #0000 steel wool, which will smooth the surface while adding a finish.

Transparent coatings such as water-soluble stains, alcohol stains, and oil stains are often used before applying the compatible varnishes. These varnishes are often plastic (polyurethanes) and provide tough durable coatings. Before applying any clear finish, use a tack rag to remove dust that would otherwise become entrapped. Where abrasion and heavy wear are factors (which won't be the case too often in most mirror designs), any one of many good plastic-based varnishes is recommended. They brush or spray directly onto the wood. Application procedures for each are described on the product labels.

A mixture of one part turpentine to two parts boiled linseed oil produces a beautiful, warm finish on many woods, like this Philippine mahogany. About five applications should be made with a soft cloth, each being allowed to soak in overnight.

Making a Basic Mirror Frame

Making a simple, basic frame is technically quite easy. This basic process is perhaps the single most important woodworking concept in mirror craft; and its mastery will allow you to create the most involved combinations of mirror frames. The key to mirror framing is accurate measurement. There are some special measurement considerations when it comes to joining pieces of wood moldings into a frame. Frame sizes are generally measured in two ways: *rabbet size* and *frame sight size*. The latter is the measure of the specific dimensions of the mirror to be seen through the frame—the visible mirror area. The rabbet size measures the larger opening at the back of the frame in which the entire mirror must sit. The rabbet size will always exceed the frame sight size by twice the width of the rabbet. (The rabbet is an extension of the wood of the molding in back, which forms a groove in which the mirror will sit.) Having the rabbet size larger than the frame sight size simply means that a lip of frame will overlap part of the mirror and hold it in place.

MAKING A BASIC WOODEN FRAME MIRROR

Picture frame moldings are available in a variety of bevels, curves, and flats, either already finished or plain for the self-finisher. All of those shown here have built-in rabbets on the back side of the molding. The mirror fits into this groove. There are many fancy moldings available, as well as a variety of fabric-clad moldings called liners. Liners are often used to effect the transition from outer molding to mirror.

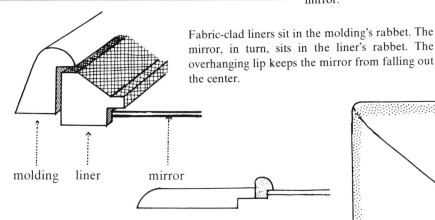

Fabric-clad liners sit in the molding's rabbet. The mirror, in turn, sits in the liner's rabbet. The overhanging lip keeps the mirror from falling out the center.

molding liner mirror

This profile of a combination frame (with a sketch of how a corner of this frame would look) uses a broad flat molding curved at the outer edge, with a half-round inner molding making the transition to the mirror center. Curved mitered joints can be made by sanding the corners after gluing and nailing but before finishing.

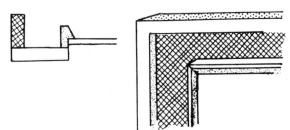

A bevel reverse molding (inside) is combined with flat wood strips that have been covered with fabric to become a liner. An outer strip of flat wood completes a handsome "moat" around the mirror.

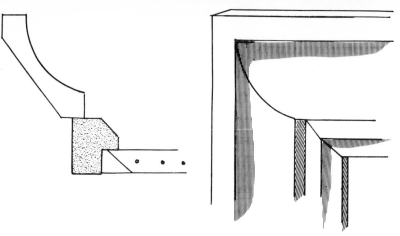

Cove builder's molding nailed onto a simple bevel frame molding adds an inward slant to the frame. Such a frame accentuates the illusion of depth produced by mirror.

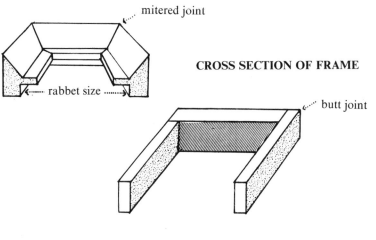

mitered joint

rabbet size

CROSS SECTION OF FRAME

butt joint

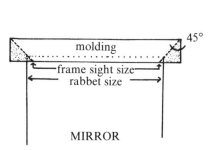

45°

molding

frame sight size

rabbet size

MIRROR

A frame made with butt joints requires no miter box, since it is only made with 90%-angle cuts. Of course some way must be contrived to hold the mirror in such a frame if a rabbet is not present. In the mitered joint, notice the difference in width between the rabbet size and where the inner lip of the visible frame ends. This is an important consideration when measuring for a fit.

In measuring the molding, take into considera-tion this difference between the rabbet size and the frame sight size. The mirror being framed fits into the rabbet, so always measure along the inner edge of the rabbet and not along the outside edge of the molding. Notice also that the length of a piece of molding that will be mitered must be equal to the length of the mirror plus twice the width of the molding itself (to compen-sate for two miterings).

A few of the tools of the trade include a miter box (inexpensive model shown here with backsaw and molding strip); assorted brads and finishing nails; medium-weight claw hammer; polyvinyl acetate (PVA) in squeeze container; an angle clamp (for holding glued mitered edges perfectly butted); a nail set for sinking nails below the surface of finished frames; a collapsible wooden ruler with metal edge (excellent for measuring molding and wood); and a metal ruler (the Stanley AR100 ruler shown here has a handy right angle in it, serving the function of a tri-square).

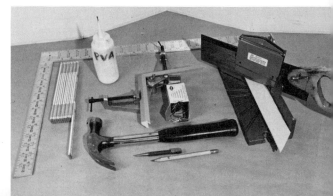

What is important in frame measurement is *not* so much the frame sight size but the rabbet size. If the shape formed by the molding's rabbet is too wide or narrow, the mirror will not fit properly—it will be either too loose or too small.

Continually recheck all lengths and angles as you make any frame. When using rabbet size measures, make these dimensions just a hair larger than the dimensions of the mirror itself. An extra $\frac{1}{16}''$ should be enough to allow the mirror to slip in and out easily without being too loose. For example, if you want to frame an $18'' \times 24''$ mirror, add on $\frac{1}{8}''$ ($\frac{1}{16}''$ for each end of the molding strip) to both length and width, making the rabbet size $18\frac{1}{8}'' \times 24\frac{1}{8}''$. This leeway is often essential because once you have cut a molding too small, there is no way of using that piece unless you recut the mirror itself.

First measure the four sides of the mirror to be framed. Cut four molding strips, leaving excess at each end of the molding to allow for miter cuts later. Add on twice the width of the wood molding strip to each piece, plus an inch or two extra for sawing. For example, if you are using a $2''$ wide molding strip to frame a mirror that is $18''$ long, you need to measure and cut a piece of molding $18''$ plus two times $2''$, or $18'' + 4'' +$ (extra length for error) $1'' = 23''$.

Cut the molding at a right angle (90°) first. Then set a miter box and backsaw for right-hand 45° cuts. (We choose to do all right-hand cuts first simply as a matter of convenience.) Execute those cuts to produce a clean, sharp 45° angle on each molding strip's right end.

A time-saver and accuracy aid is to measure the length of one molding strip from another strip already cut. This saves the remeasuring from the original mirror, and it also ensures that opposite sides of the final frame will be identical in length (and therefore will be square when joined). Use a *stop block* when using a miter box. A stop block is simply a piece of wood clamped onto the molding strip being cut. The block has a 45° mitered end already, which, while marking the proper cutting line for a piece of molding, also helps guide

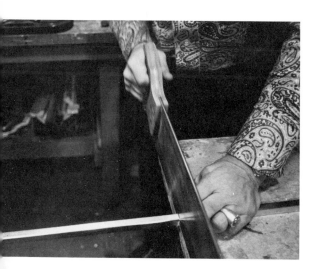

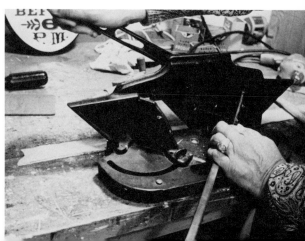

To make a basic frame, first cut the lengths of molding with a straight 90° angle.

Miter the right and left ends. Shown here is the hand guillotine (chopper), which with a swift lever action slices perfect 45° angles in thin molding bars.

the saw to a perfect cut. It is simply a device for stopping the molding from being cut longer than its match. Of course using a stop block or even measuring one molding strip from another implies two things: (1) you originally measured correctly from the mirror to the first molding strips; and (2) the mirror you are framing is a perfect rectangle. It is always wise to confirm both of these points before cutting.

Having cut the four strips at one end with a right-hand 45° angle, now recheck the lengths against the mirror's edge according to rabbet size, and cut all the left-hand 45° angles. When cutting, saw barely outside of your pencil marks. This is the *saving line,* and cutting outside your marks should guarantee that no pieces of molding are cut too short.

As you proceed, recheck the miter box to be certain that it is producing exact 45° angles. Check this by butting right- and left-hand 45° angled ends together and checking the corner for skewness with a T square or right angle. Readjust the saw if it is off angle.

If you are using a regular workbench vise to join pieces, it is a good practice to put the longer piece of molding in the vise with the mitered edge slightly above the jaws. Before gluing, always check to be certain you are not joining the wrong corners—i.e., butting two parallels together. If using angle clamps, put the two strips in the clamps. Align them so that they butt perfectly, then remove one from the clamp. Leave the other one firmly in place.

Apply all-purpose white glue to the mitered edge. Use enough to form a firm bond but not so much that a lot is squeezed out of the joint. Spread the glue evenly with a finger, stick, or brush; replace the strip in the clamp and again match it exactly with its corner mate. Allow the glued corner to dry. Follow the same procedure for the other pair of strips that form the opposite corner. Then glue the pairs of molding strips together to complete the frame. You may find it more effective to use two angle clamps at this step and glue opposite corners simultaneously.

Either before or after the gluing step, you should plan to drill nail holes with an electric or hand drill. With larger moldings you should probably drill your two or three holes in each corner *before* gluing. But in smaller, less hard-to-manage frames, it doesn't really matter whether you drill before or after. When drilling (and of course nailing, too) after gluing, be certain that the glue has set first. Leave the joints in the clamps while you drill and hammer.

Holes drilled with a drill bit slightly thinner than the nails will both guide the nails and prevent the molding from splitting. Hammer in all nails (finishing nail size should be determined according to the width of the molding, e.g., $1\frac{1}{2}''$ molding requires fourpenny finishing nails, whereas a narrow $\frac{1}{2}''$ molding needs only #17 or #18 wire brads of $\frac{3}{4}''$ to 1″ length). Now use a nail set to sink the nails slightly beneath the frame's surface. The holes can later be filled in with the appropriate color filler, specially made for different colors of wood.

Before finishing, check to see how well the mirror fits. In fact, you may want to check this before nailing the frame together. You should always check as best you can after each step. The mirror should slide easily into the rabbet. When it is viewed from the front, however, you should not be able to see the edge of the mirror because the frame was either too long or wide. If, on trial

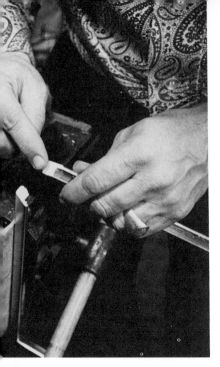
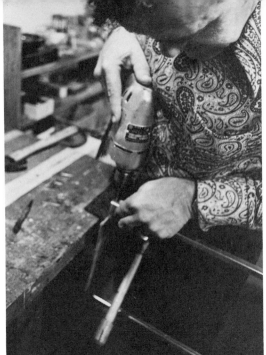

Above:
Clamp the longer strip of molding in a table vise or in an angle clamp, apply glue to the mitered end. Join the proper ends together into a perfect (smooth, flush) corner. Do this for all corners of the frame. You may choose to do the next three steps in the process for each glued corner before proceeding to glue the subsequent three corners.

Above, right:
After the glue has been applied and the piece is clamped, leave the frame in the vise or clamps, drill nail holes with an electric drill. Use a drill bit that is slightly thinner than the nails will be. For a thin frame, two nails per joint are sufficient.

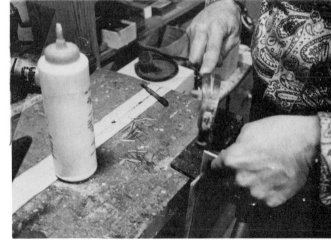

Drive in the brads.

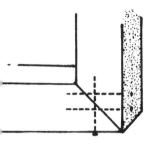

The brads or nails should enter the joint from both sides in medium and larger frames.

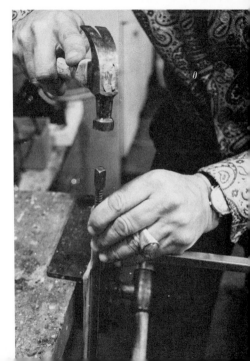

Countersink the brads slightly below the surface of the frame, using a nail set. Later these holes must be filled in with a wood filler of the appropriate color for the finish. Having glued, drilled, nailed, and countersunk one corner of the frame, proceed to the other three corners.

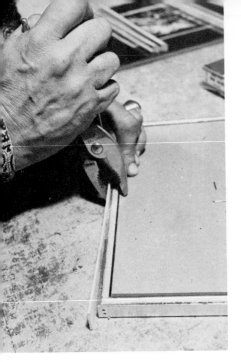

With a knife or tongue depressor, you can press wood putty filler into all nail holes. Then finish the frame by painting, staining, varnishing, gold leafing, and so on. (This obviously is not necessary if you are working with prefinished molding material.) Place the frame facedown and set the mirror facedown in the frame. Squeeze brads into the back of the rabbet to hold the mirror in place. A strip of waste wood protects the frame from the marks of the pliers.

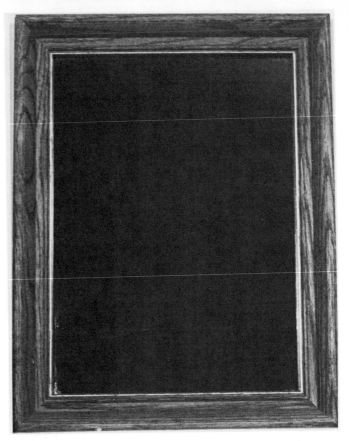

Starting from a basic wooden frame mirror, hundreds of possibilities are open.

fitting, the mirror sits well in the frame and looks good, then add surface finishes to the wood: oiling, staining, varnishing, and so on. After finishing, place the frame facedown on a clean working area and slip the cleaned mirror into the rabbet. You will notice that the rabbet usually projects higher than the back of the mirror. This helps protect the mirror backing. To keep the mirror in place, squeeze ½" wire brads into the back of the rabbet with a pair of pliers. A piece of scrap wood held against the outer finished edge of the frame molding will guarantee that no marks from the pliers will mar the finish. Flannel tape (used in shoes or on feet) wrapped around the outer jaw of the pliers will also protect the frame. Set the brads several inches apart (depending on the size and weight of the mirror enclosed) and squeeze them in so that the mirror is wedged firmly against the lip of the frame. You may also use diamond points shot from a glazier's gun to keep the mirror in the frame. If you choose this method, brace the frame against a wooden block so that the shock of the shots does not jolt the frame and break the mirror.

To hang the framed mirror, screw one of several available types of hooks or eyes into the back of the wood molding. If you are using multiple screw eyes, connect them with picture wire.

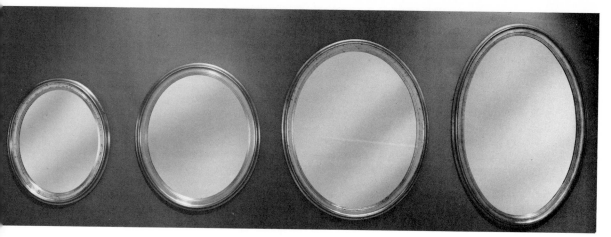

Classic oval mirrors, finished with gold leaf and silver leaf, from LaBarge Mirrors, Inc., Holland, Michigan. *Courtesy: LaBarge Mirrors, Inc.*

The mirror can be integrated with its frame by building mirror strips into the carved border. This carved Italian import is antiqued with gold leaf (32″ × 42″). *Courtesy: LaBarge Mirros, Inc.*

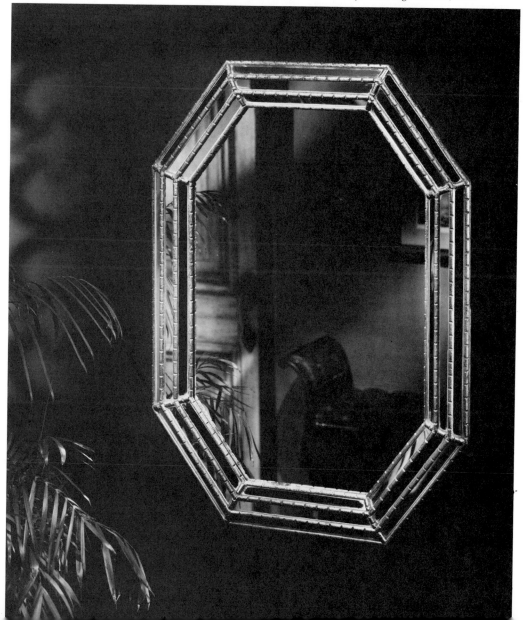

Simple frames can be handsomely embellished, like these decoupaged dried flowers by Anna Continos. Oval mirrors are manufactured in many sizes and shapes, or they can be hand carved.

Carving

Several safety precautions should be the first considerations when carving wood.

1. Always clamp the piece of wood to a bench or table when working.

2. Always keep your hands *behind* the tool to avoid accidental stabbing or slicing if the tool should slip.

3. Wear goggles.

When it comes to the carving process itself, there are several important steps and considerations.

The first cut should be made so that it severs the grain. The next cuts then should chop out the chips with the tool pointed toward the first cut. The first cut—the "stop cut"—is accomplished by pointing the chisel or carving tool straight downward. The second cuts are then made obliquely toward the stop cut.

Always consider the direction of grain—cut *with* the grain instead of fighting the wood. Some cuts will have to be made across the grain (like stop cuts), but this type of cut requires very sharp tools. It is more difficult because cutting across the grain compresses the wood. Keep tools clean and sharp. Wrap them in soft cloth and keep in a dry place.

Be careful not to undercut parts of the carving that are in low relief by going deeper than the already carved design. When you begin to carve a pattern, "block out" areas by carving the larger shapes. Gradually work down to fine details later. You should have the general shapes and outline of the entire piece roughly shaped before refining any particular area.

HAND CARVING

Carving is basically a two-step process. First a "stop cut" should be made by chiseling almost straight down into the wood—across the grain. Then a series of cuts are made at an angle to the stop cut, following the direction of the grain as much as possible.

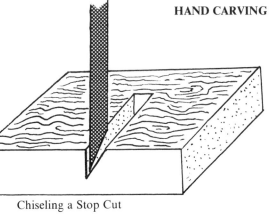

Chiseling a Stop Cut

Cutting at an Angle to the Stop Cut,
Removing Chips

In carving it is important to clamp the wood to a firm surface. After making stop cuts, chisel at an angle toward these cuts. Note that hands are kept behind the cutting tool to avoid accident.

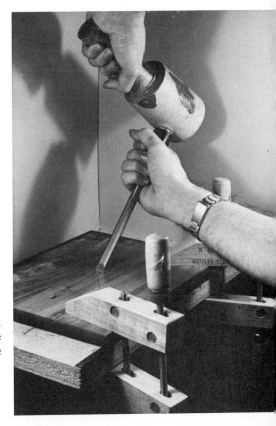

You can carve into a solid piece of wood, or you can laminate several pieces of wood together and carve that as you would a solid block. Study the grain pattern of your block. Use a pencil to indicate general areas to be carved. Clamp the block to your working surface. It doesn't matter how the piece is held down—whether by clamps, vise, special jig—just so long as the piece will not slip when being struck.

After studying grain direction, plan your first cuts. Try to cut about an inch shallower than the depth you ultimately desire to reach. Go slowly, making only those cuts needed. First, rough out the general design with larger tools. When it comes time to include finer details, switch to smaller-sized carving tools. Ultimately you may have to switch to rasps, files, even sandpaper to complete the work.

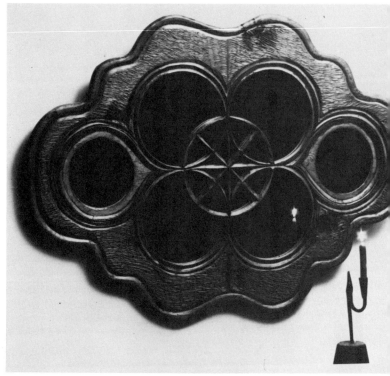

These shallow relief carvings by Louise Odes-Neaderland demonstrate some of the fine designs and textures that can be obtained with carving. *Courtesy: Louise Odes-Neaderland*

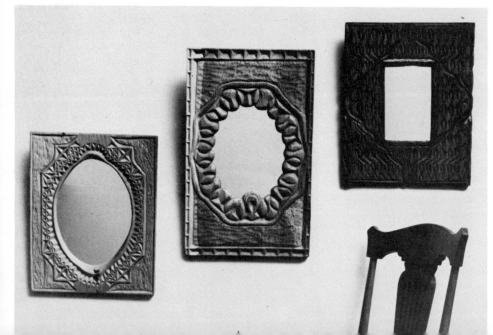

Power tools can speed up the carving process—especially in the roughing out of the form. But here again, speed can be an enemy—advance slowly to avoid ruining the wood.

Flexible-shaft tools and hand-held drills that can be fitted with Surform barrel-shaped cutting tools are effective and easy to use. Drill bits, sanding drums or disks, grinding wheels, and other attachments can also be employed in the machine-carving process. A foot-controlled rheostat or other type of speed control can be rigged to the flexible-shaft drill to expand the tool's potential.

Make several light cuts rather than using great pressure and speed to carve large chunks of wood. If the wood starts smoking, then find a way to slow the speed or to reduce the applied pressure. Safety goggles are critical, especially when you are working with power tools. The terrific centrifugal force generated can really send wood chips flying.

This circular carved mirror by Louise Odes-Neaderland was made from two boards glued edge to edge. (36″ in diameter.) *Courtesy: Louise Odes-Neaderland*

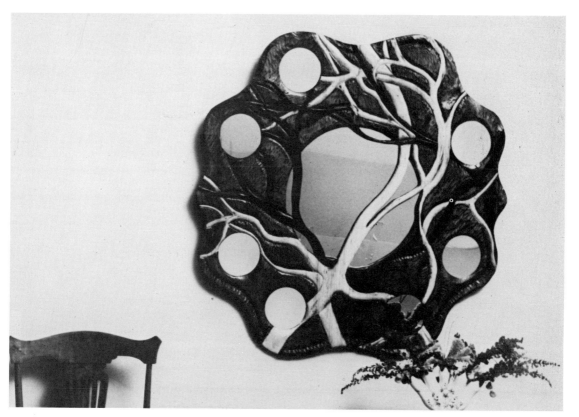

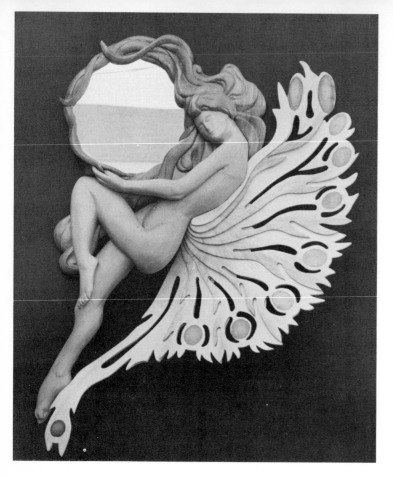

This fantastic sculptural mirror was made ? Jeffrey Briggs from three types of wood. ? hair is African mahogany. The figure is su? pine, and the wings are laminated white p? with inlaid knots. The gray coloring on ? wings is produced with a natural water st? Jeffrey Briggs begins such a piece from ? exact scale drawing transferred to the wo? The mirror itself is 10″ in diameter. The pa? is 36″ × 42″.

A single mirror can appear to be several mirrors by carving a set of windows in the piece of overlaid wood. Mirror by Carren and Noel Strock. *Courtesy: Carren and Noel Strock*

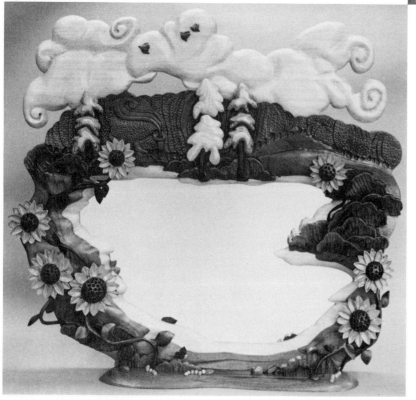

Dew Dappled Petals is a mirror relief by Priscilla Gagnon (37″ × 32″ × 6½″). This freestanding carved piece is made from mahogany, walnut, and obeche. *Courtesy: Priscilla Gagnon*

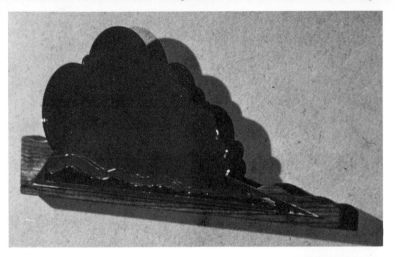

Dekalb: #1 (16" × 7" × 1⅛") by Steve Loar is a wall mirror carved of zebra wood. The mirror is acrylic. *Photos courtesy: Steve Loar*

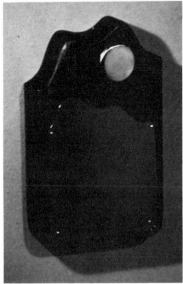

Smokey Mountain Memories: #2 (11" × 2¼") by Steve Loar. Acrylic mirror, mahogany, and brass rivets. The circular reflective piece is the back of a pocket watch.

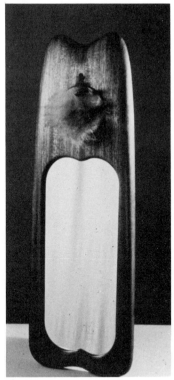

Impromptu Funk (17" × 5" × ¾") is a wall mirror by Steve Loar made from mahogany, mirror, and fur.

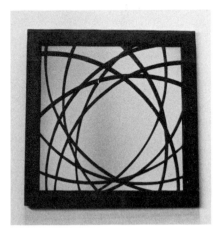

Ron Pessolano uses birch plywood to create the delicate curves in this mirror frame. *Courtesy: Ron Pessolano*

This wall cabinet combines cherry and mahogany with mirror (17" × 21" × 6"). *Courtesy: Steve Loar*

The glass mirror is fitted in a cavity routed out of a carved block. Made by John Makepeace, it stands 4½″ high.

A small hand-carved pendant routed and fitted with mirror.

Hand mirror carved from walnut by Priscilla Gagnon. The handle is 8″ long. The mirror itself is 10″ × 7½″.

Back side of the hand mirror has a rich, contoured carving. *Photos courtesy: Priscilla Gagnon*

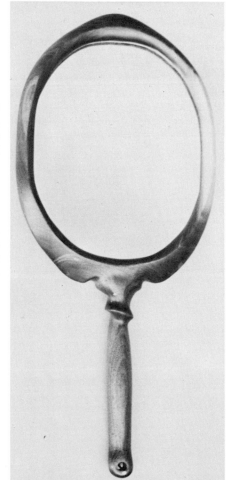

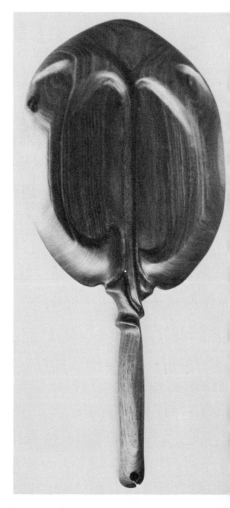

Hand mirror by Tom Eckert made from tiger wood combined with a four-legged bronze casting of a camel. It is called *Wall Hung Mirror* because it not only can be hand held but . . .

. . . can fit into a tiger wood wall bracket for wall hanging. *Photos courtesy: Tom Eckert*

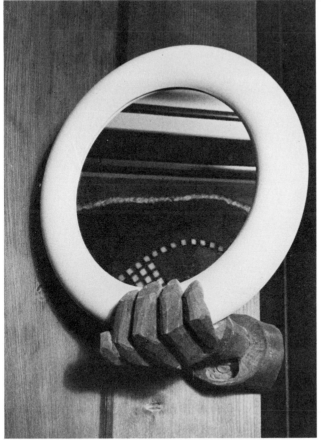

A hand (6″ high) was carved and mounted on a wall to hold a simple round mirror. By Joyce and Edgar Anderson.

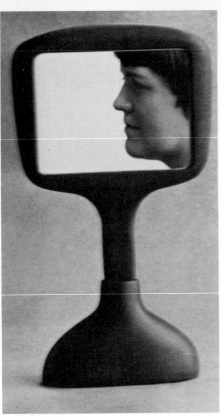

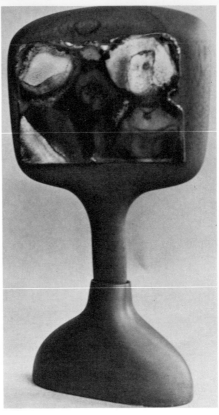

Freestanding hand mirror
E. M. Klim, with an enamel
copper plate inset on the
verse side. Glass mirror is in
in the mahogany. The mir
lifts out of its table brack
Photos courtesy: E. M. Klim

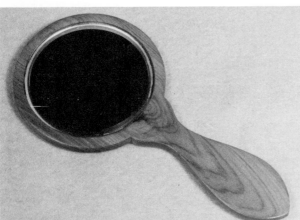

This delicate Mexican hand mirror is adorned with
inlaid mother-of-pearl.

‹

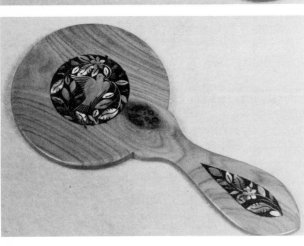

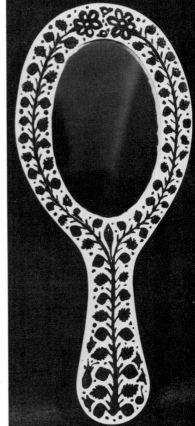

›

To decorate this hand mirror, the wood is first painted and
allowed to dry. Then a coat of dark lacquer is applied. While
the lacquer is still slightly soft, designs are etched in this coat.

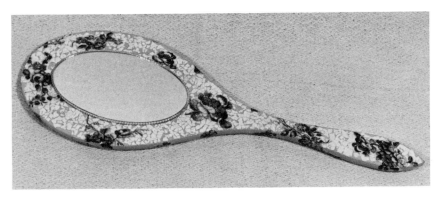

Decoupaged hand mirror by Peggy Kent.

Lamination

Wood can be glued easily. Often the glued joints are even stronger than the wood itself. Any part of the wood can be glued—edges, ends, faces. In fact, unique patterns can be created depending on how the grains of the pieces of wood are arranged when laminating.

Laminations vary from the adhering of thin veneer to the surface of a large piece of pine to the gluing of large blocks of softwood or hardwood or the sandwiching of plywood. Plywood, in itself, is an example of lamination.

The wood surfaces to be laminated should be planed and leveled just before glue is applied. The surfaces to be joined should be clean, smooth, and flat to maximize contact. The amount of glue applied varies with the glue used—consult label directions. The general rule is that enough glue should be uniformly distributed over the entire area so that when clamping pressure is applied all parts are held in close contact. A small amount of "ooze-out" of glue can be seen around edges. This is a good clue to the successful spreading of the adhesive.

As mentioned earlier, probably the best glues to use for laminating wood are plastic-resin thermosetting glues—such as Weldwood. They come as brown powders, which have to be mixed with water. Polyvinyl acetate (PVA)—such as Elmer's or Sobo—can also be used successfully in lamination.

Apply glues with a brush. After gluing pieces together, clamp them with even pressure over the entire surface. Excess glue that oozes out can be removed later by planing and sanding. Leave the wood clamped in a dry place at room temperature for at least as long as indicated on package directions before beginning any other operations.

LAMINATING A CHERRY WOOD
MIRROR FRAME BY KEN WILLIS

After designing the work, a full-size scale drawing of the piece is made.

Pieces of wood are planed smooth on the jointer.

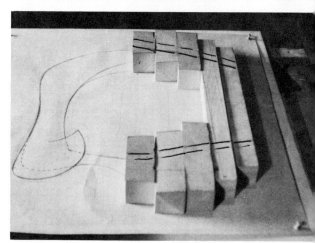

After checking against the scale drawing, pieces of wood are cut to approximate lengths and arranged on the drawing. Ken Willis works one-half of the frame at a time.

The wood strips are glued with an all-purpose white glue and then clamped with even pressure.

136

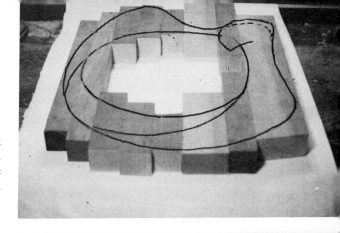

The two halves of the mirror, having been cut and glued, are placed together (but not glued together yet). The design is traced onto the wood. By leaving the mirror in two halves, machining is easier to perform.

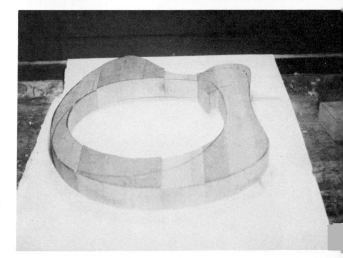

The inside perimeter is rough cut on a band saw.

After cutting out the inside shape of both pieces, the two halves are glued and clamped together. After the glue has dried, the outside shape is cut out on the band saw.

Using a router, a groove for inserting the mirror is gouged into the back of the frame. Note that the wood has been securely clamped to the worktable before routing.

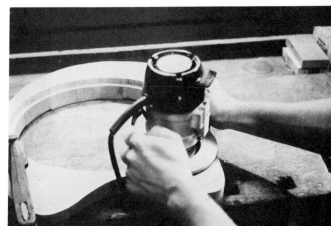

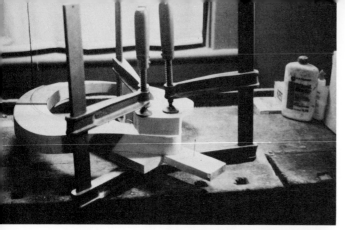

In order to carve a more three-dimensional shape, Ken Willis laminates an extra piece of planed cherry wood to the front of the frame. To avoid marring the wood with clamp marks, pieces of scrap wood are placed between the clamp and the cherry.

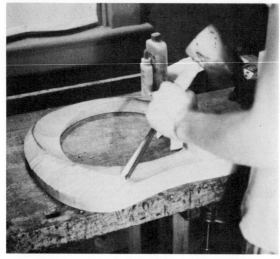

The rough contours of the frame are created with carving tools and mallet.

Shapes are refined and smoothed out with a spokeshave. To finish the piece, Ken Willis sands and oils the wood. The mirror is cut to fit the frame and is then set in its routed niche.

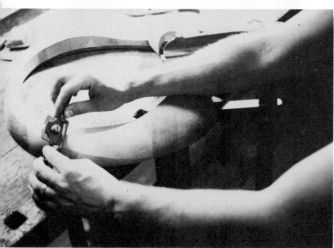

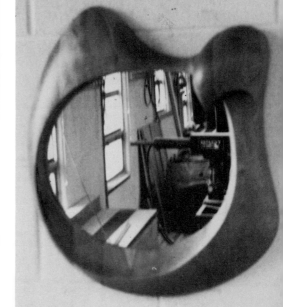

The finished mirror is 16″ × 18″. *Photos in this sequence are by Ken Willis.*

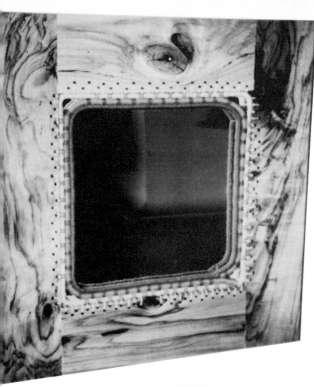

Butt-joined strips of pecan wood were laminated by Dale Beckmann. Holes were drilled around the inner perimeter to accommodate Sharon La Pierre's coiled yarn design. (Coiling is discussed in detail in Chapter 7.) *Courtesy: Sharon La Pierre*

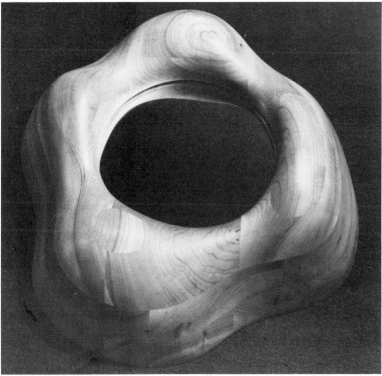

Four layers of wood were laminated one on top of another, and then carved with flexible shaft tools by Wendell Castle. The center is hollow—reducing weight, wasted wood, and cutting time. The mirror is fixed in place with putty.

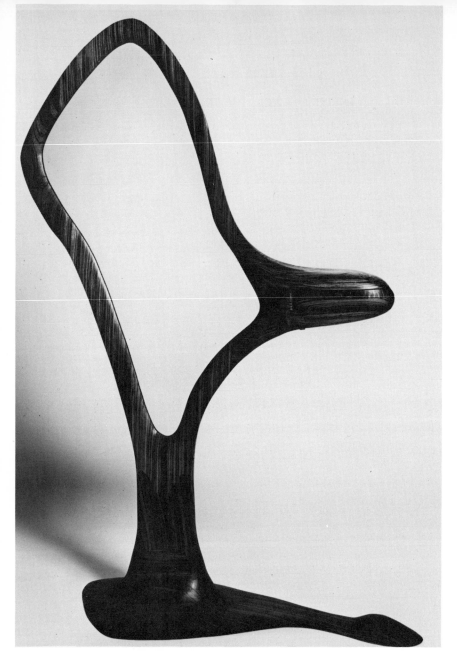

This fantastic floor-standin
mirror by Lew Korn take
maximum advantage of th
way grain direction can be ma
nipulated in lamination an
accentuated in carving. A
small drawer pivots out of th
arm of Lew Korn's laminate
wood mirror. *Courtesy: Le*
Korn

Bending

If wood is made wet and hot, its flexibility increases. After it has cooled and dried, the wood will retain the new bent shape. There are two good ways to heat and wet wood: by putting the wood in a wet-steam box or by submerging it in hot or boiling water. The steaming/soaking time is approximately one hour per inch of thickness. Green woods heat more rapidly than dry woods and are easier to bend. Woods that are too dry may splinter and crack when bent. Avoid overboiling or oversteaming because this excess may damage the wood. Just allow the wood to remain in contact with water or steam until it will bend to your contour without cracking.

After the wood is softened, quickly bend it to the shape desired. The wood will start to cool and lose a lot of plasticity in a short time, just moments after the heat source is removed. Usually the bending is done over a jig or frame. For instance, a piece of wood can be curved by bending it over a similarly curved bowl and clamping it down. If an extreme bend is desired, a tension strap is required to maintain the high pressure that is needed. Only certain woods will be suitable if the bend is extreme. Most hardwoods can be curved, but softwoods are difficult to bend without breaking. To obtain a permanent bend, allow the wood to cool and dry completely while remaining *in the mold* (or while still clamped over the jig). In time—sometimes up to a week or more—the wood becomes stiff again and loses its briefly won plasticity, thereby retaining the bend.

BENDING A WOOD FRAME BY DAN LAWRENCE

To create a circular wood frame, Dan Lawrence begins with eight strips of ¼″ to ½″ padouk wood. (Other favorite woods for bending are ash, maple, and cherry.) Strips are planed flat and cut to length. The strips are not all the same length, however, They must be cut in a progression from short to long, since the inner circumference will be smaller than the outer circumference when the pieces form a circle. The lengths needed are calculated from the formula $C = 2\pi r$. (Circumference in inches = $2 \times 3.14 \times$ radius in inches.) Decide on the radius desired, and plug into the formula to find out how much wood to cut to form the circumference. A circular mold must also be constructed to hold the bent wood in proper shape.

Dan Lawrence fills his steam-producing machine with water . . .

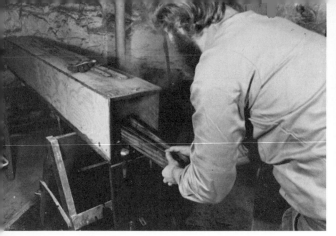

...and inserts the wood strips. The strips are set in vertically with blocks set between them as spacers.

For this ¼″ to ½″ thickness, the wood is left in the steamer for an hour.

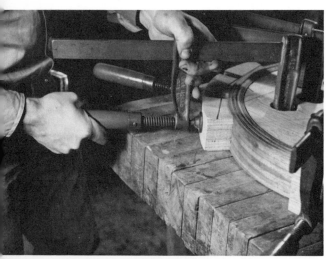

The strips are quickly removed and bent onto the mold. Clamps are applied as soon as possible.

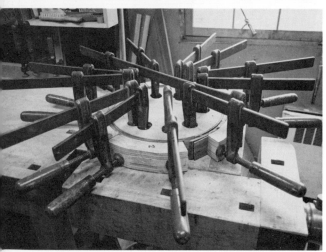

Knowing where to put clamps, how many clamps to use, and how to leave space for clamps in your mold construction takes some forethought and experience. Dan Lawrence leaves the wood in the mold overnight at room temperature or near a radiator.

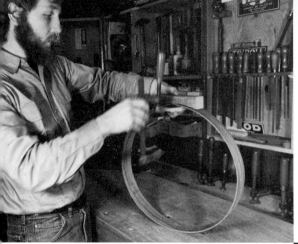

Next morning the wood will still be damp and will try to spring back. But in order to get the wood strips to dry completely, they must be separated. Dan Lawrence removes them in sequence (and numbers them, to keep the order) and clamps them temporarily to retain the circle. After several hours next to a furnace the wood is completely dry.

After the wood has dried, Dan Lawrence puts each circle strip back on the mold, smearing Weldwood Plastic Resin Glue over all surfaces. Weldwood is a good choice for such a complicated lamination job because its lay-up time is long enough to allow for alignment and spreading of glue. Now that glue has been applied, clamps are employed again—this time to hold the lamination. This frame will sit in the mold overnight.

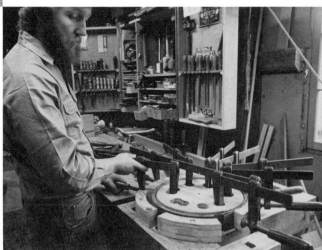

The result is a wooden hoop that holds its shape and is ready for machining. Scrape off all globs of glue that have oozed out. Then rotate the piece on the jointer to get smooth edges. (This is not a simple process, and it can be dangerous if the woodworker is not used to using this strong power tool.) If a jointer is not available, more tedious hand planing and scraping can be performed to finish the edges. After smoothing these surfaces, Dan Lawrence cuts the hoop down the middle—producing two hoops. In that way he gets two mirror frames from the single effort. (This kind of midline rip cutting of a hoop on a table saw is tricky.)

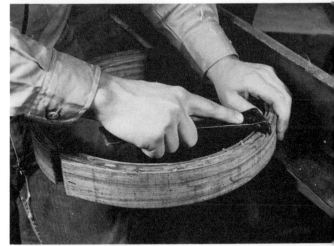

A half circle is going to be inserted at the top of the mirror hoop. First Dan Lawrence cuts a template for the circle and checks its proportions and shape against the hoop.

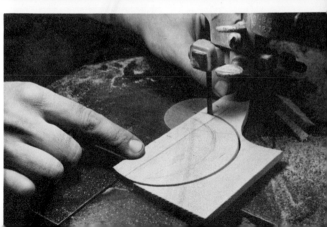

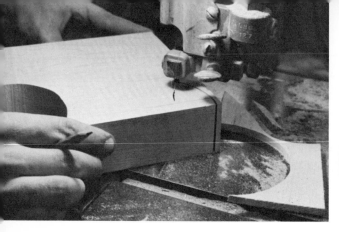

Then he cuts the actual half-circle block on the band saw.

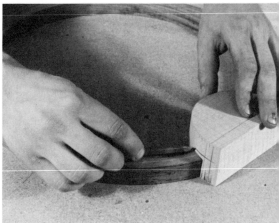

He fits it to the hoop, marking the wood to indicate where he wants to cut a rabbet. (The rabbet will run through the wood hoop and half circle.) If such a rabbet is cut in the hoop end and through the half circle, then a ¼″ strip of wood, called a spline, can slide in and hold all parts together as one unit.

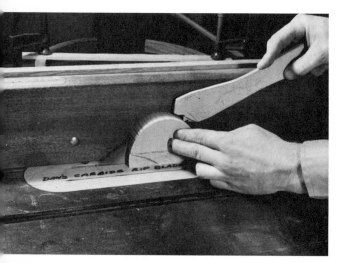

Dan Lawrence sets the table saw for the depth of the rabbet and runs the semicircular block through with a push stick. (Rabbets can also be cut with routing tools, but this method guarantees a good straight groove.)

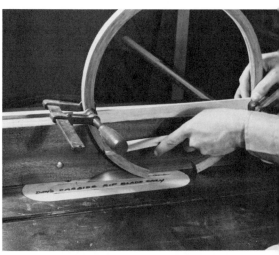

The rabbet groove is continued through the two open ends of the hoop—at the same depth as above.

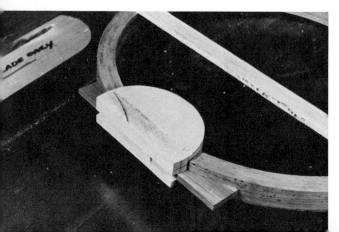

The ¼″ spline has been shoved into the rabbet. It is glued with Titebond and clamped so that there is pressure on the rabbet all along its course. After the glue dries, the spline and half circle are trimmed on the band saw. The piece is carved and shaped with files, rasps, surform, and router bits. Dan Lawrence cuts a plywood back and also cuts his glass mirror to fit. The mirror is held in place with glazier's points.

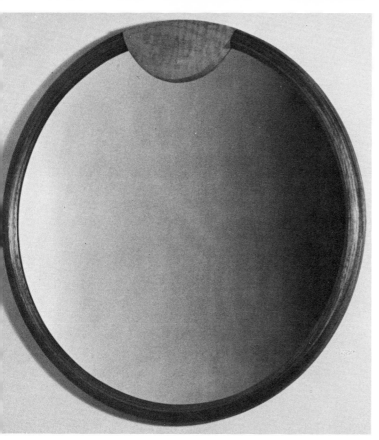

The wood is finished with linseed oil mixed with turpentine, applied with a soft cloth, and left overnight. The next day Dan Lawrence applies a coat of boiled linseed oil to add luster.

minated, bent, carved mirror Dan Lawrence.

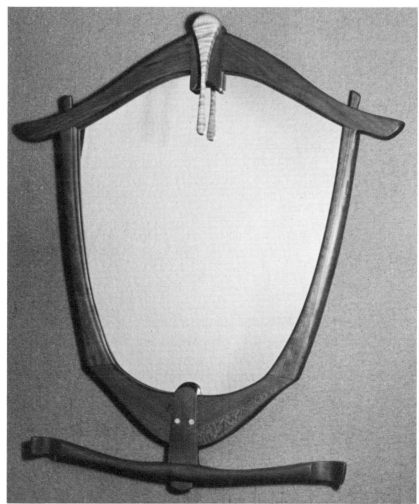

BENDING AND LAMINATING WITH VENEER—WITHOUT HEAT OR MOISTURE

These three molds are used by Glenn Gauvry to bend and laminate an elegant freestanding dressing mirror. He is able to bend the wood without steam or boiling water because he uses thin $1/16''$ cherry veneer. The veneer is thin enough to be bent without breaking and can be put directly into the molds. Weldwood is brushed on each strip. Glenn Gauvry takes advantage of this resin's twenty-minute lay-up time because the process of putting veneer into the molds is relatively slow. He does not wet the veneer before bending because he does not want to increase the moisture content of the wood any more than necessary. The molds are made of plywood lined with either veneer or Formica to ensure a smooth surface. They are then waxed so that the laminated pieces do not adhere to the mold itself. He bolts one-half of the mold to a sturdy surface, leaving the other half free for clamping. Note the holes drilled in the molds to accommodate clamps.

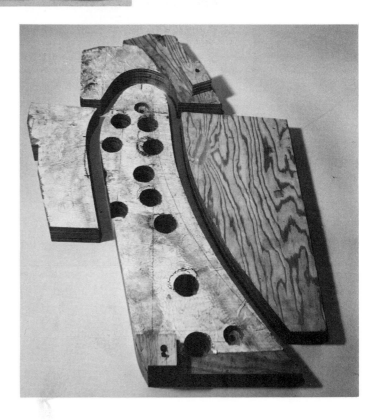

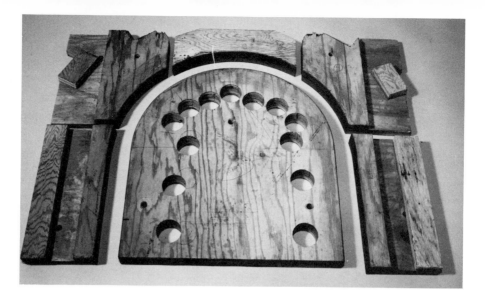

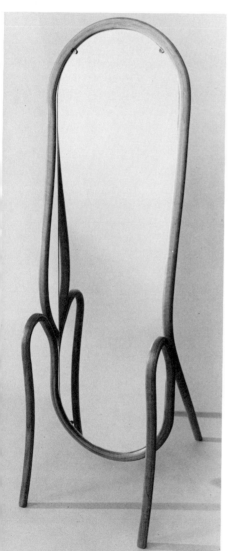

The completed laminated cherry mirror by Glenn Gauvry is made in six parts: top and bottom half circles, two back legs (which also become the sides), and two front legs. The front and back legs are joined with a long spline. The half circles are attached to the legs with splined scarf joints. The mirror is $\frac{1}{4}''$ plate glass with polished edges and $\frac{1}{28}''$ cherry veneer contact-cemented to the back with 3M Scotch Grip 1357 Adhesive. This gives a finished look to all sides of the piece. Four mirror clips hold the glass in position. The lamination technique lends a handsome flow to this piece whose design is reminiscent of the cheval glass frame. *Photos in this sequence courtesy Glenn Gauvry.*

PLASTICS as a MIRROR MEDIUM

DURING THE PAST FIFTY YEARS, PLASTICS HAVE INVADED EVERY REALM FROM art to technology. Their use as reflective materials is one of their more recent and exciting applications. As in every area in which their flexibility has been creatively harnessed, their impact here has been far-reaching. As discussed in Chapter 3, acrylic, acrylic mirror, and metallized polyester films may be readily employed with few tools to achieve dramatic effects. The effects are often impossible to achieve with any other material. This chapter employs just a few characteristics of these remarkable polymers and hints at their potential.

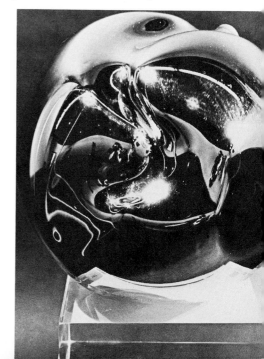

Ripple Split Series (1968) (12″ diameter) by Gary Remsing. Acrylic is heat formed and then metallized. *Courtesy: Gary Remsing. Photo: Paul Hoffman*

148

SHEET ACRYLIC MIRROR

Mirrored acrylic sheet can be cut and laminated into low-relief forms. Begin by sketching the mirror design and cutting out templates. With wax pencil, trace the template onto mirrored acrylic.

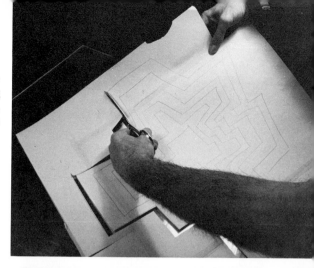

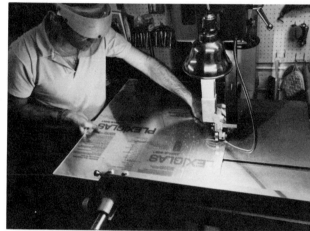

The acrylic is cut on a band saw.

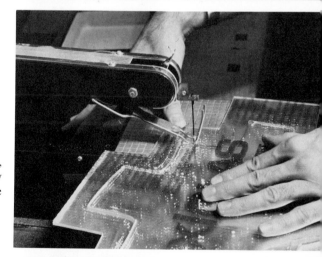

To cut out parts from the center of the sheet, first drill a small hole and then insert jigsaw blade through the hole. Cut the shape on the jigsaw.

The edges of acrylic are hand scraped with a wood scraper to remove scratches introduced by machining. The edges are then sanded smooth with a progression of sandpapers (coarse to fine). Machine polishing produces a high-luster finish on edges.

The cut and polished pieces are made to adhere with double-stick foam tape used for wall mounting. A contact adhesive could also be used, provided it does not attack the backing of the acrylic.

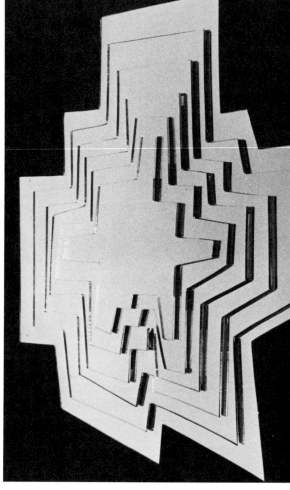

Topology Mirror by Jay H. Newman. Mirrored acrylic.

Smokey Mountain Memories: #1 (10″ × 6″ × 1½″) by Steve Loar is a toothbrush holder made of mirrored and colored acrylics, aluminum button, and transfer lettering. Acrylic pieces are bolted and riveted together. *Courtesy: Steve Loar*

150

MIRROR BOX WITH MITERED EDGES

To produce a box with mitered edges, cut the mirrored acrylic at a 45° angle.

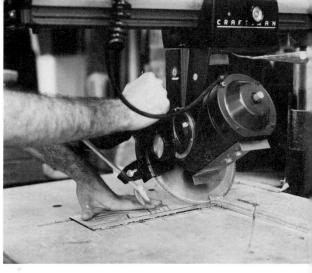

Four sides of the box are cut with mitered edges and are then scraped smooth. Methylene chloride is applied. Use angle clamps to hold the box's sides while gluing. The corners should fit together at perfect right angles if the saw was accurate. Be careful not to allow cement to touch the mirrored backing of the acrylic (let it touch only the joint). It may delaminate and mar the reflective surface if too much is applied.

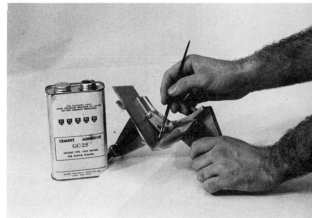

The bottom of the box is masked around the edge with tape. An area as wide as the edge thickness of the acrylic is sanded free of mirror backing. In this way acrylic will meet acrylic and a good bond will be possible between side and bottom.

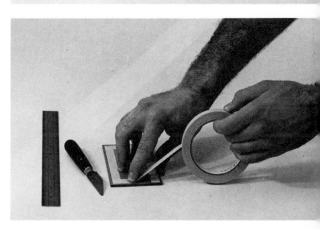

Set the sides on the bottom piece and apply the solvent cement along each side of the inside edge. Apply some weight for a few minutes after gluing.

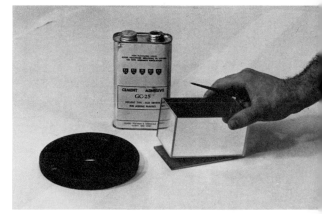

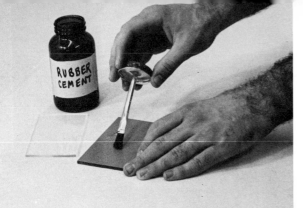

To make a lid for the box, use rubber cement to bond two pieces of mirrored acrylic. The bottom piece should be smaller so that when the lid is placed on the box it will fit into the opening of the box and hold the mirror top in place. Use clamps to hold these pieces together overnight. A piece of flannel will protect the mirror's surfaces from being scratched by clamp jaws.

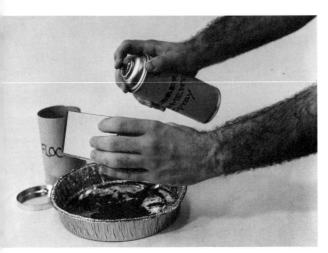

To protect the inside of the box, use flocking. Spray on a coating of rubber cement.

Pour some flocking over the wet cement. Once the flock has adhered to the cement, pour out the excess and let the cement dry. Repeat this process several times until the desired thickness of flocking is obtained.

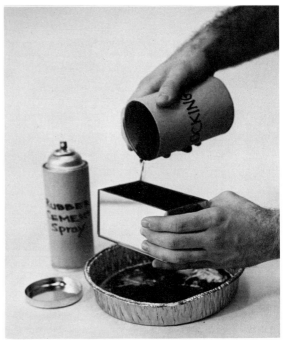

The finished mirrored acrylic box reflects on all surfaces.

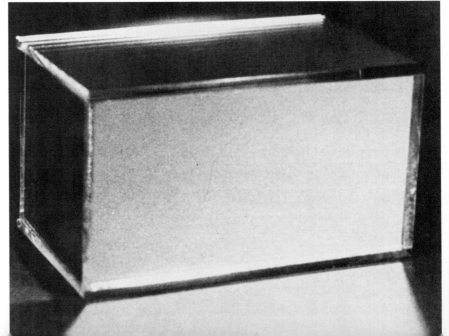

A mirrored acrylic planter can be made water-tight by using PS-30—a strong, two-part glue. Or the acrylic mirror can clad a plywood box, using a contact cement to attach acrylic to wood. *Courtesy: Rohm and Haas Company*

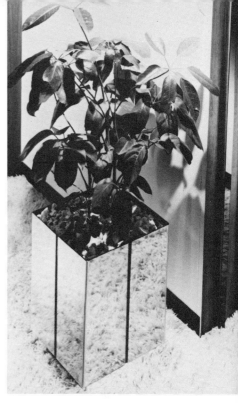

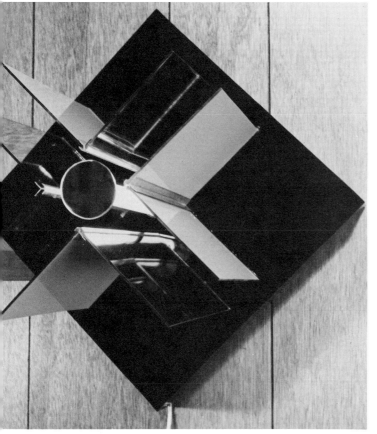

A sculptural lamp by Lee Newman produces dramatic reflections of light through the use of acrylic mirror. The base is made of plywood clad with black acrylic. Perpendicular to the base are eight panels of mirrored acrylic, whose blue backing becomes part of the design. A 12″ tubular bulb stands in the center of the lamp, extending almost the height of the acrylic fins. To eliminate glare from the bulb, a steel spring clamp with acrylic mirror disc is clipped on the head of the bulb.

Hands Lamp (33½″ × 13″ × 15″) by Lee Newman. Cast plaster arms hold a Mirron tube that has been slit open on a circular saw to permit light to shine through. A fluorescent fixture is mounted in the tube. The Mirron cylinder picks up reflections and colors from around the room.

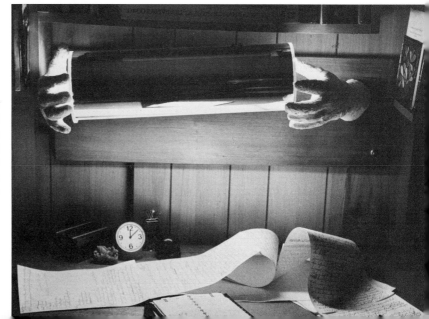

ANGULAR ACRYLIC BAS-RELIEF

A sheet of polystyrene foam is attached with rubber cement to a plywood base. Smaller pieces of polystyrene foam are cut into angles and placed on the base of the foam, in order to support projections of acrylic mirror. The foam wedges are attached to the foam base with mastic cement—the kind used to make tiles adhere to the floor.

Small pieces of mirror are cut on a circular saw and temporarily attached with masking tape in order to study position and design. Methylene chloride is applied to the joint with a syringe as more pieces are assembled and other edges are glued with solvent cement.

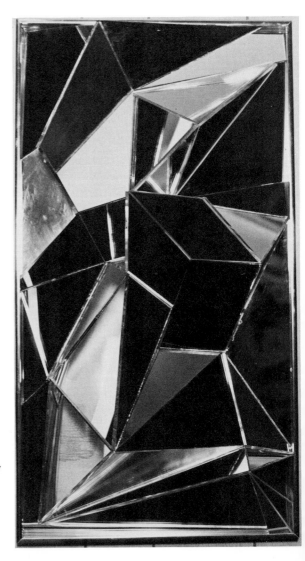

Mirror Sculpture II (29½″ × 16½″ × 7″) by Jay H. Newman.

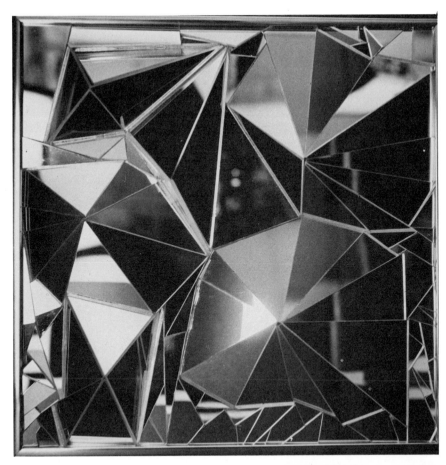

Mirror Sculpture I (16″ square) by Jay H. Newman.

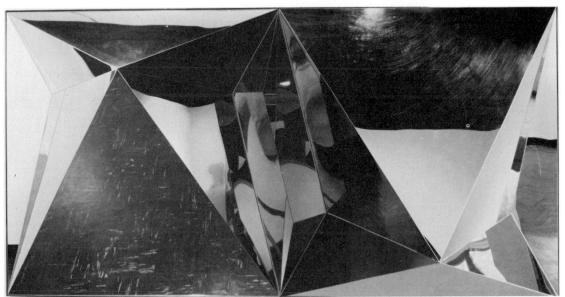

Modular Reverse (36″ × 72″) by Irene Pasinski is made with clear, yellow, red, and blue mirrored Plexiglas. *Courtesy: Irene Pasinski*

HEAT-FORMING ACRYLIC MIRROR

Mirrored acrylic—like other acrylic sheet—can be bent on a strip heater (a heating element built into a wooden frame, described in Chapter 3). Set the acrylic on the strip heater, mirrored surface up. After a few minutes on the heater, the acrylic begins to melt. (Edges were polished before bending.)

The acrylic must be watched for the ideal moment when it is hot enough to be bent but not so hot that the mirroring is badly affected or that the acrylic itself bubbles. The acrylic can be bent by hand to any desired angle. It will cool in a matter of seconds. If you want to change the angle a second time, allow it to cool briefly and then just put it back on the strip heater. Do not let the acrylic actually touch the heating element at any time.

The bent acrylic mirror can serve as a hand mirror or as a freestanding table mirror.

ith a single bend, metallized acrylic can become a
ek table mirror.

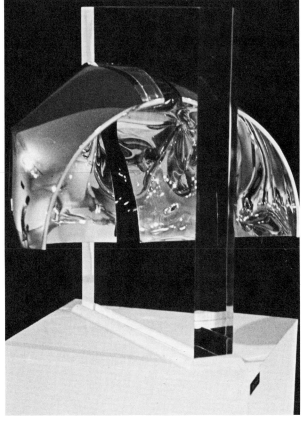

Ripple Split Series (1968) (15″ × 15″ × 15″) by Gary
Remsing. The artist heat forms acrylic, which is metallized
after forming. By oven heating an entire sheet and then
putting it in a plywood mold, dramatic sculptural forms are
achieved. He also blows on the hot acrylic with compressed
air to shape the sculpture. Pieces are then either machined
or reheated, shaped, polished, and cleaned to make them
ready for vacuum metallizing. In this series of sculptures,
Gary Remsing placed an undercoating of lacquer on the
plastic surface, baked this coating in an oven, metallized it
in a vacuum chamber (rented from a commercial metal-
lizer), and applied a topcoat of clear lacquer. *Courtesy:
Gary Remsing Photo: Paul Hoffman*

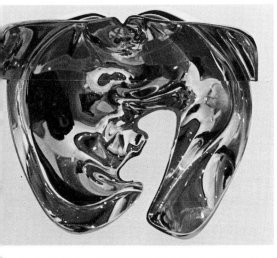

Ripple Split Series (1968) (15″ × 15″ × 4″) by Gary
Remsing. *Courtesy: Gary Remsing. Photo: Paul
Hoffman*

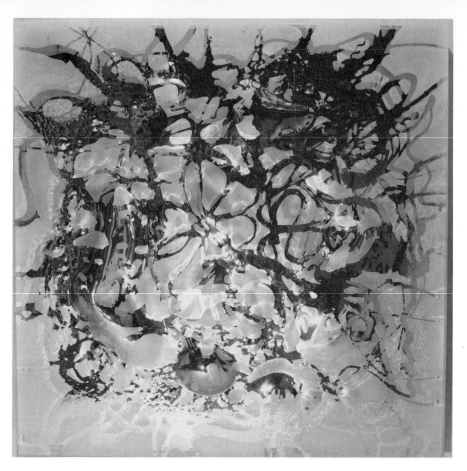

California Mirage (1970) by Gary Remsing. The artist heated and formed acrylic sheet and metallized with aluminum, this time using no lacquer coatings. Some areas of the piece are opaque and others are semitransparent. Bubbles are created during the heating of the acrylic. *Courtesy: Gary Remsing. Photo: Paul Hoffman*

WORKING WITH METALLIZED POLYESTER FILM

Metallized polyester films can be formed like paper into reflecting volumes. This construction is by Jude Johnson. *Courtesy: Jude Johnson*

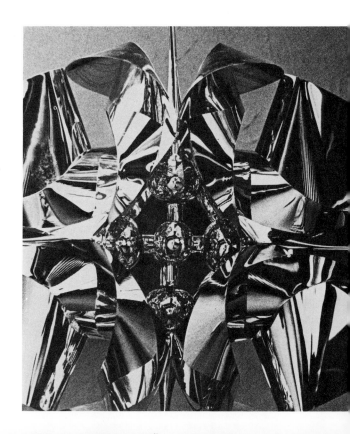

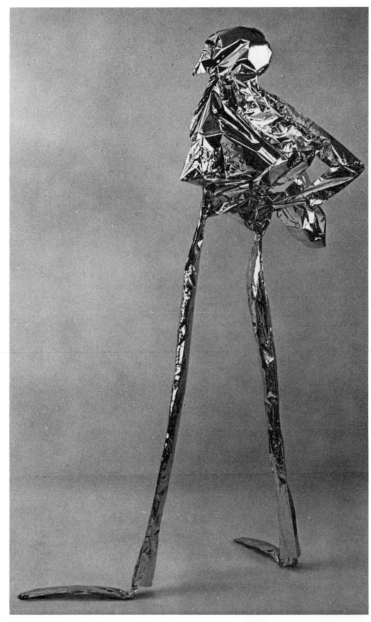

Businessman (1970) (60″) by William King. Metallized polyester film. *Courtesy: Terry Dintenfass, Inc. Photo: Walter Rosenblum*

Yantra is an environment created by Peter Nicholson of rhombicuboetohedron-shaped reflective Mylar surfaces. Warm and cool lights, manually controlled, il-luminate the environment. In close-up, the surface reflects like soap bubbles on a mirror because the metallized film is not stretched taut. *Courtesy: Peter Nicholson*

Tower Series 3 days (1973) (9′ × 5′ × 5′) by Paul Tzanetopoulos. Metallized polyester film stretched over tube steel. Towers were done in Las Vegas Basin area. *Courtesy: Paul Tzanetopoulos*

A single metallized polyester film mirror (2′ × 2′) set in the Valley of Fire outside Las Vegas in 1973. Part of a series by Paul Tzanetopoulos. *Courtesy: Paul Tzanetopoulos*

Neon Sculpture Light by Thelma R. Newman reflects back and forth from the clear acrylic case to the metallized polyester film that partially covers some areas.

DIFFRACTION GRATING CUBE SCULPTURE

A box is made from acrylic squares that have been cut, scraped, and buffed. Acrylic sides are attached temporarily with masking tape. Methylene chloride (or ethylene dichloride) is used with a syringe to join edges. The principles of gravity and capillary action move cement along the joint. Diffraction grating containing an adhesive backing is applied on a clean, dust-free surface of acrylic. Many shapes are covered and attached within the box with solvent cement.

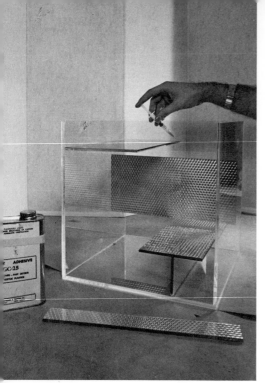

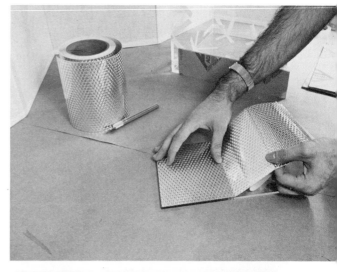

Applying adhesive-backed diffraction grating requires a clean surface and exacting application. Every speck will show through as a bump. It is nearly impossible to remove this kind of Mylar film.

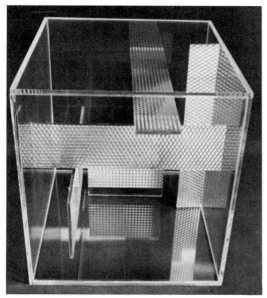

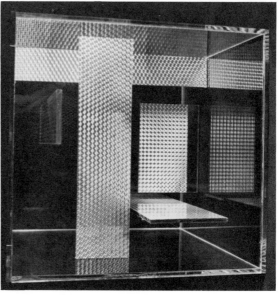

Mercurial Light I by Thelma R. Newman. The diffraction grating acts like miniature prisms, reflecting a rainbow of colors that change as the viewer moves or as the lighting changes.

METAL MIRRORS

While the variety of metallurgic materials and processes has expanded over the centuries, the essentials have remained unchanged for generations. The craftsman's basic metals—brass, copper, silver, gold, platinum, iron, steel, bronze, aluminum—are not new inventions. But today we have the advantage of being able to purchase metals as sheet, wire, precut shapes, blocks, and castings. Working processes such as casting, raising, repoussé, fabrication, and the various finishing techniques are nearly unchanged. But today craftsmen benefit from laborsaving motor tools.

Effluxes Series (4½′ × 9′) by Hal Buckner, #4 finish stainless steel and formed canvas. *Courtesy: Hal Buckner*

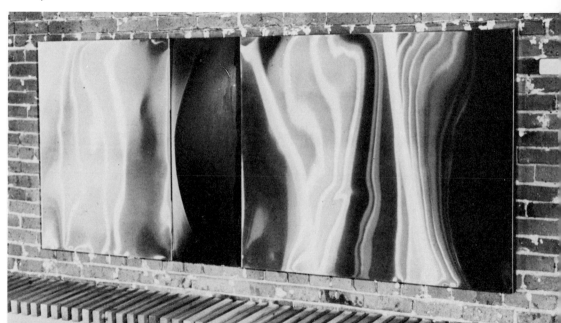

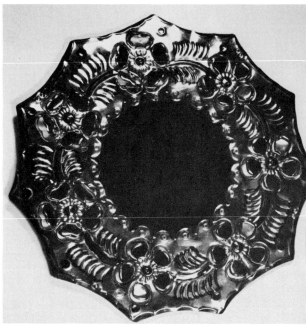

Mexican tin mirrors.

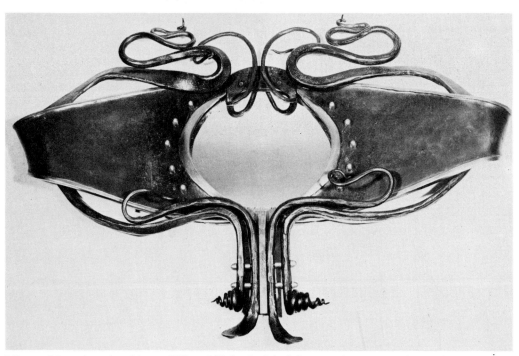

Mirror of forged steel and brass (15″ × 24″) by Joel A. Schwartz. *Courtesy: Joel A. Schwartz. Photo: Aaron Macsai*

CASTING

Of the many processes, lost-wax casting is probably the oldest. It has been used by craftsmen for more than four thousand years. The technique seems to have developed simultaneously in many parts of the world. It was known in ancient Greece, Egypt, Italy, South America, and Africa. Artisans throughout the world still use it today.

The process, in its basic form, is uncomplicated. The piece to be cast in metal is first constructed in wax, acrylic, paper, cloth, or another organic material, which is then invested, or contained, in an investment, or shell. Most often the investment is a combination of clay, charcoal, and plaster, which will accept an impression from the original object. The entire form is then heated so that the material of which the original form had been constructed will burn out, leaving a cavity within the investment. Molten metal is poured into that cavity, and when the metal cools enough to lose its cherry color, the investment is placed in water. This rapid cooling of the piece causes the still-hot investment to crack apart and free the casting. When completely cool, the cast form may be finished by sanding, filing, buffing, plating, and coloring as desired.

The lost-wax casting technique does have the disadvantage of destroying the mold, but there is a decided advantage in being able to work the original in wax or another malleable material and preserve the fine detail permanently in

Two-sided silicon bronze mirror cast by the lost-wax process (14½″ × 8″ × 2″) by John Ottiano. *Courtesy: John Ottiano*

A bronze standing mirror by John Ottiano cast directly in the lost-wax process. *Courtesy: John Ottiano*

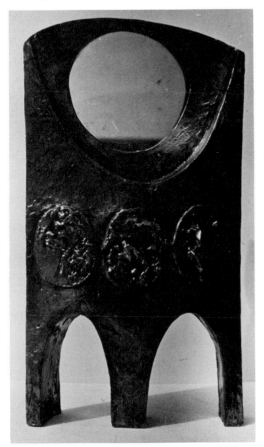

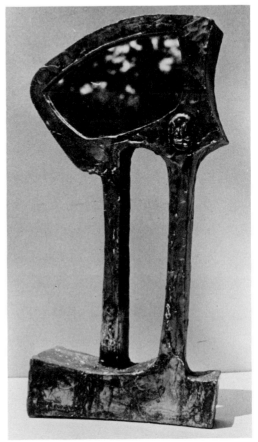

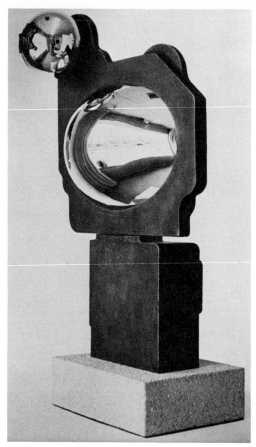

The Egg & I (1968) (21″ × 11″ × 5″), cast bronze with raised parts polished and gold-plated by J. Fred Woell. *Courtesy: J. Fred Woell*

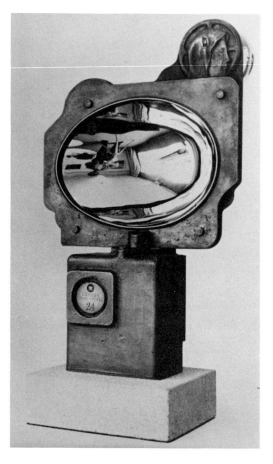

cast metal. One wax formula used today: 100 parts white beeswax, 100 parts paraffin, 50 parts petroleum oil, 50 parts petroleum jelly, and 10 parts lanolin is readily worked. Of course, once the metal form has been finished, it may, in turn, be replicated by making a two- or several-piece mold of it; this will allow multiple castings to be made.

Other casting processes, such as that used by Don Drumm and illustrated here, provide alternatives to the lost-wax process. And, of course, different materials will be better or less well suited to casting by each technique. Plastics, for example, are usually more readily cast within flexible molds of rubber or silicone, most of which would not accept the intense heat of molten metal.

CAST ALUMINUM MIRRORS BY DON DRUMM

Sand casting is another expendable mold technique. The first step is to make a model of the form to be produced—this is the pattern for the mold. Don Drumm makes his patterns by hand, often in clay.

The pattern is then placed in a metal mold frame, where sand is sifted around the form and tamped down firmly. Many substances can be used to make the mold besides sand. They include cement, fireclay, and plaster. All must be bonded in some way so that the mold material has the strength and dimensional accuracy to retain the shape of the pattern. Bonding may be achieved chemically or, with some materials, by drying. In green (damp) sand casting, drying effects the bond.

After sand has been sifted around the pattern, it is compacted by pressure or vibration and dried. The mold is then opened and the pattern is removed. Then the mold is closed, leaving a cavity into which metal is poured. Where necessary, a core may be inserted to achieve a space.

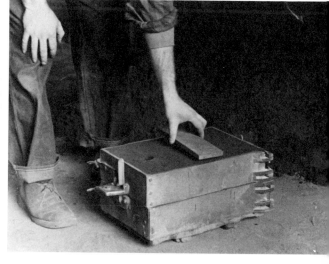

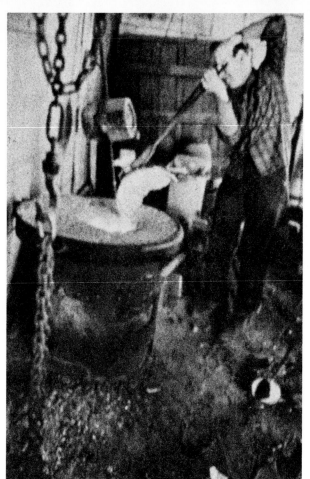

The crucible furnace is then charged with metal, and a ladle is used to introduce the molten aluminum into the mold.

The forms are finished by filing and grinding. Where necessary, pieces are arc-welded or heli-arc group-welded by an industrial process using inert gas.

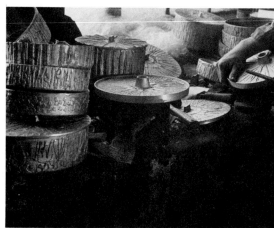

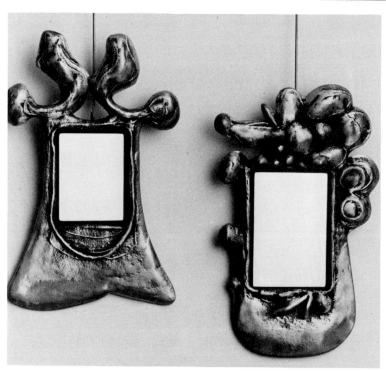

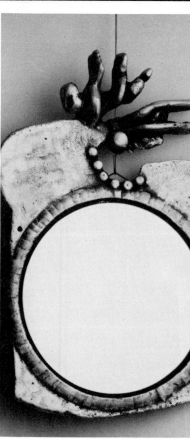

Wall mirrors of cast aluminum by Don Drumm.
Photos courtesy: Don Drumm

168

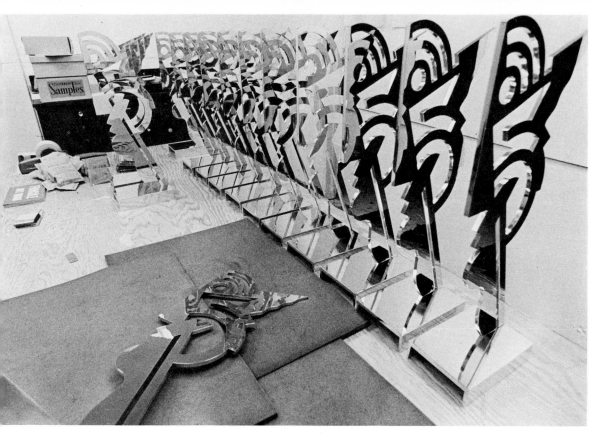

Untitled Head I (1970) by Roy Lichtenstein, of highly polished brass. *Courtesy: Gemini G.E.L., Los Angeles, California. Photo by Malcolm Lubliner Photography*

Procedures for Lost-wax Casting

The basic steps in the lost-wax casting process follow:

1. Make an original in wax, acrylic, papier-mâché, cloth, or any other organic material (wax is probably best).

2. Attach sprues, which will form canals, to the surface of the investment and allow for exit of the original material and introduction of the metal.

3. Coat the original with a solution that inhibits bubbles from forming.

4. Choose a flask in which to place the form and pour the investment.

5. Place the original in the flask, add the investment, and tap the flask to dislodge any trapped air.

6. Allow the investment to harden.

7. Place the flask in an oven or kiln, sprue holes down, to melt or burn out the original.

8. When the original has been completely burned out, remove the flask from the oven or kiln.

9. Melt the casting metal in a fluxed crucible and inject it into the cavity, either by gravity or by use of a centrifugal caster.

10. When the metal has lost its cherry color, plunge the investment into water and carefully remove the investment as it cracks away from the form.

11. Finish the metal casting when cool.

FORMING AND REPOUSSÉ

The most basic structural and decorative metal-working processes are forming (e.g., raising) and repoussé. But before these techniques are discussed, it is best to say a few words about the physical properties of the metals that are formed most often: copper, brass, bronze, silver, and gold.

These metals are relatively soft. They can be hammered and worked easily. However, hammering transforms and distorts the crystalline structure of the metal. It becomes flatter, harder, and more brittle. That change may be part of the goal. Hammering shapes metal, and the increased rigidity will allow it to hold a new shape better. But because striking metal modifies the elemental structure, the metal may eventually become too thin and too brittle. It may crack. To avoid this and to allow the metal to be worked most fully, it must be "annealed" periodically. The metal is heated to a dull red color and then allowed to cool. Heating allows the molecules to become reoriented, and a new crystalline structure results, with the metal becoming soft and malleable once again. This hammering and annealing process must be repeated often. When it is nearly complete, the piece is hammered and not annealed so that it remains hard and will not bend easily.

Hammering techniques can produce a variety of shapes. And there are an assortment of hammering styles. *Sinking, blocking,* or *hollowing* is accomplished by hammering metal on the underside of the proposed form to cause it to take the shape of the hollow within a shaped anvil of wood or metal. *Raising* is the opposite: the metal is hammered on the outside while it is held over a stake or anvil. The hammers, once made of smooth polished stone, are now highly polished metal, and they are available in a wide range of sizes, shapes, and weights.

A FORMED SILVER REAR-VIEW TABLE MIRROR BY MARCIA LEWIS

Marcia Lewis begins by creating a full-scale model in 1000 series alloy of aluminum wire and cardboard, which are attached with tape. Here she sizes the model.

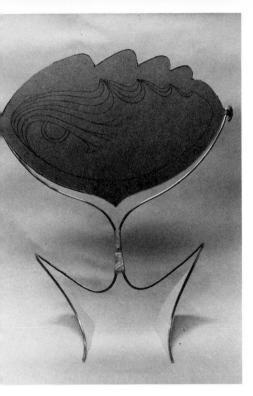

The finished model. Marcia Lewis has sketched the pattern for areas that will be formed in the silver (represented by cardboard in the model).

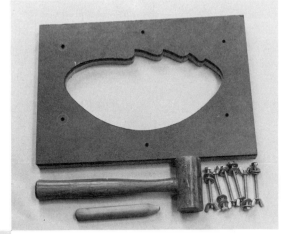

A tempered masonite die is cut in the shape of the silver, which will be sunken. The sheet of silver to be sunken and formed will be held between pieces of masonite and secured by bolts with wing nuts passed through the masonite and silver.

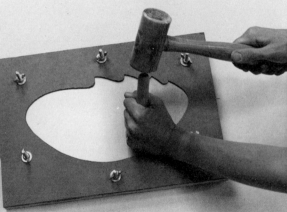

The die-forming equipment is assembled around the sheet of silver. The form is sunken into the shape defined by the masonite die with a wood dowel powered by a wooden mallet. The rounded, broader end is used to sink the center areas; the pointed end is used at the edges.

After having been sunken (note form at the right), the silver is removed from the masonite die sandwich and filled with pitch. The pitch is first softened with heat from a torch and spooned into the sunken area.

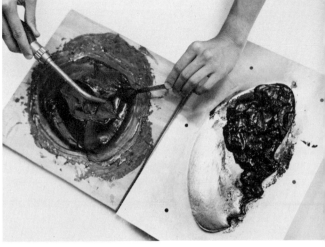

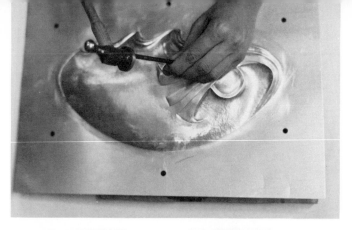

On the reverse side of the sunken silver, the details of the design are chased into the metal. To do this, the form is placed over a pitch block of pitch-covered one-inch plywood. The pitch provides support and resistance and gives greater control.

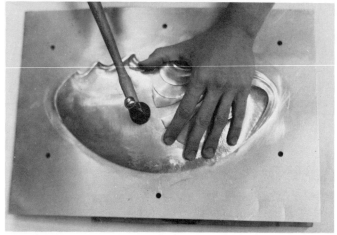

The metal is planished with a hammer designed for that purpose . . .

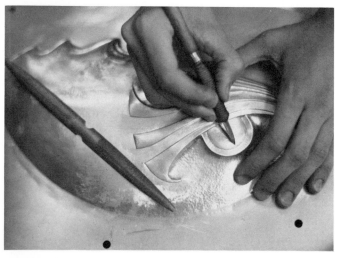

. . . and the outer surface is filed and scraped smooth. The flange—the outer rim of metal—is allowed to remain on the form until all the forming and finishing have been completed.

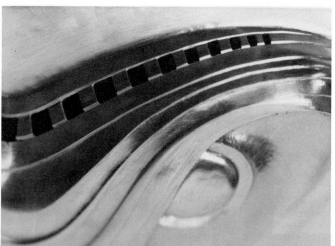

A detail showing chasing and piercing of the sunken silver form.

The legs of this mirror, constructed of 1000 series aluminum wire in the model, will be constructed of heavy 6061 series aluminum rod (½″ × ¼″) in the final form. Here the 6061 series aluminum is split with a jeweler's saw . . .

Below, left:
. . . and bent roughly to shape.

Below, right:
The sunken form is trimmed and the curve of the aluminum rod legs that will hold it is measured.

A flare is forged in the leg . . .

173

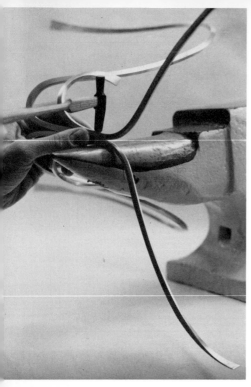

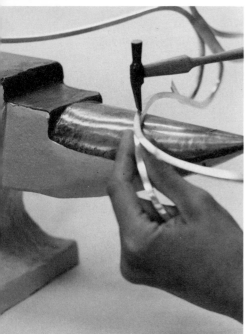

. . . and back and front legs are attached with cold joined rivets after forging.

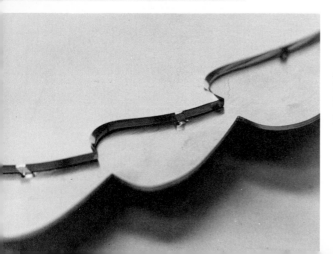

Acrylic mirror is cut to size, filed to shape, scraped, and buffed to a high gloss. It is held in place on a plate by tabs. The plate, in turn, is attached to the sunken and pierced silver form by rivets.

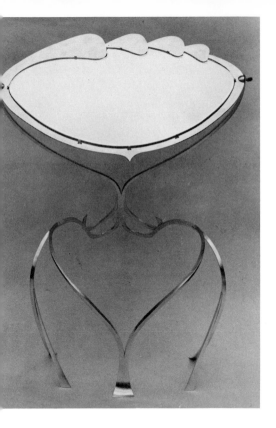

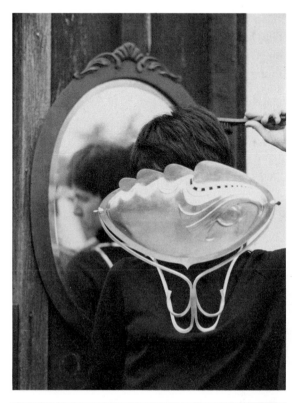

The completed mirror by Marcia Lewis will stand alone or will perch on the shoulders of the user. The mirror swivels, for ease in viewing. *All photos courtesy: Marcia Lewis*

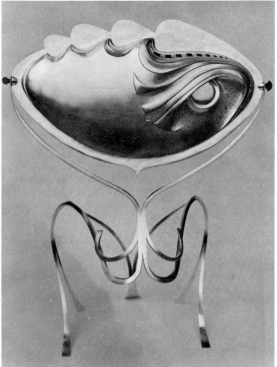

Ginna Sadler mounts patterns of the shapes to be cut on the silver sheet. She uses a dry-mounting process: rubber cement is applied to both paper and metal and allowed to dry before pressing the two surfaces together.

A FORMED AND FABRICATED MIRROR BY GINNA SADLER

The shapes are cut from the silver sheet on a bench pin (for support), using a jeweler's saw.

Each section is formed and the various parts soldered together. With copper tongs, the soldered pieces are placed in a pickle solution of Sparex or dilute acid to remove oxidation and flux. The form is then rinsed thoroughly under running water.

Edges are filed (but do not file on the backstroke) to achieve a proper fit . . .

. . . and finished with abrasive paper—this also cleans the edges in preparation for soldering. Note that Ginna Sadler rests the silver on a leather pad to avoid scratching the metal.

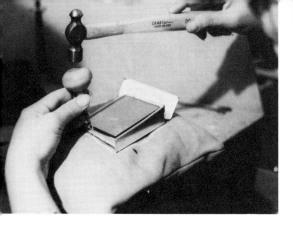
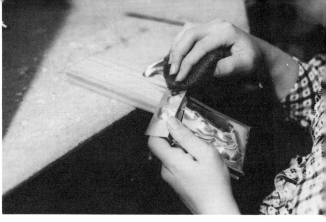

After the pieces have been soldered together, cleaned, and polished, the mirror is set in place. It is held by prongs bent over its edges with a prong pusher and hammer.

Ginna Sadler imparts the final finish with #0000 steel wool—this removes fingerprints also.

Front and back views of the formed and fabricated silver mirror by Ginna Sadler. *Photos in this series courtesy: Ginna Sadler*

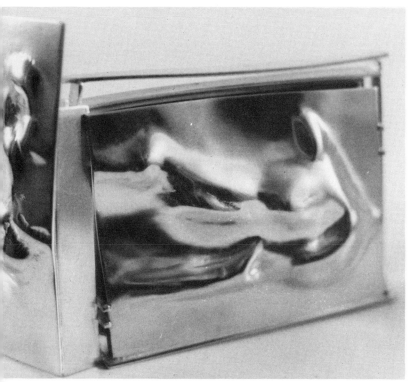

177

Raising

If you want to raise a flat piece of metal into a shape, metal thickness should begin at 14–18 gauge. To determine the raw width or size of the metal to be formed, add the desired depth to the intended diameter. The form is raised by holding the metal, in one hand, over an anvil. The hammer is wielded with the other hand. Every time the piece is struck, the piece is rotated. Each blow should be administered at the same angle.

When the metal begins to resist hammerblows, it requires annealing—copper to 700°–1200°F, bronze to 800°–1100°F, sterling silver to 1200°F, or until the metal is a dark red color.

To anneal, place the form in a pan filled with lumps of pumice or a refractory substance capable of retaining and distributing heat without melting. The metal is usually heated with a torch—propane works well—in a slightly darkened area (so that the color may be judged). The flame is moved constantly and slowly over the entire form until the piece has been heated evenly. To focus on any one spot too long might warp or melt the metal. (Where only one area is worked at a time, however, it is possible to heat that section individually.)

The piece is quenched immediately after annealing by placing it in a pickling solution (a dilute acid or other substance that cleans metal by removing oxides that build up when heat is applied). A typical pickling solution consists of ten parts of water into which one part of sulfuric acid is poured *slowly*. The water is never poured into the acid because splattering of the caustic chemical is more likely to occur. Nonacidic pickling solutions are also available. They are safer, although slightly slower working. These solutions should be stored in glass, polyethylene, or enamel containers that may be sealed tightly; they may be reused. After removal of the metal from the pickle, it should always be rinsed thoroughly in water.

After annealing, the raising procedure continues until the piece is complete or until further annealing is required.

A heavy rawhide hammer and a mushroom-shaped anvil are used to smooth hammer marks in the final stage of raising.

Hand mirror fabricated of sterling silver with mahogany inlay (1975) by Norman L. Scutt. *Courtesy: Norman L. Scutt*

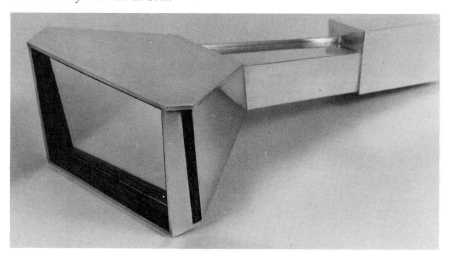

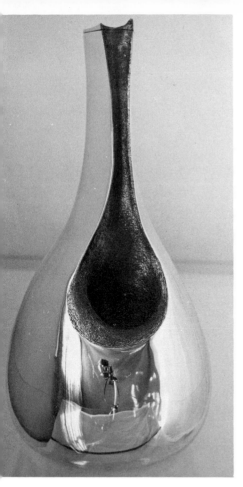

This raised and chased form of sterling silver (12″ high) by Thomas R. Bambas illustrates how reflective finely polished silver can be. *Courtesy: Thomas R. Bambas*

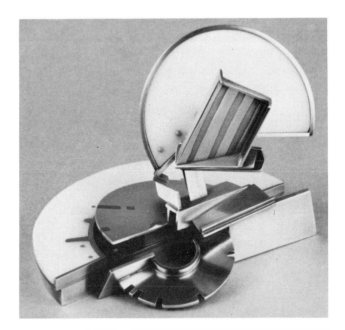

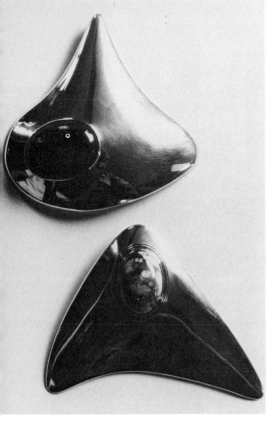

Hand mirror constructed of silver, copper, brass, and acrylic (1976) (3″ × 4″) by Helen Shirk. *Courtesy: Helen Shirk*

Silver pendants with gold bezels by Stuart Golder. *Courtesy: Stuart Golder*

Repoussé

Repoussé is a form of surface decoration that may be combined with raised forms or practiced on pieces of metal that will later be constructed or soldered together (fabrication). In repoussé, the design stands out from the surface in relief. The process begins with a sketch scratched into the metal with a sharp, pointed instrument called a scriber. The areas to be brought out in relief are then worked with tools called modeling cushions or bossing tools. These are pressed into the metal with hammerblows. During this process, the metal rests in pitch, which provides resistance to allow the metal to be formed while giving the craftsman firm control over the material and the depth of relief. Alternative supports are sandbags or leather pads.

A small, chisel-shaped tool called a tracer (and also powered by hammerblows) is used to define lines and areas around sections in higher relief. Chasing, or hammering and punchwork on the surface, further defines and refines these shapes.

It should be emphasized that the essence of raising, sinking, and repoussé (in particular) is the forming and shaping of metal. Many tools have been developed to serve different purposes in this decorative and structural process. Scribers, tracers, bossing tools, and modeling tools are the most common, but there are more specialized instruments too. All are used with repoussé or chasing hammers that have steel heads and polished faces.

To work metal in repoussé, pitch is first heated in a double boiler and poured into a hollow form. The metal is oiled, to ease later removal from the pitch, and then pressed into that softened material deeply enough so that all surfaces to be worked are in contact with it. The design is scribed onto the surface and traced with a tracer. For greatest control, the tracer is usually held between thumb and index finger, with the third and fourth fingers being used as guides, levelers, or balancers while they rest on the metal. The tracer is held nearly perpendicular to the surface of the metal, slightly back from the direction in which it is to move, and it is propelled by blows from a hammer held in the other hand. With each blow, the tool should move slowly, continuously, along the line. The result should be an unbroken line—not a jagged one. Once this outline has been established, modeling tools are used to emboss or repoussé the enclosed surfaces.

When work has been completed on one side, the metal is reversed. The form is released by heating it, the pitch, or both with a torch. Hot paraffin, benzene, or turpentine will remove all traces of pitch from the metal.

If the piece requires annealing, because of brittleness caused by the working processes, this should be done before reversing the piece for further repoussé on the other side. In fact, the form may need to be reversed many times, first being worked one side and then the other, in order to achieve a consistent surface.

The other side is chased, after reversing, to accentuate the relief. It is generally advisable to try to work the entire piece a little at a time, rather than to attempt to finish one part at once, since that may create tensions in the metal that can be avoided by treating the form as a whole.

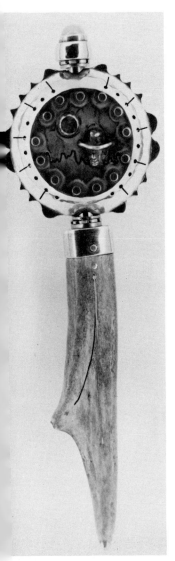

Pewter dry foliage holder with repoussé and stainless-steel tacks by Shirley Charron. *Courtesy: Shirley Charron. Collection of Ruth Ricard*

Baby's Hand Mirror (5½″ high) of silver, brass, antler, moonstone, jade, and acrylic by Dale Binford. *Courtesy: Dale Binford*

Silver Form III (1973) (6″ × 8″ × 8″), formed and constructed sterling silver (14, 16, and 18 gauges) by Helen Shirk. *Courtesy: Helen Shirk*

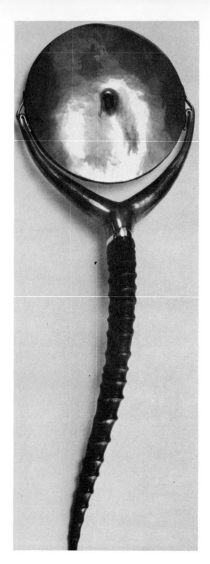 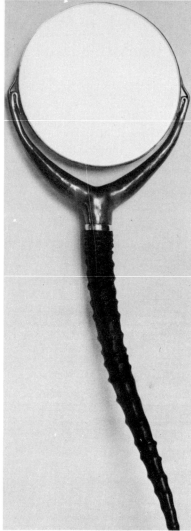

The back of this repoussé and fabricated brass and sterling silver hand mirror (15½″ × 5″) by Edward Warner represents a navel. The mirror is ¼″ plate glass; the handle is antelope horn *Courtesy: Edward Warner*

Silver Form II (1971) (4″ × 6½″), formed and constructed sterling silver by Helen Shirk. *Courtesy: Helen Shirk*

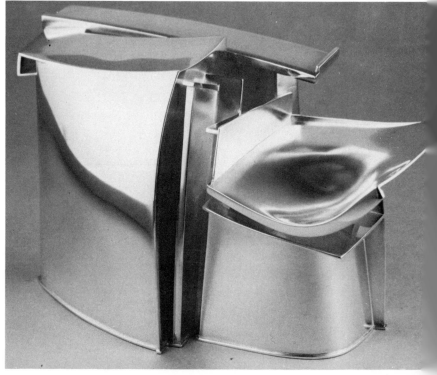

Embossed sterling silver hand mirror by Jan Brooks Loyd. *Courtesy: Jan Brooks Loyd*

The back of this 18-gauge sterling silver hand mirror by Leslie Leupp was raised and chased. The remainder was constructed of sheet silver. The handle and ring are rosewood. *Courtesy: Leslie Leupp*

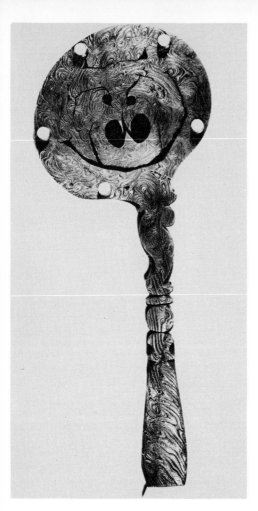

Hand mirror (8″ long) of Damascus steel, ivory, velvet, and brass by Robert A. Griffith. Patterns in the metal result from forge-welding alternate laminations of iron and steel. By careful manipulation (in this case twisting), the pattern can be controlled to display a very rich surface quality. *Courtesy: Robert A. Griffith. Photo: Aaron Macsai*

FABRICATING

Fabricating may involve forming, but it primarily refers to construction of metal forms by soldering and welding.

The word *solder* derives from the Latin *solidare,* to make solid, and that is essentially what this attachment technique does. Solder is a metal compound that combines, under heat, with the metal parts to be attached. Placed on a joint, the solder alloy melts and flows by capillary action into cracks less than $4/1000$th inch wide. Soldered connections remain secure even when subjected to physical stress—torsional strain and expansion and contraction of the metal due to temperature variation. At times, the point of attachment may prove to be stronger than the metal itself.

For the artist and craftsman, soldering is the vehicle for metal constructions of every size. Copper, brass, silver, gold, platinum, and aluminum can all be soldered. Other metals, like iron and steel, are best welded.

Procedure for Soldering

The basic steps in soldering are easily mastered:

1. Clean all metal surfaces and the solder itself in a pickling solution or with mild detergent and water; rinse well.

2. Cut solder, which is available in both sheet and wire, into manageable pieces.

3. Metal pieces to be joined must be fitted together tightly along the points or surfaces or line to be joined; if necessary, tie together with iron binding wire to maintain the fit—but always remove the iron wire before pickling.

4. Flux, a chemical that facilitates the solder bond by dissolving ever-present oxides on the metal, should be applied along the joint.

5. Place pieces of solder along the joint.

6. Apply heat to the metal—*not* to the solder. When the metal becomes hot enough, the solder will flow into the joint. Heat should be removed immediately after flow. Many torches, including propane, butane, acetylene, and oxyacetylene, may be used.

Solders should always be chosen for the particular metal to be joined—and the flux should be chosen to match the solder. Since different types of solder have different melting points (and varying strengths), experimentation will reveal the best type for a given application and material.

WELDED CHROME-PLATED FORMS BY JASON SELEY

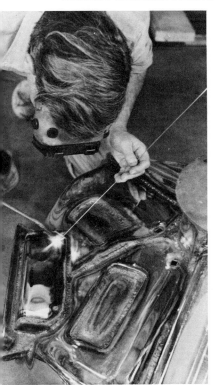

Jason Seley uses chrome-plated bumpers from junked cars to create his sculpture and furniture. This photographic sequence shows him creating a swivel chair. Acetylene torch and brazing rod are used to weld the footrest of the swivel base.

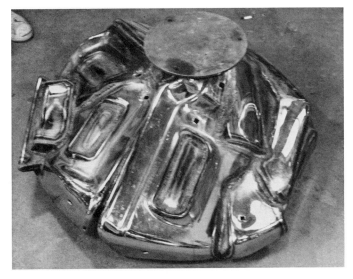

Seley cuts and fits pieces of bumper together as he constructs the form—rarely working from a predrawn plan. Holes, indentations, and weld marks become part of the overall design. A steel plate was welded onto the swivel base so that the chair could be assembled (and disassembled) with nuts and bolts.

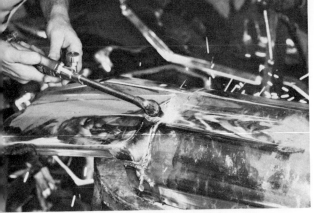

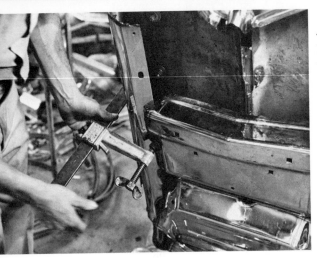

He selects the pieces of bumper from stock that lines the walls of his studio. Here, after selecting the particular form he had in mind, the artist cuts it to size using the torch.

Jason Seley may spend some time considering each piece—and the overall form—as the work progresses. Adjustments in position, shape, angle, and size may be made before a new section is added to the chair. Here a clamp is used to hold a section in place while he studies and positions it.

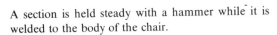

A section is held steady with a hammer while it is welded to the body of the chair.

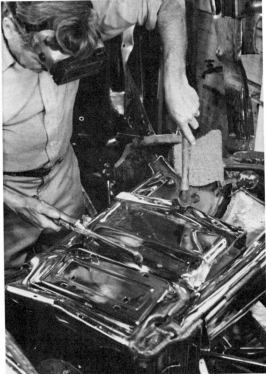

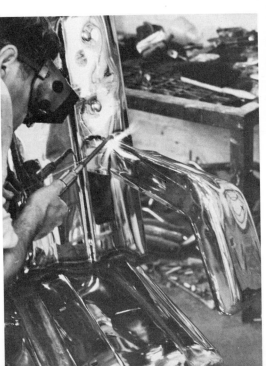

An arm of the chair was first tacked into place—and tested for comfort, height, and contribution to design. This particular arm was later replaced by another—one better suited to the chair.

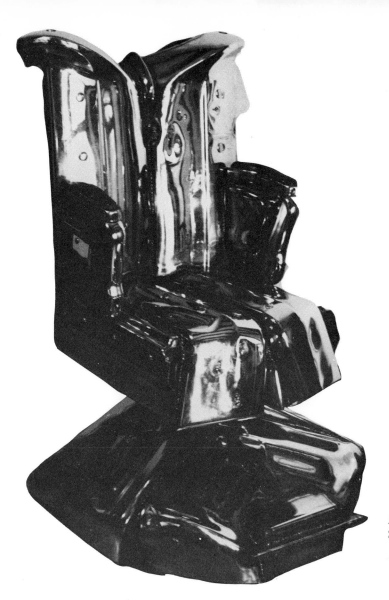

Dean's Seat (1976) by Jason Seley.

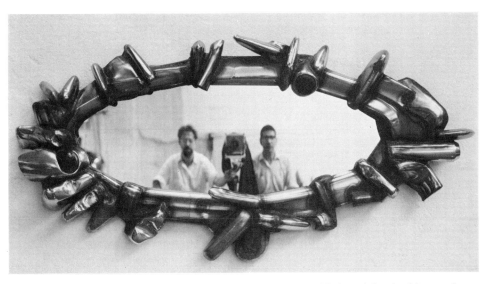

Aunt Sarah's Mirror (1965) (75″ long) by Jason Seley, of welded steel, hard rubber, and mirror glass. *Courtesy: Jason Seley. Photo: Charles Uht*

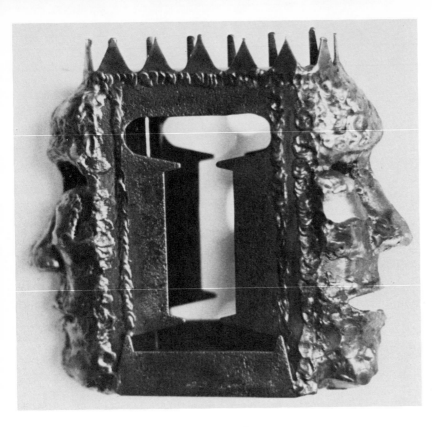

The Third Face (9½"
× 11"), welded steel
mirror by Suzanne
Benton. *Courtesy:
Suzanne Benton*

ELECTROPLATING AND ELECTROFORMING

Electroplating and electroforming have a history of industrial development
and application dating from the mid-nineteenth century. Only in recent years
have artists and craftsmen working in metal made extensive use of these
processes as structural and decorative mediums.

Both techniques are methods of covering objects with a layer of metal by
means of electrodeposition. If the object being covered is permanent, the
process is electroplating and is, essentially, the application of a thin layer of
metal to an otherwise complete form. The piece may be electroplated to
achieve a more durable or tarnish-resistant surface, or one of a different color,
texture, or reflectance. Stone, metal, plastic, ceramic, and even fabric may be
electroplated.

If the original form is removable, temporary, the process is electroforming
and the object is called a matrix. Electroforming is an extension of
electroplating: the plating is allowed to build up until it becomes the form
itself, and the matrix that served as the basis for it is then removed.
Electroforming allows the creation of articles that are hollow, light, and
difficult, if not impossible, to create by any other means. Intricate shapes made
of wax, for example, can be readily translated into metal by electroforming,
thus combining the versatility and malleability of the wax with the durability
and characteristics of the metal. Generally speaking, the wax original would
not remain a part of the finished piece but would be boiled out through spaces
left for that purpose.

Combinations of electroplating and electroforming are also possible. Deposits may be applied to an object that is part metal and part matrix: the metal portions may then be plated, and the matrix areas formed (and the matrix later removed). Electroforming and electroplating may also be used as joining techniques or to create or enrich surface texture.

What makes these processes most appealing and versatile, however, is the fact that they allow the deposition of metal without high temperatures. They make it possible to include materials in a piece that might not otherwise lend themselves—either physically or aesthetically—to more typical joining techniques such as soldering, riveting, or the use of bezels. Materials such as bone, plastic, fabric, and other fragile matter can be incorporated. In addition, because hollow forms may be created so readily, electroformed works may be extremely light in relation to their size, while remaining structurally sound.

In both electroforming and electroplating, the essential process is electrodeposition of metal. Simply put, this means that the plating metal and the object to be formed or plated are placed in an acid bath. The object is connected to a negatively charged source of electricity, while the metal is given a positive electrical charge. Since negative and positive charges attract, metal ions flow toward the object and are deposited on its surface. More precisely, current flows from the positively charged source of metal (anode) to the negatively charged object to be plated (cathode) through the plating bath or solution (electrolyte). The anode frequently serves as a continuing source of metal ions for deposition, and these ions are carried through the electrolyte to the cathode; in some cases, though, the anode is insoluble. The bath itself is then the source of the ions and must be replenished from time to time. The longer the matrix remains in the bath with the current flowing from anode through electrolyte to cathode, the thicker the electroform or plating will be.

The matrix on which you electroform may be metallic, nonmetallic, or mixed metal and nonmetal. An all-metal matrix is probably the easiest to electroform or electroplate, assuming that the matrix metal is compatible with the electrolyte (every metal is immersed in a different bath). For example, the sulfuric acid in the typical copper bath will etch mild steel, making it difficult to achieve a strong deposit of copper on this metal. Otherwise, preparation of the matrix for electroforming is simple: the cathode lead wire is attached—by soldering, gluing, or wrapping—and the matrix is cleaned to remove grease and oxidation.

Nonmetallic matrices are slightly more complicated to electroform because they must first be made electrically conductive. This is usually achieved by degreasing the form and then painting with an electroconductive paint. (Two good silver-base paints are Electrodag 416, Acheson Colloids Co., Port Huron, Michigan 48060 and Dupont Conductive Silver, Burt Bricker, Inc., P.O. Box 171, Wilmington, Delaware 19899.) Attaching the cathode wire to a nonmetal matrix can be difficult, but the process may be simplified by designing into the article a mechanism that will facilitate the attachment. Mixed metal and nonmetal matrices can be one solution. And metal, if strategically placed, can also provide reinforcement for the electroformed object. Again, the piece must be thoroughly cleaned of all grease and dirt before electroforming.

A simple way to clean the matrix or object is to scrub it with a liquid

detergent and a fine abrasive such as pumice. Ultrasonic cleaners with a mild ammonia solution are also effective. And electrocleaning may also be employed—using a commercially prepared solution in a stainless-steel tank. Metal forms may be cleaned by pickling. After all cleaning processes, the matrix should be rinsed thoroughly in tap water and then in distilled water before immersion in the electroforming bath. Of course, the form should never be touched after cleaning, since skin oil would contaminate it and retard electrodeposition.

ELECTROFORMED AND CONSTRUCTED MIRROR BY TIM GLOTZBACH

This hand mirror by Tim Glotzbach will be constructed of brass, Plexiglas, plate-glass mirror, and copper electroformed over a wax matrix. Electroformed copper plates will decorate the front and back of the hand mirror. Each will be formed over a wax matrix that will be removed after forming. Here the basis for the pattern of each copper plate is a printing plate (which has been covered with plastic wrap to prevent it from sticking to the wax and which will be given the impression of the printing plate and then electroformed).

Pink dental wax is placed between the patterned printing plate and a flat plate, and this sandwich of wax is placed in a vise. Pressure is applied, which transfers the pattern of the plate to the wax. During electroforming, the metal will fill the impression and create an electroform in shallow relief.

After removal from the vise, the impressed dental wax is connected to a cathode wire and painted with an electroconductive solution (Electrodag 416)—on the front. No forming will be done on the other side of the wax so that it may be removed easily after forming.

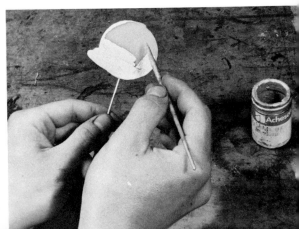

The wax matrix is then immersed in the plating bath, and the cathode wire is attached to the cathode bar by means of an alligator clip.

The amperage is set and the rectifier turned on to begin plating. After an hour of forming, the piece is removed from the bath, and the wax is melted off the formed piece. The electroform is then cleaned and placed into the bath once again to plate the area previously covered by the wax. That done, the cathode wire is cut off. These electroformed copper plates will be attached to the brass (which will form the body of this hand mirror) with two-part epoxy adhesive, which will hold them in place during the final electroforming cycle.

The pattern, which had been sketched first, is transferred to a template and dry mounted onto a sheet of brass. The shape is then cut using a jeweler's saw. This will become the body of the hand mirror.

The same pattern is used on a piece of acrylic, which is also cut using a jeweler's saw.

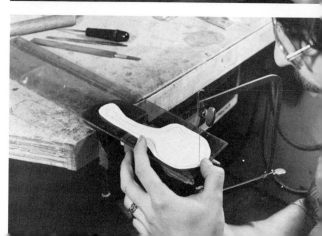

A third piece is cut from the same pattern—this one also of brass, to serve as a bottom of the form. All three are filed and sanded. They are then stacked and marked for the drilling of rivet holes.

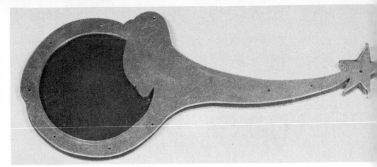

The top piece of brass is drilled first. It is then used as a template for the drilling of rivet holes in the acrylic and the other piece of brass, which are then drilled, too.

Rivets are made of wire by securing the wire in a vise and spreading the end with a hammer to form a head. A rivet is then inserted into each of the drilled holes. The wire rivet is hammered at its other end to form a head and secure the pieces of acrylic and brass. A circle of plate-glass mirror fits with the acrylic form and is secured by the brass plate at top and bottom.

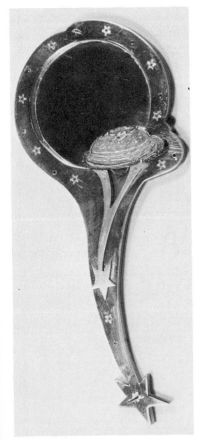

The electroformed copper plates are secured with two-part epoxy adhesive and the entire form is prepared to be electroformed again.

Preparation, at this point, consists of stopping out the areas of the mirror body, which should *not* receive plating. Here a solution which will prevent the buildup is brushed onto the metal. This stop-out will be removed later, before the brass is finished.

The completed hand mirror by Tim Glotzbach. The final electroforming created a raised edge of plating the edge of the mirror. The piece was then finished by imparting a soft patina. *Photos in this series by aron Macsai*

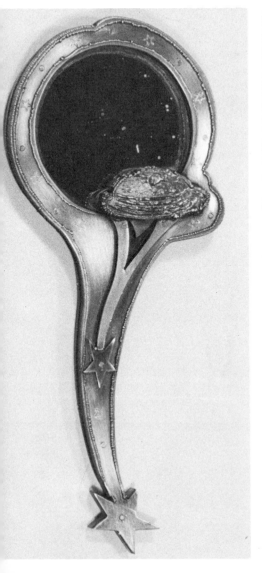

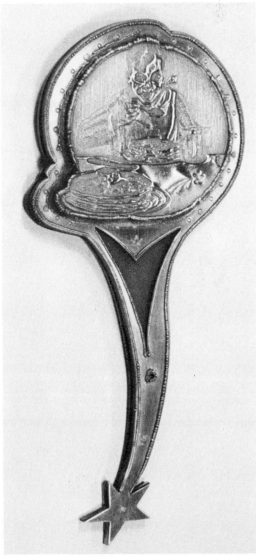

Procedure for Electroforming

These are the basic steps in the electroforming process:

1. Preparation of the matrix.
2. Attachment of the cathode wire.
3. Cleaning of the matrix. If the matrix is metal and certain areas are to be "stopped out" (painted with a nonconductive material to avoid deposition of metal), this should be done at this point. Do not touch the surface of the form after cleaning.
4. Matrix should be made electrically conductive, if it is not metal.
5. Attachment to cathode bar above tank and placement of matrix in bath. Alligator clip works nicely to hold cathode wire to bar.
6. Electrical current is turned on (low) until the matrix has been given a thin covering of metal. If current is too high at the beginning, it may burn the conductive paint or otherwise interfere with adhesion of the metal.
7. Raise amperage. Leave amperage up as long as you intend to plate. If uncertain about the length of time to electroplate/electroform, check the piece periodically. Also check for uneven growth.
8. Turn off the electricity and remove the form from the bath, rinse it in water, and neutralize in solution of baking soda and warm water.
9. Remove stop-out material, if used.
10. Remove matrix, if used.
11. Remove cathode wires. Piece may be reelectroformed to cover area of cathode connection, if desired.
12. Finish piece as desired (patina, etc.).

Hand mirror of copper electroformed over a wax matrix by David Luck. *Courtesy: David Luck*

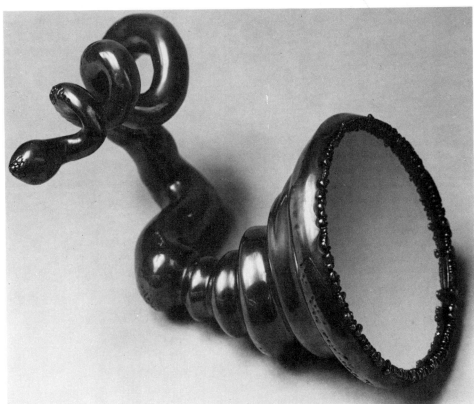

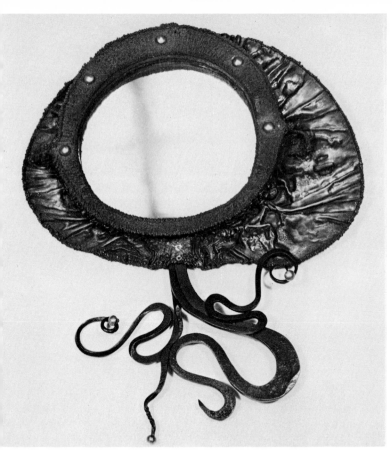

Mirror of forged iron and electroplated metal
and metal foil by Tim Glotzbach. *Courtesy:
Tim Glotzbach. Photo: Aaron Macsai*

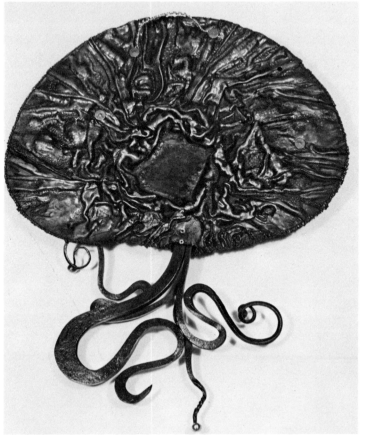

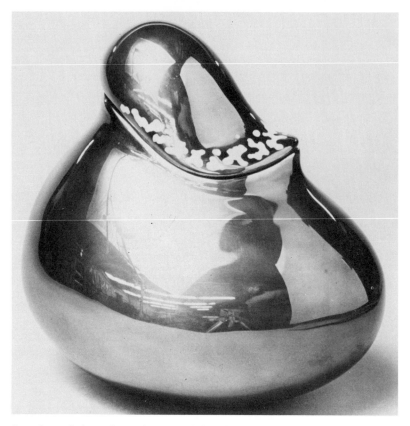

Container of electroformed copper, 24k gold foil, and silver foil with epoxy resin inlay by Barbara Anne Nilaūsen. *Courtesy: Barbara Anne Nilaūsen*

MIRRORS of SOFT MATERIALS and LEATHER

ASIAN ARTISTS HAVE USED MIRROR CHIPS TO ADD A SPARKLE TO THEIR embroideries for centuries. They were among the first to combine "soft" materials with "hard" mirror. Now craftsmen have started a "soft" craft explosion. Interest in trapunto, macramé, weaving, crocheting, quilting, embroidery, and leather-work is surging. Exciting mixed-media products emerge from this celebration of soft crafts—everything from soft sculpture and soft containers to "the soft mirror."

Some of the craftsmen whose work is included in this chapter enjoy presenting whimsical and fantasy themes through soft media—like Peggy Moulton's trapuntoed comic piece *Mirror, Mirror on the Wall, Who's the Fairest One of All?* or Maud Guilfoyle's plush, dreamlike mirrors. Craftsmen Julie Connell, Lillian Ball, and Arlene Pitlick create less fanciful mirror designs using weaving and macramé techniques. Skilled leather worker Marcia Lloyd shows how to combine rich leather qualities with reflective surfaces in a "handy" way.

Each of the craftsmen presents an original answer to a common question: Given a reflective material and one or more soft techniques, what are the design possibilities?

But still other craftsmen have changed that question—by changing mirror materials. With the advent of metallized polyester films and other soft reflective plastics, we can now cut, bend, shape, embroider, weave, glue, stretch "mirror" itself. With the exception of work by just a few artists and

197

craftsmen like Cynthia Schira and James Gilbert—who weave the mirror itself—such directions for *soft* mirror materials remain unexplored and suggest an enormous, untapped potential.

Approaches to making soft mirrors vary considerably. This variety is determined by the craftsman's choice of materials and his decision on how to work those materials. Stuffed, quilted, or crocheted pieces appeal to many craftsmen because construction is very direct. You can see and manipulate the form as it grows in three dimensions. Woven mirrors are fabricated in flat form and then are worked into three dimensions—secondarily combined with mirror elements. In such cases great planning of the total design is required at the outset.

As a walk through any fabric or leather store proves, the number of different "soft" materials is vast. The yarns available for weaving, wrapping, or crocheting; the plethora of fabrics that can be stuffed, quilted, or trapuntoed; and the threads available for embroidery radically increase the craftsman's freedom of design. Some of the most popular soft mirror craft techniques are discussed below.

STUFFING, QUILTING, AND TRAPUNTO

Quilting is a very old technique that uses stitches to attach and hold a sandwiched layer of filler (batting, wadding, stuffing) between two layers of fabric. Stitching throws the fabric into relief as it compresses the layers of fabric together, puffing the filled areas. The pattern formed by stitches can vary immensely, from simple geometric lines to meandering free-form designs.

Variation in type and amount of stuffing adds more diversity. A stuffed soft mirror border is three-dimensional—even squeezable—because of the over-stuffed appearance.

Quilted and stuffed patterns do not necessarily depend upon color or light/dark values of the fabric itself. The patterns are more dependent upon the relief design created by compression of some areas (where the stitches are) and the bulging out of other areas (where the batting is entrapped). Stitches function both to keep the stuffing from shifting around within a demarcated area and to decorate the surface or define a shape with a slight relief pattern.

Trapunto is high-relief quilting in which densely stuffed pockets formed by layers of cloth are enclosed within the stitching. Because in trapunto only certain selected areas are stuffed—as opposed to stuffing flat planes—the sculptural effect is pronounced. In one trapunto technique, the bottom layer of fabric is a loosely woven lining. If you push and draw aside the warp and weft of this lining so that a temporary hole is formed, the stuffing can be inserted into areas between the two layers of cloth. A blunt tapestry needle or crochet hook functions well as your stuffing ramrod. After the proper amount of stuffing is metered into the area, the threads of lining are pushed back to normal position, covering the stuffing and "erasing" the hole. In another method, where the lining threads cannot be manipulated, a slit is made in the lining for entry of stuffing. After the batting is pushed through the slit, the

opening is sewn closed. In some instances a patch is sewn over the slit on the underside.

The selection of stuffing materials has expanded greatly since the twentieth-century textile industry boom. Fillers were once limited to cotton or wool batting, down and feathers, kapok, straw, rice, and scrap fabrics. Today, besides the traditional fillers and the use of scrap, there are many densities of flexible and rigid foams, polystyrene pellets, polyester (Dacron) batting, polyethylene bubble "paper," cork, rock wool insulation (fiber glass), terry cloth, felt, and so on. The use of scrap materials can be extended to include not only rags but also nylon stockings and the varied types of stuffing reclaimed from old mattresses and pillows.

Procedure for Making a Stuffed, Quilted, Trapuntoed Mirror Form

1. Plan your design in detail.
2. Cut patterns for the form.
3. Trace or cut pieces around pattern for each shape.
4. Assemble cut forms into a sandwich using a filler if it is for quilting. (No filler at this point if it is for trapunto or to be a more three-dimensional stuffed mirror piece.)
5. Sew elements together:
 a. For simple stuffed three-dimensional forms:
 (1) Sew around the unit, leaving opening for turning fabric inside out.
 (2) Stuff the unit.
 (3) Sew opening closed.
 b. For complex stuffed three-dimensional forms:
 (1) Sew around each unit, leaving opening for turning fabric inside out.
 (2) Stuff the unit.
 (3) Sew opening closed.
 (4) Repeat for each unit.
 (5) Attach units together and with the mirror.
 c. For quilted forms:
 (1) Make a sandwich of two layers of fabric with filler in between.
 (2) Draw quilting pattern on top of the bottom piece.
 (3) If possible, attach to a quilting frame or portable hoop.
 (4) Proceed to quilt in a plain running stitch, up and down through all layers, or sew on sewing machine.
 (5) Manipulate the piece and attach edges together or hem edges closed.
 d. For trapuntoed forms:
 (1) Draw design on one of the layers of fabric.
 (2) Put both layers together.
 (3) Sew around the outline with a tight running stitch or sew on sewing machine.
 (4) From underside (lining), force an opening (or else make a slit to form an opening).

(5) Stuff filler into area, compacting it as much as desired to create relief pattern.

(6) Close the opening (may require stitching or patching of the lining).

(7) Complete the form by joining mirror and trapuntoed elements.

COMIC TRAPUNTO MIRROR BY PEGGY MOULTON

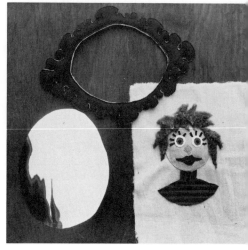

Peggy Moulton begins with a rough sketch *(left)* and then does a refined drawing to the scale desired *(right)*.

Pieces of cloth are cut according to the paper pattern and are stitched together into a face. The face is sewn onto muslin lining and is then stuffed from behind. The muslin's warp and weft can be spread enough to permit easy trapunto stuffing. The "frame," at top, is made of two pieces of knit fabric with polyester filler between. This stuffed frame was machine sewn and then trimmed close to the stitching. A cut piece of metallized plastic film will serve as mirror *(left)*.

The muslin lining is trimmed away from the figure. The figure is sewn onto metallized film.

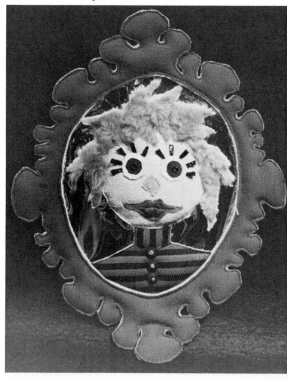

The soft frame is sewn to the film and backed. *Mirror, Mirror on the Wall, Who's the Fairest One of All?* by Peggy Moulton.

STUFFED AND PAINTED SOFT MIRRORS
BY MAUD GUILFOYLE

Maud Guilfoyle begins by making a plywood frame for the mirror. One-quarter-inch plywood is cut with a jigsaw. The center portion, in which the mirror will sit, is also cut out. The backing for the mirror is a piece of thick illustration board.

The mirror is inserted in the hole in the plywood. Contact cement holds mirror to illustration board. White glue is used to make the plywood adhere to the backing.

A piece of felt is stretched over the back of the mirror/plywood and stapled to the front of the piece. The cloth not only finishes the back of the mirror neatly but provides a surface for later attaching the stuffed frame.

The pattern of the plywood shape is traced on fabric. The center area—where the mirror will be exposed— is also traced.

Maud Guilfoyle hand paints designs for her work. She draws directly on smooth-surfaced unsized cotton (percale preferably) using a crow-quill-point pen and Pelikan drawing ink (Castell TG, India ink, or Sanford's Nēpo needlework markers also work well). She is careful not to pause but to draw with a continuous line. Pauses cause the ink to blot as the fabric absorbs excessive amounts of ink.

She uses AD markers (Cooper Color, Inc., Jacksonville, Florida) for coloring. These are more colorfast and do not bleed excessively. To fix color, she soaks her work in vinegar and water for ten minutes, air dries to dampness, and steam irons the piece for five minutes. When coloring with the markers, Maud Guilfoyle does not go to the line but just below it to accommodate some natural spread of the ink to the line.

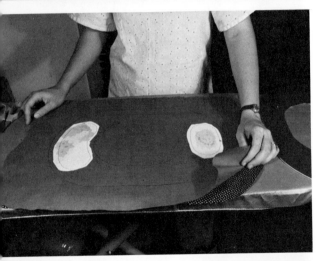

The two picture inserts are sewn to the back side of the cloth. Then holes are cut in the main cloth so that the pictures peek through, as a reverse appliqué. This cloth is laid over a second piece of cloth, which will serve as the backing.

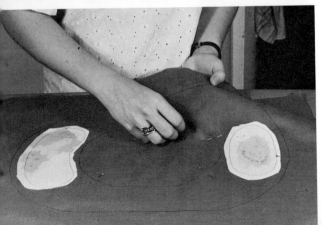

The two fabrics are basted together. Note that the wrong sides of both fabrics are face out.

The fabrics are sewn together following the center outline. The center area is stitched entirely around. Very small stitches are used here because a great deal of tension will be placed on this seam when the piece is later stuffed.

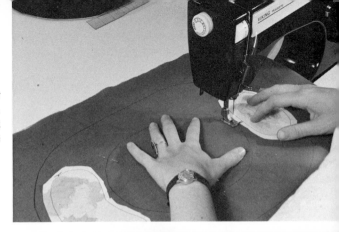

Cut out the inside (where the mirror is to be) as closely to the seam as possible (about ¼″).

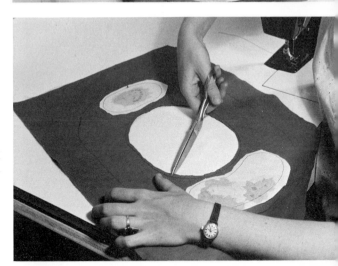

Clip this ¼″ margin around the curves, making more snips as the curve becomes tighter. This snipping will prevent distortion of the curve when the piece is turned right side out and stuffed.

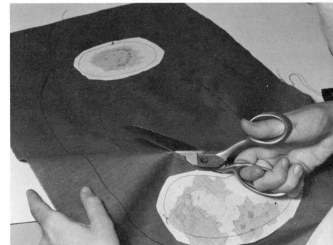

Turn the piece right side out.

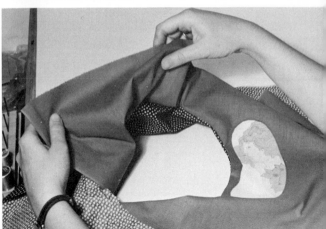

203

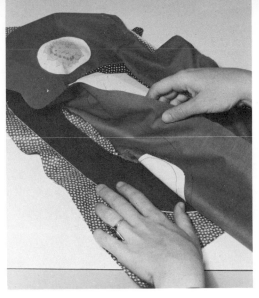

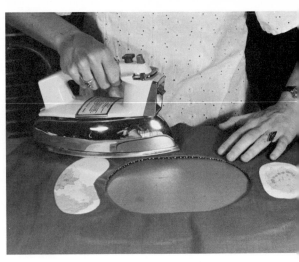

A piece of cardboard is cut to the outside dimensions of the plywood frame and to the inner dimensions of the inner cloth oval. The cardboard is sandwiched between fabrics.

Maud Guilfoyle presses the inside edge with a steam iron . . .

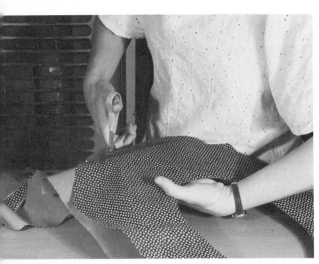

. . . and trims around the shape, leaving about an inch excess as an allowance for the stuffing.

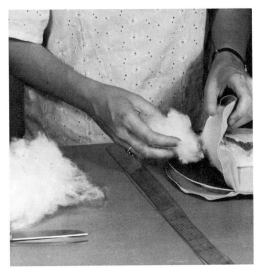

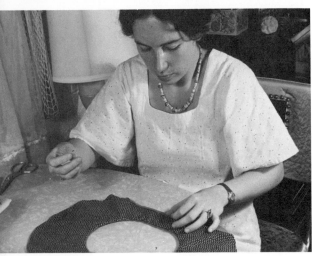

She hand stitches the outer edge. But stitching is not completed all the way around until . . .

. . . stuffing is inserted. Here Poly-fil (Fairfield Processing Corp., Danbury, Connecticut 06810) is used. The hole through which the stuffing was added can then be stitched closed with invisible stitches.

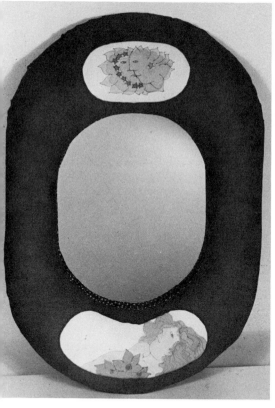

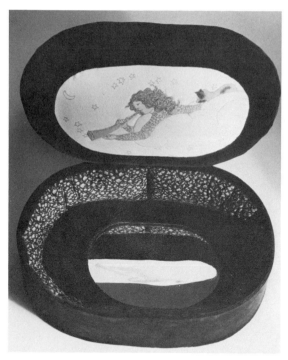

ewing the mirror's felt backing to the stuffed frame
ompletes Maud Guilfoyle's piece.

A fanciful stuffed mirror box by Maud Guilfoyle.

These "back-to-nature" mirrors by Perregrine Higgins combine hand painting with stuffing, trapunto, and collage.

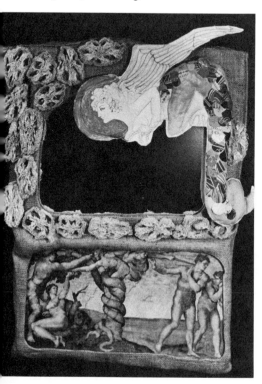

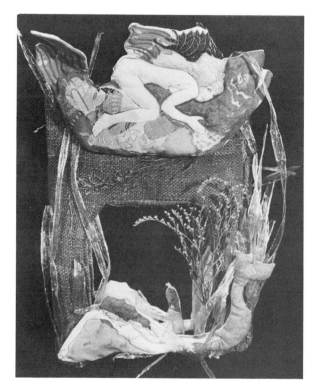

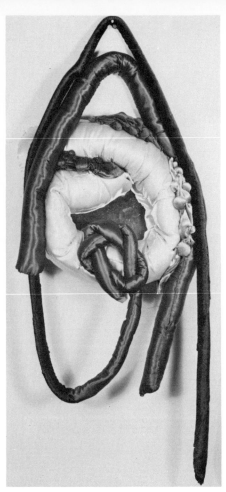

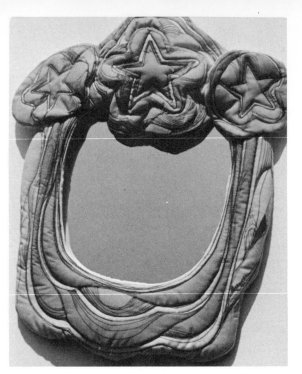

Three Star Mirror by Sara Drower is a quilted piece. A pocket that unsnaps in back allows the mirror to be removed.

The Wedding Funeral Piece by Elisa Lottor is a soft sculpture surrounding mirror with varying shades of purples, satins, and velvets. It combines wrapping and trapunto in soft sculpture.

TABLETOP STUFFED MIRROR

Begin with a tapered cylinder pattern cut from construction paper.

After determining that the height and angle of the cylinder are in good proportion, lay the paper out on a piece of felt.

Since this shape is symmetrical, the pattern can be folded in half and laid with the fold on a folded edge of the felt. The paper pattern is traced onto the felt, and a ¼″ margin is added on all sides. Cut along the outline.

The edge that forms part of the wall of the cylinder is basted and machine sewn. Leave the top two inches unsewn, since the form will later be filled with beans through this gap.

A corrugated cardboard disc is cut to fit the base of the cylinder. From the cardboard a piece of felt is traced and cut—again with a ¼″ in excess all around. Sew this felt base to the broader base of the tapered felt cylinder (¼″ in from the edge). Use small stitches, since this seam will be under pressure when stuffed. Note that the entire form, thus far, is being worked inside out.

Clip around the sewn felt margin. This snipping will prevent lumping and awkward stretching of the curved seam.

Because felt is somewhat stretchable, it is possible to insert the cardboard base after sewing the bottom in place. The cardboard disc helps keep the base flat. It is rubber cemented to the inside of the felt bottom.

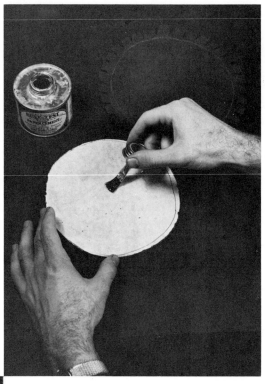

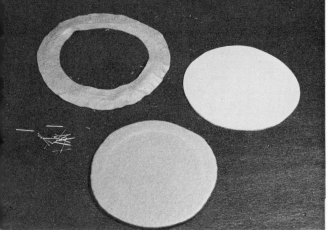

A second cardboard disc is cut to the size of the *top* of the cylinder. A felt disc is traced from it, with an extra ½" scalloped margin. Glue the felt to the cardboard with rubber cement, thereby jacketing one side of the board. This will be the backing of the mirror.

A piece of acrylic mirror *(right)* was cut on a band saw to the same size as the cardboard disc. A circle of felt with a hole to expose part of the mirror is traced and cut *(left)*. The diameter of the felt circle's cut center is about 1" less than the mirror itself. This felt overlap will hold the mirror in place.

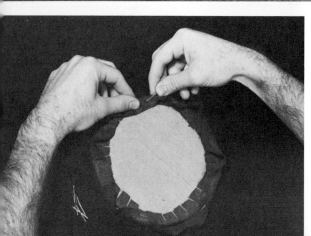

Put the mirror on the felt-jacketed cardboard; center the felt circle over the mirror and pin this felt frame to the back of the jacketed cardboard.

The shape of the tapered cylinder reminded the craftsman of a friend—so hands, feet, arms, and legs had to be added to the torso. The hands are first cut from cardboard. The felt is too thin so double-thickness hands are cut.

To make the two thicknesses of felt hands adhere, a piece of Poly-Web fabric fuser (Pellon Corporation, Avenue of the Americas, New York, N.Y.) is sandwiched between the felt pieces and steam ironed, according to package directions.

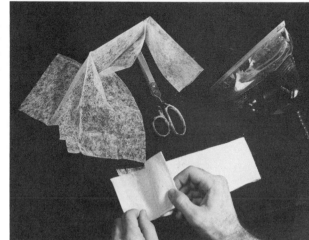

Arms for the mirror man are simple sewn felt tubes. The hands are machine sewn to the end of the arms. Arms are then stuffed with small pieces of polyurethane foam.

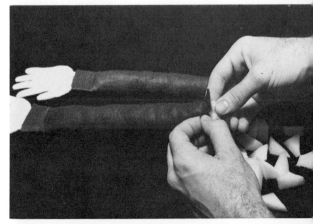

Legs and feet are made the same way as arms and hands. Legs are stitched to the bottom of the felt cylinder. Arms are attached to the sides of the cylinder by cutting holes in the "torso" and then reclosing the holes with the arms stitched in place. Sew the felt-framed mirror to the top of the felt cylinder.

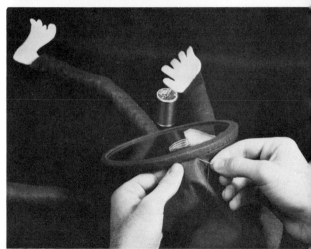

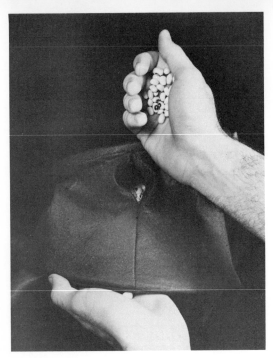

At this point only one hole should remain—in the top two inches of the first seam. Black-eyed peas were chosen as stuffing material, since they will provide enough weight for the mirror to free-stand without toppling. Also, the beans can be shoved around so that the mirror will hold new positions when rotated to different angles. Just enough beans are added to fill out the form but *not* so many that the mirror would be hampered in its anglings.

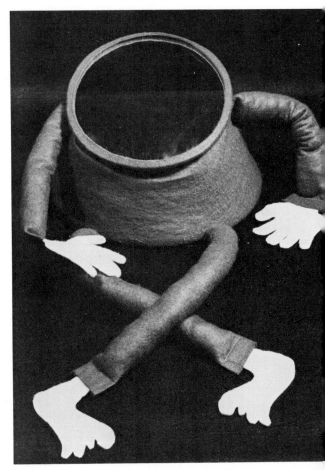

Jay-Babe by Lee Newman has movable limbs and tilting mirror face.

WEAVING

Woven mirrors can be considered in two classes: (1) works in which yarn is woven and then fitted around a piece of mirror, and (2) works in which strips of reflective material are woven directly into a fabric. Weaving is an ancient art with origins dating back to prehistoric times. Weaving techniques, types of looms, kinds of yarns, and types of patterns are extremely diverse because of this vast history.

Each textile is constructed from two sets of threads that cross each other in various ways but with some kind of warp and weft. The warp stretches lengthwise on or off the loom, and the weft runs in and out of the warp, usually horizontally.

There are a great many variations on the theme of weaving—darning, braiding, two-harness and backstrap loom weaving, card weaving, multiple harness weaving, and so on.

Weaving has classically been considered a two-dimensional art form. But although most weaving is done in two dimensions, the weaver can construct three-dimensional forms. It is possible to double weave using multiple harnesses and then fold or stuff the form—or to weave strips that are manipulated in various ways into three dimensions. Waffle weaving on a convex mirror, as shown by Julie Connell, is one example of how a two-dimensional technique can expand into a third dimension. And once a flat weaving comes off the loom it can be curved, folded, cut, sewn, and gathered into a variety of mirror forms, as Cynthia Schira and James Gilbert illustrate.

The process of weaving is too vast to be dealt with here. If you are not familiar with weaving processes, it is best to refer to one of the references listed in the Bibliography for in-depth instruction.

Procedure for Creating Woven Framed Mirrors

1. Plan and design your form. Decide on size, texture, pattern, and color, and how mirrors would be fitted in the design. Cut any needed patterns.
2. Set up loom.
3. Weave.
4. Remove fabric from loom and fit it with the mirror.

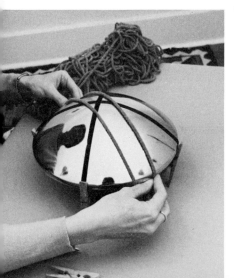

WEAVING ON CHROME DOMES BY JULIE CONNELL

Julie Connell weaves chenille yarn, ribbon, and metallic thread over Volkswagen chrome hubcaps. She crisscrosses the yarns over this unusual convex mirror in several layers. Yarns are held in place at the rim with clothespins. (Styrofoam and pins can also be used to hold yarns in position.) The yarns are tied wherever they intersect. This knotting at interstices produces a grid. By varying the yarns, colors, and spacing, she creates different patterns.

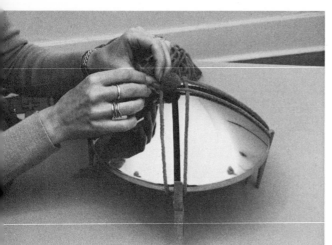

She ties chenille and pompons (ball fringe) at the intersections to add still more variety.

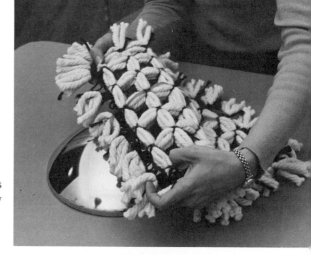

After the weaving is completed, the yarn is sometimes kept taut on the dome surface by invisibly epoxying to the hubcap.

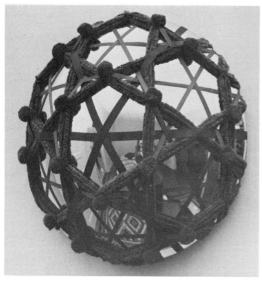

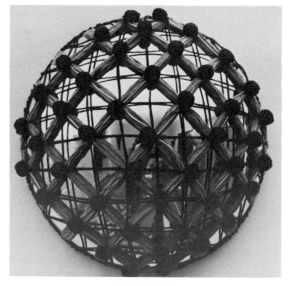

Baby Moons by Julie Connell

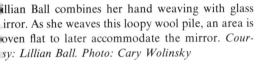

LILLIAN BALL'S LOOM-WOVEN MIRRORS

illian Ball combines her hand weaving with glass irror. As she weaves this loopy wool pile, an area is oven flat to later accommodate the mirror. *Courtesy: Lillian Ball. Photo: Cary Wolinsky*

fter completing the weaving, Lillian Ball crochets a order for the mirror and then sews the crocheted ece to the woven fabric. This makes it possible to move the mirror for cleaning. *Courtesy: Lillian all. Photo: George Peet*

Large Pointed Mirror (32″ × 70″) by Lillian Ball has a brown-and-rose-colored crocheted center surrounded by an all-wool weaving and accentuated with feathers. *Courtesy: Lillian Ball. Photo: Victor Bono*

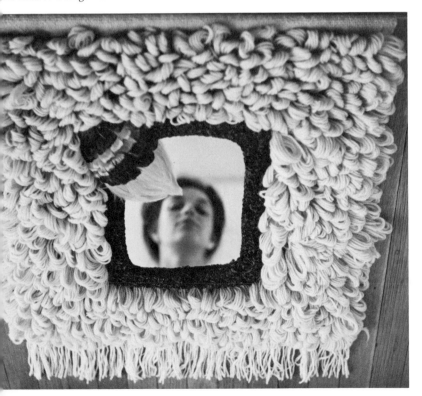

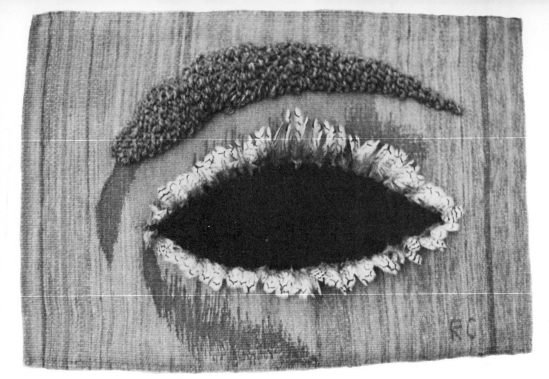

This piece by Rochella Cooper is done with a tapestry weave of camellia-petal-dyed wool. Quail feathers form eyelashes around smoked-mirrored acrylic. *Courtesy: Rochella Cooper*

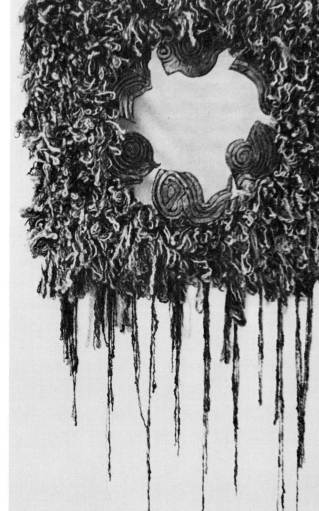

A coiled ceramic frame is surrounded by woven looped wools. Yellow mirrored acrylic is set in the ceramic frame by Rochella Cooper. *Courtesy: Rochella Cooper*

214

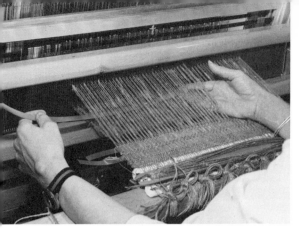
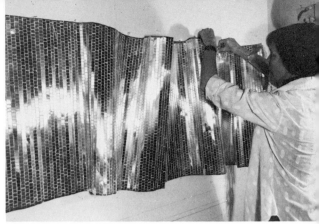

WEAVING OF REFLECTIVE MATERIALS BY CYNTHIA SCHIRA
AND BY JAMES GILBERT

In the 1960s Cynthia Schira began including reflective metals in her weavings, flexing reflective planes into sculptural reliefs. She uses aluminum foil strips (temper of A-18, gauge 0.010, in ½″-wide strips; Crawford Foil Company, Inc., 3921 West 139th Street, Hawthorne, California 90250). Between each strip of aluminum she weaves two rows of neutral beige linen. The warp is also linen.

Cynthia Schira manipulates the semiflexible tapestry into three dimensions and uses T-pins to hold the weaving in position.

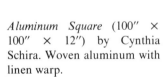
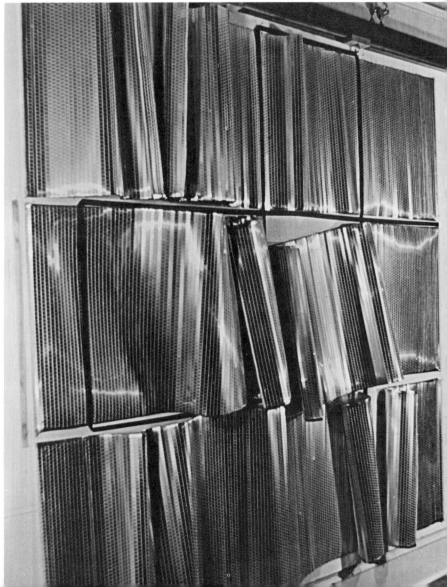

Aluminum Square (100″ × 100″ × 12″) by Cynthia Schira. Woven aluminum with linen warp.

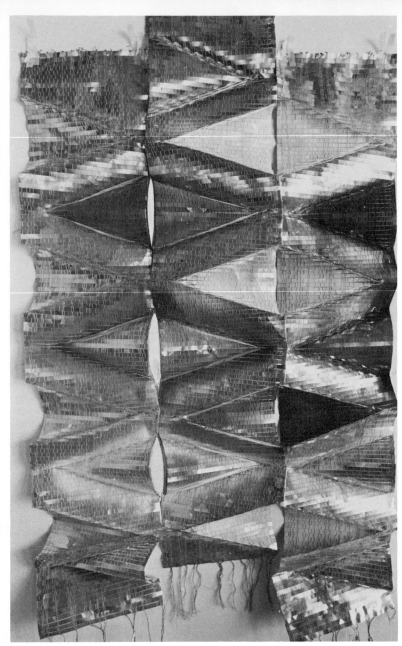

Folded Aluminum (60″ × 90″ × 6″) by Cynthia Schira. Woven aluminum with linen warp.

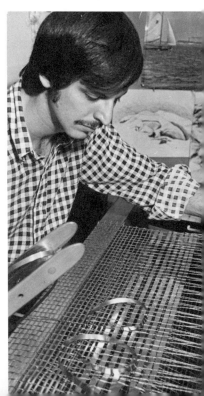

James Gilbert makes monumental reflective installations by weaving a combination of dyed rayon, anodized aluminum, and varying widths of cut brass. The weaving is done on a loom.

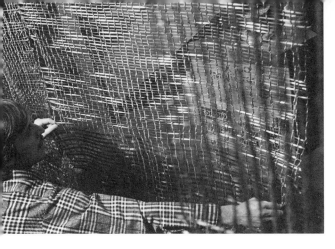

After weaving, the piece is checked for errors. The longest panel is 12½″ long in this construction.

The entire piece is made up of 43 woven panels; it is 135′ in total length. It not only is highly reflective but colorful, too—with brown, red, yellow, orange, and blue in the weaving.

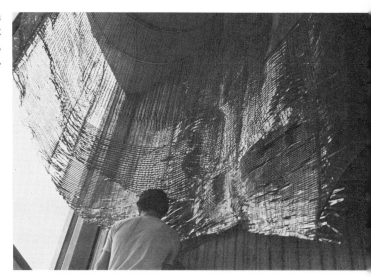

Where the Sky Meets the Earth by James Gilbert. *Photos courtesy: James Gilbert*

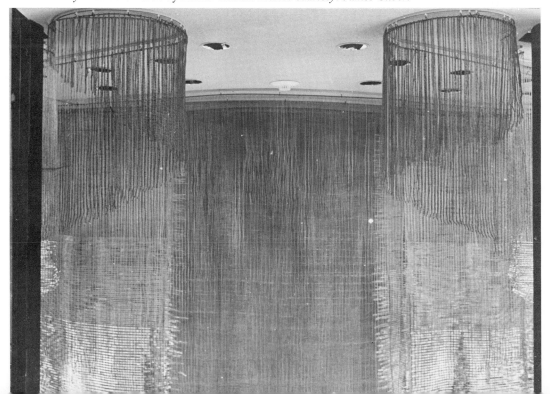

MACRAMÉ

The popularity of macramé can be explained by its versatility. With a pair of hands as the only tools, lengths of jute, twine, or cord can be knotted into beautiful borders for a mirror.

Macramé looks complicated, but it is actually easy to learn. By working with just a few basic knots, you can create handsome and surprisingly elaborate designs.

The best cords to use for macramé knotting are those that (1) are flexible enough to be readily knotted, and (2) are not so elastic that they lose their knotted shape. This obviously leaves a large range of materials to choose from: natural or dyed jute, butcher's twine, rayon or cotton cord, clothesline, sewing threads, and so on. Avoid materials like fuzzy knitting yarns (which tend to stretch and look messy), leather thongs (which are hard to keep under knotted control), or nylon filaments (which won't hold a knot).

To facilitate macramé, a knotting board can be made out of Styrofoam, cork bulletin board, or even corrugated cardboard. Bank pins or T-pins can be stuck into the board to keep knotted areas in place while you work.

A few basic knots are shown in this chapter. For a complete presentation of fancy macramé knots, consult one of the references noted in the Bibliography.

Procedure for Making Macramé Mirrors

1. Select type of cord, in light of design objectives.
2. Start cords on mounting board (usually using a lark's head knot or reverse lark's head knot).
3. Bundle each cord to make knotting easier. Hold bundles with rubber bands.
4. Knot.
5. Work the design to incorporate the mirror. Be certain to contrive some way to afix the mirror (with the cords or by mounting or taping).
6. Complete knotting.
7. Cut off excess lengths of cord. Use all-purpose white glue on cord ends that may fray.

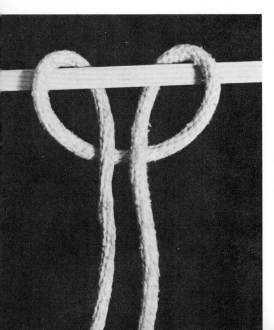

MACRAME KNOT VOCABULARY

Reverse lark's head knot. It is a standard way of beginning a macramé piece. Pull tight. What follows are photographs depicting some basic macramé knots.

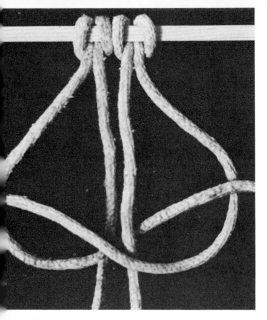

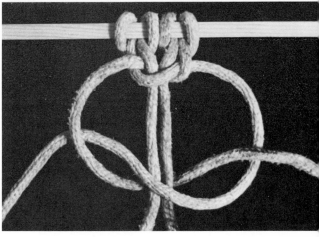

Macramé square knot is not the same as the Boy Scout square knot. It begins with two reverse lark's heads. It is always done with four cords. Bring the right cord under the two middle cords and over the left cord. Left cord is brought over the middle cords and under the right cord.

Then, after tightening the first half of the knot, bring the left cord under the middle cords and over the right cord. Right cord goes over the middle cords and under the left cord.

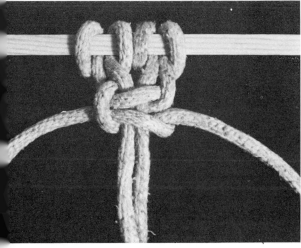

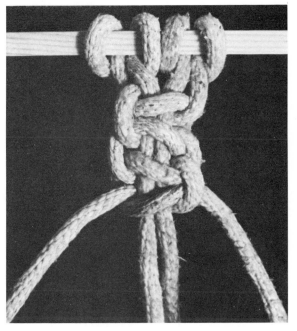

Tighten the second half of the knot to complete the square knot. A chain of half knots can produce a twist effect.

A series of complete square knots in a row forms a chain or sennit (two square knots shown here).

Alternating square knot begins with at least six reverse lark's head knots. Put a square knot in each set of cords.

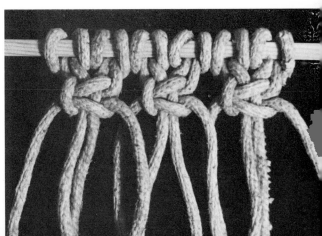

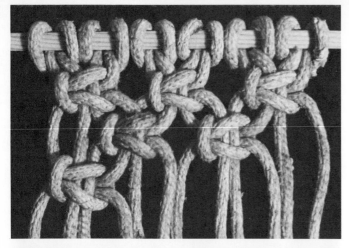

The second row skips the first two cords, makes a square knot with the next four and continues to make square knots across, ending with two skipped cords. The third row is done just like the first row ...

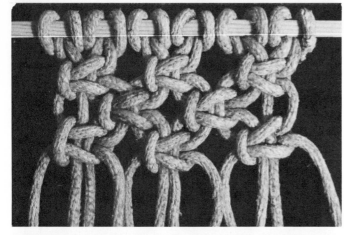

... starting with the farthest left cords and knotting all cords with square knots.

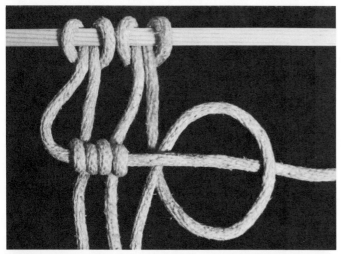

A *cording* effect is produced with a series of *double half hitches.* Here it is shown in the horizontal direction. The cord farthest to the left (anchor cord) is placed straight over the other (working) cords. Loop each working cord under and over the anchor cord.

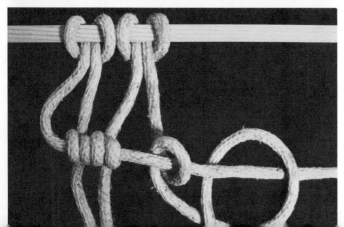

The same working cord is then looped under the anchor cord to the right of the first half hitch.

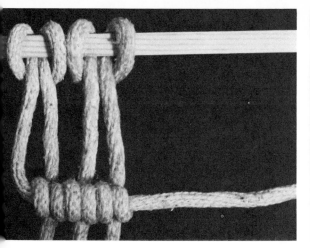
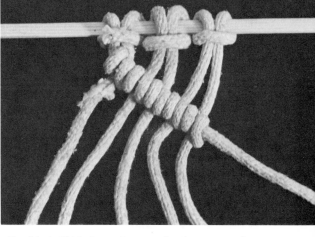

Pull all half hitches tight to produce the cording effect.

Double-half-hitch cording can be done on a *diagonal,* too. You can work cording from the right or left, diagonally up or down, depending on where you lay down the anchor cord and whether that anchor is farthest left or farthest right. Diagonals can be made to intersect to form crosses, and multiple adjacent rows of cording can be made by repeating the process.

MACRAMÉ MIRRORS BY ARLENE PITLICK

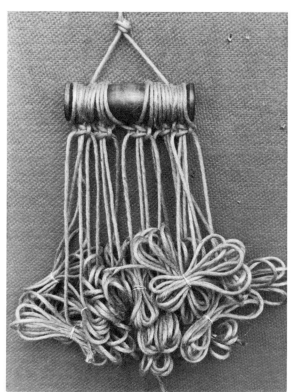

As with most macramé pieces, you begin the work by mounting the cords on some kind of cross support—such as a carved wood dowel or a mounting cord. This piece by Arlene Pitlick is begun with lark's head and square knot. In macramé you always begin with excessively long cords because it is difficult to estimate just how much of the cord will be taken up in the knotting. The long cords are wrapped into butterflies for easier knotting. *Photos in this sequence courtesy Arlene Pitlick.*

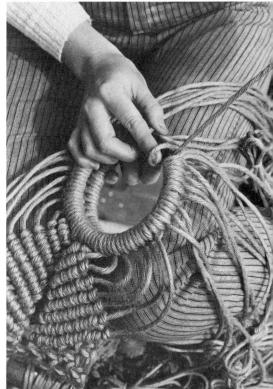

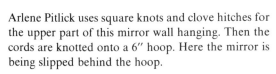

Arlene Pitlick uses square knots and clove hitches for the upper part of this mirror wall hanging. Then the cords are knotted onto a 6″ hoop. Here the mirror is being slipped behind the hoop.

221

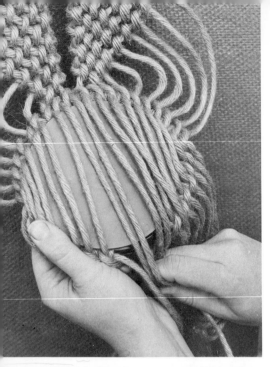

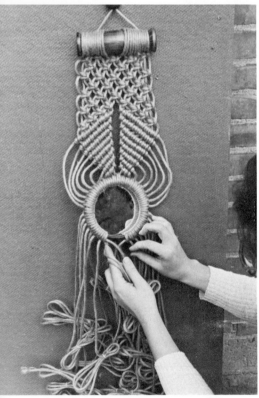

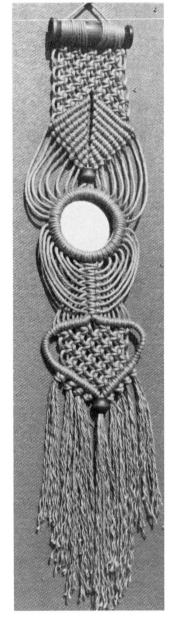

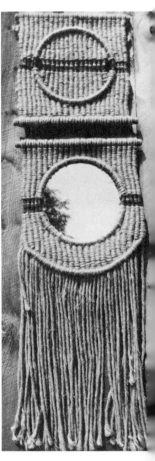

Cords at the top of the hoop are pulled down over the back of the mirror to secure it in place and then are knotted to the bottom of the hoop.

The finished wall hanging (12″ × 36″) has a 6″ mirror.

Two-Piece (18″ × 4′) b
Arlene Pitlick is made of jut
wool, and a 14″ mirror.

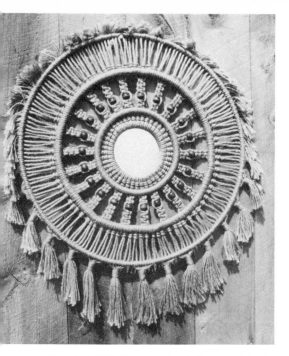

Sun-dial (36″ diameter) by Arlene Pitlick. An 8″ mirror is surrounded by macraméd welt cords with wooden beads interspersed along the spokes of square knots.

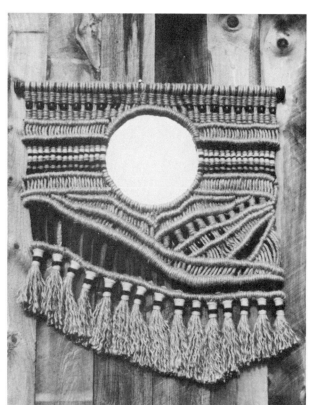

Reversible (42″ × 42″) by Arlene Pitlick. Many half hitches of jute and wool are used in this piece.

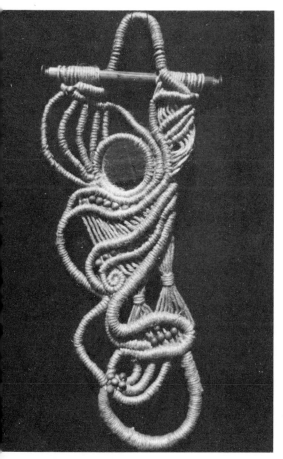

Movement (3′ × 5′) by Arlene Pitlick.

WRAPPING AND COILING

You can produce handsome surface textures around a mirror by wrapping and coiling yarns, raffia, reeds, and other fibers.

Wrapping is usually done over a "foundation" fiber material—such as reed, cane, sea grass, upholsterer's cording, or heavy cord. In selecting the material for the foundation, bear in mind that the foundation must be firm—so that the desired shape will be held. The foundation material must still be flexible, however, so that it can be bent without snapping or splintering. Many types of cord fulfill these requirements. Jute, sisal, cotton, and linen cords are good, and they are available in hardware and craft stores.

A "binder" is used to stitch coiled foundation cords together. The binder needs to be strong but should be seriously considered as a textural element, too. Raffia is a popular binder owing to its durability and rugged textural qualities. Yarns in a variety of colors and materials can also be used with great success in binding and wrapping. Several standard basketry stitches, combined with simple wrapping of binder around the foundation coil, are used in the binding process.

Procedure for Coiling and Wrapping a Mirror

1. Determine the shape and purpose of forms and how the mirror is to be incorporated.
2. Select materials.
3. Wrap outside fiber around foundation strands or cording, covering completely and evenly.
4. Coil into shape, stitching coils together with invisible or decorative stitches.
5. Incorporate mirror at most advantageous stage.
6. Complete coiling.

WRAPPING AND COILING MIRRORS

Medusa Basket by Sharon Robinson is brown raffia coiled around a reed foundation cord. A *shisha* mirror is set into the lid of the basket. The Medusa face is made of nylon stocking stuffed with cotton. The features are stitched. The snakes are pipe cleaners wrapped with raffia. *Courtesy: Sharon Robinson*

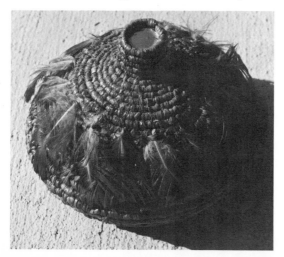
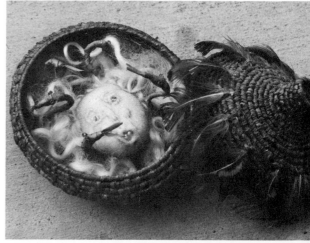

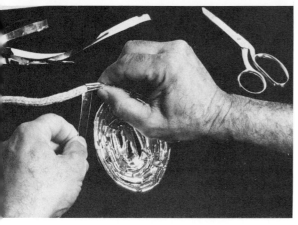

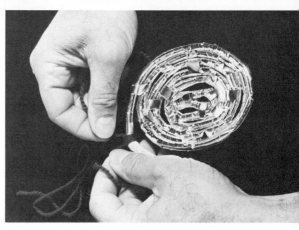

Strips of thin metallized polyester film can be cut and used as wrapping. Here it is wrapped tightly over clothesline foundation cord. As the wrapping proceeds, the piece is coiled into a basket.

Yarn is wrapped and tied periodically to add color and texture to the basket.

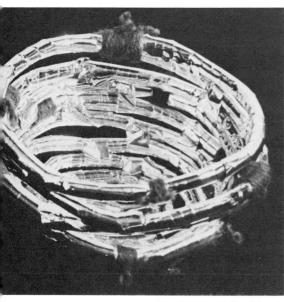

Loose basket of coils wrapped in metallized film.

Reeds wrapped with cotton floss, framing mirrored acrylic. By Rochella Cooper. *Courtesy: Rochella Cooper*

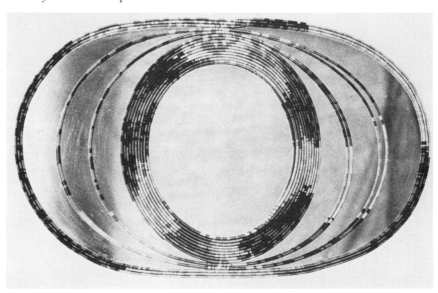

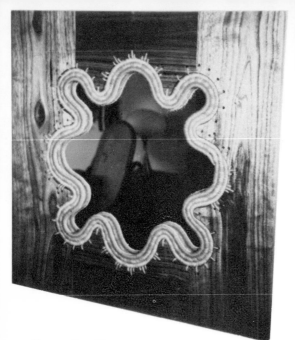

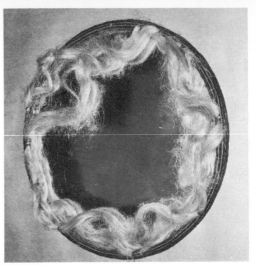

Sharon La Pierre executed this handsome combination of coiling and woodworking. The walnut was laminated by Dale Beckmann. *Courtesy: Sharon La Pierre*

Wistful Reflections (18″ diameter mirror) by Mary Jean Fowler. The coiled frame is made of jute core wrapped with rayon/linen. Flax surrounding the frame is reflected by the mirror. *Courtesy: Mary Jean Fowler*

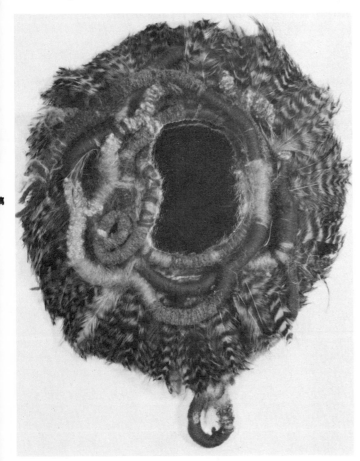

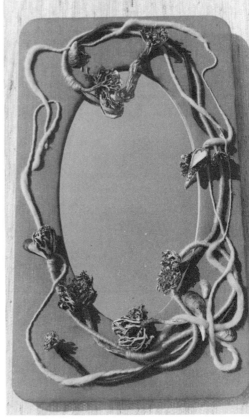

Fetish Mirror was made by Elisa Lottor from old blue mirror and coiled and wrapped hand-spun yarns, chenille, and feathers. *Courtesy: Elisa Lottor*

This oval mirror is set in a wooden frame jacketed with fabric. Nelle Rootes's meandering decorations are wrapped yarns combined with the root portion of seaweed (called holdfasts). *Courtesy: Nelle Rootes*

226

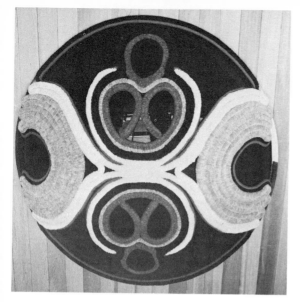

Some of the hubcaps that Julie Connell works with have car company initials pressed into their surfaces. But that doesn't stop her from taking advantages of those reflective parts of the hubcap that are not recessed. This coiled piece uses upholstery cording as the foundation cord wrapped with various yarns. The wrapped and coiled shapes are sewn together, edge to edge.

Beeswax is applied to an underlying piece of wood, and yarn is stuck onto the beeswax to form a design on this Mexican hand mirror.

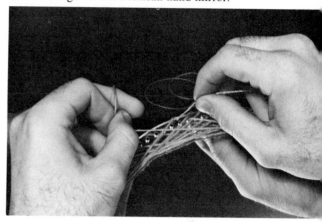

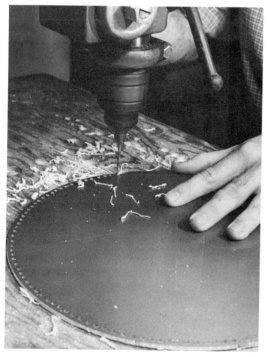

Then yarn is threaded through the holes. In this case yarn was threaded between every 25 holes (skipping 24 in between). The yarn-threading continues until a complete pattern of yarn frames the mirror.

The craft of symmography—in which wire or yarn is threaded into Op Art patterns—can be used in mirrors. Holes are drilled around the circumference of a circle of mirrored acrylic.

A second symmographic pattern was generated using a red-coated brass wire, threaded between every 35 holes.

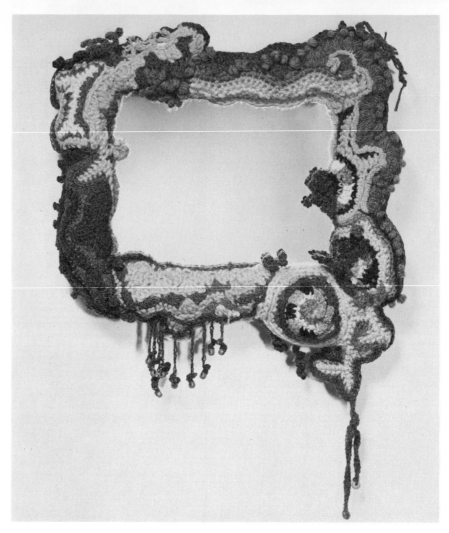

Diana Schmidt Willner uses a multitude of colors and makes frenetic twists and "bubbles" in the yarn chains of this crocheted mirror. The crocheted part is sewn to a felt backing and is stuffed. The stuffed felt crochet frame is then sewn to a felt-jacketed block of Styrofoam and the mirror itself is set into the Styrofoam (18″ × 16″ × 4″). *Courtesy: Diana Schmidt Willner and the Newark Museum. Photo: Armen Photographers*

CROCHETING AND EMBROIDERING

Crochet and embroidery are two very direct needlework processes that lend themselves to mirror designs.

The yarns, cords, and threads used for crocheted or embroidered mirrors include a vast assortment of rayon, cotton, linen, wool, Dacron, nylon, jute, sisal, and so on.

Crocheting with the hooklike needle produces a firm, fine meshwork. The size of the needle used is dependent upon the thickness of the yarn or fiber. Simple crochet is based upon a chain. By joining chains you make a loop. To increase, add more chains; double or triple crochet into the same loop; or cast

more yarn around the needle. To decrease, skip a stitch or two; or slip one stitch into another.

Sometimes the crocheted piece is turned around and worked on both sides. Other times stitches are made only in one direction, ending the thread at the end of each row. Patterns are created by varying stitch direction; skipping stitches; crocheting chains within stitches; doubling stitches; going through both threads (double crochet) or into just the top or single crochet. To crochet a loop, work around a dowel and then crochet a line or two at the top of the loop after the stick has been removed. Thread can be pulled through several stitches at one time; or different colors of thread can be introduced into the base color.

Embroidery was one of the first decorative textile techniques to be combined with mirror. Embroidery stitches have functioned to tie or frame a mirror in place on a fabric. And embroidery still offers some of the greatest potential. Mirror can be used with embroidery in many ways because embroidery has so many options of stitches and threads—from cross-stitch and silk to white work and linen. Although we normally think secondarily of adding mirror to embroidered cloth, a new possibility has been provided by the invention of metallized plastic film and clothlike reflective materials. Try hand or machine embroidering directly onto the film.

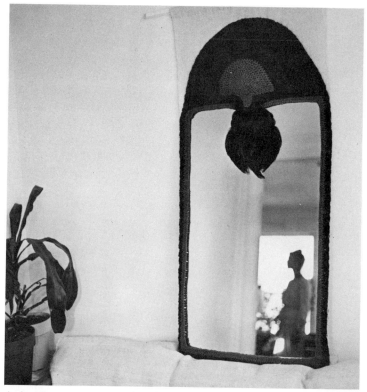

A handwoven, cream-colored fabric serves as background for the crocheted border. Lillian Ball selected blue, green, and teal for the crocheted frame (24″ × 42″). *Courtesy: Lillian Ball. Photo: George Peet*

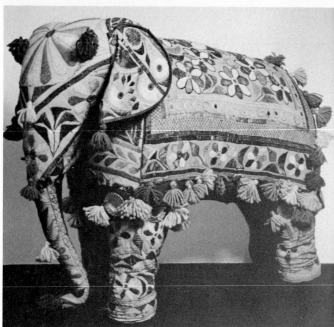

MIRRORED EMBROIDERIES

This antique embroidered elephant from India incorporates many small reflective discs known as *shisha* mirrors.

The caps that men wear in Pakistan and Afghanistan (both with and without a turban) often have many *shisha* mirrors. This cap is done entirely in gold thread and was made in West Pakistan.

Pillowcase embroidered in red, black, and white with *shisha* mirrors. It was made in Afghanistan; its design includes the classic Asian seedpod motif.

A traditional use of mirrors in an embroidered shirtfront from Afghanistan. *Collection of Sas Colby*

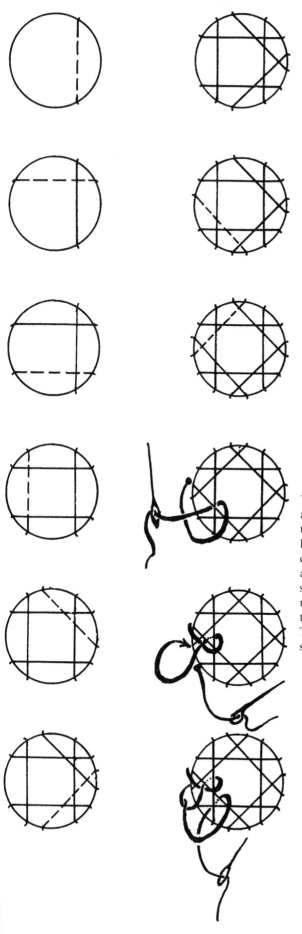

The *shisha* stitch is not as difficult as it initially appears. In this diagram, dotted lines correspond to the next stitch in the sequence. Begin by holding the mirrored disc (Mylar, cardboard covered with aluminum foil, or metal) in place and stitch so that you overlap the mirror as shown. After eight overlapping stitches have been made, wrap the overlap (as shown in the last three illustrations) all around the circumference. This is a combination cross-stitch and buttonhole stitch.

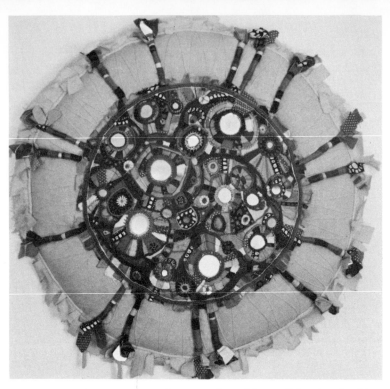

A contemporary interpretation of the traditional embroidery technique by Peggy Moulton.

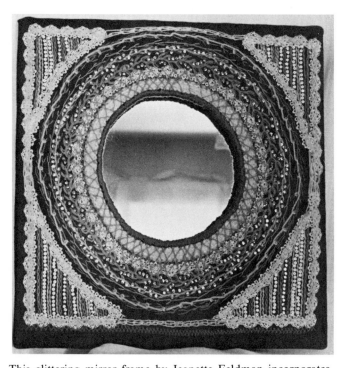
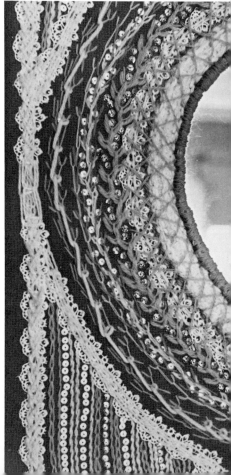

This glittering mirror frame by Jeanette Feldman incorporates lace and sequins with a great variety of yarns and stitches.

Detail of embroidery by Jeanette Feldman.

A coarse cord is embroidered through fabric and applied to a wood frame in this piece by Nelle Rootes. *Courtesy: Nelle Rootes*

On the Fourth of July, We Have a Glorious Fireworks Display was embroidered by Jeanette Feldman.

Metallized polyester film can be treated as cloth. A pair of lips are machine embroidered on a film that comes with an adhesive backing.

The embroidery was based on a preliminary sketch done with marking pens.

The adhesive backing is protected by waxed paper. Strip the waxed paper from the back.

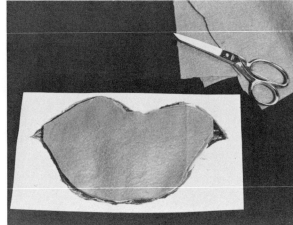

To make the lips three-dimensional, felt stuffing is cut.

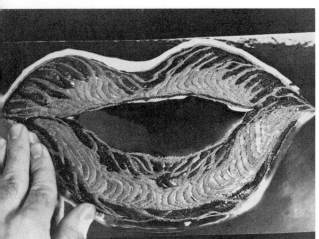

The embroidered metallized film with stuffing behind it is pressed onto a piece of black acrylic. By pressing hard, the outer perimeter of the lips adheres firmly to the acrylic.

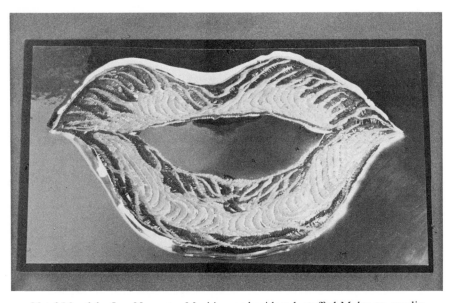

Metal Mouth by Lee Newman. Machine embroidered, stuffed Mylar on acrylic.

MIRROR APPLIQUÉS

Blue and white felts are appliquéd in this mirror frame made in Rumania.

...etail shows how fabric is ...tched after the shapes are ...t.

The mirror itself slides into a pocket. Enough of the appliqué design overlaps the front of the mirror to keep it from falling out.

235

Iron-on metallic Mylar can be applied to paper, cloth, or any other surface that can be ironed. If put on clothes, the material can be washed only in cold water. The Mylar can be cut, decorated with marking pens, and ironed. (This is an experimental product of the Transilwrap Company, Inc., 2615 North Paulina Street, Chicago, Illinois 60614).

Put the pieces of iron-on metallized film on the material to be decorated and cover with a sheet of paper. Iron should be on a medium setting. After just a few seconds the adhesive on the back of the film will effect a permanent bond.

Advertisement for Myself. T-shirt with silver Mylar appliqué. *Photo: Connie Newman*

LEATHERWORKING

Basic Types of Leather

The history of leather can be traced through both its products and the complex tanning processes. Tanning of hides and skins arrests decomposition, increases their strength, makes them more pliable, and keeps leather from becoming soluble in water or from drying out in air. Despite the excellent chrome-tanned leather we have today, leather that has been oak-tanned (a traditional process that dates back to 2500 B.C.) is still very much with us. Such vegetable-tanned leathers are the best for forming and carving. Unlike oak-tanning, chrome-tanning (a nineteenth-century innovation) is an open tannage process creating a more porous material. Therefore chrome-tanned leather cannot be used for forming. When wet, the leather becomes stiff rather than flexible and will not hold its shape.

To determine whether a leather is chrome-tanned or vegetable-tanned, look at its cross section. A bluish gray streak in the center often indicates chrome-tanning. Vegetable-tanned leather is more uniform in color. Another test is to moisten the leather with warm water and then fold it. The vegetable-tanned piece will feel slippery but will hold a crease. Chrome-tanned pieces will feel drier and spring back.

Basic Leather Tools

Leather can be worked with minimal tools or, of course, in a workshop where many tools and machines are at hand. The machine processes save time, but the end product could look the same.

To begin, some area should be reserved for laying out a hide and cutting out the pattern. Another space should be available for hammering and pounding. Some accommodation should be made for storage of supplies and for the use of dyes and coatings. And a clean, dry place (not hot) should be available for storing leathers (laid flat or individually rolled).

The basic tools are single-edged razor blades; sharp knives; 7½″ to 8″ sharp shears for cutting; an awl for piercing holes; a ball-point pen for marking lines and patterns; a ruler for measuring and obtaining straight cuts; hammer or mallet for striking, fixing seams, and attaching rivets; a brush; daubers or cotton swabs for applying edge coatings; sponges or soft rags for applying dye, wetting down leather, and polishing; a square for getting the proper angles; a fork or spacing wheel to indicate spacing for holes (in stitching); a revolving punch or thonging chisels for forming various holes and slits in leather for sewing or thonging.

Of course the list could be much longer. The basic machine tools are a buffing wheel, an electric sander for carving and roughing surfaces, and a drill press. For some designs, a jigsaw, band saw, or saber saw can save time when you are cutting thick leather (5 ounces and up).

A Neolite sheet (available from your shoemaker) placed under the leather makes a good cutting base to keep from dulling sharp tools and scratching counter tops.

Threads of various kinds, such as heavy-duty carpet thread, linen book-

binder's thread, waxed threads, and cotton-covered Dacron, are excellent for sewing leather parts together. The choice of thread is determined in part by the type of leather being used. Dacron thread can be used to sew thin garment leather, but it is not recommended for use with heavy leather. Thonging, thin strips of leather or plastic in various colors and thicknesses, can be used for attaching parts, too.

Leather cement, such as rubber cement, Barge, or other leather-specific adhesives, is also useful for attaching parts and laminating layers.

Dyes are important for coloring leather, and polishes and waxes protect the top grain.

Although each item will not be necessary for the sequence shown here, sooner or later all these tools and supplies will be put to use by the intent leather craftsman.

Basic Leather Processes

PATTERN MAKING

After the mirror is designed, patterns should be cut for each piece. If there are any doubts as to how well parts fit, artisans usually cut and sew fabric into the intended shape as a trial run. Making adjustments in this way will reduce the potential for error.

Paper patterns are translated into leather by tracing around each pattern shape with a ball-point pen or the sharp point of an awl.

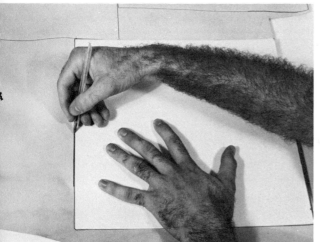

LEATHER AND MIRROR PHOTOGRAPH ALBUM

To make a leather photograph album with a reflective surface framed on the cover, begin with a cardboard template the size of the covers. Cut out the template and trace it onto leather. In this case a fine smooth leather surface was desired for both inside and outside of the covers. Therefore each cover is a double thickness of 3 oz. cowhide. So a total of four pieces of leather are traced.

Cut the leather from the hide.

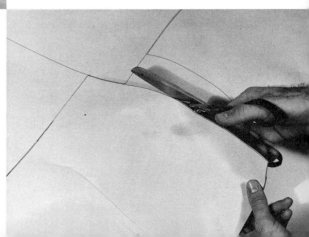

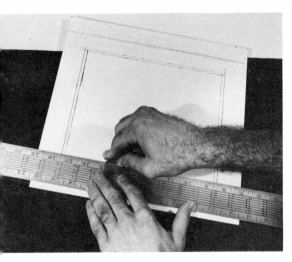

The front cover will have a window for a piece of acrylic mirror, so a window is cut in the template.

The mirror is tried out in the template to be certain that there is enough overlap on top of the mirror to hold the acrylic in place.

CUTTING LEATHER

Sharp knives, single-edged razor blades, or heavyweight shears are excellent for cutting leather. Any cutting tool with a sharp edge will do, but dull blades tear the leather and leave a ragged edge. If the leather is thick and heavy, a handsaw or saber saw may be necessary.

When cutting, craftsmen usually place the leather wrong side up over a heavy piece of leather, hard rubber, vinyl, or Neolite sheet, so that when the cutting edge passes through, it will not catch on or be dulled by the counter top. Steel rulers or T squares make good guides for straight edges. The best cutting technique is to hold the knife at a 45° angle and press down firmly and continually while cutting. Try to apply enough pressure to cut through the first time around.

The window can be cut in the leather so that it has a beveled edge—beveling in toward the center. The most professional angling of the edge is obtained using a mat cutter.

But the beveling can also be achieved with skilled knife handling and straightedge.

SKIVING

If several edges are to meet at a joint, they should be thinned—or skived—(by slicing away part of its thickness) so that when overlapped the two together are as thick as the original. Of course, only the areas that are to be made to adhere need to be thinned, and skiving is not necessary when thin leathers are used.

Skiving is usually done on the flesh side (underside) with a very sharp knife, starting about ½″ in from the edge. The blade is held at a shallow angle to make short cuts until the proper amount of leather has been skived away.

EDGING, BENDING, FOLDING, AND CREASING

To finish an edge, many artisans use an edge cutter or sharp knife. Removing a sliver of leather at a very slight angle along the edges chamfers and finishes the edge.

Lightweight leathers may be bent, folded, and creased by running a bone folder or inkless ball-point pen along the line with sufficient pressure to leave a mark. Heavier leathers (those over 3 oz.) require more preparation. Dampening the crease area will help to maintain the crease. But most often a shallow U-shaped or V-shaped groove is gouged out of the flesh (back) side so that heavy leather will lay flat and not bunch at the crease. Creases can also be made by pounding with a dull chisel and hammer.

The cover of the photo album must be able to fold open. A crease is made where the cover should "hinge." The crease is actually a small U-shaped channel gouged out with a special tool. A V-shaped channel can be gouged with a knife.

In preparation for dyeing the leather, first clean off all grease and stains with saddle soap and water. Do not oversoak the leather, however. The saddle soaping will aid even absorption of dye.

JOINING LEATHER PARTS

Overlapped parts are usually attached by applying a rubber-type leather cement to both surfaces. When this adhesive becomes tacky, the leather parts are joined and pounded together with a mallet.

Leather can be sewn, with sewing machine or by hand, if it is thin enough. When hand stitching, prepunch holes with an awl, thong chisel, or hole punch. Which instrument you use depends upon the thickness of the thread or lacing. Various kinds of stitches can be employed. Some fancier ones can produce a decorative knotted pattern along the edge of the seam. To maintain depth of stitching and to mark distances between stitches, a line should be ruled, and stitch holes marked with an awl or spacing wheel.

DYEING

Leather is usually dyed and finished before sewing commences (but after holes are made for stitching, if any). Since undyed leathers are porous, they will absorb dyes readily. Dye application should be performed with even, continuous, rapid, circular strokes. Most commercial dyes for leather are water, oil, spirit soluble. They penetrate deeply into the grain. Holding the dye too long on one spot will cause it to penetrate deeper, imparting a darker, uneven color.

To prepare leather for dyeing, make certain the grain side (top) is free of all grease and dirt. Wool, terry towel, and sponge are good dye applicators.

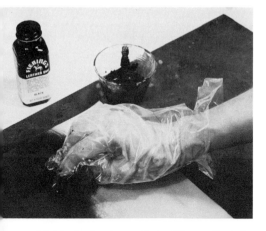

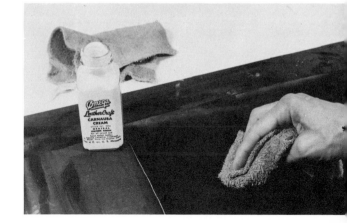

Fiebing's dye is applied with a soft cloth. Use a circular, massaging motion all over the leather. Allow to dry for a few minutes, and then you may apply a second coat.

Apply a light coat of carnauba wax after the dye has dried. This will protect the dye during the gluing stages.

FINISHING

The most efficient finishes are those that protect the leather without being obvious. (Dull surfaces such as suedes should not be coated.) Saddle soaps, petroleum jelly, waxes, and some oils, such as castor oil, make good polishes. Rub the finish over the surface, allow it to be absorbed, and then buff off excess.

LAMINATING AND FORMING

Although leather comes in limited thicknesses, it can be built into thicker forms by laminating several layers and by forming it into three-dimensional shapes.

Lamination involves making one piece adhere to another with a leather adhesive. After shapes have been stacked and glued, they can then be carved and formed with wood-carving tools or with various bits attached to a flexible shaft drill.

Forming is accomplished by soaking vegetable-tanned leather until wet and then stretching, shaping, and forming it over some kind of mold. Pine, balsa, or plaster make adequate molds. Collar or saddle 4- to 8-oz. leather perform best in this application, owing to its greater elasticity. Marcia Lloyd used this wet-forming technique to create her mirror of formed leather hands.

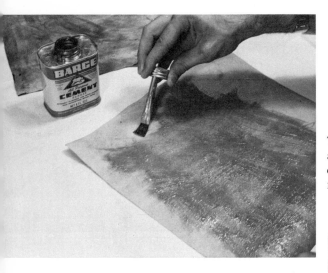

To laminate the inside and outside of the front and back covers, spread an even coat of Barge cement (or other leather cement) on all surfaces. Allow the Barge to nearly dry.

Then line up the leather pieces and press them together. Start from one corner, making certain that there are no air pockets, wrinkles, or bulges. When doing the front cover, set the acrylic mirror onto the leather and then sandwich it between the window front piece and the solid bottom piece. There should be enough overlap to keep the mirror in place, and yet there should be enough width of leather-meeting-leather to permit a permanent lamination.

The laminated leather should be sandwiched between cardboard sheets during pounding. (This protects the leather.) Pound the leather with a rubber mallet to guarantee a strong adhesive bond. Trim and bevel outside edges. Touch up with dye, and then wax all surfaces and edges.

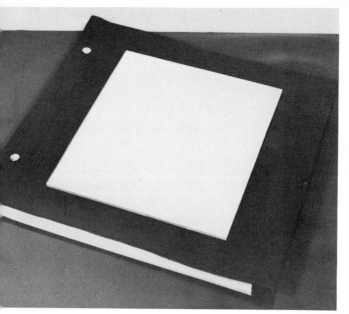

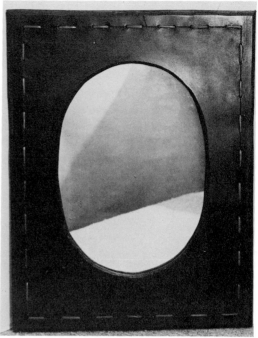

The mirrored leather photograph album mirrors the present, while the book's contents reflect the past.

A running stitch with thread (and cement) was used in the construction of this mirror by Murray Kusmin.

Leather lends itself to many soft craft processes, such as embroidery. These embroidered and fringed mirrors by Florence Sohn and Ed Ghossn were done for L'Insolite. The background is dark brown and cream-colored suede. Embroidery "thread" is also suede.

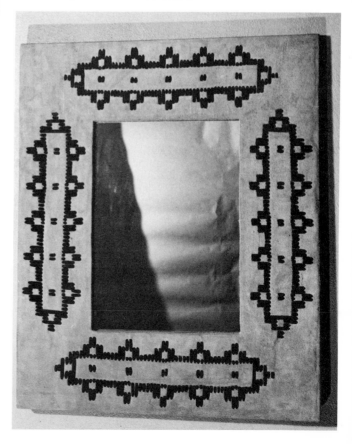

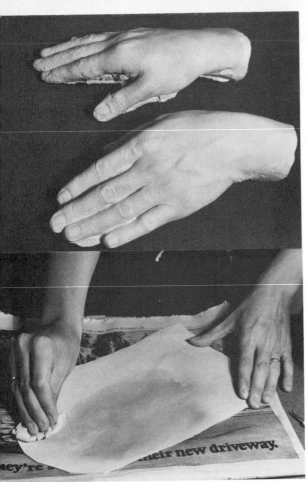

WET-FORMING A LEATHER MIRROR
BY MARCIA LLOYD

Marcia Lloyd's oval hand mirror is *not* a mirror that fits in your hand—it is a mirror which has a pair of leather hands built into it. The hands are wet formed over plaster casts of the real thing. We will begin by showing the wet-forming process and then illustrate how these hands are combined with a wet-formed oval leather mirror frame. Marcia Lloyd first makes molds of the object to be modeled—such as these two plaster hands.

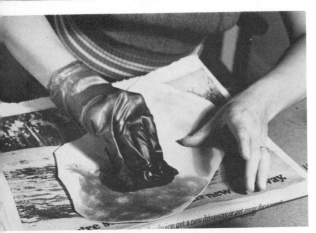

A piece of 2-oz. oak-tanned leather is cut large enough to fit over the plaster hand. Before dyeing, soap the leather with liquid saddle soap. The dyeing can be controlled better if this is done.

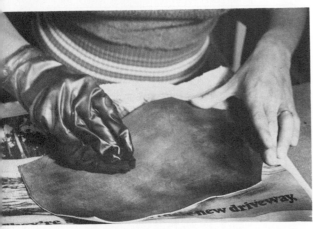

Marcia Lloyd applies Fiebing's dye with a soft cloth. She uses a massaging motion, moving in a continuous circular pattern all over the leather.

244

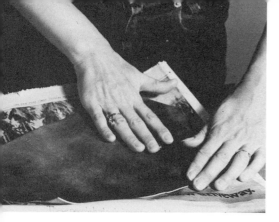

Petroleum jelly is applied by hand to the freshly dyed leather. Wipe away excess before . . .

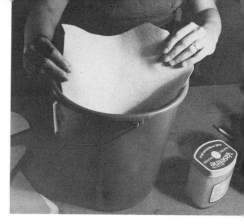

. . . putting the leather into water.

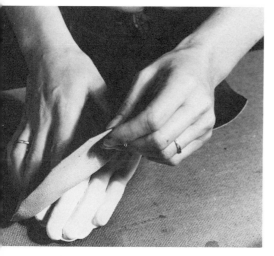

The leather is left in the water to soften. When the leather becomes very soft, remove it from the water and absorb as much water from it as possible using paper towels. Place it over the mold.

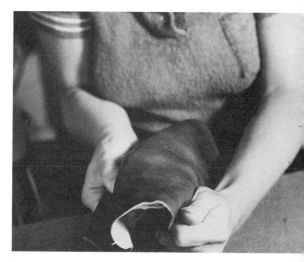

Stretch the leather over the mold to establish its position.

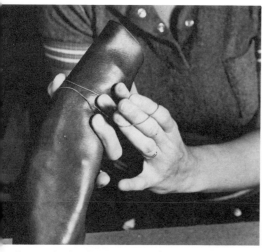

Secure the leather to the mold with a rubber band (rubber band marks can be burnished out of the leather later).

Keep stretching until the main contours of the mold have been imparted to the leather.

Marcia Lloyd uses a hair dryer to dry out the leather in stages. You can also dry the piece in an oven by setting the piece on an aluminum cookie sheet. Be certain that rubber bands are removed before hot drying.

Burnish the leather to bring out finer details. Marcia Lloyd uses a modeling tool to do this when the leather is almost dry. If dried too much, the leather hand can also be remoistened.

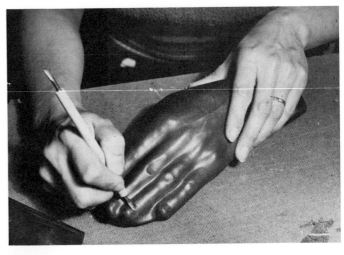

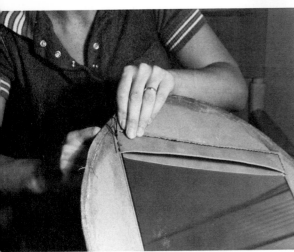

The main leather frame of the mirror is made from two oval pieces of 6-oz. leather cut from an oval pattern. An oval window in the center of one piece is cut away so that the mirror will be seen later. Dye both oval pieces of leather as discussed above. Marcia Lloyd glues the mirror to the oval, which will serve as the back of the piece. Barge cement is used to attach mirror to leather. With a double running stitch, a leather pocket is attached around the bottom of the mirror to hold it in place in case the mirror comes loose. In order to stitch leather to leather, punch holes first with a pliers punch or a drive punch. Then stitch with a #1 harness needle and waxed linen thread.

Marcia Lloyd sews a hook to the back for hanging the finished mirror.

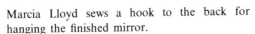

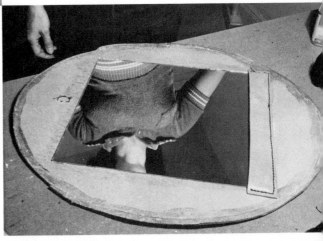

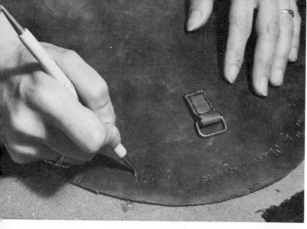

With burnishing tool, the piece is signed on the back while the leather is still wet and impressionable.

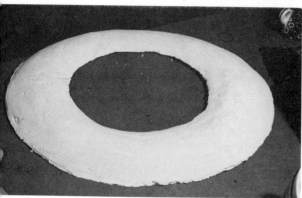

The leather oval—the one that has a central oval window cut out—is wet formed over a plaster mold by the procedure described above.

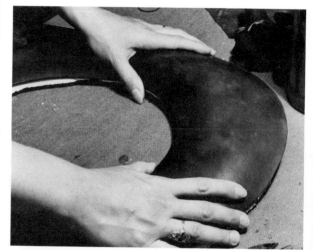

After the front oval piece is shaped and dried, cut approximate openings for inserting the hands. Starting at the wrist, punch holes and then stitch the hand to the mirror front. Use 5-ply waxed linen thread.

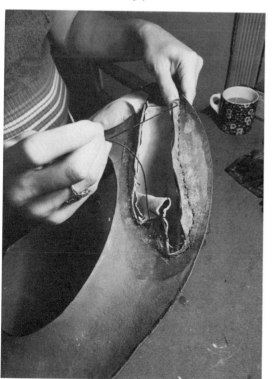

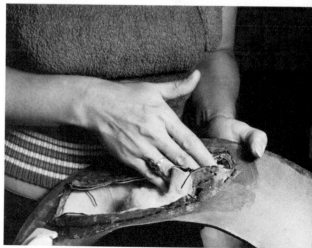

Stuff the space in the hands wtih Fiberfil, being careful to keep this filler away from glue (it sticks very easily).

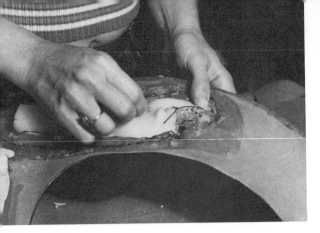

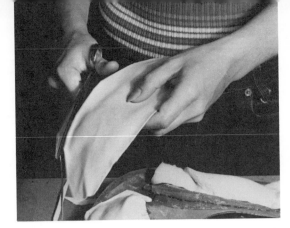

Marcia Lloyd next wedges flexible foam scraps into the hands. To make the hands hard and heavy, it is also possible to fill the form with an epoxy resin.

Cut a skiver—a thin leather used as a lining—to patch over the filled area.

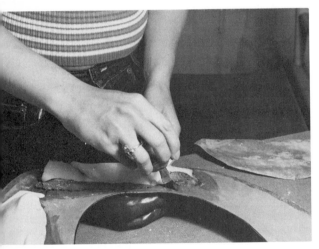

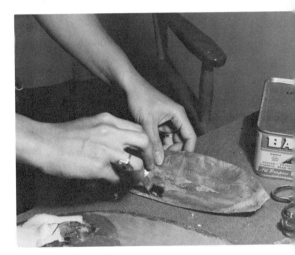

Apply Barge cement to both the leather . . .

. . . and the patch.

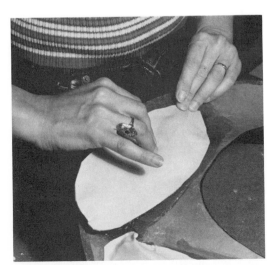

Allow the cement to nearly dry, and then press the patch onto the filled area. Let the Barge cement dry for fifteen minutes.

In preparation for stitching the back of the mirror to the front oval, Marcia Lloyd smears a tacking cement on the leather. Tandy's Leathercraft Cement works well in holding the leather ovals in place while stitching proceeds. After applying cement on the edge, let it dry for a few minutes before assemblying.

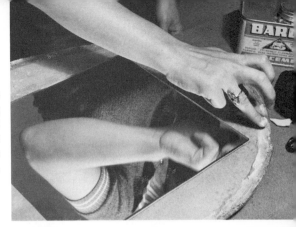

Set the top oval onto the bottom oval. The Tandy cement allows some time for shifting pieces around for a good fit.

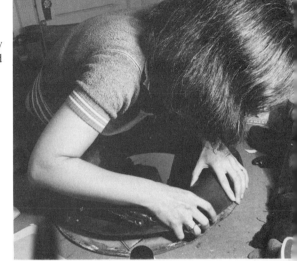

Marcia Lloyd is careful to maintain the curvature of her top oval when gluing. It requires some playing with the parts. Because the top oval was curved by the wet forming, it is now slightly smaller in circumference than the flat bottom oval.

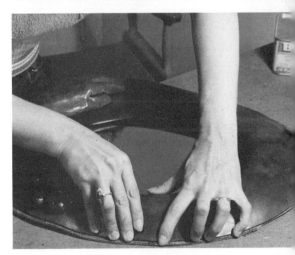

With a sharp knife she trims excess leather from the back piece.

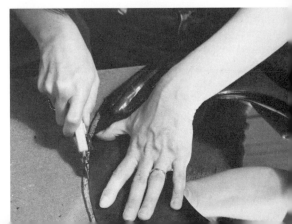

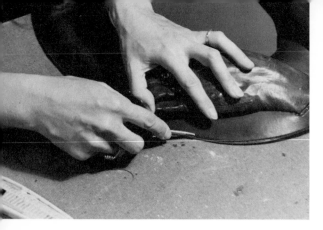

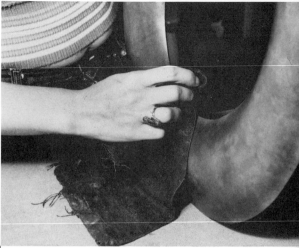

And she bevels the top edge for a more finished look.

Dye is applied to all exposed leather edges.

An edging wax is rubbed over the edge to further seal it, protecting from future wear.

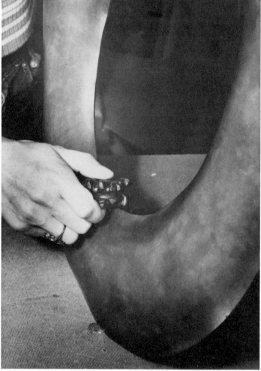

Fiebing's acrylic Resolene also acts as a sealer to retard wear.

Slits are made in the outer edge with the pliers punch, and the edge is stitched.

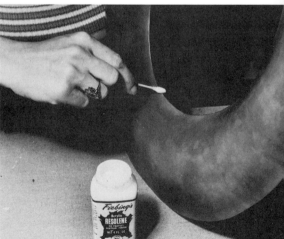

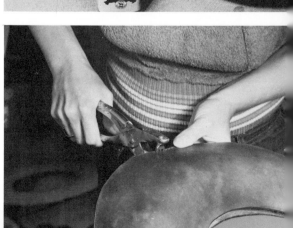

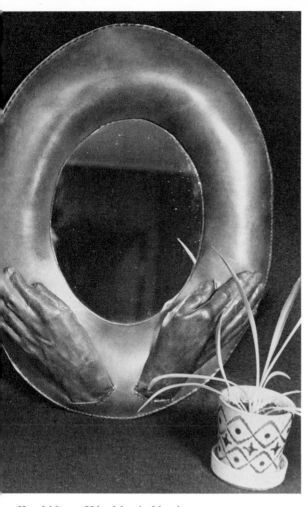

Hand Mirror II by Marcia Lloyd.

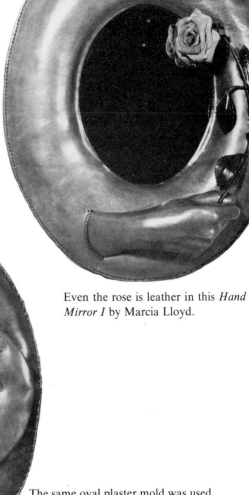

Even the rose is leather in this *Hand Mirror I* by Marcia Lloyd.

The same oval plaster mold was used to create this wet-formed and hand-tooled leather mirror by Marcia Lloyd.

Procedure for Creating Leather Mirrors

1. Construct model.
2. Make paper or cardboard patterns.
3. Trace pattern onto leather.
4. Cut leather parts. Dye leather, if appropriate.
5. If you are forming, wet leather and shape over a mold. When it is dry, trim and refine contours.
6. If you are laminating, glue layers, carve, and refine contours.
7. If necessary, punch or pierce holes along edges to be joined with thread or thonging.
8. Coat edges.
9. Decorate and/or dye top or grain side of leather if it has not been appropriate to do so earlier.
10. Join parts by gluing and/or sewing or lacing.
11. Polish/protect surface.
12. Wherever appropriate in this sequence, fit mirror into leatherwork.

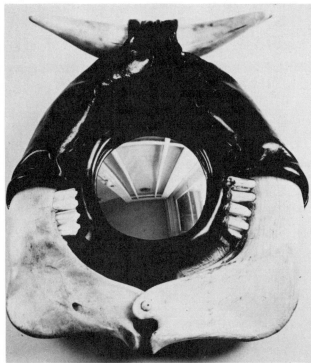

Hog Jaw Mirror (12½″ × 15″) by Nancy Flanagan. Made of formed leather, bone, horn, and a convex mirror. *Courtesy: Nancy Flanagan*

A variety of surface textures can be created with leather. Ed Viola carved into this leather with a woodcutting tool.

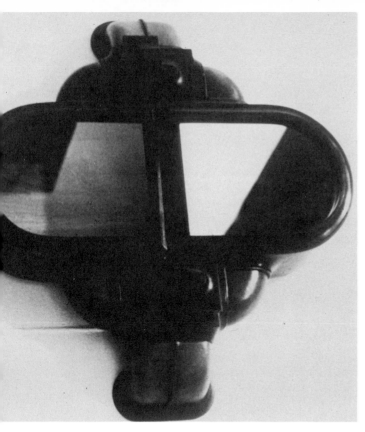

Formed leather mirror by John Cederquist. *Courtesy: John Cederquist*

The length of this mirror can be adjusted by moving the belt buckle a notch. Mirror by Richard Rosengarten.

Special leather punch tools are used by Barry Miller to make these hand mirrors. Light and dark areas are created by selective dyeing of the leather.

CERAMIC MIRRORS

CENTURIES OF EXPERIMENTATION BY CRAFTSMEN FROM EVERY PART OF THE world have produced a rich body of information for contemporary ceramicists. The chemical and physical properties of clays and glazes have been dissected to the point that they can be compounded to achieve very specific effects. Some artists and craftsmen do just that, but clay workers can and do function successfully without becoming involved in the physics of ceramics. Clays and glazes are premixed and packaged. Formulas keyed to firing temperatures and times nearly ensure technical success. But better clays and greater control have not led to a sacrifice of aesthetics. If anything, the quality of the available materials and the ease with which they may be employed have aided and encouraged the development of good design by removing technical obstacles from its execution.

Because the potter's craft has been practiced for centuries, the range of processes and decorative techniques is immensely varied, yet nearly all have been used by clay workers at any point during the last thousand years. Slab and coil construction, wheel throwing, molding, and draping are among the traditional and contemporary techniques. The basic properties of clay and the art of firing it have been understood for nearly as long. Porcelain, stoneware, raku-fired and reduction-fired ceramics, all are of ancient lineage.

Surface treatments of ceramic forms are part of that same heritage. We still carve, incise, mold, model, pull, and allow the pattern to evidence the structure—such as when coils are allowed to retain their individual identities.

254

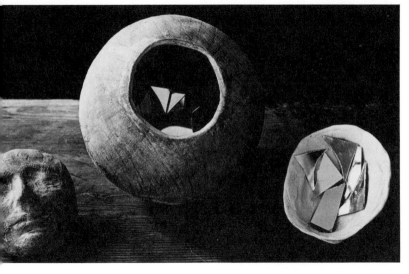

Susan Felix's hand-built container is lined with pieces of glass mirror. *Courtesy: Susan Felix. Photo: Sandy Solmon*

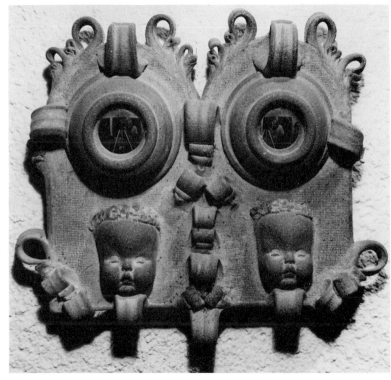

Baby Face Mirrors Plaque (18″ × 18″), stoneware with two convex automotive mirrors by Barbara Grygutis. *Courtesy: Barbara Grygutis*

And we continue to use an ever-increasing range of slips and glazes in the same ways that they have always been used.

Of course, even in a medium so indebted to tradition as this one is, there are continual innovations in materials and in technique, but the most significant innovations appear to emerge from the artists' perception of materials, images, forms, and functions. Skillful and creative ceramicists such as those whose work is included here must be given the largest share of the credit for the very use of ceramics in mirror frames. Until recently, clay was considered a highly unusual vehicle for mirrors. Thanks to high technical standards and keen perception, ceramic mirror frames are today widely appreciated. Good design, of course, means the integration of materials, style, technique, and function.

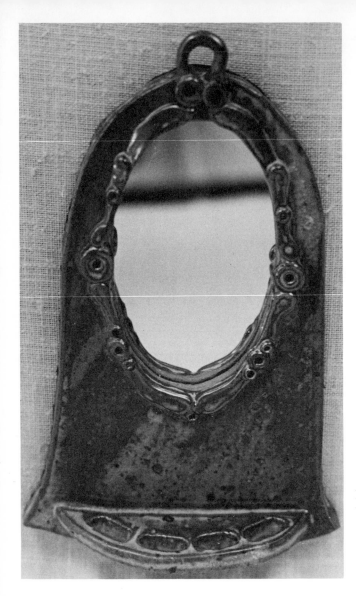

Hand-built stoneware mirror and toothbrush holder by Lynda Katz.
Courtesy: Lynda Katz

That demanding combination is shared by Lynda Katz's slab mirrors, thrown forms by Jan Axel, and Carol Jeanne Abraham's unique pulled porcelain mirror frames, as well as by the work of the many other ceramicists included.

As these varied ceramic mirrors prove anew, significant form is not the province of a particular medium or mode of expression. Fine design and sensitivity to materials and technique invest every form with a special significance its function would otherwise belie.

THE RAW MATERIAL OF CERAMICS

After millions of years of weathering, feldspar (hydrated compound of alumina and silica) is worn down into microscopic particles. Water has combined chemically with each particle to form the basic element of clay—the platelets. When wet, these platelets slip and slide over one another, causing the mass of damp clay to stick together and to accept shapes when manipulated. Clay is a thermosetting material; once hard, it keeps its shape. But before it

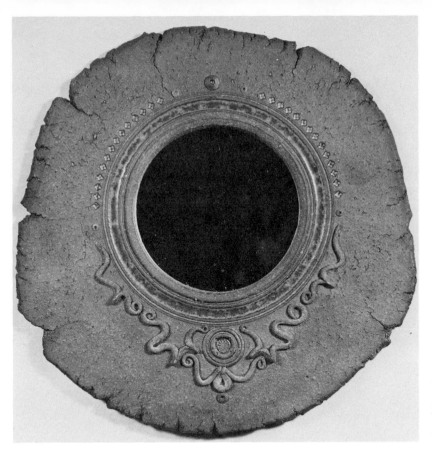

Decorated ceramic slab mirror (10″ diameter) by Herb Schumacher. *Courtesy: Herb Schumacher*

has been baked to become permanently fixed, wet clay is plastic and can be readily shaped at room temperature.

Clays have varying degrees of plasticity. Ball clays are very fine grained and are highly formative. They are often added to kaolin, a less plastic variety, in order to produce porcelain. Most of the time, different clays are mixed together to create workable clay bodies with different degrees of plasticity and different handling characteristics, and different responses to specific cone-firing temperatures. For example, earthenware bodies are low firing; clay bodies for wheel throwing must be very plastic; stoneware bodies are usually prepared bodies that are very hard when fired; porcelain, also high firing, is a white clay that is a prepared body.

Ready prepared clays are ground, sieved, and blended. Sometimes they are sold in a powdered state. Moist clay must be stored in airtight, watertight containers, such as polyethylene garbage pails, so that moisture and workability are maintained.

CLAY PREPARATION

Clay must be worked into a uniform texture that is free of air bubbles if it is not to distort or blow apart in the kiln. Kneading and wedging the clay accomplishes this. In the wedging process, clay is sliced and then slammed down on a plaster bat, one slice over another, forcing out trapped air.

Paul Taylor prepares clay by kneading and wedging it on a plaster-topped table.

He compresses the clay into a ball . . .

. . . and slices it on a taut wire. Each slice is then slammed down on the plaster table, one slice over the other, to force out trapped air.

FORMING MIRROR FRAMES

Slab Mirrors

After clay has been conditioned, it can be formed into mirror frames in a variety of ways. One approach is to cut the basic form from a slab of clay. Thick coils or balls of clay can be rolled into flat slabs with a rolling pin. The rolling pin rides on two sticks or dowels, one on either side of the clay, which determine the eventual thickness of the uniform slab. The clay may then be cut to shape easily. Decorative elements may be added, but care should always be taken to seal all joints and connections, since inadvertently trapped air expands during firing and may explode the form.

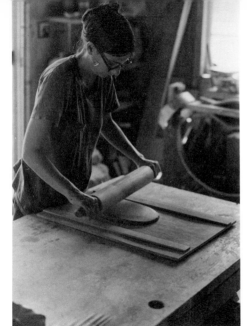

SLAB MIRRORS BY LYNDA KATZ

A clay slab is rolled to an even thickness of ¼″ between two strips of ¼″ plywood.

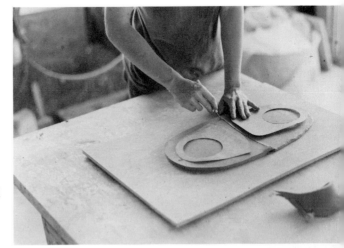

The cardboard pattern for the mirror is placed on the slab, which is cut to approximate size.

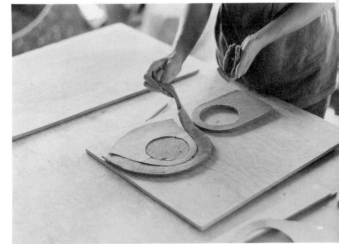

The clay is cut to the precise outline of the cardboard pattern, and the excess clay is removed.

This mirror by Lynda Katz will also be a toothbrush holder. Here the form which will hold the brushes is being cut from a slab of clay.

259

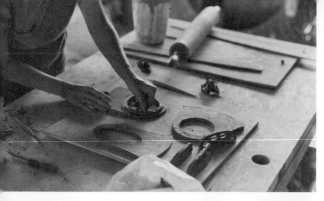

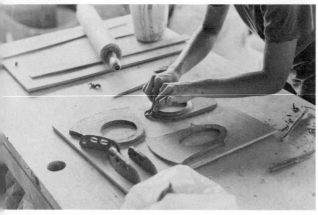

A rim of clay, which will hold the mirror, is added to the slab. The clay is carefully joined, making certain that no air is trapped.

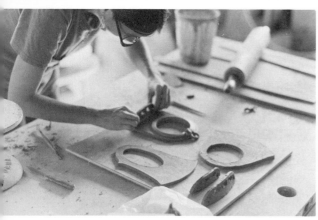

A loop of clay, from which the toothbrush holder will hang, is added at the top of the mirror.

The slab that will hold the toothbrushes is added with slip, and all edges are smoothed and rounded. The entire piece is then dried and bisque fired. It is then glazed and fired again. A circular mirror is inserted from the back and held permanently in place with clear two-part epoxy adhesive. The entire back of the mirror is then covered with felt for protection.

Finished hand-built stoneware mirrors and toothbrush holders (8″ tall) by Lynda Katz. *Photos courtesy: Lynda Katz*

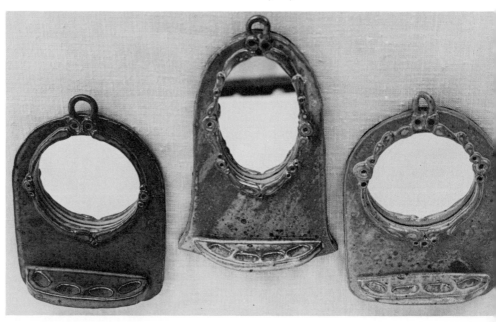

Circular ceramic slab mirror suspended by cord knotted at the temples.

Sheila Speller's slab mirrors were designed in the Art Deco style. The round is 20″ in diameter. The rectangular piece is a hand mirror, 6″ × 8″. *Courtesy: Sheila Speller*

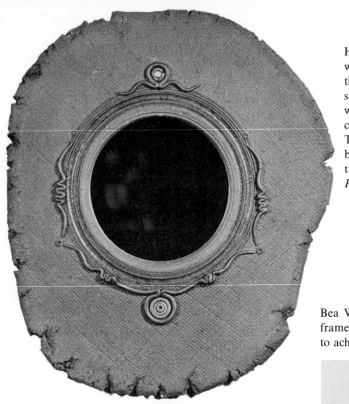

Herb Schumacher allows the cracks in the edges—which result from rolling the slab to an even thickness—to become part of the design. The surface of this mirror frame has been given a woven texture by pressing a rough fabric into the clay (on a bias) to impart the pattern of the fibers. Thin clay coil squiggles pressed gently onto the body (9″ diameter) emphasize the mirror aperture. *Courtesy: Herb Schumacher, Chalk Creek Pottery*

Bea Wax impressed this asymmetrical ceramic mirror frame with a variety of stamps, dies, and random forms to achieve this rich surface. *Courtesy: Bea Wax*

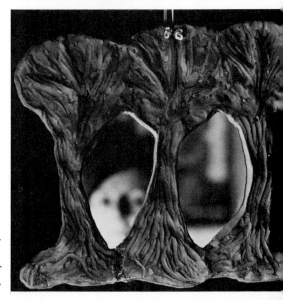

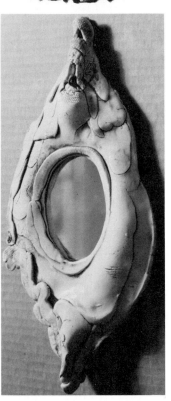

In contrast to the highly developed surface of her other work shown here, this slab form by Bea Wax has a smoother surface, more flowing lines. Layers of clay slabs and coils are both the structure and design of the piece. *Courtesy: Bea Wax*

Susan Felix chose to suspend this mirror by a leather thong knotted at the front through two holes in the slab. This piece, with its distinctive rough texture, looks as if it were carved. *Courtesy: Susan Felix. Photo: Sandy Solmon*

Right:
Hands and arms constructed of clay slabs reach out from this expressive mirror frame.

Below:
A ceramic mirror by Florence Cohen. *Courtesy: Florence Cohen. Photo: Steve Bernstein*

Below right:
Erni Cabat's philosophy is to invite participation in the form by providing "receptacles" for dry arrangements of candles, flowers, and weeds, and holes for beads and baubles. *Courtesy: Erni Cabat*

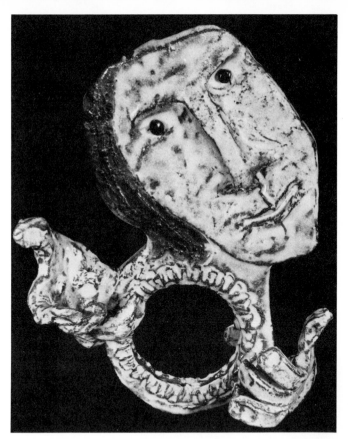

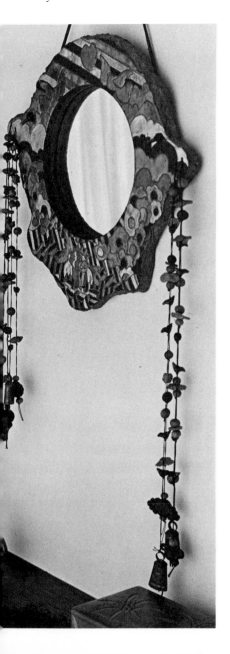

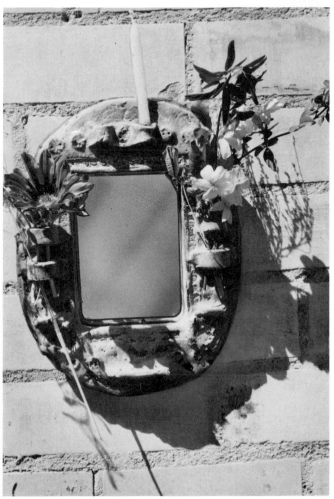

Molding and Draping

Slabs of clay can also be pressed into molds or draped over or into a form. The clay will conform to the new configuration. When leather-hard, the new shape will be maintained.

Thrown Pieces

Clay can also be thrown on a potter's wheel. As the wheel revolves, centrifugal force causes the clay that is centered on it to move outward. This is probably the clay-forming skill that requires the most practice. In order to create a rounded form, all that is necessary is to increase the outside pressure; one hand is placed outside and the other inside the container, with the one inside slightly above the other. This forces the clay outward. Narrowing is accomplished by moving the inside pressure above the outside so that the final pressure is on the outside; or by collaring, which is the application of pressure with both hands around the outside with no inside pressure.

THROWING A MIRROR FRAME BY JAN AXEL

Prepared clay is secured to a plaster bat, which is attached, in turn, to a wheel. *Photos in this series by Robert Axel*

The mound of clay is centered on the bat by raising and lowering it until it ceases to wobble.

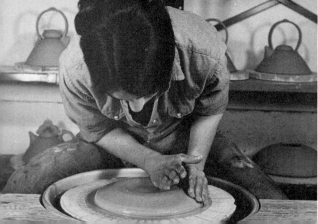

The clay is flattened and compressed to the desired base size.

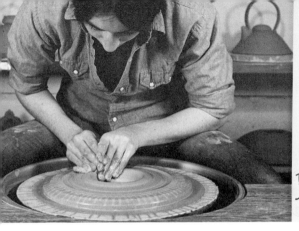

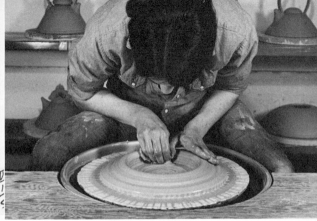

A well is made to open the clay form.

The clay is opened to the bat and the base is compressed and expanded to form the walls of the frame.

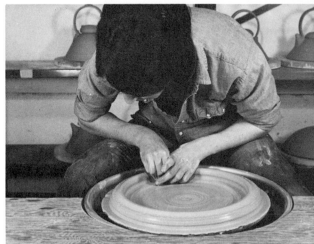

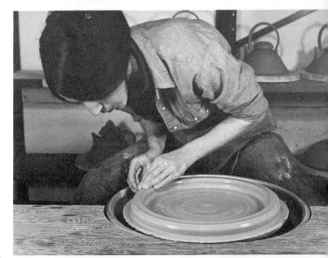

The frame is then shaped, first by hand and then with the aid of a tool.

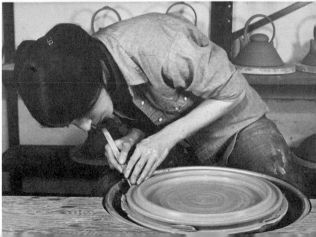

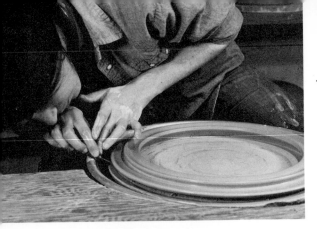

The outside shape is tooled.

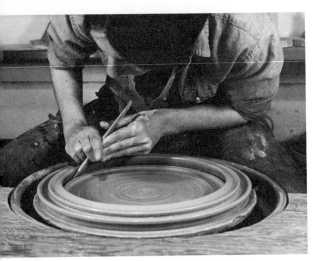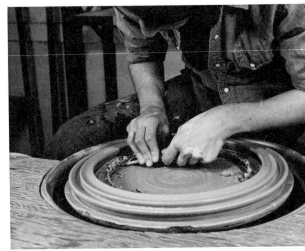

Excess clay is loosened from the inside of the frame . . .

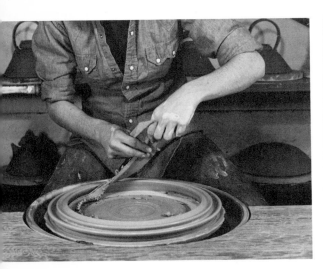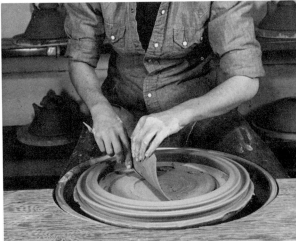

. . . and lifted out.

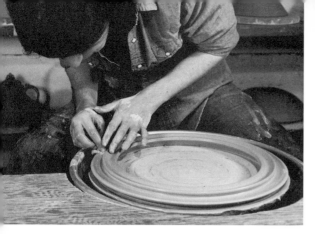

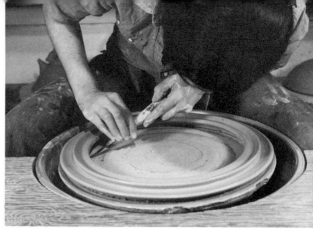

The outside of the frame is given a final shaping using a soft, wet sponge.

The frame is loosened from the bat.

The bat is removed from the wheel and set aside in order to allow the frame to dry slightly.

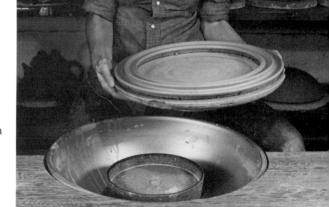

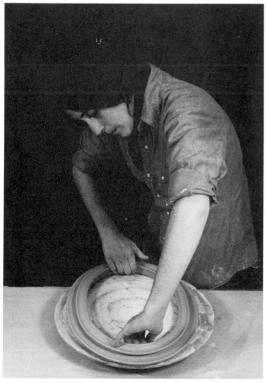

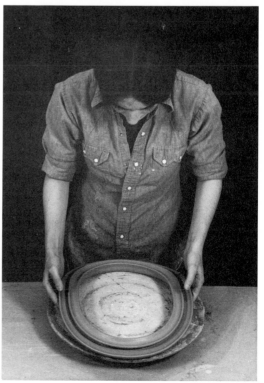

The frame is shaped into an oval by pulling and then gently easing in the sides. Care must be taken to avoid distorting the surface and shape.

Clay is forced into a plaster press-mold from which it will gain a decorative shape.

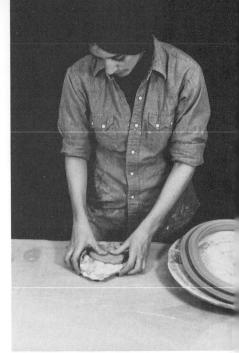

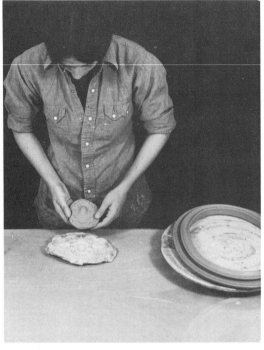

After several minutes the clay is removed and smoothed. Excess clay is cut away from the perimeter of the ornament . . .

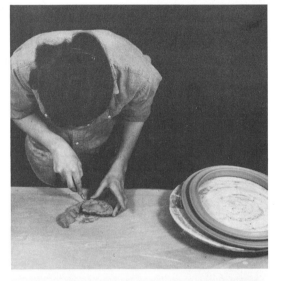

. . . and the decorative emblem is attached to the frame.

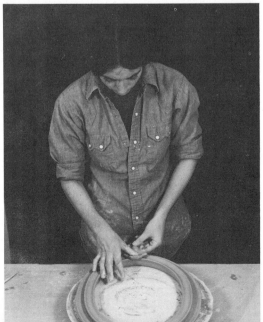

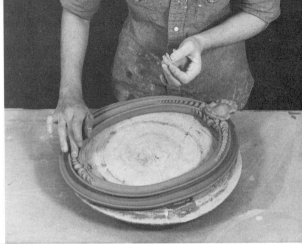

"Sprigs" are added . . .

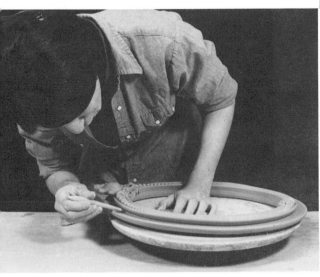

. . . and a needlelike tool is used to make holes for feathers that will embellish the finished mirror.

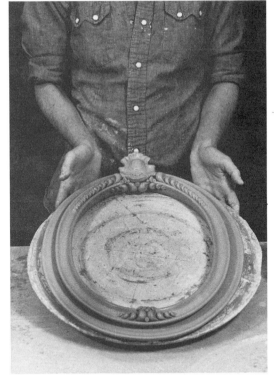

The finished piece in wet form. The frame is dried slowly, and when it is completely dry, it is bisque fired to cone 06 for easier handling.

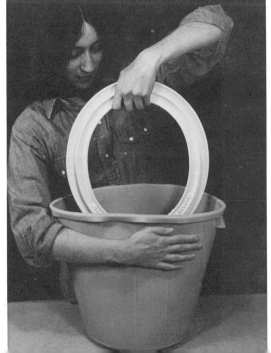

The bisque-fired piece is dipped into a bucket of glaze and fired again to a high temperature. Then lusters are applied and the work is fired once more, but this time to a very low temperature.

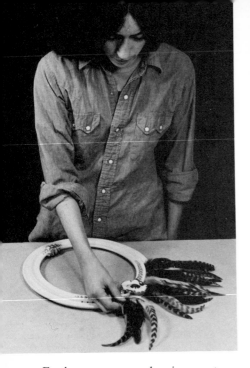

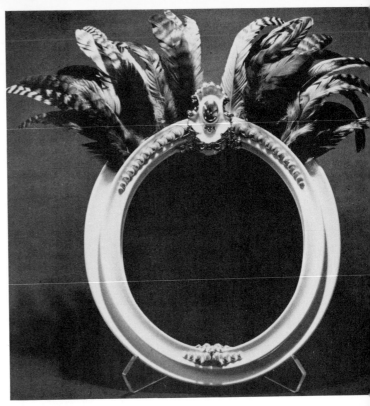

Feathers are secured using a strong adhesive, and the mirror is set into place.

The completed mirror (12″ × 18″) by Jan Axel, in porcelain with lusters and feathers. *Courtesy: Jan Axel*

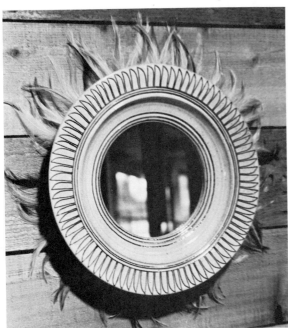

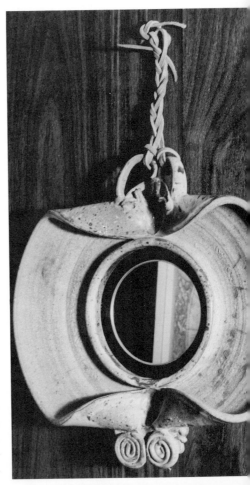

This thrown mirror frame (16″ diameter) by Bob Richardson is stoneware (cone 10) decorated with white glaze, gold luster, and feathers. *Courtesy: Bob Richardson. Photo: Curtis E. Culp*

Angelo C. Garzio distorted this wheel-thrown stoneware wall mirror (14½″ diameter × 3″ deep) by pinching the edges on the vertical axis in toward the center. The decorative elements were pulled and coiled. The piece was reduction fired to cone 09 with yellow-orange glaze and suspended from a laced leather thong. *Courtesy: Angelo C. Garzio*

Coiling

Another approach is to employ coils of clay. Each coil may be aligned, edges touching, and pressed into abutting coils to effect a bond, or a pastelike clay may be used to fill spaces. The shape may be controlled by varying the thickness or character of the coils or clay. Carol Jeanne Abraham employs a unique coiling material and technique: thixotropic porcelain, which is shaken, folded, and pulled to create the mirror frame.

A PULLED MIRROR FRAME OF THIXOTROPIC PORCELAIN BY CAROL JEANNE ABRAHAM

Because thixotropic porcelain is a fragile material, these mirrors are made directly on kiln shelves, covered with 3–4 layers of newspaper. Since clay shrinks only 4 to 6 percent, the exact mirror size is drawn onto the newspaper. *Series courtesy: Carol Jeanne Abraham. Photos: Boyd D. Redington, SUSC Photo Service*

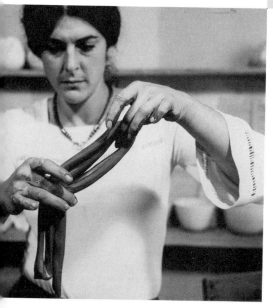

Linear patterns are created in the clay by shaking the porcelain and folding it into coils again and again as it flows.

The porcelain is shaken and folded many times until numerous coils are joined.

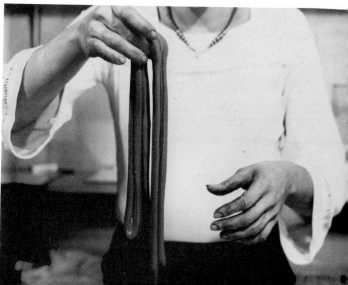

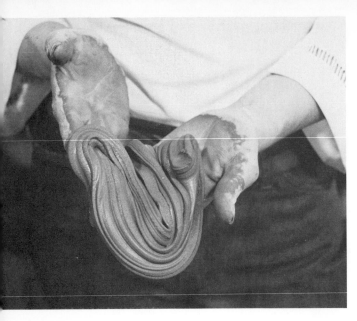

As the clay is folded and softly shaken, many patterns are formed and larger units adhered to one other.

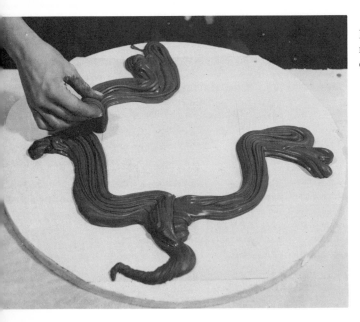

Each group of shaken coils is placed on the newspaper-covered kiln shelf so that it slightly overlaps the outline of the mirror.

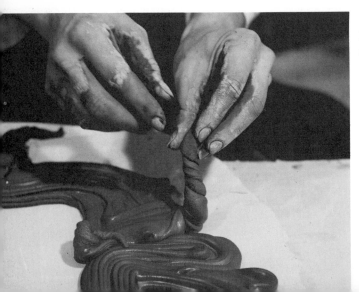

Hornlike decorative elements are formed by shaking and twisting the thixotropic porcelain.

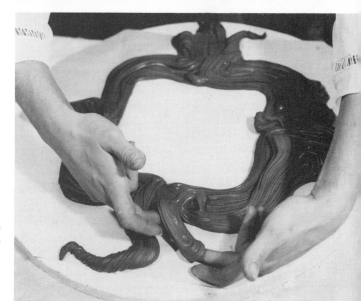

The design and structure of this frame is developed by further shaking and pulling the clay in specific areas.

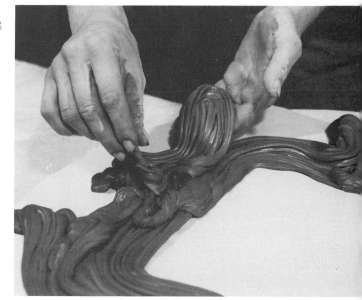

Width of the frame is increased by adding coils of porcelain to the outer edges.

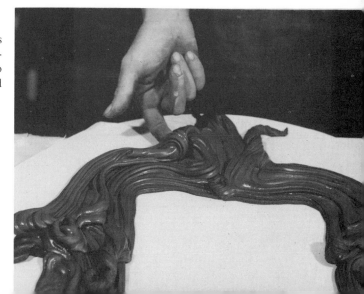

Finishing touches to the decorative elements are made and controlled by placing one finger-nail under the specific portion of the frame to be worked and then lifting, shaking, and pulling the porcelain.

273

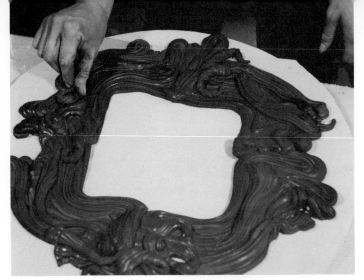

Details are added by wetting the surface of the clay, shaking and twisting a coil, and touching the two clay surfaces together.

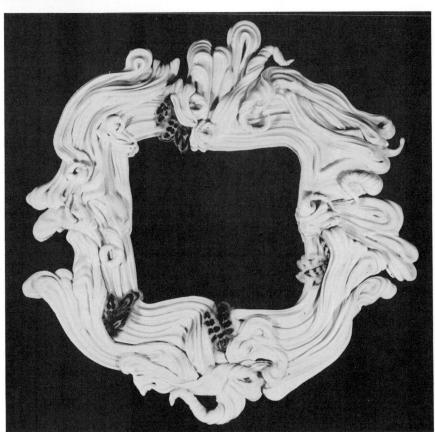

The finished mirror frame of thixotropic porcelain by Carol Jeanne Abraham.

Composite Mirror Frames

Of course, many different techniques may also be combined in a single work. Thrown units might be appended to slab forms or molded pieces. The composite method invites a sculptural technique and permits the construction of extremely large pieces.

274

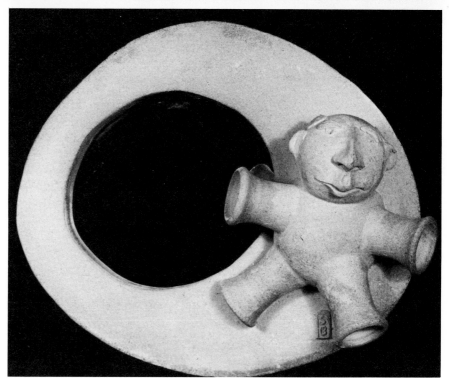

A slab mirror with a unique figure constructed of thrown and sculpted elements.

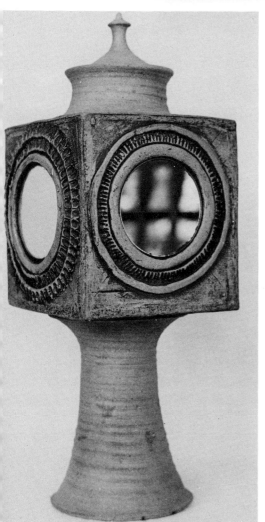

Lynda Katz combined hand-built and thrown elements in this lidded stoneware jar with mirrors (19″ high). *Courtesy: Lynda Katz*

Sue Wrightsman's inquisitive people are perched upon this slab constructed mirror. *Courtesy: Sue Wrightsman*

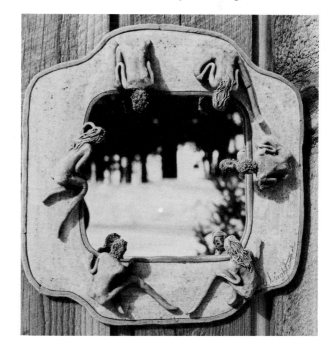

INTEGRATION OF THE MIRROR

Both glass and acrylic mirror may readily be employed within ceramic mirror frames. The key is to anticipate the method of attachment. Some mirrors may lend themselves to the integration of a rabbet into the back of the frame, within which the reflective material may rest securely. The mirror may then be held in place by caulking, a silicone sealant, adhesive backing, or a two-part epoxy adhesive. If a rabbet is impractical, a ridge of clay might be added to the back of the form. And, of course, if the material or the design will admit of neither solution, the mirror may be affixed directly and held in place entirely by the adhesive. As in all mirror designs, the reflective materials must be integrated into the overall form.

DECORATION

After the basic form has been created, pieces can be further individualized through decoration. Most mirrors may be complete with the application of a suitable glaze. Others will require further embellishment. Pieces may be press-molded by pressing a dab of clay into a mold and then superimposing it onto the mirror form. Bits of clay can be carved away. Or by marking, designs can be incised into the body of the mirror. Tools such as saw blades can be used to impart texture. Patterns can also be made by pressing a form (wood, wire, burlap, etc.) into the clay, leaving the impression of that material. Slip, a water-diluted mixture of another clay color, can be painted onto the surface before the form has been fired. Sometimes scratches in the slip are used to reveal the undercolor in a process called sgraffito.

Glazes

Glazes are essentially glass. Glass is made of silica, which can be found in sand, flint, and quartz. Firing to about 1800°C. will melt these materials into a glaze. To raise or lower the melting point of silica in order to make the silica compatible with the clay body, fluxes are added. Lead, soda ash, potash, lime, or borax are commonly employed fluxes.

In order to avoid stresses in the cooling and heating process and effect a permanent bond of the glass (glaze) to the clay body, some flint (glass) is added to the clay body and some clay body to the glaze. This helps to overcome compatibility problems. Therefore, glazes consist of silica, flux, clay, and coloring materials.

The principle of applying glaze to a biscuit piece (unglazed form after first firing) is to apply (by spraying, dipping, pouring, or brushing) nonsoluble materials in a water body so that the water is absorbed by the thirsty surface of the fired clay, leaving the insoluble glaze material on the surface. In effect, the surface is sucking on the glaze coating. To make water-soluble materials into water-insoluble ones, the substance—soluble potash or borax and flint—is melted in a crucible and shattered into fine particles by pouring the hot melted frit into cold water.

Color is added to glaze with the addition of metal oxides (which do not burn away in firing). Oxygen in the air from water in the air combines in various proportions with metal oxides to form color. These colors vary greatly, depending upon the amount of oxygen permitted in the kiln (oxidizing atmosphere). If oxygen is excluded from the kiln altogether, as in reduction firing, the oxygen-hungry molecules, starving for oxygen, will seize oxygen from any source. Therefore, if a glaze contains iron oxide, the oxide is "stolen," producing a celadon green, whereas the usual final color of iron oxide in an oxidizing atmosphere is a tan or brown.

Glazes can vary considerably in texture, from transparent glazes with glossy or matte finishes in various colors, to opaque glazes (addition of about 10 percent tin oxide) that produce a dense glaze. Introducing salt into a kiln atmosphere at about 1200°C. will cause the salt to vaporize, resulting in the production of hydrochloric acid and soda. These materials react with the chemicals (silica, flux, and oxides) in the clay body to produce a rough textured glaze.

If a glaze does not fit the clay body, then all kinds of surface aberrations occur. Crazing, peeling, crackle, and crawling are some of the effects. Sometimes they are considered desirable, other times not—depending on the design, purpose, and statement.

Specific glaze formulas are plentiful in the many books dedicated to both that topic and ceramic materials generally. Special luster glazes—which impart a highly reflective surface to the ceramic, nearly making a mirror of the glazed clay—are of particular interest. These are being employed with increasing frequency. Although the images such reflective surfaces produce may not be optically accurate, they certainly achieve the reflective effect.

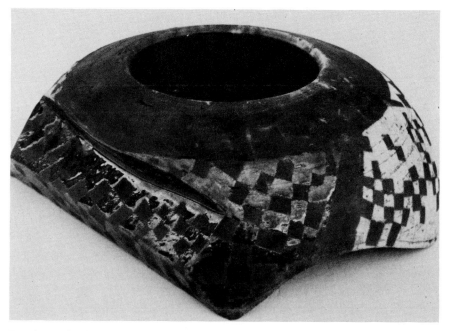

Penelope Fleming employed highly reflective metallic luster glazes in contrast to a black glaze in this sculptural raku form. *Courtesy: Penelope Fleming*

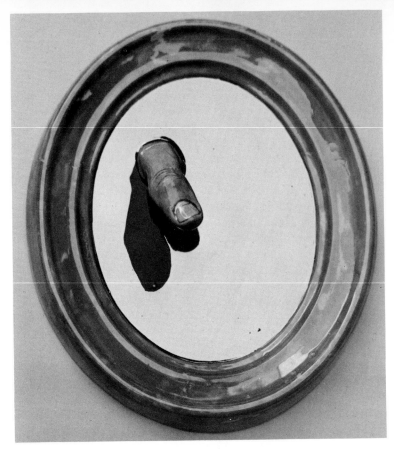

In *Shadow Regression* (1974) (12″ × 9″) by Lukman Glasgow, a thumb emerges from a mirror of metallic salts luster. One shadow is part of the piece. *Courtesy: Lukman Glasgow*

CERAMIC PROCESS IN SUMMARY

Gathering clay: china clay, porcelain, terra-cotta, ball clay.

Gathering additives to mix clay body: silica, grog (ground-fired clay), flux, clay, metal oxides.

Optional: purifying clay—removal of impurities by soaking, adding other ingredients, such as water.

Conditioning clay: pounding, kneading, wedging.

Shaping clay: slab, draped, molded, coiled, thrown.

Drying of clay form: first at room temperature and then in a warm spot.

Form fired in kiln: removing water driven off, chemical changes occur; surface becomes irreversibly hard.

Result: bisque, or biscuit, pottery—porous form with unglazed surface. Terra-cotta or earthenware can be complete at this stage.

Biscuitware glazed with water-suspended particles of glass by spraying, dipping, pouring, brushing.

Glaze dries at room temperature.

Mirror form placed in kiln a second time—temperature buildup in kiln varies with clay body and type of glaze.

Powdered glass ingredients melt and fuse to clay body.

Form completed: mirror set in place and affixed.

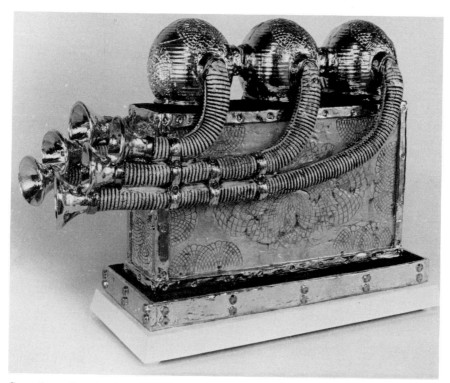

Ceramic sculpture glazed with highly reflective metallic lusters by Greer Farris.
Courtesy: Greer Farris

STAINED-GLASS MIRRORS

THE BEGINNINGS OF THE STAINED-GLASS CRAFT HAVE BEEN OBSCURED BY TIME. We do know that the windows of Hagia Sophia at Constantinople were glazed but not whether the original glass was colored. Leaded stained glass probably did not emerge until several centuries after the advent of Christ.

Legend accounts for the discovery of gold-colored glass. A young Franciscan brother working in the craft was, apparently, about to place some painted pieces of glass in the kiln when he was called from his work. As he rushed away, a silver button loosened from his clothes and fell on one of the pieces. When the glass was fired, a lovely yellow stain spread where the button had rested. That craftsman, Blessed James of Ulm, is the patron of glassworkers.

From clear and bright yellow glass, a complete range of richly colored glasses was developed. The good Abbot Suger of St. Denis played an important part in shaping the development and interpretation of stained glass during the twelfth century. The cathedral at Chartres is a treasure-house of twelfth- and thirteenth-century jeweled windows. Their full, brilliant color rivals the work of every age.

From the laborious process of painting each piece of glass in order to stain and color it, artisans developed other techniques, and during the nineteenth century Louis Tiffany and his contemporaries learned how to make translucent glass, thereby eliminating the costly and time-consuming process of painting each piece by hand.

Stained glass, of course, is best known for its use in windows and lamps, but contemporary glassworkers have adopted the use of mirrored glass to a great, and increasing, extent. In fact, at a time when stained-glass windows are becoming more rare, stained-glass mirrors incorporating mirrored glass are beginning to be created in a wide variety of shapes and sizes. Because glass mirror is worked in precisely the same manner as is stained glass, the combination of the two materials is a natural one.

No matter what form stained glass and mirror work takes—and the products may range from hand mirrors to windows and decorative screens—it all exhibits a consistent goal: to display as much glass as possible with a minimum of connecting framework. It makes good sense, after all, to attempt to maximize color and to minimize the interstitial elements that support the form. Both traditional and contemporary working processes are calculated to achieve such results.

The most traditional method of constructing stained-glass forms—lead caming molded, cut to size, and soldered in place—is still employed and remains virtually the same technique as has been used for centuries. But an equally valid and an often more flexible alternative has emerged: the use of adhesive-backed copper tape. This material was originally developed for electricians, and it is still used primarily by them. But for glass craftsmen it has meant a new way of working, an easier means of creating stained-glass forms, which might never have been produced at all using the traditional technique. Most contemporary workers in stained glass have embraced the new method; it extends the range of expression that is open to them without sacrificing aesthetics.

MAKING THE PATTERN

The first step in making any stained-glass form is to plan it carefully. Although many mirrors will lie flat, other forms will be three-dimensional, particularly containers embodying mirrored elements, and those must be conceptualized as objects in space rather than as two-dimensional transcriptions of a drawing. In addition, because most stained glass embodies patterns of texture and color, the flow of that grain and color should be planned in order to use these natural variations to the best advantage. To achieve this, craftsmen cut apart their overall pattern to obtain patterns for each individual piece, which are then laid upon the glass, traced onto it, or made to adhere to it temporarily in order to provide a reference for accurate cutting.

Depending on the design and its tolerances, extra space may need to be allowed for between pattern pieces to accommodate lead cames or copper tape. The scissors used by glass craftsmen, therefore, often have a special feature: a third blade that cuts a thin sliver from the edge of the paper pattern to allow for the supporting material that will wind between the pieces of glass. Trimming with a standard scissors can accomplish the same result. However, that technique and device was developed for use with traditional lead caming; since copper tape is considerably thinner, this accommodation is less crucial and will be unnecessary in many instances.

Patterns, of course, should be saved whenever possible for reuse or adaptation. Many craftsmen save the original sketch and transfer the pattern to light cardboard or construction paper, which is then cut apart to provide a working pattern of individual pieces; those pattern units are saved as well.

A STAINED-GLASS MIRROR BY GEORGE KUNZE

George Kunze first creates a master pattern on paper.

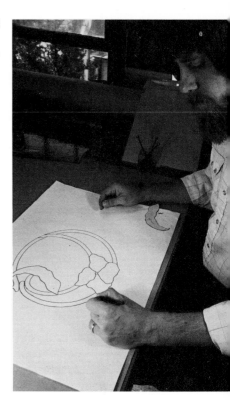

This pattern is transferred to poster paper by tracing the original over carbon paper. The individual sections are cut from the poster paper to create a template for each piece of glass. During the cutting, a sliver of paper is removed from the edge of each section by drawing a double line or by using the special scissors employed by glass craftsmen, in order to accommodate the copper tape. Both the original pattern and templates are saved for future reference and use.

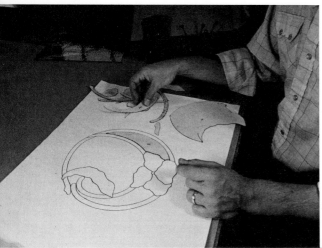

George Kunze transfers the shape of each section directly onto the stained glass by tracing around each template with a fine-tip marking pen. The distinctive grain and pattern of the stained glass is considered within the context of the overall design in determining how to trace and cut each piece.

TYPES OF GLASS

Workers in stained glass use primarily two types of glass—transparent and translucent—but within the two categories there is an enormous range of colors, grain, thickness, intensity, and purity. Because such variety exists, craftsmen generally plan a design not only for the structure of the form but also for the qualities of the glass that will be used to execute it. Subtle changes in coloration or intensity of color may provide useful transitional devices—and understanding of such variations in a piece of glass will prevent undesirable combinations as well. Just as caming and copper tape provide a pattern and a structure to stained-glass forms, so do variations in color, grain, and pattern of the glass. Use of those elements can create rhythms and excitement quite apart from (and in addition to) that achieved by the shape of the form and the combination of individual pieces of glass.

Similarly, the type of mirror that will suit a particular design or application must be given careful consideration. In addition to silver color mirror and a wide range of other colors (made by silvering the back of stained glass), mirror is available in many textures and with special effects, as in the veined or speckled mirrors that are frequently employed to achieve an "antique" look. (See Chapter 3 on basic materials.)

Both stained glass and mirror are available from specialists in those materials found in every large city. Many such specialists in the stained-glass field offer only the glass of a particular factory or a single country. Use the telephone directory to locate sources. In addition, discarded stained-glass panels and lamps may offer a further source of materials. Conservation of natural resources and energy can be achieved effectively by reusing glass from damaged pieces.

CUTTING GLASS

Stained glass is cut in the same manner as glass and glass mirror. See Chapter 3 for a discussion of the glass-cutting process.

After tracing the shape onto the glass a line is scored to create a piece of glass somewhat larger than this particular shape. The glass is tapped gently but firmly on the underside of the score line with the ball end of the glass cutter . . .

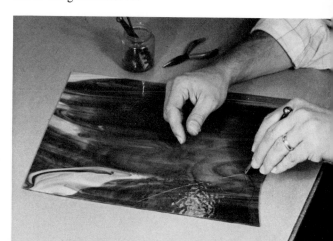

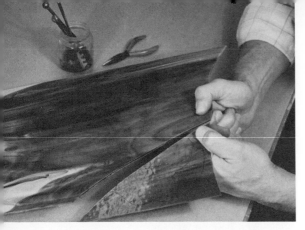

. . . and the section of glass containing the pattern of the desired piece is broken away. First the larger area is cut because when, as here, the shape includes complex curves, fine cutting is more readily accomplished on a smaller unit, as shown below. George Kunze uses a Fletcher glass cutter with a replaceable wheel. The cutter should be stored in a jar lined with enough steel wool to cover its bottom and filled with enough kerosene or kerosene and 3-1 oil (in a 50/50 mixture) to cover the wheel axle.

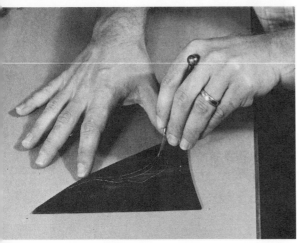

The outline of the glass shape is scored, and a series of "parallel" curves are scored in shallower arcs to relieve the tension that would be placed on the glass were the delicate concave curve shown on the pattern to be broken directly.

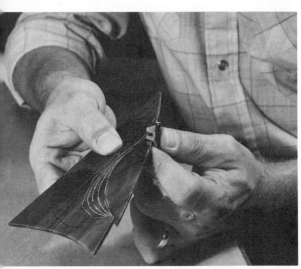

Sections are broken away one at a time at each of the parallel curves, using the teeth of the glass cutter to provide leverage . . .

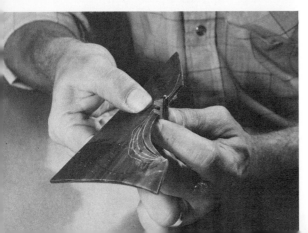

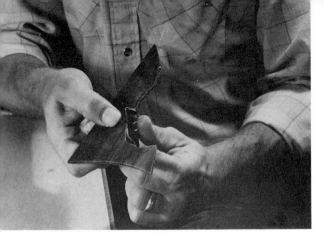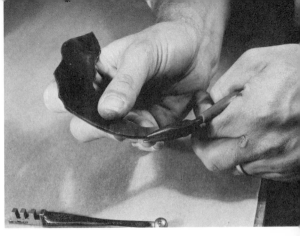

... until the desired curve has been reached. George Kunze files and nibbles the edges gently with the back of the glass cutter to eliminate any sharp, rough ridges.

The remaining portion of the pattern is scored and excess glass broken away. Pliers are used to aid in gripping and breaking the smaller pieces and those pieces that do not break easily.

ATTACHMENT TECHNIQUES AND CONSTRUCTION

There are, essentially, two alternative attachment techniques for stained glass. One, the traditional method, employs lead caming. The nontraditional alternative is adhesive-backed copper tape. Both are valid techniques. Lead caming is still used extensively in larger stained-glass forms, but, increasingly, skilled craftsmen are employing copper tapes on smaller forms. The reasons for this shift in materials are clear: Although lead provides great strength, copper tape is a faster, easier material to work with, and it is lighter, a benefit on smaller forms. Actually, copper tape allows craftsmen to achieve results that might be difficult or impossible to obtain with traditional lead caming. Curved and intricately shaped forms, difficult to contain with lead, are readily built using the newer technique. Of course, curves are possible with lead too, but they usually require a larger diameter. Except for very large forms, copper tape should be considered a primary working technique, a method that professional craftsmen now employ extensively.

Lead Caming

The technique of using thin channels of lead to hold intensely colored pieces of cut glass in place is, of course, still valid and basic. The very principle forms the basis for the use of adhesive-backed copper tape. Malleable lead, though soft enough to be fit readily to the shape of the glass, allows craftsmen to tightly encase those rigid units to create large structurally sound forms. Lead caming, as these channels are called, comes in two configurations called "H" channel and "U" channel because the cross section of each is shaped like the letter. "H" channel is used between two pieces of glass within the body of a form, an edge of glass fitting into the channel on each side. "U" channel—with only one groove—is used to finish edges, usually on the outside of the form.

In the traditional working techniques, "U" channel is laid along a row of nails set into a board—they define part of the outside perimeter of the panel. Each piece of glass is individually cut and placed in position and cames are soldered into place—each with a connection to the perimeter of "U" channel—

in order to contain each unit. Meanwhile, nails are hammered into the baseboard to hold both glass and cames in position. Wherever possible, unbroken pieces of lead caming are continued throughout the panel, since continuous lengths create a stronger form than many short strips.

The preferred solder is known as 60/40, which stands for 60 percent tin and 40 percent lead. (Be certain that you use solid-core wire solder. Some solders contain a flux core, which eliminates the need to apply a flux but causes the deposition of ugly oxides on the lead caming.) Flux must first be applied to the surface of the lead in order to prepare it to accept the solder, and many craftsmen find that a liquid flux works best. Specific brands of flux are recommended for specific solders. The flux should be brushed on the caming immediately before soldering. Its function is to remove oxides that prevent chemical bonding of solder and metal.

Adhesive-backed Copper Tape

Adhesive-backed copper tape is, with little doubt, the easiest method of construction for high-quality stained-glass forms. The edges of the glass are wrapped with the tape. The wrapped pieces of glass are placed one against the other. And the tapes are soldered together to provide structural support for the piece. Because the tape is so fine and flexible, very small pieces of glass may be employed. As with lead cames, the stained-glass form may be constructed flat or over molds of plastic, metal, or wood. Soldering proceeds in precisely the same manner as with lead cames. The tape is first painted with flux, and then solder is applied—first to "tack" the pieces together at a few points and then to coat the tape entirely. The outline or shape of the solder area may be controlled and varied by trimming the copper tape, which overlays the top and bottom of each glass piece, with a sharp knife before soldering.

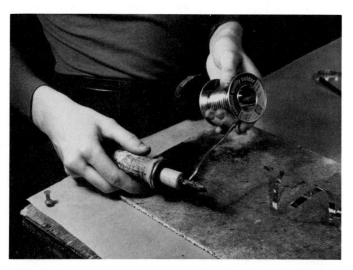

The soldering iron is heated and "tinned" with 50 percent tin/50 percent lead solder.

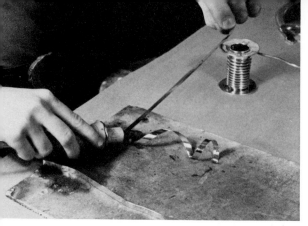

Although many craftsmen employ adhesive-backed copper foil tape and allow that adhesive to grip the glass, George Kunze employs tape without adhesive, which he makes adhere with a white glue. The reason is that when the tape is wrapped around a piece of mirror, the mirror picks up the reflection of the tape and will show a fine line of copper color at the edge of the reflection. This may be desirable in some applications, but to obtain a silver color, this master glass craftsman uses the unbacked tape, which he first tins with solder by drawing it across the tip of a soldering iron. The tin (silver) color will then be the basis for reflection, rather than the copper. He uses #.001 copper foil in a $\frac{3}{16}''$ width for normal glass (approximately $\frac{3}{32}''$–$\frac{5}{32}''$ thick), $\frac{1}{4}''$ foil for mirror glass ($\frac{1}{8}''$ thick), and $\frac{3}{8}''$ foil for the outside edge.

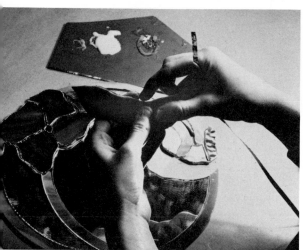

All pieces of glass are first cut to size and placed over the master pattern to make certain that they fit together precisely, with only enough space between them to accommodate the copper foil. The edges of each section are then individually daubed with just enough white glue to coat the outside edge . . .

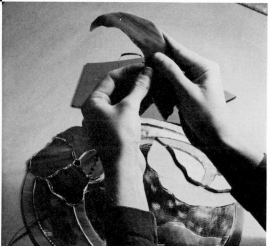

. . . and wrapped with the copper tape (tinned side in) so that the tape overlaps the face and back of the glass and so that the ends overlap slightly where they meet. The foil is then burnished against the edges and faces of the glass to conform to and snugly meet all contours. Special tools are made for burnishing, but a piece of wood cut from a dowel and made round and smooth works well, too.

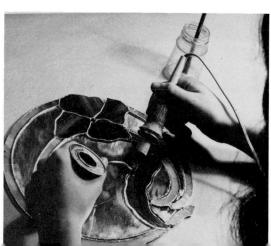

After all individual pieces of glass have been wrapped with the copper foil, they are assembled on a flat surface and roughly soldered together at the front to hold the forms in place. George Kunze uses solid core 50-50 solder, with a zinc-chloride-based liquid flux, and a 50-watt Unger #777 soldering iron with a 40-34 or 40-37 tip.

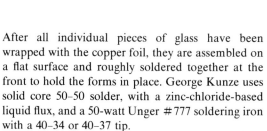

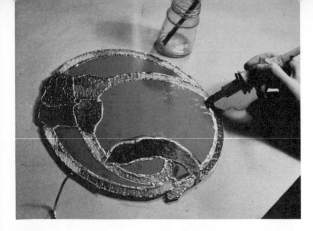

During soldering, the iron should be kept moving constantly so that heat never builds up in any one area and cracks the glass. After the front is roughly soldered, the same is done to the underside of the piece.

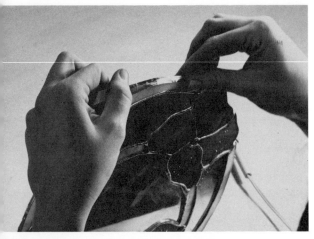

An additional band of copper foil ⅜″ wide is wrapped around the outside edge of this circular mirror to provide an accent to the form and to give additional support.

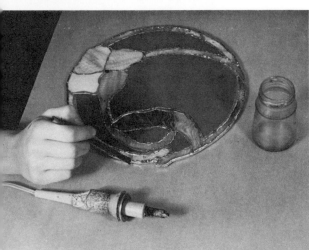
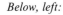

As with all application of the tinned copper foil, a white glue is first applied to the glass to aid adhesion, and the foil is then burnished to the shape of the outside edge of the mirror and the front and back surfaces.

Below, left:
A raised bead of solder is finally laid upon all seams and the outer edge for purely decorative reasons—the result is an attractive, uniform surface, Properly done, this bead will be smooth and almost hemicylindrical in appearance. To obtain a beaded edge or seam, the iron is laden with solder, held with the tip ⅛″ above the surface, and moved evenly across the seam so that the solder flows to a head. After soldering has been completed, acids that might attack the backing of the glass mirror must be removed from surfaces of the metal and glass. The solder surfaces may be cleaned with a steel wool pad, such as Brillo or S.O.S., to obtain a silver effect (since such soaps contain a jeweler's polish). If a patina is to be added, use steel wool and a strong detergent instead, since polish retards the patina. The patina applied to the solder here consists of 3 parts copper sulfate, 3 parts water, and 1 part flux. A commonly used formula, in addition to this one, is 40 percent copper sulfate solution. The patina solution is applied once by wiping on with a soft rag. The areas that received it should then be rinsed thoroughly with a strong detergent solution, and then with water applied with a soft rag.

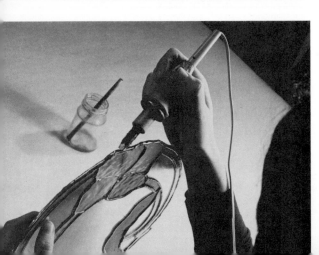

The wire rings from which this mirror will hang are made by wrapping wire around a wooden dowel several times . . .

. . . and snipping to create circular jump rings . . .

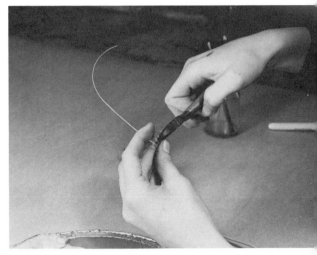

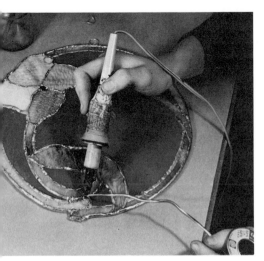

. . . which are soldered into place at two seams not adjacent to any mirror sections, at the back of the piece. The mirror may be cleaned with glass cleaner and the soldered areas shined with a silicone polish or paste wax. Mirror sections should be protected on the back with adhesive-backed felt.

The finished stained-glass mirror by George Kunze.

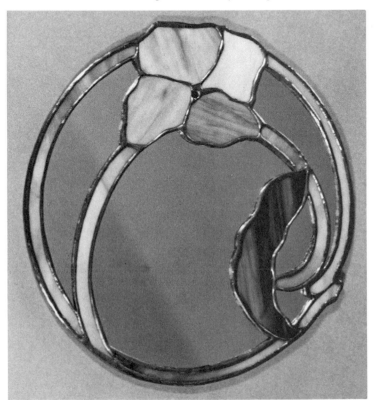

289

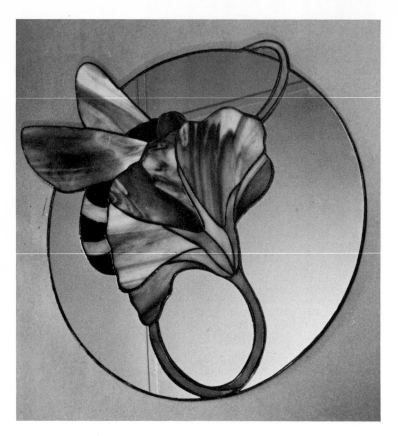

Mirrors in floral motifs by George Kunze.

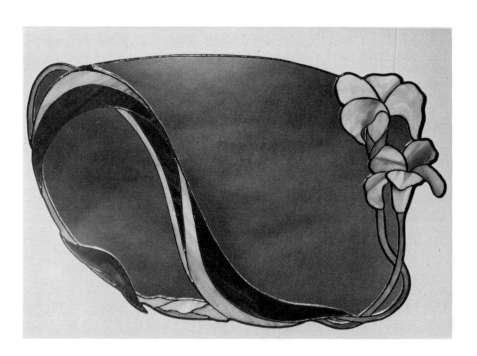

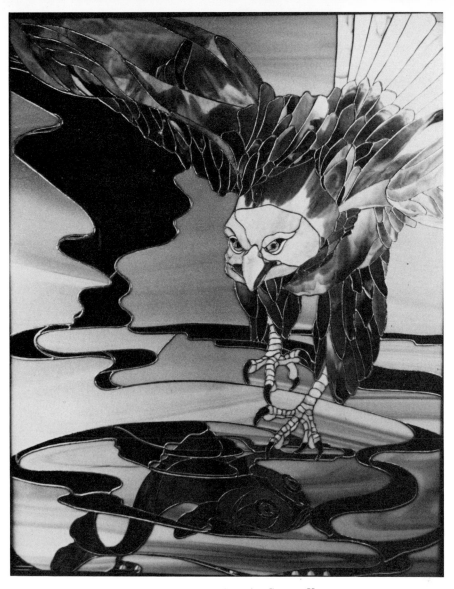

A masterpiece of stained-glass and glass mirror by George Kunze.

STEPS IN MAKING A STAINED-GLASS MIRROR WITH ADHESIVE-BACKED COPPER TAPE

The steps in constructing a mirror of stained glass with adhesive-backed copper tape as caming are:

1. Planning the mirror.
2. Making a paper pattern and cutting out the patterns for each individual piece.
3. Cutting the glass to shape with the aid of the paper pattern (as described above).
4. Grozing the edges of the glass to remove rough edges.
5. Wrapping the edges of the glass with adhesive-backed copper tape.
6. Burnishing the copper foil onto the front and back faces of the glass with a burnisher or another blunt tool.

7. Cutting away excess copper tape from the faces of the glass with a sharp knife in order to create a finer line (optional).
8. Placing the pieces adjacent to each other so that they meet.
9. Painting the surfaces to be soldered with flux.
10. Tacking the pieces together with solder at two or three points to hold the glass in place.
11. Soldering the form fully, first on one side, then on the other.
12. Finishing the soldered areas.

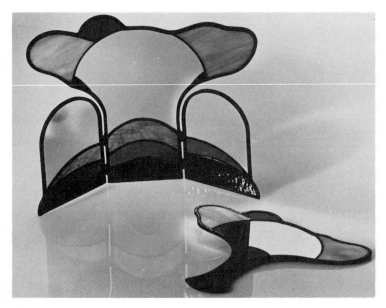

Small Clouds Three, stained-glass screen (12″ × 16″), and *Clouds,* hand mirror (12″ × 13″), by Frank Wright. *Courtesy: Frank Wright*

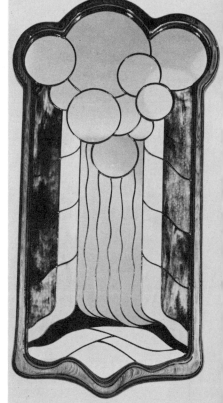

By a Waterfall (5′ × 2′8″), stained-glass and mirror panel by Frank Wright. *Courtesy: Frank Wright*

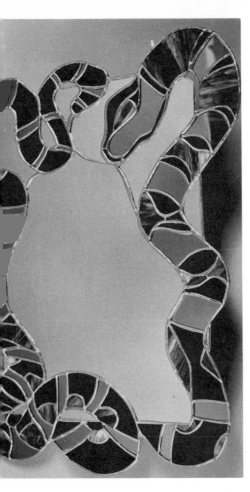

Snake Mirror (12″ × 20″) of black-tinted and green-tinted glass mirror, and variegated opalescent stained glass, by Carol Sitarsky. *Courtesy: Carol Sitarsky. Photo by Barrett.*

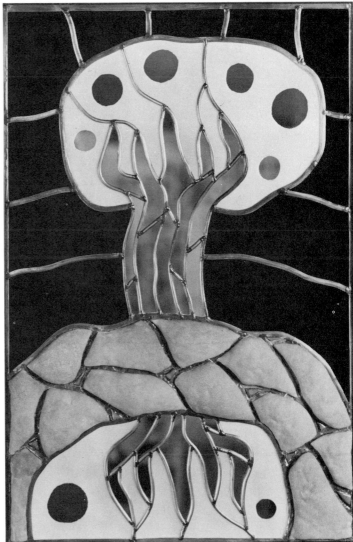

Ching/Tree-well by Beverly Reiser is a combination of mirror with sandblasted detail, black glass, and ceramic relief, contained by lead. *Courtesy: Beverly Reiser. Collection of William Henderson*

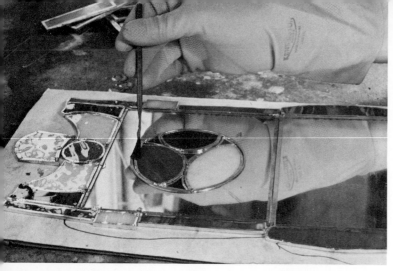

Malcolm Fatzer's technique for creating the tour de force of a circular hole within a piece of glass mirror is illustrated in Chapter III. Once such a space has been created, many design possibilities exist. Here Malcolm Fatzer fills this space within a mirror with foiled stained glass.

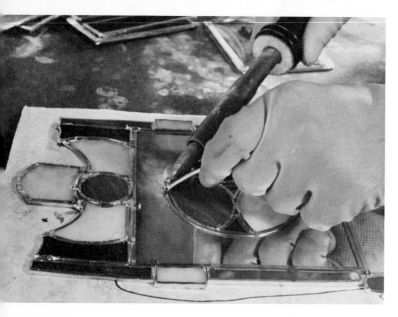

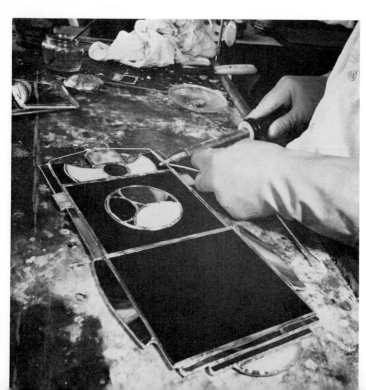

294

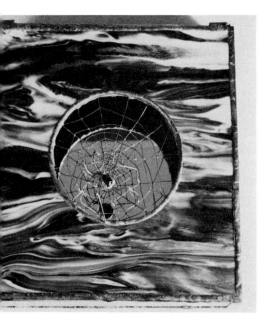

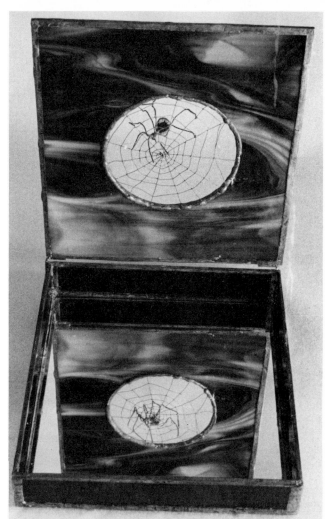

Other treatments are possible too. In this stained-glass box with mirrored bottom, Malcolm Fatzer has constructed a web of fine wire—and a jeweled spider to inhabit it.

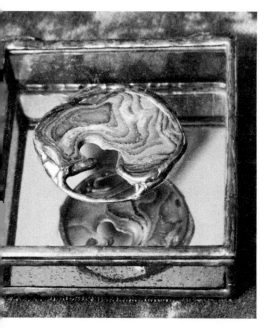

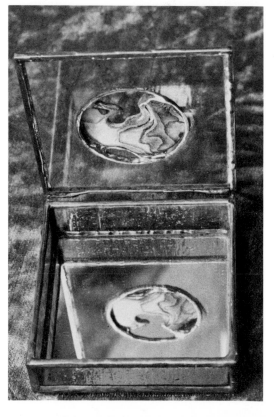

Judith Anderson and Scott Bliss employed the same basic unit with an attractive piece of glass that only partially fills the space. The clear glass top and mirrored bottom of this container allow the viewer to see the reflection of the underside of the lid even when the box is closed.

This *Green Box* (8″ × 8″ × 4″) of antique green glass and green-tinted mirror, by Carol Sitarsky, further illustrates the reflective possibilities of combinations of mirror and transparent stained glass.

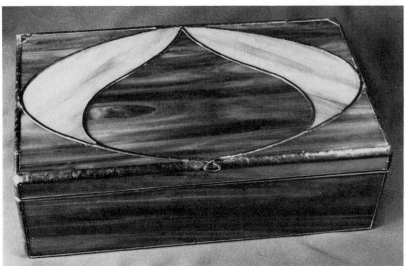

This striking stained-glass chest employs glass mirror internally—on the bottom and in the removable divider tray.

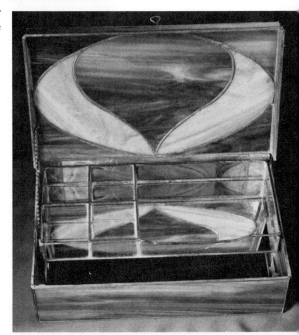

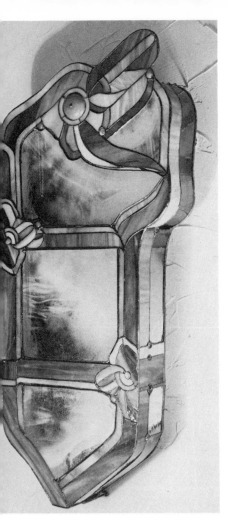
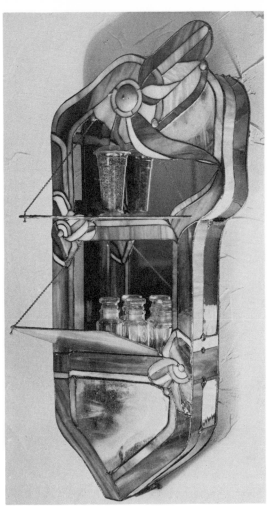

Carol Savid's wall-mounted stained-glass cabinet makes use of mirror too—and shows both the decorative and practical potential of the medium as an interior material that enlarges and enhances small spaces.

Malcolm Fatzer's marvelous street scene makes innovative use of both stained glass and mirror.

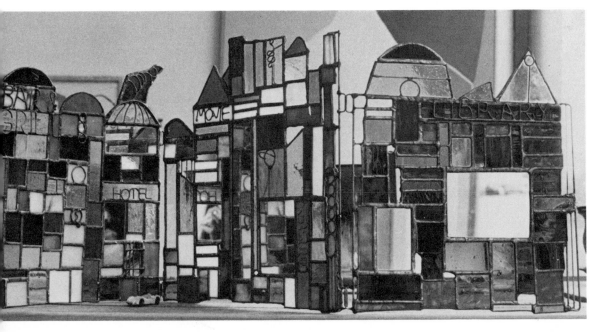

10

A GALLERY of MIRRORED, REFLECTIVE ART

"Mirrors should reflect a little before throwing back images."
—JEAN COCTEAU, *Des Beaux-Arts*

WHEN THE ARTIST USES REFLECTION AS HIS MEDIUM, THE VIEWER MUST anticipate something more than a simple looking-glass image.

A number of contemporary artists masterfully manipulate the reflective properties of mirror celebrated in this book. Some exalt mirror's illusory depth and illusory light. Others use mirror to approach infinity. Reflective materials—just like oil paint, clay, or wood—have their own vocabulary of textures, feelings, ways of being worked. In chrome plating, the reflection can be as hard and glimmering as new machinery. Cut glass mirror can present fractured images or redouble images to present new meanings—as in works by Samaras and Bridenthal. But the mirror medium can also be lighthearted—like a fried egg of chrome by Dennis Ching.

Artists have diverse attitudes toward the reflective medium. Some respect mirror's ability not just to reflect but to reflect with precision and untiring repetition. Others pay homage to mirror's power over that narcissist in each of us, over our own self-image, over our introspection. Many artists articulate their concern about reflection. Mirrors *seem* to speak the truth—except everything's in reverse. We *think* we gain understanding by looking in the mirror, but all the time that two-dimensional panel is deceiving us. The inverted self does not exist, after all.

298

So whereas some artists may emphasize mirror's positive attributes, others—like the surrealist Man Ray—mock our mirrored pleasures. They laugh at our vanity by perverting the looking glass in innumerable ways. Sometimes we are unwittingly thrown into the artwork by mirrors. We are exteriorized, made part of the art's changeable environment. Some artists use mirror to deceive us, playing optical jokes by distorting linear perspective. The mirror generates tension in their work. Eccentric mirror placement is a tool to make us doubt our already fragile view of the world. The artists tell us that the distortions they've induced are only as untrue as the simple looking-glass image we adore.

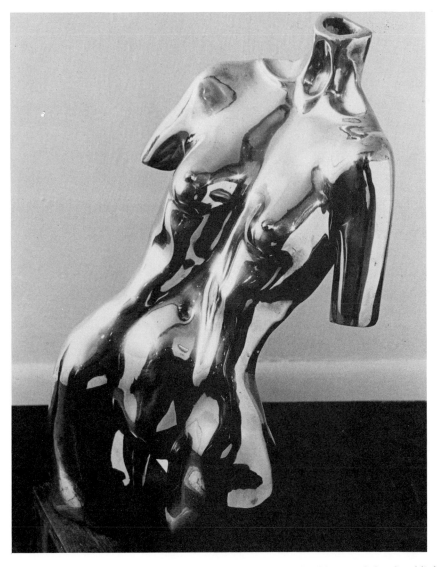

Cast bronze torso (20″ h) by Sharon Corgan-Leeber. Much of her work is of welded steel that is ground, polished, and chrome-plated to a high reflection. *Courtesy: Sharon Corgan-Leeber*

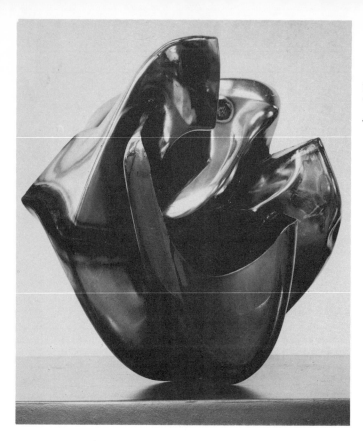

Untitled sculpture (1967) by Jason Seley. Welded chrome-plated steel. *Courtesy: Jason Seley. Photo: Charles Uht*

Optical Reflector #3 by Shirley Charron. Pewter and stained glass on a teak base. *Courtesy: Shirley Charron*

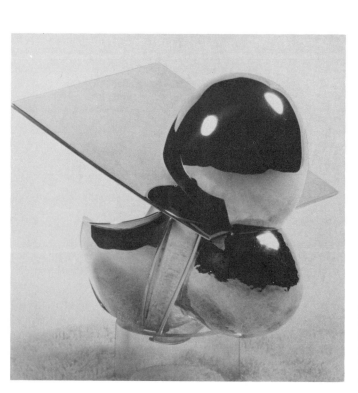

Sculptural Mirror (6″ × 5″) by Jacqueline Fossée. The sterling silver sculpture sits on an acrylic base. The bulbous forms are raised from 14-gauge sterling. Sections are then cut and soldered directly to one another. *Courtesy: Jacqueline Fossée*

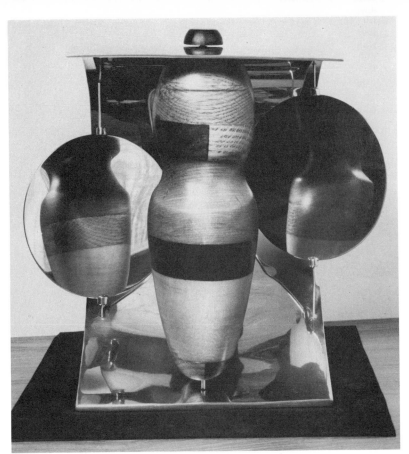

You're So Vain by Shirley Charron is also made in her medium—pewter. The figure is laminated lathe-turned wood. The figure is turned by a knob at the top of the sculpture to reflect in a variety of pewter mirrors. The piece takes a lighthearted look at man's favorite application of mirrors. *Courtesy: Shirley Charron*

Dreaming Child (1971) by Frank Mayer. A chrome baby is suspended in glycerin. The baby reflects on the walls of the glycerin-filled case.

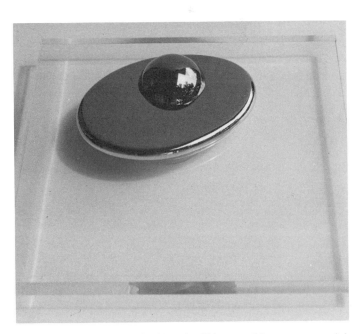

301

This fried egg sculpture by Dennis Ching combines two materials both of which produce reflections. The egg white is chrome-plated brass plate. The sunny-side-up yolk is injection-molded plastic with gold reflective polyester film. *Courtesy: Dennis Ching*

#1 Mirror (1971–73) (11¾" × 35⅜" × 27½") by Robert Graham. The fractional images produced by strips of mirror generate illusions of the two bronze figures. The illusions vary with the viewer's perspective. *Courtesy: Collection, Walker Art Center, Minneapolis*

Polyurethane foam sculptures by Hans Breder. *Courtesy: Max Hutchinson Gallery. Photos: Eric Pollitzer*

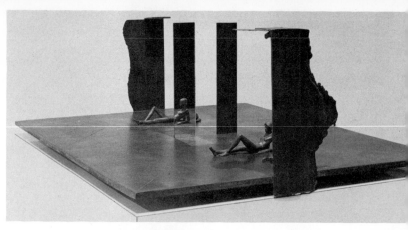

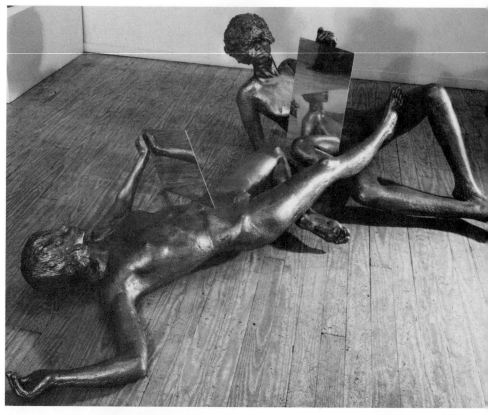

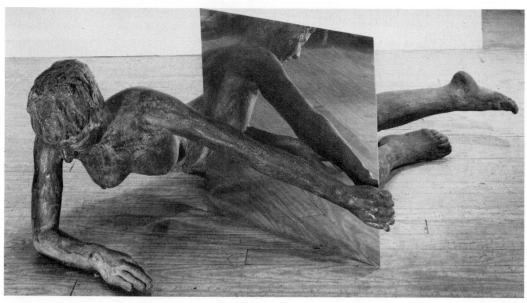

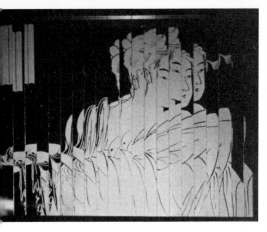

Ambivalence by Beverly Reiser is based on a portrait by Japanese painter, designer, and printmaker Utamaro of a girl he describes as promiscuous. At the same time, one gets the feeling that he is attracted to the woman in spite of or because of this. "I attempted to enlarge upon this ambivalence by repeating and cutting up and shifting the image so that the viewer is caught in putting it together while it drifts apart," writes the artist. Raw edges of mirror are part of the content and design. *Courtesy: Beverly Reiser*

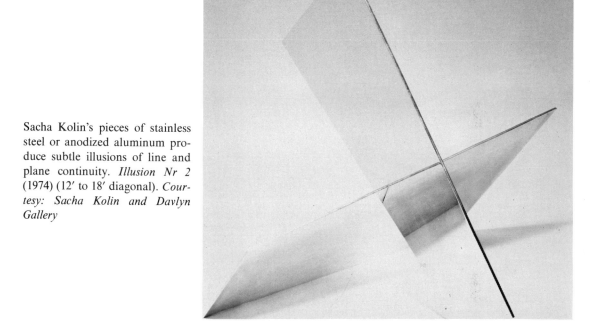

Sacha Kolin's pieces of stainless steel or anodized aluminum produce subtle illusions of line and plane continuity. *Illusion Nr 2* (1974) (12′ to 18′ diagonal). *Courtesy: Sacha Kolin and Davlyn Gallery*

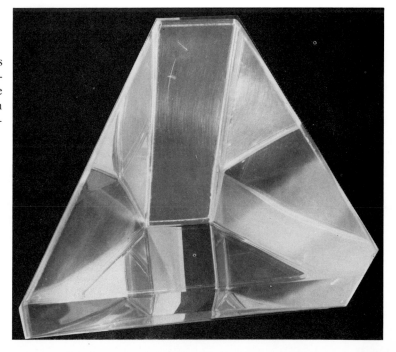

Prism (1967) (19½″ h) by Charles Ross. Solid, or in this case, fluid-filled, prismlike forms enclose multiple reflections of their own angles. *Courtesy: William Rockhill Nelson Gallery of Art*

303

Untitled #9 (1975) by Fred Eversley. The 3′ diameter cast polyester resin piece has a concavity with a deep, subdued reflection *Courtesy: Andrew Crispo Gallery*

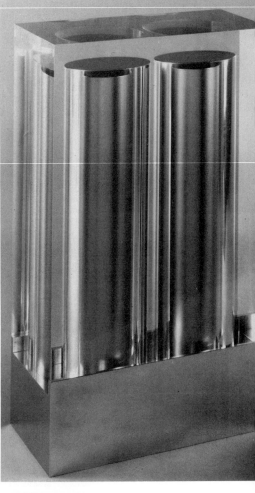

The polished aluminum cylinders are partially reflected and fractured by the sharp planes of the acrylic block. By Charles J. Roitz. *Courtesy: Charles J. Roitz*

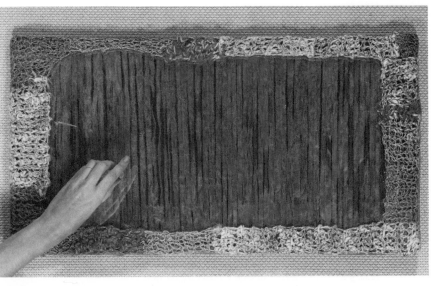

After Forty by Mary Anne Mauro. The face of the mirror is wrapped in torn screening. "The subject has to do with aging. The screening renders a 'not quite there' image," writes the artist. *Courtesy: Mary Anne Mauro. Photo: Bill Titus*

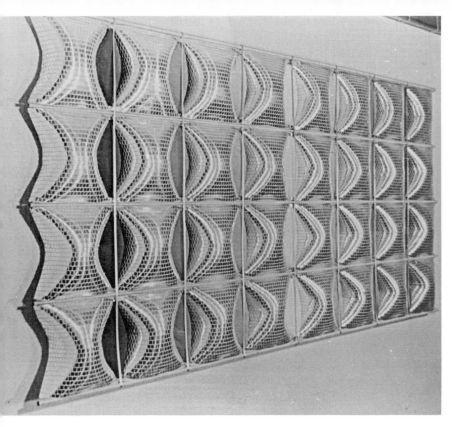

Cynthia Schira is one of relatively few artists who work with reflective materials as a soft medium. *Multitude* (4' × 8' × 6") is woven aluminum and linen. *Courtesy: Cynthia Schira*

Richard Brooker uses mirror to manipulate light and shadow. In this painted wood construction (1975) (54" × 80"), glass mirror edges pick up light from angled spotlights. *Courtesy: Richard Brooker*

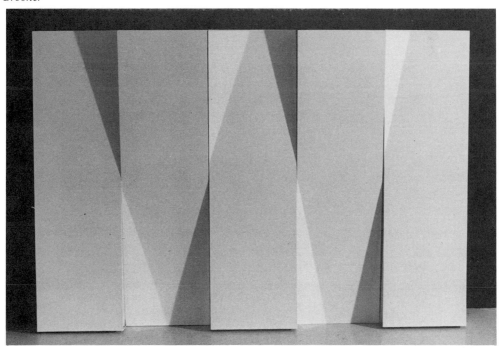

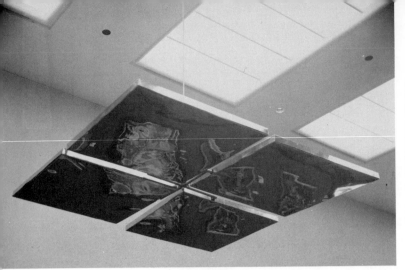

Like many of George Rickey's sculptures, *Four Planes, Hanging* (1966) (96″ × 96″ × 24″) was designed for some movement. The suspended steel planes offer a distorted, unstable reflection of the environment. *Courtesy: William Rockhill Nelson Gallery of Art. Gift of Mr. Richard Shields*

Love of Polyphemus (1974) (19″ × 8″) by Meret Oppenheim. Four-color silkscreen on altuglass, mirrorized. This hand mirror "thrusts back at the narcissist an image of a face pressed against the looking glass, with eyes fused into one, nose crushed and tongue encountering the unappetizing polished surface." From *Mirrors of the Mind* (1975). Published by Multiples, Inc., and Castelli Graphics.

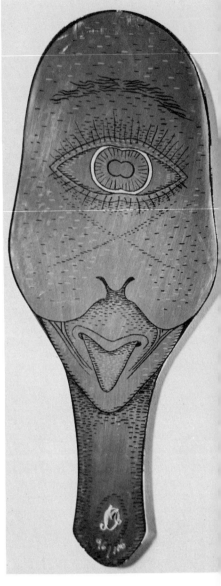

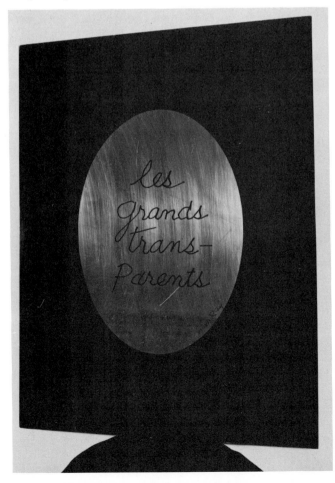

les grands trans-Parents (1974) (25½″ × 19½″) by Man Ray. Two-color silkscreen on altuglass, mirrorized. "The handwritten inscription upon the surface of the mirror tends to confirm the impression that the object's transparency is real, while in fact negating this belief by not inverting the writing mirror-wise," from *Mirrors of the Mind* (1975). Published by Multiples, Inc., and Castelli Graphics.

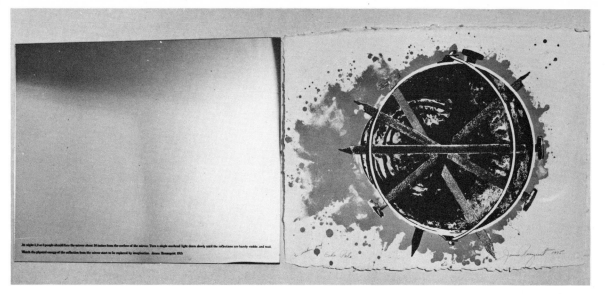

Echo Pale (1975) by James Rosenquist. Five-color lithograph and two-color silkscreen (23½″ × 31¼″), Plexiglas mirror with one-color silkscreen (23″ × 29½″), one dimmer switch. "In *Echo Pale*, a pail impaled with spikes echoes the mirror. Both are containers; for liquid a bucket, for light particles a looking glass." On the mirror, the artist has silkscreened an invitation: "At night, 1, 2, or 3 people should face the mirror about 30 inches from the surface of the mirror. Turn a single overhead light down slowly until the reflections are barely visible, and wait. Watch the physical energy of the reflection from the mirror start to be replaced by imagination." From *Mirrors of the Mind* (1975). Published by Multiples, Inc., and Castelli Graphics.

Sawdy (39½″ × 36″ × 7″) by Ed Kienholz includes the viewer in the window reflection. The piece is made of car door, mirrored window automotive lacquer, polyester resin, silkscreen, fluorescent light, and galvanized sheet metal. *Courtesy: Gemini G.E.L., Los Angeles, California*

307

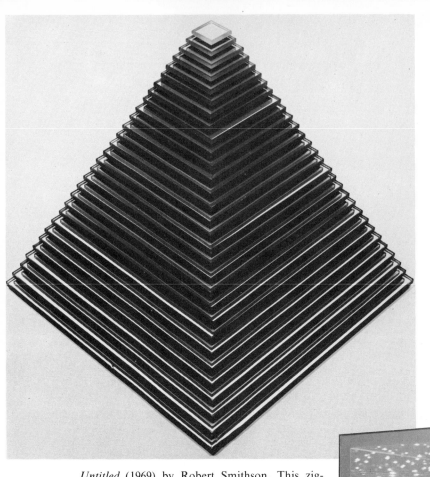

Untitled (1969) by Robert Smithson. This zigguratlike structure is made of mirrored glass. Each level reflects down on the previous level. It comes in two sizes (8⅜″ × 8⅜″ × 5″), (12⅛″ × 12⅛″ × 7½″). Published by Multiples, Inc.

Infinity Light (1967) (59⅛″ × 27½″ × 23⅞″) by Stanley Landsman. Small lights suspended randomly throughout the inside of the mirrored box are reflected to infinity by mirrors. Two sides of the box have one-way mirrors—which can be seen through—to allow viewers to see the infinity of lights while not themselves becoming part of the enclosed reflections. *Courtesy: William Rockhill Nelson Gallery of Art. Gift of the Friends of Art*

The Difficulties of Introspection (1974) by Tad Bridenthal is an asymmetrical, truncated icosahedron. It is mirrored on the inside and receives illumination from colored lights that change through a five-minute cycle. The light change causes the tunnels to move and "gives somewhat the feeling of a science fiction space movie," writes the artist. A person can sit or stand inside and contemplate his disembodied reflection repeated in the diamonds, pentagons, and triangles of mirror. *Courtesy: Tad Bridenthal*

Whitey's Way (1969) (9¾″ × 16¾″ × 10″) by Betye Saar. This mixed-medium assemblage box uses mirror to duplicate and reduplicate the white alligators. *Courtesy: Monique Knowlton Gallery, New York. Photo: Don Farber*

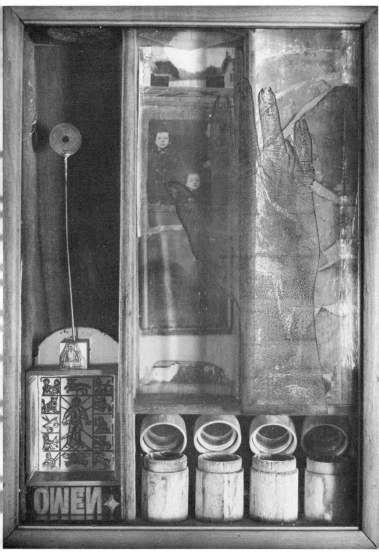

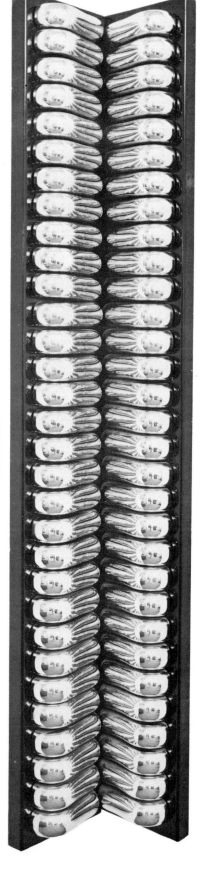

Omen by Betye Saar is a mixed-medium assemblage box. Antiqued broken mirrors are set behind the hand on the right. Small round mirrors are inside the lids of the wooden cylinders. When you look into this box, you become part of the assemblage. *Courtesy: Monique Knowlton Gallery, New York. Photo: Frank J. Thomas*

62 on Black (1970) by Jason Seley. *Courtesy: Jason Seley. Photo: Charles Uht*

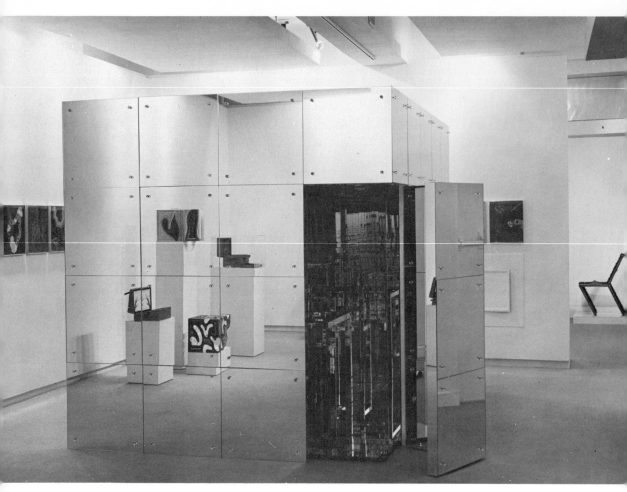

Mirrored Room #2 (1966) (8′ × 10′ × 8′) by Lucas Samaras. The outside of the room gives a partial illusion of invisibility. The inside toys with an infinity of reflections. *Courtesy: The Pace Gallery, New York*

APPENDIX

CHEMICAL MIRRORING TECHNIQUES

GLASS AND ACRYLIC CAN BE MADE INTO MIRROR BY THE CRAFTSMAN WHO IS willing to make a modest investment in chemicals and who has some experience in handling caustic substances. Parts of this appendix are reprinted from the *Methods and Materials Manual* of the American Scientific Glassblowers Society, an internal publication available only to members of the Society. We are grateful to them for sharing this information.

The bulk of this appendix discusses methods of metallizing glass with silver, copper, and gold. Acrylic mirroring requires modified procedure, also discussed below. There are primarily three methods of metallizing glass: (1) reduction from solution, usually aqueous; (2) reduction by heat; (3) evaporation in a vacuum. This appendix will emphasize only the reduction from solution methods, since they afford good control with excellent results and minimal equipment.

It must be emphasized that all the techniques described involve dangerous chemicals. Protective gloves should be worn at all times. Adequate ventilation is essential. If spray techniques are used, then face masks are required. All chemicals should be stored in metal cabinets, out of reach of children. Spent solutions should *never* be left standing. This rule especially applies to the ammoniacal silver solution left over from silvering. It may form silver amide and/or silver azide. The azide is a sensitive explosive. To inactivate this solution, add common table salt. The salting precipitates the silver. Only then should the substance be discarded. Refer to the end of the appendix for a brief

discussion of the individual chemicals being used. This paragraph is not intended to deter the interested craftsman—it is only to open all eyes to the potential dangers in using chemicals.

PREPARATION OF THE GLASS SURFACE

Generally, soft soda glass is better for metallizing than other types of glass, and new or recently worked glass is preferred to old glass. To produce good mirror quality, the glass must be cleaned free of loose dirt, grease films, and other substances that would interfere with a tenacious metal-to-glass bond. Cleaners that can be used are soap and water, naphtha, or alcohol. These are then followed by a chemical cleaner such as concentrated nitric acid, chromic acid, ammonia, concentrated sodium hydroxide, sodium bicarbonate (brush vigorously), or nitric acid followed by 10 percent sodium hydroxide. Whatever method you choose, be certain that all grease has been removed; otherwise the mirroring will be imperfect.

After cleaning, do not handle glass except with rubber gloves—to avoid depositing new grease. The glass to be metallized must next be treated with a special reagent that *sensitizes* the glass for silvering. Traditionally, reducing agents have been used in this capacity. More recently, a solution of stannous chloride (also called tin salt) is used. In this "tinning" process, the glass is immersed in dilute solution—roughly 1 part stannous chloride to 1,500 parts distilled water) for 20 seconds. Or you can dip or swab the glass with 5 to 10 percent solution of stannous chloride. For example: 7.5 g of stannous chloride crystals dissolved in 750 ml of water is a good solution. The stannous chloride is said to promote and increase adhesion of the metal to the glass, to reduce initial metal deposit time, and to result in a more uniform deposit. If an uneven deposit of tin salt is made, then the mirror may appear irregular and brownish in spots. This irregularity is capitalized upon in creating antiqued mirror effects.

SILVERING PROCEDURE

The same basic chemical process applies to most mirror manufacture. Metals deposit on the glass or plastic from a solution of metal ions, with the assistance of a reducing agent. These agents include dextrose, inverted sugar, tartaric acid, Rochelle salt, among others.

Reduction from Solution

There are three sets of solutions that can be used to deposit silver on glass: (1) the Brashear Process, (2) Rochelle Salt Process, and (3) Formaldehyde Process. All three yield good mirror surfaces and afford the craftsman some control over the mirroring. A caution: Do not attempt to mix stock solutions for one technique with the stock solutions from another technique. It is true

that the fundamental reduction processes are the same for all three techniques. But the inadvertent substitution of solutions will usually yield poor-quality products and potentially hazardous chemical combinations.

All water used in these solutions must be purified or distilled; otherwise the water will introduce impurities. All mixing flasks, like the glass itself, must be well cleaned and rinsed with distilled water.

A single silvering application leaves a metal film that is very thin—about .0005 mm. With any of the following processes, several layers of metal can be applied to obtain thicker silver deposits.

BRASHEAR PROCESS

This process begins with the preparation of three solutions:

SOLUTION A: 20 g silver nitrate dissolved in
 300 ml water
SOLUTION B: 14 g potassium hydroxide dissolved in
 100 ml water
SOLUTION C: (The reducer solution. Three reducer solutions are listed here,
 any one of which works well.)
 1. 90 g table sugar
 4 ml concentrated nitric acid
 175 ml isopropyl or ethyl alcohol
 1 L water
 (This solution must age for two weeks to a month.)
 2. 11 g table sugar
 4.8 ml concentrated nitric acid
 120 ml water
 (Boil and cool. Ready for use.)
 3. 7.8 g dextrose
 120 ml water
 (Ready for use.)

Add concentrated ammonia to Solution A until the dark silver oxide that appears (precipitates) begins to clear. Add this ammonia drop by drop while gently shaking the flask. When solution just clears, add a few more drops of Solution A until the mixture has a distinct straw color. Now add Solution B *slowly* to the Solution A/ammonia. Stir. Again add ammonia until the solution just clears; then add a few drops of Solution A until a thin straw—or brown-colored—precipitate appears. Exercise caution with the mixing of this silver nitrate/ammonia/potassium hydroxide solution—it can potentially form fulminating silver, which is explosive.

Filtering of this combined solution is optional. Next add 120 ml of Solution C, and *immediately* pour the mixture into or over the object to be metallized. (The glass should have already been cleaned, sensitized, and lightly rinsed with distilled water. It should be set in a tray, which will collect all solution runoff.) Gentle swirling of the glass for a second or two up to several minutes is suggested, to try to achieve even distribution of metal film. In designing your pouring tray, be certain to make it large enough to catch all runoff. Often the

The silvering process should always be done in a tray that will collect spent solutions. Here, for instance, a turkey roasting pan (made of aluminum) is used. The glass is perched on the rim so that it needn't touch the solutions lying in the bottom. A tray with wooden slats in the bottom is an even better solution, since the glass could sit stably deeper in the pan. Distilled water is one of the staples of metallizing. Between virtually every step in silvering, distilled water rinses are essential.

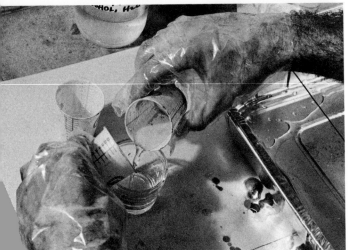

Plastic, or preferably glass, measuring cups and containers are used for mixing solutions.

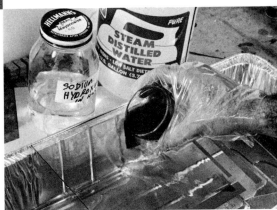

In some silvering processes, the mixed chemical solutions will immediately start to react, precipitating silver. Quickly pour mixed solutions onto the cleaned and sensitized glass surface.

pouring in the tray is done onto glass laid across wooden slats. The slats keep the glass suspended in the tray so that excess solution does not come back in contact with it.

After plating, gently rinse the glass in distilled water. A full silver coat by this process requires 6 to 10 minutes. If the plate is thin, another coat may be applied without letting the mirror dry between applications. This entire process is ideally performed at 18° to 20°C.

There are many other versions of this Brashear Process. One other popular version is provided here:

SOLUTION A: 50 g silver nitrate
2 L distilled water
SOLUTION B: 90 g potassium hydroxide
2 L distilled water
SOLUTION C: 80 g cane sugar
800 ml distilled water
3.5 ml nitric acid (of specific gravity 1.42)
100 ml alcohol

Add ammonia, following the same procedure as outlined above. Instead of using equivalent (1:1:1) amounts of the three solutions, this procedure calls for 16 volumes of Solution A combined with 8 volumes of B and 1 volume of C (A:B:C, 16:8:1). Cleaning of glass for this procedure should be done with sodium bicarbonate at 80°F for 30 to 45 minutes, followed by six rinses with distilled water, prior to sensitizing and silvering.

Under proper conditions, one gram of the silver nitrate (which is the most expensive chemical in the process) will cover about 525 cm^2 (square centimeters) of glass by the Brashear Process.

ROCHELLE SALT PROCESS

Deposition by this process is slow, and it may require one hour to form a thick film. This feature makes the process desirable for producing partially reflecting surfaces (such as one-way mirrors). The longer time permits you to visually judge the progress of the metal deposition. Adding 1 to 2 mg of a copper salt for each liter of silvering solution improves the properties of the mirror.

The process involves two solutions:

SOLUTION A: 5 g silver nitrate dissolved in
300 ml water

Ammoniate Solution A as described above in the Brashear Process. Then dilute to a total volume of 500 ml.

SOLUTION B: 1 g silver nitrate dissolved in
500 ml water

Boil Solution B, then add to it:
0.83 g Rochelle salt dissolved in a small quantity of water
(Rochelle salt is the sodium-potassium salt of tartaric acid.)

Filter Solution B/Rochelle salt while hot. Then add water to bring total volume to 500 ml.

To silver, mix equal volumes of Solutions A and B (A:B, 1:1) and pour immediately onto the surface to be silvered. With stated quantities, 200 cm^2 of glass may be silvered.

FORMALDEHYDE PROCESS

This process involves the reduction of ammoniacal silver nitrate solution by formaldehyde solution (formalin), usually without the addition of any alkaline

hydroxide. When using formalin, make certain there is adequate ventilation. Mirrors made by this process are more apt to be uneven and may become spotted in a short time. Factors favoring a good mirror by this process are a low concentration of reducing agent, addition of alcohols, and additional sugar.

Two solutions are mixed:

SOLUTION A: 1 g silver nitrate dissolved in
 100 ml water

Ammoniate Solution A as described earlier in the appendix under the Brashear Process.

SOLUTION B: 50 ml of 40 percent formalin in
 1 L water

Combine Solutions A and B in equal amounts (A:B, 1:1) and pour on prepared glass.

SPRAY METHOD

The reduction methods described thus far involve the hand mixing and pouring of metallizing solutions. Solutions can also be sprayed onto mirror using one or two sprays or jets directed onto the object to be plated. The chemicals mix on the glass surface, where the reduction reaction takes place. This method provides for more stable silver solutions because the ammonia may be added to the reducing solution. Since reduction must be rapid, special fast-acting reducing agents are employed. A number of such reducing agents have been patented, including hydroxylamine sulfate, nitrate, hydrate and hydrochloride, glyoxal, and hydrazine sulfate, nitrate and hydrate. The ratio of reducing solution to silver solution in this process is about 1:1. Special caution should be exercised when using sprays. Protect the face from chemicals that are briefly suspended in the air. Preferably, you should work in a ventilated spraying room.

One set of solutions using hydroxylamine sulfate calls for:

SOLUTION A: 3 oz silver nitrate
 3 oz ammonia
 128 oz distilled water

SOLUTION B: $2\frac{2}{3}$ oz hydroxylamine sulfate (nitrate, hydrate, or hydro-chloride)
 100 oz distilled water

Solutions A and B are sprayed so that they focus on the glass and mix in an approximate 1:1 ratio.

An alternative spray method, using glyoxal as the reduction agent is

SOLUTION A: 3 oz silver nitrate
 2.5 oz ammonia per gal distilled water

SOLUTION B: 2 oz glyoxal per
 1 gal distilled water

Again, a 1:1 ratio is sought in spraying these two solutions on glass. For further details of spray methods (and for greater detail on other mirroring processes), see *Mirrors: A Guide to the Manufacture of Mirrors and Reflective Surfaces* by Bruno Schweig.

Colored Mirrors

The best way to produce colored mirrors is to start with colored glass. For example, silvering of amber glass produces gold mirror. All colors of mirror can be created in this way. If you are interested in making colored mirror by chemical means, various metal deposits can be used to produce distinctive hues. However, we recommend that you use the silvering techniques to metallize colored glass—they require no additional purchase of chemicals and they afford greater options in color selection.

METALLIZING GLASS WITH GOLD

Originally, gold mirror was obtained by gold leafing on glass. Such a reflective surface, while quite decorative, could hardly be used as a looking glass. Reduction techniques for applying gold were developed almost as long ago as silvering methods.

One of the classic formulas for mirroring with gold is the following:

SOLUTION A: 25 g gold chloride (50 percent) dissolved in
 1 L distilled water
SOLUTION B: 20 g citric acid
 10 ml ammonia
 1 L distilled water

Use equal quantities of the solutions (A:B, 1:1) and apply to glass by pouring.

METALLIZING GLASS WITH COPPER

Copper coatings on glass are generally obtained by reducing an aqueous solution of a complex copper salt in the presence of a small quantity of silver or other noble metal that acts as a catalyst. In some processes, a thin film of silver or other noble metal is necessary before the glass will bind the copper. A suitable film of this kind may be prepared by rinsing the glass in stannous chloride solution, then dipping it in an alkaline (basic) solution of a noble metal. Many silver mirrors purchased today are made by first plating a thin layer of silver, and then backing the silver with a coating of copper as protection.

Many different solutions have been suggested for copper mirroring. Two popular formulations are described here. The first process requires three solutions:

SOLUTION A: 30 g copper sulfate
 20 ml concentrated ammonia
 80 ml glycerol (glycerin is the same)
 1 L distilled water
SOLUTION B: 9 percent solution of sodium hydroxide
SOLUTION C: 100 g sucrose
 0.5 ml nitric acid
 250 ml distilled water

Heat Solution C until it turns amber; then add
 500 ml formalin (this is a 40 percent solution of formaldehyde
 in water)

Then add enough distilled water to bring total volume of Solution C to 1,250 ml.

Mix the three solutions in a ratio of A:B:C, 1000:400:200. Immediately apply to the glass surface, as described in the silvering process.

A second formulation of coppering solutions is:

SOLUTION A: 4 g copper sulfate
 6 g sodium hydroxide
 15 g sodium potassium tartrate (Rochelle salt)
 1 L distilled water
SOLUTION B: 100 ml formalin

Mix A and B in a ratio of A:B, 10:1. Pour over the glass surface. Rinse with distilled water after plating.

Metallizing Acrylic

Acrylic is silvered in nearly the same way as glass. The major change is in the sensitizing solution applied before silvering. Treat the acrylic with a solution of 3 g tannic acid dissolved in 1 L of distilled water. Then follow normal silvering procedures.

AFTER-TREATMENT OF METAL FILMS

The silver film applied to glass is extremely thin. It can be scratched, damaged by chemicals, or even distorted by particles in the air.

A common procedure in mirror manufacture, therefore, is the application of a coat of copper after the silver film has been applied. A chemical technique for pouring the copper layer was described above. Manufacturers prefer to use a spray method to deposit the copper. The copper is deposited on silvered mirrors by simultaneously applying a copper sulfate solution and a suspension of zinc dust or powder. The copper sulfate may be as concentrated as 6 to 40 oz. per gallon of distilled water. The zinc concentration can vary from 1 to 6 oz. per gallon of distilled water. The most effective mixtures seem to be 16 oz. copper sulfate per gallon and 3.2 oz. zinc powder per gallon. For complete details on this and almost all other metallizing processes, see *Mirrors* by Schweig, listed in the Bibliography.

Other methods of protection include lacquering. Most lacquers, however, tend to reduce the reflectivity of the mirror, due to frilling. Test out any lacquers or paints beforehand on sample mirrors. Asphaltum varnish applied to dry metallic film with a clean, soft brush will prevent scratches, guard against deleterious effects of the atmosphere, and resist chemical marring by backing paints.

After the coat of shellac or varnish dries, commercially available mirror-backing paints can be applied. Brush, spray, or roll on the paint in even coats. Critical note: The silver film must be *absolutely dry* before any coating is applied. Setting newly metallized mirror in a warm room or on a heating table facilitates desiccation.

REMOVAL OF MIRROR FILM

There are many reasons for removing metal film from glass. If a silvering job is too nonuniform, you can strip off the silver and start again. As a decorative device, you may choose to remove areas of silvering, leaving regions of clear glass.

And, of course, the front face of a newly silvered and painted mirror will require cleaning after being hand poured and backed. Although you try to mirror only one side of the glass, it is usually impossible to avoid getting some of the chemicals depositing on the front of the glass. When cleaning the front, avoid using chemical solvents. The chemicals are liable to seep onto the back of the mirror and instantly mar the metallized finish. Use steel wool, razor blades, or a flexible shaft tool equipped with a glass-polishing brush and polishing rouge.

To intentionally remove metal film from the *back* side, try one of several craft products (such as Mir-Off), which are manufactured in easily controlled concentrations that will not damage hands. With these products it is possible to mask parts of the mirror so that only certain parts of the metal film will be dissolved. Concentrated nitric acid is the means most commonly employed in industry to remove a silver finish, but it is rather dangerous to handle. Dilute hydrochloric acid is also an effective metal film remover. (In higher concentrations it also etches glass.) If the mirror is protected by varnish or lacquer, a suitable paint remover or solvent for these coatings must first be used. A warm 5 percent solution of sodium hydroxide in water will also serve as a general solvent.

DEFECTS

There are some common defects that can be traced to specific chemical and procedural errors. Defects seen in the completed mirror—such as *specks* and *blurring*—can often be attributed to dirt or grease left on the glass. Cleaning procedure should be improved. Also, glassware used in the mixing of solutions should be scrubbed. Be certain that *only* distilled water is used in all cleaning and solutions.

Browning of areas of the mirror can be caused by a too-concentrated solution of sensitizer (e.g., stannous chloride) or by not applying enough distilled water after the sensitizing solution was applied. *Brush marks* may be left in the mirror if the lacquer brush was too stiff. *Scalloped spots* (frilling) usually indicate a release of the bond between metal and glass. This can be caused by grease on the glass or by atmosphere or chemicals attacking through an imperfect protective backing. This can also result from applying backing materials before the metal film has completely dried.

SPECIAL EFFECTS

Designs can be incorporated in mirrors by painting, masking, or silkscreening glass before it is metallized. Apply designs, allow to dry, clean the glass and

sensitize it as normally, then silver right over the painted/screened/masked designs.

Mirror can be given that "antiqued" deteriorating look during the silvering process. After applying stannous chloride, randomly speckle the surface with tap water, or destroy parts of the stannous chloride coating with dilute hydrochloric acid. Or try smearing the stannous chloride solution unevenly on the glass surface. Then silver the mirror as you normally would. The silver film will be intentionally flawed to create an antique effect wherever sensitizing coat was tampered with. Mirror can be distorted *after* it is silvered by speckling the back with small stannous chloride crystals. The antique effect can be enhanced further by scratching "veins" into the silver film from the back, and then lacquering and painting.

One-way mirrors—which from one side seem to be perfect mirrors but actually can be seen through from the other side—are made by applying just a thin coating of silver. Because the Rochelle Salt Process is relatively slow, it is recommended as a means of producing one-way mirrors. Just stop the silvering at a point when you can still see through the silver from one side but get a good reflection from the front. To protect the thin metal film without losing the one-sided transparency, apply a clear lacquer after the film has dried. Such mirrors can best be seen through when the light is brighter on the side being spied upon. Anyone on the "normal" looking-glass side will see only his own reflection.

CHEMICAL INFORMATION

Ammonia: (NH_3) This is a pungent-smelling, colorless gas usually handled in water solution. In water it is believed to form a base, ammonium hydroxide (NH_4OH). When combined with silver nitrate in the silvering process, it complexes with the silver: $Ag(NH_3)_2NO_3$. Keep ammonia solutions well stoppered and in a cool place. Usual solutions to be purchased contain 35 percent ammonia gas in weight.

Copper Sulfate: ($CuSO_4 \cdot 5H_2O$) Has large blue crystals. Like copper chloride, it serves as a source of copper ions in copper metallizing.

Dextrose (or Glucose): ($C_6H_{12}O_6 \cdot H_2O$) Derived from sweet fruits, it is a good reducing agent for silver nitrate. It is especially effective in the presence of a strong base such as sodium hydroxide or potassium hydroxide.

Formaldehyde (or formalin): (HCHO) This is an odorous gas readily absorbed by water. It is an extremely strong reducing agent and is widely used in

mirror manufacture. Usually sold at a concentration of 40 percent water by weight. Good ventilation is required when using it.

Glycerol (or glycerin): ($C_3H_5 (OH)_3$) A thick colorless liquid that is used as a complexing agent with copper in copper metallizing process. Has a long shelf life.

Glyoxal: (CHO·CHO) It is made by the oxidation of formaldehyde. Like formaldehyde, it is a potent reducing agent, although somewhat milder. Sold in 30 percent solution, its odor is less abusive. It usually replaces formaldehyde in spray applications of silver film.

Gold Chloride: Its sodium salt ($AuNaCl_4$·$2H_2O$) contains about 50 percent gold and is easily dissolved in water. Such a solution has a long shelf life.

Hydrazine (and hydrazine sulfate): When hydrazine (N_2H_4—a relative of ammonia) is combined with sulfuric acid to form hydrazine sulfate (N_2H_4·H_2SO_4) it is useful in silvering. A white crystalline solid, it is made soluble in water by heating.

Hydrochloric Acid: (HCl) A strong acid that should not be handled in the same room with silvering materials—it can spoil the silver finish just by its vapor's presence in the air. It is used to dissolve silver from mirror or to precipitate out silver from spent solutions. Be careful when diluting HCl: as with any acid, the acid should be added to the water. *Never* pour the water into a flask of acid; otherwise acid may explode or splatter.

Hydroxylamine (or hydroxylamine sulfate): Hydroxylamine (NH_2OH) is a relative of ammonia. Its sulfated form is a strong reducing agent similar to hydrazine sulfate.

Inverted Sugar (or inverted sucrose): It is a chemical modification of sugar, which is made in the following way: Dissolve 100 g sucrose (table sugar) in 1 L water. Add 20 ml dilute nitric or sulfuric acid that has been diluted to 10 percent by volume. Boil for several minutes. The result is inverted sugar, a reducing agent with a shelf life of only about one week if kept well stoppered and in a cool place.

Nitric Acid: (HNO_3) This is one of the strongest of acids and must be handled with great respect. It can be bought diluted to 10 percent by volume, which is comparatively harmless. However, many silvering processes require a more concentrated acid. Keep it well stoppered in glass vials. When handling it, wear gloves. (You should always wear gloves when working with these chemicals.) Always pour acid into water when diluting. Never pour water into acid. Too much heat and splattering is produced.

Potassium Hydroxide: (KOH) It is a base that can be used interchangeably with sodium hydroxide in most applications. It is more expensive than the

sodium hydroxide. Like sodium hydroxide, some heat may be produced when it is dissolved in water. It should be put into solution in a container that will not crack from heat (e.g., earthenware jug). Stir with a glass rod until dissolved. After heat dissipates, transfer to a storage container with a tight lid.

Rochelle Salt (sodium potassium tartrate): ($C_4H_4O_6KNa \cdot 4H_2O$) This salt readily dissolves in water. In the presence of sodium or potassium hydroxide it will complex with either silver or copper. Rochelle salt solutions must be made up regularly, since they have a shelf life of only a few days.

Silver Nitrate: ($AgNO_3$) This is the source of silver in most silvering processes. The rhomboid crystals are extremely water soluble and can be stored in solution for a fairly long period of time. Silver nitrate is poisonous but is no threat in small amounts. If the crystals or solution gets on hands or clothes, black stains will *not* come out. When the skin layer wears off, the black spots disappear.

Sodium Hydroxide: ($NaOH$) Also known as caustic soda, it is available in rod, pellet, or flake form. It is an extremely strong base. When immersed in water, sodium hydroxide develops a great deal of heat. The heat may crack a glass container and the chemical may splash up in eyes. Use protective gear, and earthenware or heat-resistant containers for mixing. Stir with glass rod. Cool the water immediately by setting the mixing container in an ice water bath. After cooling, the solution may be transferred to another container with a tight-seal screw top. Avoid containers with glass stoppers, as they might fuse with the glass bottle.

Stannous Chloride: ($SnCl_2 \cdot 2H_2O$) Also called tin salt, this is among the strongest reducing agents. It is used as a sensitizing solution on glass before applying silvering solutions. Because it is so readily oxidized, the solution must be made fresh regularly. If crystals become yellow, do not use them, they will have lost their potency. Stannous chloride can be made by dissolving tin foil in heated concentrated hydrochloric acid.

Sugar (or Sucrose): See Inverted Sugar.

Zinc Sulfate (or Zinc dust or Zinc powder): ($ZnSO_4 \cdot 7H_2O$) This metal salt is useful for causing copper to deposit on glass.

BIBLIOGRAPHY

CALAS, NICHOLAS. *Mirrors of the Mind.* New York: Multiples, Inc., and Castelli Graphics, 1975.

DELLY, JOHN GUSTAV. "Deposition of Metals on Glass: A Practical Laboratory Guide and Formulary." In *Methods and Materials Manual.* Wilmington, Del.: American Scientific Glassblowers Society, 1969.

GLUCK, IRVIN D. *It's All Done with Mirrors.* New York: Doubleday and Co., 1968.

HELD, SHIRLEY E. *Weaving: A Handbook for Fiber Craftsmen.* New York: Holt, Rinehart and Winston, 1973.

LOWENKEIM, FREDERICK. *Modern Electroplating.* New York: John Wiley and Sons, 1963.

MEILACH, DONA Z. *A Modern Approach to Basketry.* New York: Crown Publishers, Inc., 1974.

———. *Macramé: Creative Design in Knotting.* New York: Crown Publishers, Inc., 1971.

NEWMAN, JAY HARTLEY, AND NEWMAN, LEE SCOTT. *Plastics for the Craftsman.* New York: Crown Publishers, Inc., 1972.

———. *Wire Art.* New York: Crown Publishers, Inc., 1975.

NEWMAN, THELMA R. *Contemporary Decoupage.* New York: Crown Publishers, Inc., 1972.

———. *Crafting with Plastics.* Radnor, Pa.: Chilton Books, 1976.

———. *Leather as Art and Craft.* New York: Crown Publishers, Inc., 1973.

——. *Plastics as an Art Form.* Radnor, Pa.: Chilton Books, 1969.

——. *Plastics as Design Form.* Radnor, Pa.: Chilton Books, 1972.

——. *Plastics as Sculpture.* Radnor, Pa.: Chilton Books, 1974.

——. *Quilting, Patchwork, Appliqué, and Trapunto.* New York: Crown Publishers, Inc., 1974.

——. *Woodcraft.* Radnor, Pa.: Chilton Books, 1976.

——, AND NEWMAN, JAY HARTLEY. *The Container Book.* New York: Crown Publishers, Inc., 1977.

——, NEWMAN, JAY HARTLEY, AND NEWMAN, LEE SCOTT. *Paper as Art and Craft.* New York: Crown Publishers, Inc., 1973.

NILAŪSEN, BARBARA. *The Process of Electroforming and Its Application to Ceramics.* Iowa City: University of Iowa, 1972.

ROSSBACH, ED. *Baskets as Art.* New York: Van Nostrand Reinhold Co., 1973.

SCHWEIG, BRUNO. *Mirrors: A Guide to the Manufacture of Mirrors and Reflective Surfaces.* London: Pelham Books, Ltd., 1973.

SOUTHALL, JAMES P. C. *Mirrors, Prisms and Lenses: A Textbook of Geometrical Optics.* New York: Dover Publications, Inc., 1933.

SPIRO, PETER. *Electroforming.* London: Robert Draper, Ltd., 1971.

UNTRACHT, OPPI. *Metal Techniques for Craftsmen.* New York: Doubleday and Co., 1968.

ZNAMIEROWSKI, NELL. *Step by Step Weaving.* New York: Golden Press, 1967.

INDEX

Pages in italic refer to illustrations.

bending of, 140–47
carving of, 127–31
finishing of, 117–18
gluing of, 115–17
joining of, 115–117
lamination of, 135–38
mirror frames of, 119–26
woodworking tools, 114–15
wrapping and coiling, 224–26
Wright, Frank, 292
Wrightsman, Sue, 275

Z

Zimmerman, Elyn, 40